Bob Ross'

New

Joy of Painting

by Annette Kowalski

COLLINS LIVING
An Imprint of HarperCollinsPublishers

Library of Congress Cataloging-in-Publication Data

Ross, Bob, 1942–1995
 Bob Ross' new joy of painting
 / [edited by] Annette Kowalski.
 p. cm.
 ISBN 0-688-15158-2
 1. Landscape painting—Technique. I. Kowalski, Annette. II. Joy
of painting (Television program). III. Title.
ND1342.R59 1993
751.45´436—dc20 93-25347
 CIP

Manufactured in China

10 11 12 13 SCP 20 19 18 17 16 15 14 13 12 11

To Bob Ross,

who not only put the joy in the painting,

but put the joy back into my life.

a.k.

ACKNOWLEDGEMENTS

So many very, very special people have helped to make this book possible. To name but a few:

• Bill Adler and all of the dedicated people at the William Morrow Company.

• James Needham, WIPB-TV

• Jerry Harper, Cover Portrait

• Joan Kowalski, Editorial Assistance
 Joseph Kowalski, Editorial Assistance

• Nancy Cox, How-to Photography

• Rick Kinkead, a very special thank you.

• Last, but never least, Walt Kowalski.
 How would we ever have done it without you!

TO THE ARTIST

I have always known that there was a creative person living inside of me and for years I purchased literally hundreds of art books and had attempted most styles of painting. I had achieved a reasonable degree of success; my family and friends had offered me encouragement, support and praise, but I personally felt unfulfilled in my art and knew there must be more to it than what I was experiencing.

In 1981, I lost a child in a traffic accident and my world came crashing down around me. In desperation, I turned to art as diversion from the intense pain that was clouding my world. I had heard about an artist from Alaska who was traveling around the country teaching a completely different style of painting than I had ever been exposed to. After some diligent detective work, I found that this artist was holding open classes in Clearwater, Florida, a small town almost a thousand miles from my Washington, D. C. home. I am blessed with a loving, but more importantly, an understanding husband who did not flinch when I told him I wanted to go to Florida and find this artist that I had only heard about. Plans were quickly made and my husband, Walt, loaded our van and he, my son Joe and I left on a trip that would ultimately change the course of all our lives.

In the beginning I assumed this would be just another routine art class, but nothing could have been further from the truth. It was in this class that I met Bob Ross and for the first time I truly did experience the Joy of Painting. This 6'2" bushy headed, ex-GI walked around the class room spouting his arm-chair philosophy about nature, love, concern for each other, the environment and other positive ideas; at the same time he shared his passion for his art and instilled in each of us the confidence to try a new method of painting. His soothing, gentle voice, which has been described as a liquid tranquilizer, took away all my fears and his constant reassurance convinced me that not only could I paint like him, but that I could face the future with a positive outlook.

I painted with Bob for five days and in that short period of time I knew I had found the style of painting that I had been searching for so many years. I had also discovered a reason to continue on with my life and I wanted desperately to share my discovery with everyone I knew. On the drive back to our home, I convinced my husband to allow me to bring Bob to our area to teach. Walt agreed and little did I know that from this simple beginning a friendship, and eventually a partnership, would evolve.

Since that day, so many years ago, I have had the opportunity to work and travel with Bob around the world. I have watched him work his magic over and over again with people from every walk of life. I have seen him share the excitement of success with his students and I've also seen him cry as he shares their grief when they experience personal pain. I've seen him pass up celebrities or the heads of giant corporations to give encouragement to a timid child or to hug an elderly person who felt the world had forgotten them. Over the years I have come to understand that the joy is not in the painting, the joy is in the man, Bob Ross. In this book I have taken sixty of Bob's favorite paintings and presented them in an easy-to-understand format that will allow you to share the joy that comes from creating your own beautiful works of art. The paintings in this book are not arranged in order of difficulty. Each painting and the accompanying instructions are complete and independent, so all you have to do is locate a painting that interests you and begin. I suggest that you take the time to read the instructions completely and review the how-to photographs before beginning to paint, in order to familiarize yourself with the progressional steps involved in the painting of your choice.

Use each painting as a learning experience and evaluate the good areas as well as the weaker parts of your painting. Remember, there is no failure in painting, only learning. And as I've heard Bob say a thousand times, I hope you never create a painting that you're totally satisfied with, for it's this dissatisfaction that will create the motivation necessary for you to start your next painting, armed with the knowledge you acquired from the previous one.

You may never know Bob the way that I know Bob, but through his television series, books and instructional video tapes, you can share the "Joy" he has brought to the world through his paint brush.

May you always have The Joy of Painting,
Annette Kowalski

INTRODUCTION

There are no great mysteries to painting. You need only the desire, a few basic techniques and a little practice. If you are new to this technique, I strongly suggest that you read the entire Introduction prior to starting your first painting. Devote some time to studying the instructions, looking carefully at the "how-to" pictures and at the finished paintings. Use each painting as a learning experience, add your own ideas, and your confidence as well as your ability will increase at an unbelievable rate. For the more advanced painter, the progressional "how-to" photographs may be sufficient to paint the picture.

PAINTS

This fantastic technique of painting is dependent upon a special firm oil paint for the base colors. Colors that are used primarily for highlights (Yellows) are manufactured to a thinner consistency for easier mixing and application. All of the paintings in this book were painted with the Bob Ross Paint Products. The use of proper equipment helps assure the best possible results.

The Bob Ross technique is a wet-on-wet method, so normally our first step is to make the canvas wet. For this, apply a thin, even coat of one of the special base paints (Liquid White, Liquid Black or Liquid Clear) using the 2" brush. Long horizontal and vertical strokes, assure an even distribution of paint. The Liquid White/Black/Clear allows us to actually blend and mix colors right on the canvas rather than working ourselves to death on the palette.

The Liquid White/Black/Clear can also be used to thin other colors for application over thicker paints much like odorless thinner or Copal Medium. The idea that a thin paint will stick to a thick paint is the basis for this entire technique. This principle is one of our Golden Rules and should be remembered at all times. The best examples of this rule are the beautiful highlights on trees and bushes. Your Liquid White/Black/Clear is a smooth, slow-drying paint which should always be mixed thoroughly before using.

Liquid Clear is a particularly exciting ingredient for wet-on-wet painting. Like Liquid White/Black, it creates the necessary smooth and slippery surface. Additionally, Liquid Clear has the advantage of not diluting the intensity of other colors especially the darks which are so important in painting seascapes. Remember to apply Liquid Clear *very* sparingly! The tendency is to apply larger amounts than necessary because it is so difficult to see.

Should your Liquid White/Black/Clear become thickened, thin it with Ross Odorless Thinner (not turpentine or other substances).

I have used only 13 colors to paint the pictures in this book. With these 13 colors the number of new colors you can make is almost limitless. By using a limited number of colors, you will quickly learn the characteristics of each color and how to use it more effectively. This also helps keep your initial cost as low as possible. The colors we use are:

*Alizarin Crimson	*Sap Green
Bright Red	*Phthalo (Phthalocyanine) Blue
*Dark Sienna	*Phthalo (Phthalocyanine) Green
Cadmium Yellow	Titanium White
*Indian Yellow	*Van Dyke Brown
*Midnight Black	Yellow Ochre
*Prussian Blue	

(*Indicates transparent or semi-transparent colors, which may be used as underpaints where transparence is required.)

MIXING COLORS

The mixing of colors can be one of the most rewarding and fun parts of painting, but may also be one of the most feared procedures. Devote some time to mixing various color combinations and become familiar with the basic color mixtures. Study the colors in nature and practice duplicating the colors you see around you each day. Within a very short time you will be so comfortable mixing colors that you will look forward to each painting as a new challenge.

Avoid overmixing your paints and strive more for a marbled appearance. This will help keep your colors "alive" and "vibrant." I try to brush mix a lot of the colors, sometimes loading several layers of color in a single brush. This double and triple loading of brushes creates effects you could never achieve by mixing color on the palette. Pay very close attention to the way colors are loaded into the brushes or onto the knife.

THE PAINTER'S GLOVE

To solve the problem of removing paint from hands after completing a painting project, try using a liquid hand protector called THE PAINTER'S GLOVE, which I developed. This conditioning lotion is applied to the hands *before* you begin painting. Then, simply wash with warm, soapy water.

PALETTE

To me, my palette is one of the most important pieces of equipment I own. I spent a lot of time designing the palette I use, making it both functional and comfortable. It is large enough to provide ample working space for the large brushes and knives, yet lightweight. I recommend that your palette be made from a smooth, nonporous material such as clear acrylic plastic. Avoid wooden palettes which have not been varnished, or fiberboard or paper palettes. Wood palettes are rarely smooth and, unless well sealed, will absorb the oil from your paint as will fiberboard and paper. These types of palettes can cause your paint to become dry and chalky causing numerous problems. My palette is clear, so it will not distort color, is extremely smooth for easy brush or knife loading, and the plastic will not absorb oil and is easy to clean.

Form the habit of placing your paints in the same location

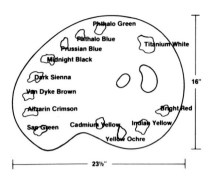

on your palette each time you paint. You can spend an unbelievable amount of time looking for a color on an unorganized palette. The illustration gives the dimensions and color layout of my palette as used on the TV series.

Unused colors may be saved for several days if covered with plastic wrap or foil; for longer periods, cover and freeze. To clean your palette, scrape off excess paint and wipe clean with the thinner. Do not allow paint to dry on your palette. A smooth, clean surface is much easier to work on.

BRUSHES

The brushes you use should be of the finest quality available. Several of the brushes I paint with look very similar to housepainting brushes, but are specifically designed for this method of painting. They are manufactured from all-natural bristles and come in four basic shapes: 2", 1", 1" round and 1" oval. Be careful not to confuse natural bristle with manmade bristles such as nylon, polyester or other synthetic bristles. AVOID WASHING THE BRUSHES IN SOAP AND WATER. Clean your brushes with odorless thinner.

The four large brushes will normally be your most used pieces of equipment. They are used to apply the Liquid White/Black/Clear, paint clouds, skies, water, mountains, trees, bushes and numerous other effects with surprising detail. The 2" brush is small enough that it will create all the effects the 1" brush is used for, yet large enough to cover large areas very rapidly. Another member of the large-brush family is the 1" round brush. This brush will create numerous fantastic effects such as clouds, foothills, trees and bushes. Using several of each brush, one for dark colors and one for light colors, will save you brush-washing time and lessen the amount of paint used.

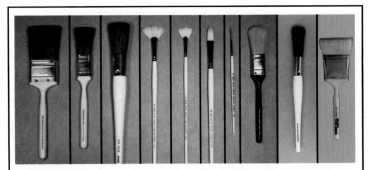

Left to right: 2" Brush, 1" Brush, 1" Round Brush, #6 Fan Brush, #3 Fan Brush, #6 Filbert Brush, Liner Brush, 1" Oval Brush, Half-Sized Round Brush, and 2" Blender Brush.

A #6 Filbert Bristle Brush is used mostly for the seascapes and can also be used for tree trunks and other small detail work. The 1" Oval Brush is primarily used for making evergreen trees and foothills and for highlighting trees and bushes. The small Half-Sized Round Brush will create beautifully shaped trees, bushes and foliage.

Two other brushes that I use a great deal are the #6 and #3 bristle fan brushes. Your fan brush may be used to make clouds, mountains, tree trunks, foothills, boats, soft grassy areas and many other beautiful effects. Devote some practice time to these brushes and you will not believe the effects you can achieve.

A #2 script liner brush is used for painting fine detail. This brush has long bristles so it holds a large volume of paint. Normally, the paint is thinned to a water consistency with a thin oil (such as linseed or Copal oil) or odorless thinner. Turn the brush in the thin paint to load it and bring the bristles to a fine point. This brush is also used to complete one of the most important parts of the painting, your signature.

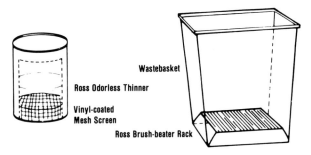

Wastebasket

Ross Odorless Thinner

Vinyl-coated Mesh Screen

Ross Brush-beater Rack

The 2" Blender Brush makes it possible now, as never before, to achieve all of those soft, delicate, subtle areas so often found in landscapes and seascapes: skies with soft, wispy clouds, the misty areas at the base of mountains, background trees and waterfalls. In seascapes, the 2" Blender is especially effective for blending the transparency or "eye" of the large wave.

CLEANING THE BRUSHES

Cleaning the brushes can be one of the most fun parts of painting. It's an excellent way to take out your hostilities and frustrations without doing any damage. I use an old coffee can that has a ¼" mesh screen in the bottom. The screen stands about 1" high and the Ross Odorless Thinner is approximately ¾" above that. To clean your brush, scrub the bristles firmly against the mesh screen to remove the paint. (Be sure to use a screen with vinyl coating to avoid damage to your brush bristles.) Shake out the excess thinner then beat the bristles firmly against a solid object to dry the brush. Learn to contain this procedure or you will notice your popularity declining at a very rapid rate. One of the simplest and most effective ways of cleaning and drying your brushes is illustrated below (left).

Bob Ross Brush Cleaning System Kit, Ross Odorless Thinner, Brush-beater Rack, Thinner Screen.

The brush is shaken inside the wastebasket to remove excess thinner, then the bristles are firmly beaten against the Ross Brush-beater Rack. (The rack size is 10¾" L x 5¼"W x 5¾"H.)

Odorless thinner never wears out. Allow it to settle for a few days, then reuse. Smaller brushes are cleaned with the thinner and wiped dry on a paper towel or rag.

After cleaning, your brushes can be treated and preserved with THE PAINTER'S GLOVE lotion before storing. Take care of your brushes and they will serve you for many years.

PALETTE KNIFE

The palette knives I use are very different from traditional painting knives. They are larger and firmer. Practice is required to make these knives into close friends, so spend some time learning to create different effects.

I use two different knives, a large one as well as a smaller knife. The smaller knife is excellent for areas that are difficult to paint with the standard-size knife. The knives have straight edges, so loading is very easy and simple.

The palette knives are used to make mountains, trees, fences, rocks, stones, paths, buildings, etc. Entire paintings can be done by using only knives. The more you use the knives the more your confidence will increase and very soon you will not believe the many effects you can create.

The edge on both knives is straight for easy loading and use.

GESSO CANVAS PRIMERS

Available in White, Black and Gray colors, gesso is a flat acrylic liquid primer used in a variety of projects requiring a dry pre-coated canvas. This water-based paint should be applied very thinly with a foam applicator (NOT A BRUSH) and allowed to dry completely before starting your painting. Clean the foam applicator with water.

EASEL

A sturdy easel that securely holds the canvas is very important when painting with large brushes. I made the easel I use for mounting on a platform ladder. Any type of step ladder also works well for this type of easel.

CANVAS

The canvas you paint on is also very important. You need a good quality canvas that will not absorb your Liquid White/Black/Clear and leave you with a dry surface.

For this reason, I do not recommend canvas boards or single-primed canvases. I use only very smooth, pre-stretched, double-primed, canvases that are covered with a Gray primer. (The Gray-primed canvas allows you to see at a glance if your Liquid White is properly applied.) You may prefer a canvas with a little tooth, particularly when your painting involves a great deal of work with the knife. Whether the canvas is ultra-smooth or has a little tooth is a matter of individual choice.

All of my original paintings in this book and on the TV series were painted on 18" x 24" canvases. The size of your paintings is totally up to you.

Basic "How To" Photographs: Learn and master these procedures as they are used repeatedly to complete the paintings.

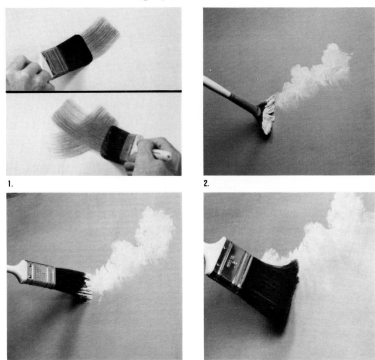

1.

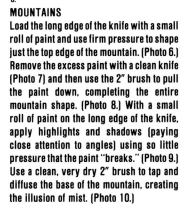

2.

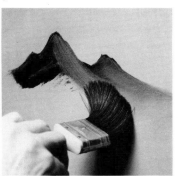

3.

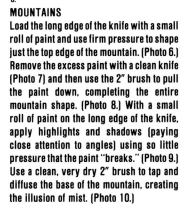

4.

SKIES

Load the 2" brush with a very small amount of paint, tapping the bristles firmly against the palette to ensure an even distribution of paint throughout the bristles. Use criss-cross strokes to begin painting the sky, starting at the top of the canvas and working down towards the horizon. (Photo 1.) Add cloud shapes by making tiny, circular strokes with the fan brush (Photo 2) the 1" brush (Photo 3) or you can use the 2" brush, the 1" round brush or the oval brush. Blend the base of the clouds with circular strokes using just the top corner of a clean, dry 2" brush. (Photo 4.)

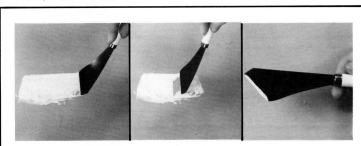

5. Pull the paint out flat on your palette—then cut across to load the long edge of the knife with a small roll of paint.

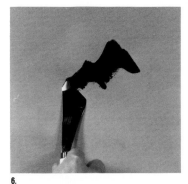

6.

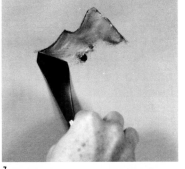

7.

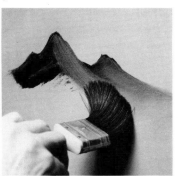

8.

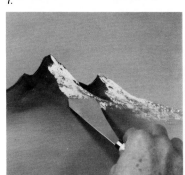

9.

MOUNTAINS

Load the long edge of the knife with a small roll of paint and use firm pressure to shape just the top edge of the mountain. (Photo 6.) Remove the excess paint with a clean knife (Photo 7) and then use the 2" brush to pull the paint down, completing the entire mountain shape. (Photo 8.) With a small roll of paint on the long edge of the knife, apply highlights and shadows (paying close attention to angles) using so little pressure that the paint "breaks." (Photo 9.) Use a clean, very dry 2" brush to tap and diffuse the base of the mountain, creating the illusion of mist. (Photo 10.)

10.

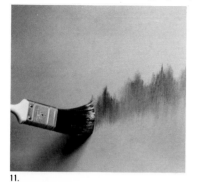

11.

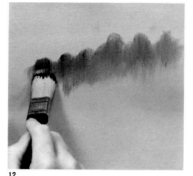

12.

13.

14.

15.

16.

FOOTHILLS

Foothills are made by holding the 1" brush vertically (Photo 11) or the oval brush (Photo 12) and tapping downward. Use just the top corner of the 2" brush to firmly tap the base of the hills, to create the illusion of mist. (Photo 13.) Indicate tiny evergreens by tapping downward with the fan brush. (Photo 14.) The grassy area at the base of the hills is added with the fan brush (Photo 15) and then highlighted, forcing the bristles to bend upward. (Photo 16.)

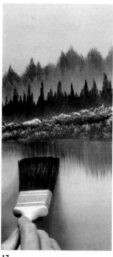

17.

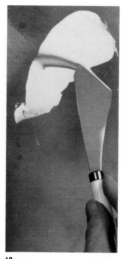

18.

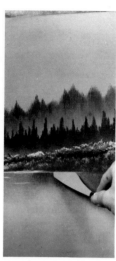

19.

REFLECTIONS

Use the 2" brush to pull the color straight down (Photo 17) and then lightly brush across to give the reflections a watery appearance. Load the long edge of the knife with a small roll of Liquid White (Photo 18) and then use firm pressure to cut-in the water lines. (Photo 19.) Make sure the lines are perfectly straight, you don't want the water to run off the canvas.

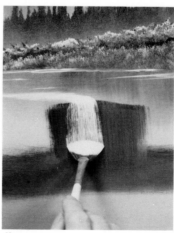

20.

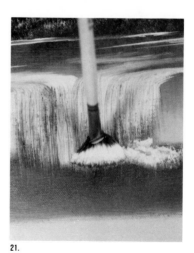

21.

WATERFALLS

Use single, uninterrupted strokes with the fan brush to pull the water over the falls (Photo 20) then use push-up strokes to "bubble" the water at the base of the falls. (Photo 21.)

Basic "How To" Photographs, *Continued*

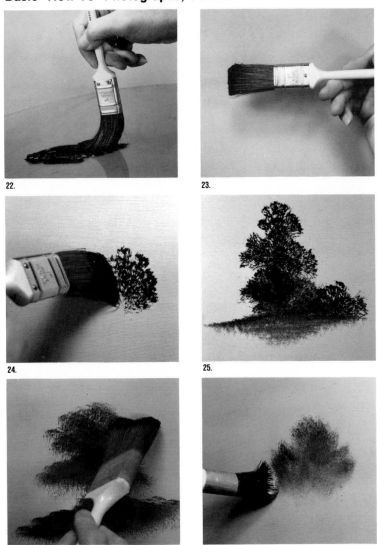

22. 23. 24. 25. 26. 27.

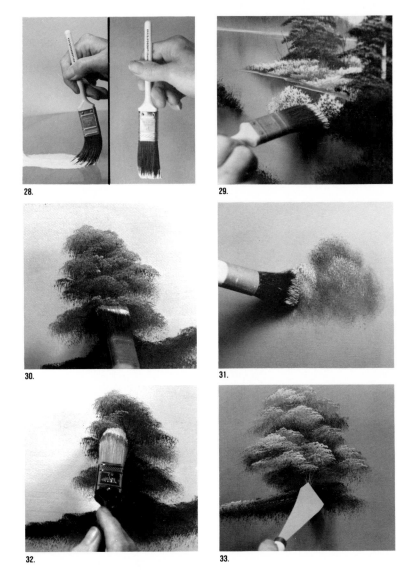

28. 29. 30. 31. 32. 33.

LEAF TREES AND BUSHES
Pull the 1″ brush in one direction through the paint mixture (Photo 22) to round one corner. (Photo 23.) With the rounded corner up, force the bristles to bend upward (Photo 24) to shape small trees and bushes. (Photo 25.) You can also just tap downward with the 2″ brush (Photo 26) or the round brush. (Photo 27.)

HIGHLIGHTING LEAF TREES AND BUSHES
Load the 1″ brush to round one corner. (Photo 28.) With the rounded corner up, lightly touch the canvas, forcing the bristles to bend upward. (Photo 29.) You can also tap to highlight using the corner of the 1″ brush or 2″ brush (Photo 30) the round brush (Photo 31) or the oval brush. (Photo 32.) Use just the point of the knife to scratch in tiny trunks, sticks and twigs. (Photo 33.)

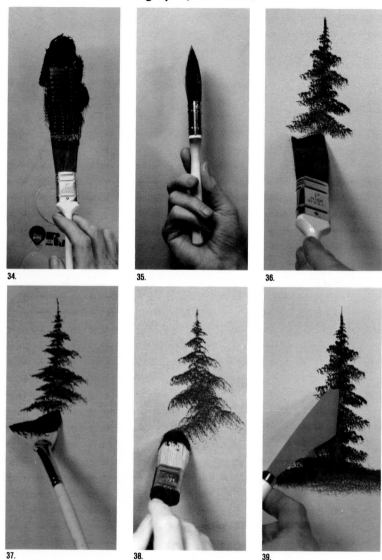

34. 35. 36.

37. 38. 39.

EVERGREENS

"Wiggle" both sides of the 1″ brush through the paint mixture (Photo 34) to bring the bristles to a chiseled edge. (Photo 35.) Starting at the top of the tree, use more pressure as you near the base, allowing the branches to become larger. (Photo 36.) You can also make evergreens using just one corner of the fan brush (Photo 37) or the oval brush (Photo 38.) The trunk is added with the knife. (Photo 39.)

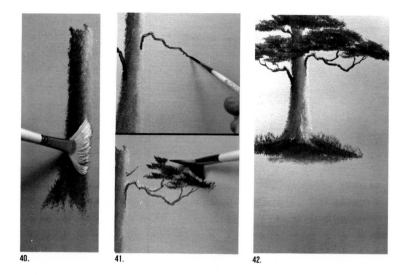

40. 41. 42.

LARGE EVERGREEN TREES

Hold the fan brush vertically and tap downward to create the "fuzzy" bark (Photo 40.) Use thinned paint on the liner brush to add the limbs and branches then push up with just the corner of the fan brush (Photo 41) to add the foliage (Photo 42.)

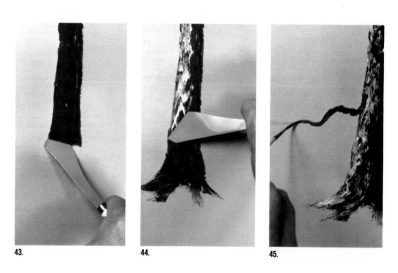

43. 44. 45.

LARGE TREE TRUNKS

Load the long edge of the knife with paint and starting at the top of the tree, just pull down. (Photo 43.) Apply highlights, using so little pressure that the paint "breaks." (Photo 44.) With a very thin paint on the liner brush, add the limbs and branches. (Photo 45.)

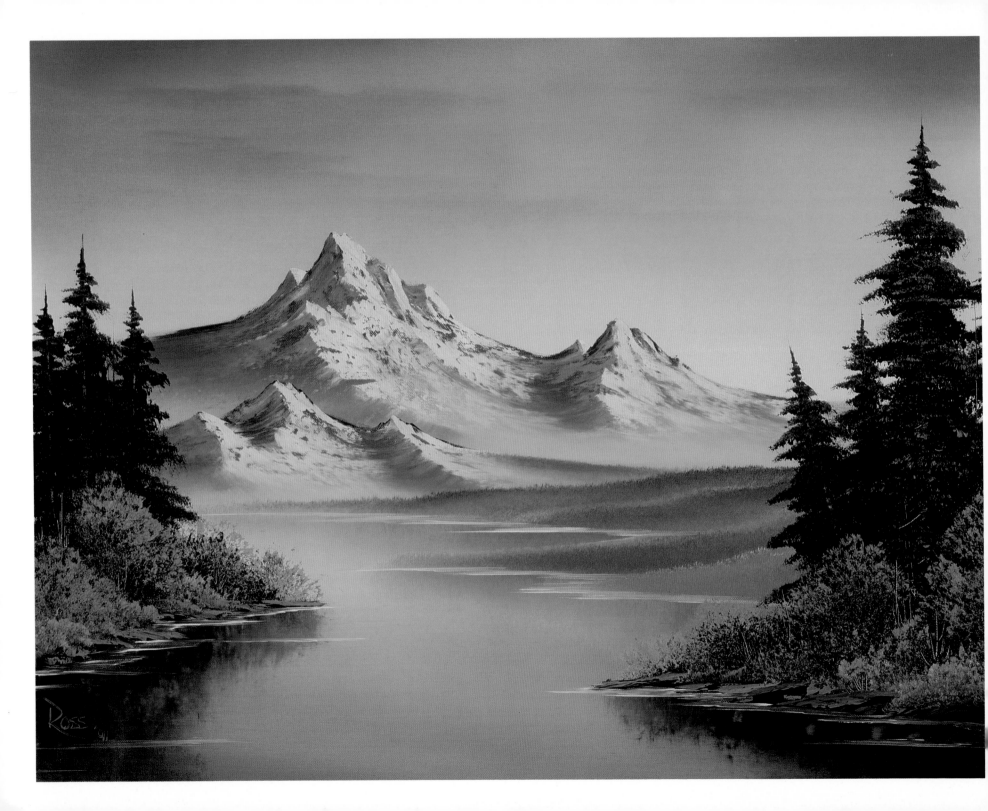

1. GRAY MOUNTAIN

MATERIALS

2" Brush	Midnight Black
1" Brush	Dark Sienna
#6 Fan Brush	Van Dyke Brown
#2 Script Liner Brush	Alizarin Crimson
Large Knife	Sap Green
Liquid White	Cadmium Yellow
Titanium White	Yellow Ochre
Phthalo Green	Indian Yellow
Phthalo Blue	Bright Red
Prussian Blue	

Begin by using the 2" brush to cover the entire canvas with a thin, even coat of Liquid White. With long horizontal and vertical strokes, work back and forth to ensure an even distribution of paint on the canvas. Do NOT allow the Liquid White to dry before you begin.

SKY

Load the 2" brush with a small amount of Indian Yellow and begin by creating the Golden glow in the sky with criss-cross strokes across the canvas, just above the horizon. Use Indian Yellow and horizontal strokes to reflect the glow into the water, just below the horizon.

Without cleaning the brush, reload it with Yellow Ochre and continue working upward in the sky with criss-cross strokes. Again, reflect the Yellow Ochre in the water with horizontal strokes, below the Indian Yellow.

Still without cleaning the brush, reload it with a very small amount of Bright Red and continue with criss-cross strokes near the top of the sky and horizontal strokes near the bottom of the canvas.

Reload the 2" brush with a mixture of Alizarin Crimson and Phthalo Blue and use criss-cross strokes across the top of the sky. Hold the brush horizontally and just tap downward to indicate the cloud shapes. (Photo 1.)

Use the Alizarin Crimson-Phthalo Blue mixture and long, horizontal strokes across the bottom of the canvas to complete the water. With a clean, dry 2" brush, blend the entire canvas with long, horizontal strokes.

MOUNTAIN

Use the knife and a mixture of Midnight Black, Prussian Blue, Alizarin Crimson and Van Dyke Brown to paint the large mountain. Pull the mixture out very flat on your palette, hold the knife straight up and "cut" across the mixture to load the long edge of the blade with a small roll of paint. (Holding the knife *straight up* will force the small roll of paint to the very edge of the blade.) With firm pressure, shape just the top edge of the mountain. (Photo 2.)

When you are satisfied with the basic shape of the mountain top, use the knife to remove any excess paint. Then, with the 2" brush, blend the paint down to the base of the mountain. Highlight the mountain with various mixtures of Titanium White and Midnight Black. Again, load the long edge of the knife blade with a small roll of paint. Starting at the top (and paying close attention to angles) glide the knife down the right side of each peak, using so little pressure that the paint "breaks". (Photo 3.)

Use a mixture of Titanium White, Prussian Blue, Midnight Black, Van Dyke Brown and Alizarin Crimson, applied in the opposing direction, for the shadowed sides of the peaks. Again, use so little pressure that the paint "breaks".

Use a clean, dry 2" brush to tap to diffuse the base of the mountain (carefully following the angles) and then gently lift upward to create the illusion of mist.

To create depth in your painting, use the same mixtures to add the small mountains at the base of the large mountain. (Photo 4.)

FOOTHILLS

Load the 2" brush with a mixture of Titanium White and the mountain color. Hold the brush horizontally and tap downward to paint the foothills at the base of the mountains. (Photo 5.) Still holding the brush horizontally, make short upward strokes to

indicate the tiny tree tops. Hold the brush flat against the canvas at the base of the foothills and pull the color straight down to reflect the hills into the water *(Photo 6)* then lightly brush across.

You can make several ranges of hills; each one getting progressively darker as you work forward in the painting. Add a small amount of a mixture of Sap Green and Cadmium Yellow to the brush and lightly tap to highlight the closer hills.

Water lines and ripples are made with the knife and a mixture of Liquid White with a very small amount of Bright Red. Use the knife to pull the mixture out very flat on your palette, then cut across to load the top of the blade with a small roll of paint. Push the blade straight into the canvas and use firm pressure to cut in the water lines and ripples. *(Photo 7.)* Be sure the lines are perfectly straight, parallel to the top and bottom of the canvas. *(Photo 8.)*

EVERGREENS

Load the fan brush to a chiseled edge with a very dark mixture of Midnight Black, Prussian Blue, Phthalo Green and Alizarin Crimson. Holding the brush vertically, touch the canvas to create the center line of each evergreen tree. Use just the corner of the brush to begin adding the small top branches. Working from side to side, as you move down each tree, apply more pressure to the brush, forcing the bristles to bend downward and automatically the branches will become larger as you near the base of each tree. *(Photo 9.)*

FOREGROUND

Underpaint the small trees and bushes at the base of the evergreens with the same dark mixture on the 1" brush, extending the color into the water for reflections. *(Photo 10.)* Use the 2" brush to pull the reflections straight down, then lightly brush across. *(Photo 11.)*

To highlight the trees and bushes, first dip the 1" brush into Liquid White. Then, with the handle straight up, pull the brush (several times in one direction, to round one corner of the bristles) through various mixtures of Sap Green, all of the Yellows and Bright Red. With the rounded corner of the brush up, force the bristles to bend upward to highlight the individual trees and bushes. Concentrate on shape and form—try not to just "hit" at random. If you are careful to not completely destroy all of the dark undercolor, you can use it to separate the individual tree

and bush shapes. *(Photo 12.)*

Reverse the brush to reflect the highlights into the water. Use the 2" brush to first very lightly pull the reflections down (one hair and some air) then brush across to give the reflections a "watery" appearance. *(Photo 13.)*

Add the evergreen trunks with a small roll of a mixture of Titanium White and Dark Sienna on the knife. *(Photo 14.)* Use the fan brush to very lightly touch highlights to the right side of the branches.

Use Van Dyke Brown on the knife to add the land area at the base of the foreground trees, with close attention to angles. Highlight the land with a mixture of Van Dyke Brown and Titanium White on the knife, using so little pressure that the paint "breaks". *(Photo 15.)* With a small roll of Liquid White on the edge of the knife, cut in foreground water lines and ripples. *(Photo 16.)*

FINISHING TOUCHES

To complete your painting, use the point of the knife to scratch in the indication of tiny trunks, sticks and twigs. *(Photo 17.)*

Don't forget to sign your name with pride: load the liner brush with thinned color of your choice. Sign just your initials, first name, last name or all of your names. Sign in the left corner, the right corner or one artist signs right in the middle of the canvas! The choice is yours. You might also consider including the date when you sign your painting. Whatever your choices, have fun, for hopefully with this painting you have truly experienced THE JOY OF PAINTING!

Gray Mountain

1. Paint the sky with the 2" brush.

2. Use the knife to paint the mountain . . .

3. . . . and add snowy highlights.

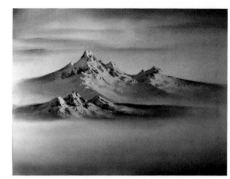

4. Add small mountains at the base of the large mountain.

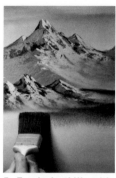

5. Tap in foothills with the 2" brush . . .

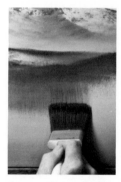

6. . . . then pull down reflections.

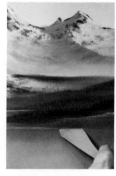

7. Use Liquid White on the knife . . .

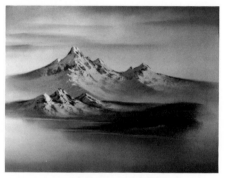

8. . . . to cut in water lines and ripples.

9. Add the evergreens with the fan brush . . .

10. . . . and the small trees and bushes with the 1" brush . . .

11. . . . then pull down reflections with the 2" brush.

12. Highlight the bushes with the 1" brush . . .

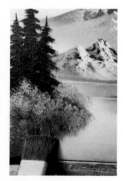

13. . . . then pull down reflections with the 2" brush.

14. Use the knife to add tree trunks . . .

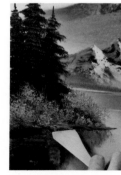

15. . . . the land area . . .

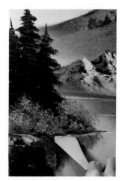

16. . . . water lines . . .

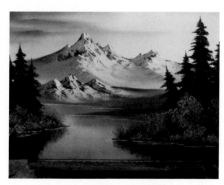

17. . . . and your painting is complete!

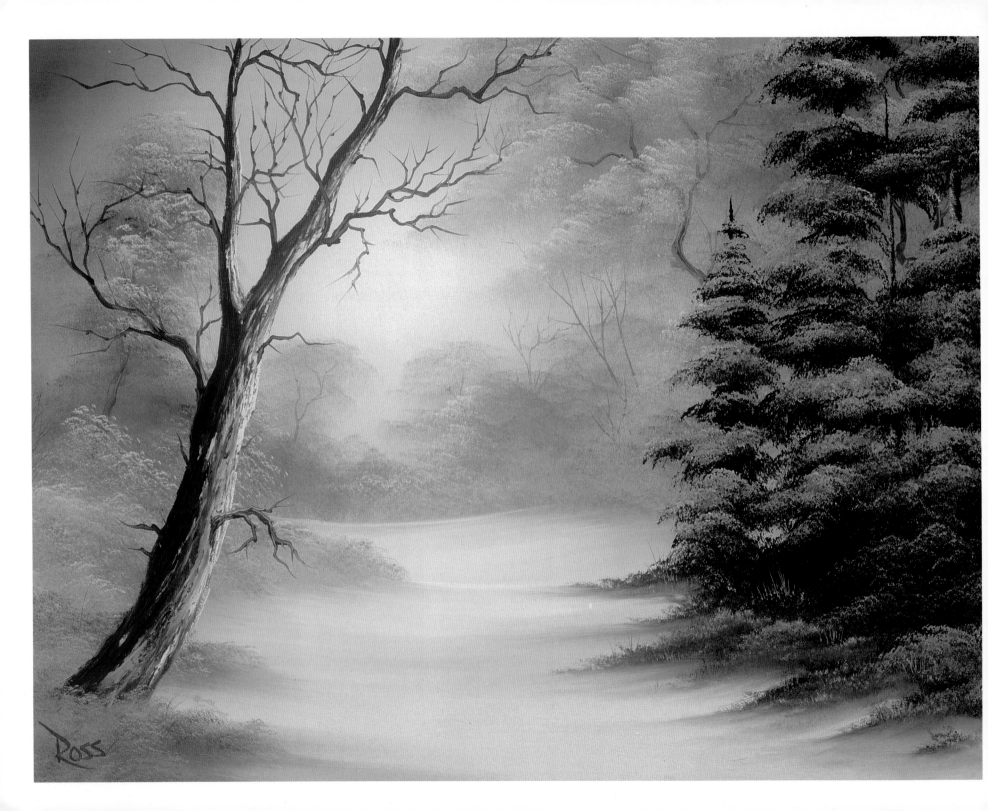

MATERIALS

2" Brush	Phthalo Blue
1" Oval Brush	Dark Sienna
#6 Fan Brush	Van Dyke Brown
Script Liner Brush	Alizarin Crimson
Large Knife	Cadmium Yellow
Liquid White	Yellow Ochre
Liquid Clear	Indian Yellow
Titanium White	

Use the 2" brush to cover the entire canvas with a VERY THIN, even coat of a mixture of Liquid White and Liquid Clear. With long horizontal and vertical strokes, work back and forth to ensure an even distribution of paint on the canvas. Do NOT allow the canvas to dry before you begin.

SKY

Load the 2" brush with a very small amount of Yellow Ochre, tapping the bristles firmly against the palette to evenly distribute the paint throughout the bristles. Use criss-cross strokes to create a Golden glow in the center, light area of the sky. *(Photo 1.)* Continuing to work outward with criss-cross strokes, add a mixture of Yellow Ochre and Dark Sienna to the brush and finally reload the brush with a mixture of Alizarin Crimson and Phthalo Blue as you near the edges of the canvas.

Reinforce the center, light areas of the sky with Titanium White on the 2" brush, still using criss-cross strokes. *(Photo 2.)* Blend the entire sky with a clean, dry 2" brush, again working from the center outward. Add the sun with Titanium White on your fingertip, then lightly blend the entire sky with a clean, dry 2" brush. *(Photo 3.)*

BACKGROUND

With a mixture of Prussian Blue, Alizarin Crimson and Dark Sienna on the 2" brush *(Photo 4)* tap in the basic shape of the background trees *(Photo 5)*.

Use the same tree mixture on the liner brush to add background tree trunks. *(Photo 6.)* (To load the liner brush, thin the mixture to an ink-like consistency by first dipping the liner brush into paint thinner. Slowly turn the brush as you pull the bristles through the mixture, forcing them to a sharp point.) Apply very little pressure to the brush as you shape the trunks. By turning and wiggling the brush, you can give your trunks a gnarled appearance.

Highlight the trees with various mixtures of Titanium White, all of the Yellows, Alizarin Crimson and Dark Sienna on the 2" brush. (Proper loading of the brush is essential to these highlights: Hold the 2" brush at a 45-degree angle and tap the bristles into the various paint mixtures. Allow the brush to "slide" slightly forward in the paint each time you tap, this assures that the very tips of the bristles are fully loaded with paint.)

Tap downward with one corner of the brush, carefully forming individual leaf clusters—try not to just hit at random. *(Photo 7.)* Working in layers, be very careful not to completely cover all of the dark under-color. *(Photo 8.)*

Paying close attention to the lay-of-the-land, use Titanium White on the 2" brush and long horizontal strokes to add the snow at the base of the background trees. *(Photo 9.)*

You can create shadows in the snow by allowing your brush to pick up some of the dark tree-color from the base of the trees and bushes. *(Photo 10.)*

EVERGREENS

To paint the evergreen trunks, load the fan brush to a chiseled edge with a mixture of Phthalo Blue, Alizarin Crimson, Dark Sienna and Van Dyke Brown. Holding the brush vertically, and starting at the top of each tree, tap downward to create the "fuzzy" tree trunks. *(Photo 11.)*

Use the fan brush to highlight the trunks with a mixture of Titanium White and Dark Sienna. Hold the brush vertically, touch the edge of the trunk and make tiny, curved horizontal strokes. *(Photo 12.)*

Use the same mixture on the oval brush to add foliage to the evergreens. With just the end of the brush, begin by adding the small top branches. Working from side to side, as you move

down each tree, apply more pressure to the brush, forcing the bristles to bend upward *(Photo 13)* and automatically the branches will become larger as you near the base of each tree.

Use Liquid Clear on the oval brush (to thin the paint) and various mixtures of Titanium White, all of the Yellows, Alizarin Crimson and a very small amount of Phthalo Blue to lightly touch highlights to the evergreen foliage. *(Photo 14.)*

Again, use Titanium White on the large brush to add snow to the base of the evergreens, allowing some of the dark tree color to create the shadowed areas.

Use the same dark tree-mixture on the fan brush to add the grassy areas at the base of the trees *(Photo 15)* then use a clean fan brush to blend the base of the grass into the snow *(Photo 16)* for shadows (Photo 17).

FOREGROUND

Underpaint the small bushes in the foreground with the dark tree mixture on the 2" brush *(Photo 18)* and use the Titanium White-Yellows-Alizarin Crimson mixtures for highlights, again properly loading the 2" brush *(Photo 19)*.

LARGE TREE

Use Van Dyke Brown and Dark Sienna on the fan brush to paint the large foreground tree trunk. Don't paint a telephone pole, be sure to give your trunk shape and character. *(Photo 20.)* Highlight the trunk with a small roll of a mixture of Titanium White and Dark Sienna on the knife. *(Photo 21.)* Add the limbs and branches with thinned Dark Sienna and Van Dyke Brown on the liner brush *(Photo 22)* to complete your painting *(Photo 23)*.

FINISHING TOUCHES

Don't forget to sign your name with pride: Again, load the liner brush with thinned color of your choice. Sign just your initials, first name, last name or all of your names. Sign in the left corner, the right corner or one artist signs right in the middle of the canvas! The choice is yours. You might also consider including the date when you sign your painting. Whatever your choices, have fun, for hopefully with this painting you have truly experienced THE JOY OF PAINTING!

Tranquil Dawn

1. Use the 2" brush and criss-cross strokes to paint the sky.

2. Then use the 2" brush . . .

3. to add the light area in the center of the sky.

4. Tap down with the 2" brush . . .

5. to shape the background trees.

6. Add tree trunks with the liner brush . . .

Tranquil Dawn

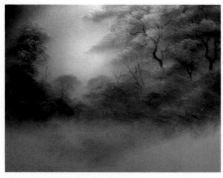

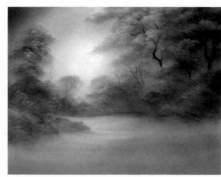

7. . . . and highlights with the corner of the 2" brush . . .

8. . . . to the background trees.

9. Use long, horizontal strokes . . .

10. . . . to add snow to the base of the trees.

11. Use the fan brush to pull down trunks . . .

12. . . . then pull across for highlighting.

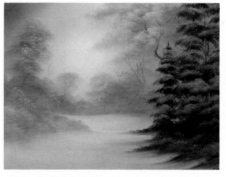

13. Add foliage to the trees . . .

14. . . . and foliage highlights with the oval brush.

15. Add the grassy areas . . .

16. . . . and the snow . . .

17. . . . to the base of the evergreens.

18. Continue using the 2" brush . . .

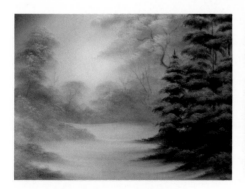

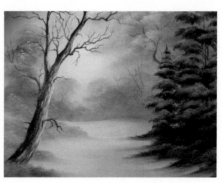

19. . . . to paint bushes in the foreground.

20. Paint the large tree trunk with the fan brush . . .

21. . . . then highlight with the knife . . .

22. . . . add limbs and branches with the liner brush . . .

23. . . . and the painting is complete.

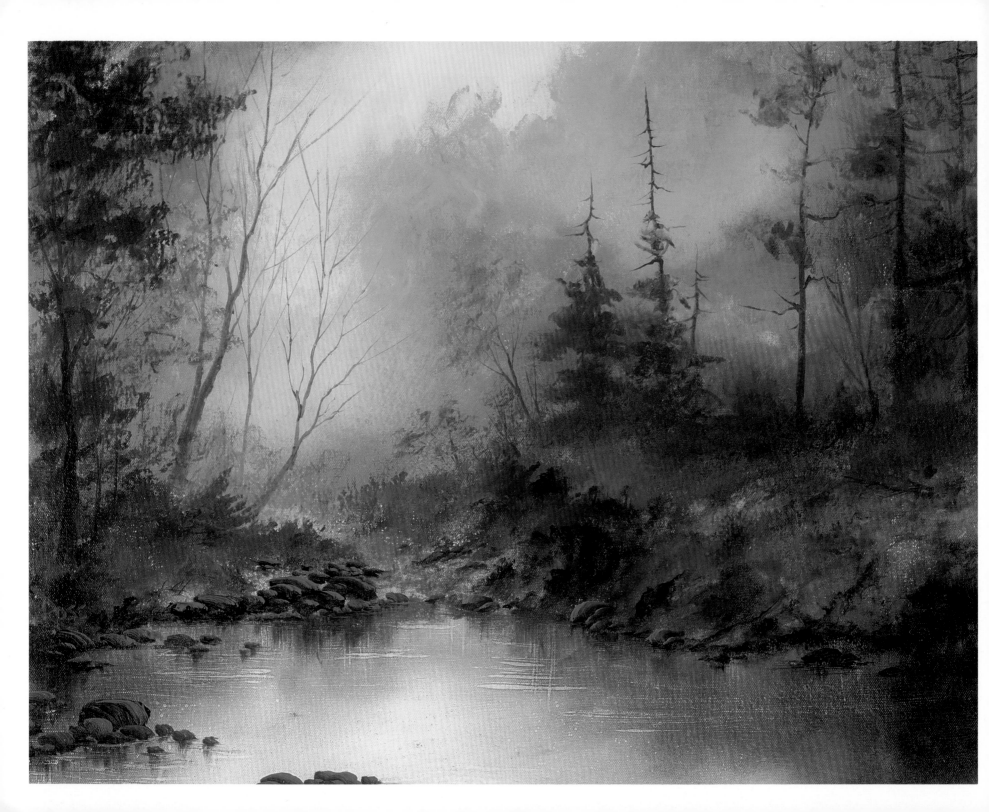

3. GOLDEN GLOW OF MORNING

MATERIALS

2" Brush	Liquid Clear
#6 Filbert Brush	Titanium White
#6 Fan Brush	Phthalo Blue
#2 Script Liner Brush	Midnight Black
Large Knife	Alizarin Crimson
Adhesive-Backed Plastic	Sap Green
White Gesso	Cadmium Yellow
Alizarin Crimson Acrylic Paint	Yellow Ochre
Burnt Sienna Acrylic Paint	Indian Yellow
Burnt Umber Acrylic Paint	Bright Red

To prepare your canvas, use a small disposable paint roller to apply a thick, textured coat of White Gesso to the entire canvas. When the Gesso is dry, use a foam applicator and various mixtures of the acrylic colors (Alizarin Crimson, Burnt Sienna and Burnt Umber) to underpaint the dark foliage areas of the painting. Allow the canvas to DRY COMPLETELY before proceeding. *(Photo 1.)*

Use the 2" brush to completely cover the canvas with a VERY THIN coat of Liquid Clear. (It is important to stress that the Liquid Clear should be applied VERY, VERY sparingly and really scrubbed into the canvas! The Liquid Clear will not only ease the application of the firmer paint, but will allow you to apply very little color, creating a glazed effect.)

SKY

Load the 2" brush by tapping the bristles into a small amount of Indian Yellow. Use criss-cross strokes to paint the entire canvas. Reload the 2" brush with a small amount of Titanium White and continue using criss-cross strokes to paint the light, misty areas above the horizon. *(Photo 2.)* You can also add very small amounts of Alizarin Crimson, Bright Red and Phthalo Blue to the sky areas.

BACKGROUND

With a Brown color (made from equal parts of Alizarin Crimson and Sap Green) on the 2" brush, hold the brush hori-zontally, touch the brush to the canvas, just below the horizon, and pull straight down *(Photo 3)* to begin underpainting the water. Lightly brush across to create reflections. *(Photo 4.)*

Use the knife to make two Lavender mixtures on your palette with Midnight Black, Phthalo Blue and Alizarin Crimson. One mixture should be mixed to the Red–the other mixture to the Blue.

Begin adding the background tree trunks with the Lavender mixtures and the liner brush. (To load the liner brush, thin the Lavender mixture to an ink-like consistency by first dipping the liner brush into paint thinner. Slowly turn the brush as you pull the bristles through the mixture, forcing them to a sharp point.) Apply very little pressure to the brush as you shape the trunks *(Photo 5)*, limbs and branches *(Photo 6)*. By turning and wiggling the brush, you can give your trees a gnarled appearance. *(Photo 7.)*

Continue using the thinned mixtures on the liner brush to add the basic foliage shapes *(Photo 8)* to the background trees *(Photo 9)*. Working forward in layers continue using the Lavender mixtures and the Brown mixture to paint the background trees. *(Photo 10.)* Use the thinned mixtures on the liner brush to add foliage to the base of the trees, paying close attention to the lay-of-the-land. *(Photo 11.)*

The larger tree trunks are made with thinned color on the liner brush *(Photo 12)* but the foliage is added with the corner of the fan brush *(Photo 13)*. Use various mixtures of the Lavenders, the Brown mixture, all of the Yellows and a small amount of Bright Red to add foliage to the base of the trees and along the water's edge.

WATER

Use the 2" brush to pull the colors into the water for reflections and lightly brush across. *(Photo 14.)* Add water lines and ripples with just paint thinner on the liner brush. Notice how the thinner reacts with the Liquid Clear already on the canvas. *(Photo 15.)*

Use the knife to make a mixture of Midnight Black and the

Brown color on your palette. Thin the mixture by adding a small amount of paint thinner. Also make a thinned mixture of Titanium White and Midnight Black. Load the filbert brush with the thinned, dark mixture, then pull one side of the bristles through the thinned light mixture, to double-load the brush. With the light side of the brush up, use a curved stroke to paint each rock. You can highlight and shadow each rock with just a single stroke. (Photo 16.) Extend a small amount of the dark color into the water at the base of each rock. (Photo 17.) With the 2" brush, pull the dark color straight down and lightly brush across to create reflections. (Photo 18.)

FINISHING TOUCHES

With thinned light color on the liner brush, add subtle water lines and ripples at the base of a few rocks and your masterpiece is ready for a signature. (Photo 19.)

Golden Glow of Morning

1. Underpaint the foliage with acrylic paints . . .

2. . . . then paint the sky with criss-cross strokes.

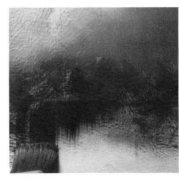

3. Use the 2" brush and pull straight down . . .

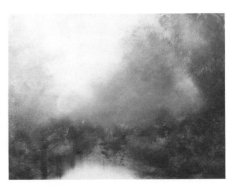

4. . . . to underpaint the water.

5. Use thinned paint on the liner brush to paint trunks . . .

6. . . . limbs and branches.

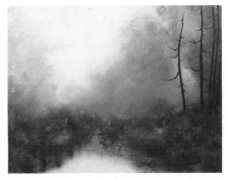

7. Turn the brush to give the trees a gnarled appearance.

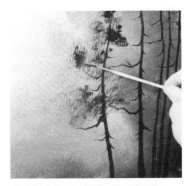

8. Add foliage with the liner brush . . .

Golden Glow of Morning

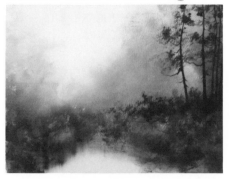

9. . . . to the background trees.

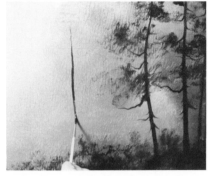

10. Continue adding trees with the liner brush . . .

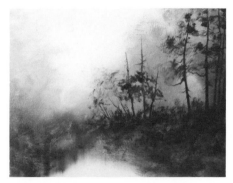

11. . . . to the right side of the background.

12. Add trunks on the left side with the liner brush . . .

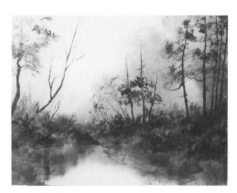

13. . . . then use the fan brush . . .

14. . . . to add the foliage.

15. Paint water lines with thinner on the liner brush.

16. Use the filbert brush to paint rocks . . .

17. . . . and their reflections.

18. Pull down reflections with the 2" brush . . .

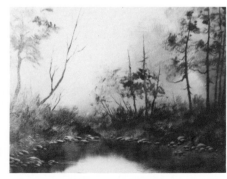

19. . . . to complete your masterpiece.

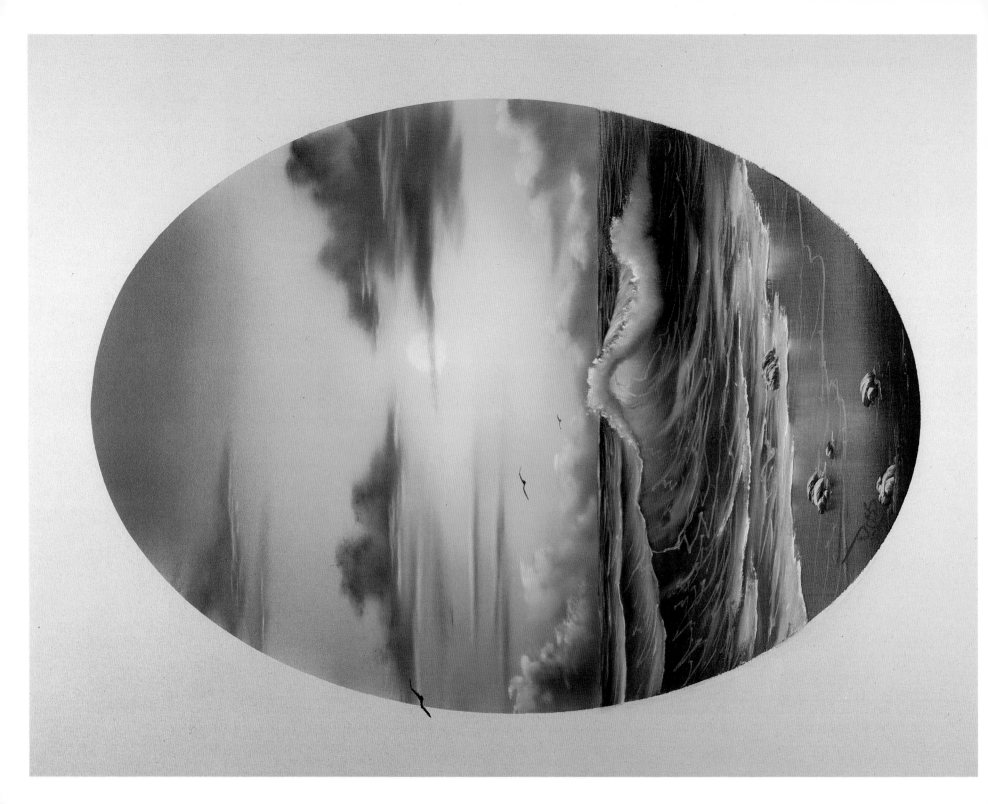

MATERIALS

2" Brush	Titanium White
#6 Filbert Brush	Phthalo Blue
#6 Fan Brush	Midnight Black
#2 Script Liner Brush	Dark Sienna
Small Knife	Van Dyke Brown
Adhesive-Backed Plastic	Alizarin Crimson
Masking Tape	Cadmium Yellow
Liquid White	Yellow Ochre
Liquid Clear	Bright Red

Start by covering the entire canvas with a piece of adhesive-backed plastic (such as Con-Tact Paper) from which you have removed a center oval shape (A 16 x 20 oval for an 18 x 24 canvas.) *(Photo 1.)*

Mark the horizon, below the center of the oval, with a strip of masking tape.

Use the 2" brush to cover the area above the horizon with a thin, even coat of Liquid White. With long horizontal and vertical strokes, work back and forth to ensure an even distribution of paint on the canvas.

Cover the area below the horizon with a VERY THIN coat of Liquid Clear. Do NOT allow the Liquid White and Liquid Clear to dry before you begin.

SKY

Load the 2" brush with Cadmium Yellow, tapping the bristles firmly against the palette to ensure an even distribution of paint throughout the bristles.

Begin by creating the Yellow glow in the center of the sky with criss-cross strokes. Without cleaning the brush, load it with Yellow Ochre and continue with criss-cross strokes around the Yellow. *(Photo 2.)* Add a small amount of Bright Red to the same brush and continue moving outward, still using criss-cross strokes. Use a mixture of Bright Red and Phthalo Blue at the top of the sky. Blend the entire sky with a clean, dry 2" brush.

Blend Titanium White into the center of the Yellow area with

the corner of the 2" brush. Into the center of this very light area, use Titanium White on your finger to paint the sun. *(Photo 3.)* Again, lightly blend with a clean, dry 2" brush.

Use Alizarin Crimson and Phthalo Blue (to make Lavender) and small circular strokes with the corner of the fan brush to shape the fluffy clouds. *(Photo 4.)* The "stringy" clouds are made with short, horizontal strokes. *(Photo 5.)* Blend all of the clouds with a clean, dry 2" brush. *(Photo 6.)*

Highlight the edges of the clouds with a mixture of Titanium White and a small amount of Bright Red on the fan brush. *(Photo 7.)* Again, blend with a clean, very dry 2" brush. Use circular strokes to blend the fluffy clouds, horizontal strokes to blend the stringy clouds. When you are satisfied with your sky, remove the masking tape from the canvas. *(Photo 8.)*

BACKGROUND WATER

Load the 2" brush with a Lavender mixture made with Phthalo Blue and Alizarin Crimson; proportionately more Blue than Crimson. (You can test the color by mixing a small amount with some Titanium White.)

Starting just below the horizon, use horizontal strokes to under-paint the background water. *(Photo 9.)* As you near the lower portion of the oval, add Dark Sienna to the brush and then paint the bottom of the oval with Van Dyke Brown for the sandy beach. Lightly blend. *(Photo 10.)*

Use Titanium White on the filbert brush to roughly sketch the large wave *(Photo 11)* then remove excess paint from the "eye" of the wave with a paper towel *(Photo 12)*.

Use Titanium White on the fan brush to outline the top of the large wave and to create the background swell with long, horizontal strokes. *(Photo 13.)* With a clean fan brush, use short, rocking strokes to pull the top edge of the waves back, to blend. *(Photo 14.)* Be very careful not to destroy the dark color that separates the individual waves. *(Photo 15.)*

LARGE WAVE

Use a mixture of Titanium White and Cadmium Yellow on the

filbert brush to scrub in the "eye" of the large wave. *(Photo 16.)* Blend with the top corner of a clean, very dry 2" brush. *(Photo 17.)*

Load a clean filbert brush with Titanium White and the Lavender mixture. With small, circular strokes, scrub in the foam shadows along the edges of the large wave. *(Photo 18.)*

With Titanium White on the fan brush, pull the water over the top of the crashing wave. *(Photo 19.)* Be very careful of the angle of the water here.

Highlight the top edges of the foam, where the light would strike, using Titanium White on the filbert brush and small, circular, push-up strokes. *(Photo 20.)* Again, use circular strokes with the top corner of the 2" brush to lightly blend the foam highlights into the shadows. *(Photo 21.)*

Still paying close attention to angles, use Titanium White on the filbert brush to add the foam patterns to the water. *(Photo 22.)* With thinned Titanium White on the liner brush *(Photo 23)* you can add small highlights and details to the water *(Photo 24)*.

FOREGROUND

Load the long edge of the small knife with a very small roll of Titanium White by pulling the paint out very flat on your palette and just cutting across. Hold the knife flat against the canvas

and use firm pressure and long horizontal strokes to add the foamy water action on the beach. *(Photo 25.)* Use a clean fan brush to pull the top edge of the paint back towards the large wave, creating swirling foam patterns. *(Photo 26.)* Pull the edge of the paint straight down with the fan brush, to create the reflections on the beach. *(Photo 27.)*

Add a very small amount of paint thinner to the bristles of the filbert brush. Load the brush with a mixture of Van Dyke Brown, Dark Sienna and a small amount of Midnight Black, then pull ONE side of the bristles through a thin mixture of Liquid White, Dark Sienna and Yellow Ochre, to double-load the brush. With the light side of the brush up, use a series of curved, single strokes to shape the rocks and stones on the beach. *(Photo 28.)*

Use a thinned light mixture on the liner brush to add the water lines to the base of the rocks and stones. *(Photo 29.)* The birds are made with thinned Midnight Black on the liner brush, just make "m" strokes. *(Photo 30.)*

FINISHING TOUCHES

Remove the Con-Tact Paper from the canvas (Photo 31) and then complete your masterpiece with one more bird, outside the oval *(Photo 32)*.

Ebb Tide

1. Cover the canvas with an oval-removed piece of Con-Tact Paper.

2. Use criss-cross strokes for the sky . . .

3. . . . and your finger for the sun.

4. Circular strokes . . .

5. . . . and horizontal strokes paint the clouds.

6. Blend clouds with the 2" brush.

7. Highlight clouds with the fan brush . . .

8. . . . then remove the tape from the canvas.

Ebb Tide

9. Use the 2" brush and long strokes . . .

10. . . . to paint the background water.

11. Sketch wave with the filbert brush.

12. Remove excess paint from the "eye" of the wave.

13. Add wave tops . . .

14. . . . and then pull back strokes . . .

15. . . . to blend the water with the fan brush.

16. Use the filbert brush to scrub in the "eye" of the wave . . .

 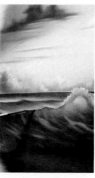 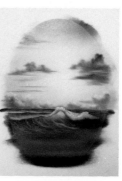

17. . . . then blend with the 2" brush.

18. Paint foam shadows with the filbert brush.

19. Pull water over the wave with the fan brush.

20. Highlight the edges of the foam . . .

21. . . . then blend into shadows.

22. Use the filbert brush . . .

23. . . . and the liner brush . . .

24. . . . to add foam details to the water.

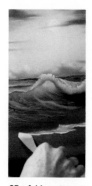 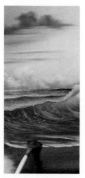 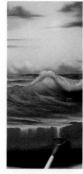 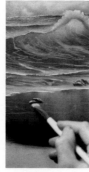 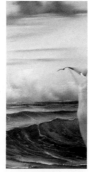 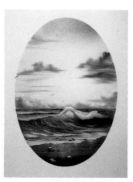

25. Add water on the beach . . .

26. . . . then pull back to blend.

27. Pull down to add reflections.

28. Rocks are made with the filbert brush.

29. Make water lines . . .

30. . . . and birds with the liner brush.

31. Remove the Con-Tact Paper . . .

32. . . . from the painting.

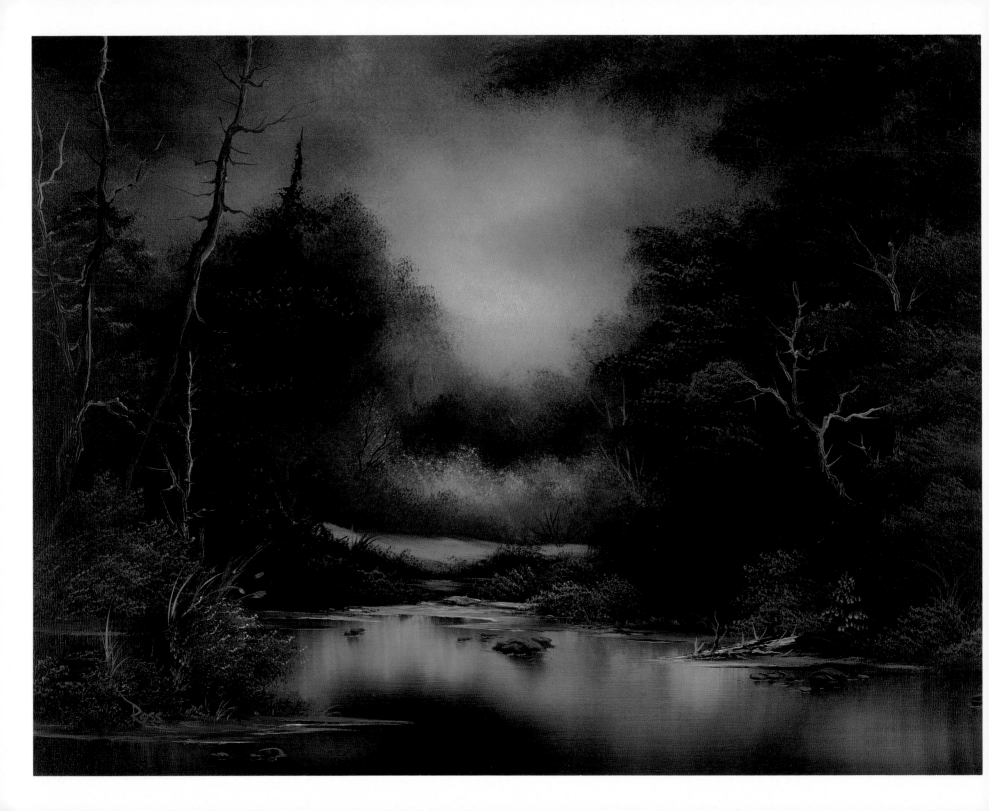

MATERIALS

2" Brush	Phthalo Blue
1" Brush	Prussian Blue
Filbert Brush	Midnight Black
#2 Script Liner Brush	Dark Sienna
Large Knife	Van Dyke Brown
Black Gesso	Alizarin Crimson
Liquid White	Sap Green
Liquid Clear	Yellow Ochre
Titanium White	Bright Red

Use a foam applicator to cover the entire canvas with a thin, even coat of Black Gesso and allow to DRY COMPLETELY before you begin.

When the Black Gesso is dry, use the 2" brush to cover the entire canvas with a thin even coat of a thin Lavender mixture made with Liquid Clear, Phthalo Blue and Alizarin Crimson. Do NOT allow this paint to dry before you begin.

SKY

Load the 2" brush by holding it vertically and tapping the top corner into a small amount of Titanium White. Begin painting the sky by holding the brush vertically and just tapping in cloud shapes with the top corner of the brush. (Notice how the White blends with the Lavender color already on the canvas.) *(Photo 1.)* Use a clean, dry 2" brush and small criss-cross strokes to blend the clouds. Continue layering clouds, adding small amounts of Dark Sienna and Phthalo Blue to the Titanium White. *(Photo 2.)* Blend with a clean, dry 2" brush *(Photo 3)* to complete the sky *(Photo 4)*.

BACKGROUND

Load the 2" brush by tapping the top corner into a mixture of Sap Green, Van Dyke Brown, Midnight Black, Prussian Blue and Dark Sienna. Holding the brush vertically, use the top corner of the brush to tap in the dark, background tree-shapes, just above the horizon. *(Photo 5.)* Add the lighter trees with a mixture of Titanium White and Yellow Ochre. *(Photo 6.)*

Reload the 2" brush with the dark tree mixture. Working forward in layers, hold the brush horizontally and begin tapping in the basic shape of the larger trees. *(Photo 7.)* These trees should be very dark, but you can vary the color by adding small amounts of Yellow Ochre to the dark tree-mixture. *(Photo 8.)*

Use the knife to mix a Brown color with equal parts of Sap Green and Alizarin Crimson. Load the knife with a mixture of the Brown and Titanium White and use horizontal strokes *(Photo 9)* to add land area at the base of the background trees *(Photo 10)*.

MIDDLEGROUND

Load the 1" brush by tapping the bristles into various mixtures of the Brown and Midnight Black, Sap Green, Yellow Ochre and small amounts of Bright Red. Continue working forward in layers by tapping in the basic shape of small trees and bushes *(Photo 11)* and adding land areas with the Brown and Titanium White mixture on the knife *(Photo 12)*.

Highlight the large trees and bushes with the 2" brush. Load the brush by holding it at a 45-degree angle and tapping the bristles into the various mixtures of Sap Green, Yellow Ochre and Bright Red. Allow the brush to "slide" slightly forward in the paint each time you tap (this assures that the very tips of the bristles are fully loaded with paint). Hold the brush horizontally and gently tap downward to shape individual branches, trees and bushes. *(Photo 13.)*

EVERGREEN

Load the 2" brush to a chiseled edge with a mixture of Midnight Black, Prussian Blue, Van Dyke Brown and Alizarin Crimson. Holding the brush vertically, touch the canvas to create the center line of the large evergreen. Use just the corner of the brush to begin adding the small top branches. Working from side to side, as you move down the tree, apply more pressure to the brush, forcing the bristles to bend downward, and automatically the branches will become larger as you near the base of the tree. *(Photo 14.)*

Add the trunk with a small roll of the Brown mixture on the

knife, then use a mixture of Sap Green and Yellow Ochre on the 2" brush to very lightly touch highlights to the evergreen branches. *(Photo 15.)*

Continue blocking in trees and bushes with the dark tree mixture on the 2" brush; highlighting with mixtures of Sap Green, Yellow Ochre and Bright Red. Allow these tree colors to extend into the water area of the painting.

Add tree trunks with a mixture of Dark Sienna and Titanium White on the liner brush. (To load the liner brush, thin the mixture to an ink-like consistency by first dipping the liner brush into paint thinner. Slowly turn the brush as you pull the bristles through the mixture, forcing them to a sharp point.) Apply very little pressure to the brush as you shape the trunks. *(Photo 16.)* By turning and wiggling the brush *(Photo 17)* you can give your trunks a gnarled appearance *(Photo 18).*

FOREGROUND

Load a clean, dry 2" brush with Titanium White. Hold the brush flat against the canvas and pull straight down to add the foreground water, then lightly brush across to create reflections. (Notice how the White blends with the Lavender and the tree-color already on the canvas.) *(Photo 19.)*

With a mixture of the Brown and Titanium White on the knife, use firm pressure for banks along the water's edge. *(Photo 20.)*

To add the peninsula, block in small trees and bushes with the dark-tree mixture on the 2" brush, then highlight with Sap Green and Yellow Ochre. *(Photo 21.)* Pull the tree colors into the water for reflections *(Photo 22)* and lightly brush across. Add the land area to the base of the trees with the Brown-White mixture on the knife. *(Photo 23.)*

Add small sticks and twigs with thinned mixtures on the liner brush *(Photo 24)* and additional small bushes to the water's edge with mixtures of Liquid White and the highlight colors on the 1" brush.

FINISHING TOUCHES

Use Van Dyke Brown on the knife to add the fallen tree trunks in the water. Highlight the tree with a small amount of Titanium White on the knife, then use the point of the knife to just scratch in the indication of a few limbs and branches. Add water lines to the base of the tree with a small roll of Liquid White on the knife.

To add small rocks and stones to the water, load the filbert brush with a mixture of Midnight Black and Van Dyke Brown, then pull one side of the bristles through a thin mixture of Liquid White, Van Dyke Brown and Dark Sienna, to double-load the brush. With the light side of the bristles up, use a curved stroke to paint rocks and stones. *(Photo 25.)* With just a single stroke, you can paint each rock and its highlight. *(Photo 26.)*

Wayside Pond

1. Tap down with the 2" brush to paint clouds.

2. Blend clouds with criss-cross strokes . . .

3. . . . then continue layering clouds and blending . . .

4. . . . to complete the sky.

5. Add background trees . . .

6. . . . then highlight with the 2" brush.

7. Continue using the 2" brush . . .

Wayside Pond

8. . . . to block in the large trees.

9. Use the knife to add the land area . . .

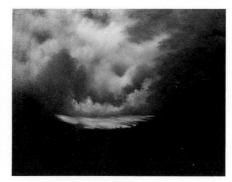

10. . . . at the base of the trees.

11. Work forward in layers with foliage . . .

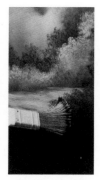

12. . . . and land areas.

13. Use the 2" brush to highlight the large trees . . .

14. . . . and to paint the large evergreen . . .

15. . . . before working forward.

16. Use thinned mixtures on the liner brush . . .

17. . . . to add tree trunks . . .

18. . . . to the background.

19. Pull down reflections with the 2" brush . . .

20. . . . then use the knife to add the water's edge.

21. Continue using the 2" brush to highlight foliage . . .

22. . . . and add reflections.

23. Add the foreground water's edge with the knife . . .

24. . . . then pull up long grasses with the liner brush.

25. Paint rocks and stones with the filbert brush . . .

26. . . . to complete the painting.

MATERIALS

2" Brush	Midnight Black
#6 Fan Brush	Dark Sienna
#2 Script Liner Brush	Van Dyke Brown
Large Knife	Alizarin Crimson
Small Knife	Sap Green
Masking Tape	Cadmium Yellow
Liquid White	Yellow Ochre
Titanium White	Indian Yellow
Phthalo Blue	Bright Red
Prussian Blue	

Start by masking-off portions of the canvas. Cover a 2" border around the perimeter of the canvas with tape. Then, add two vertical strips of tape to divide the canvas into three portions. *(Photo 1.)*

Cover the entire canvas with a thin, even coat of Liquid White using the 2" brush. Use long horizontal and vertical strokes, working back and forth to ensure an even distribution of paint on the canvas. Do not allow the Liquid White to dry before you begin.

SKY

With Alizarin Crimson on the 2" brush, begin making criss-cross strokes just above the horizon to create a Pink glow in the sky. *(Photo 2.)* Without cleaning the brush, pick up a mixture of Phthalo Blue and Midnight Black. Start at the top of the canvas with criss-cross strokes and cover the remainder of the sky. Add Midnight Black to the same brush and use long horizontal strokes to cover the lower portion of the canvas, below the horizon. Blend the entire canvas with a clean, dry 2" brush. *(Photo 3.)*

The clouds are Titanium White on a clean, dry 2" brush. Use just the top corner of the brush and small circular strokes to add the cloud shapes. Very lightly blend with a clean, large brush. *(Photo 4.)*

MOUNTAIN

The mountain is made with a mixture of Midnight Black, Van Dyke Brown, Prussian Blue and Alizarin Crimson. Load the long edge of the knife with a small roll of paint by pulling the mixture out flat on your palette and just "cutting" across. Use firm pressure to push the paint into the canvas, shaping just the top edge of the mountain. *(Photo 5.)*

Use a clean, dry 2" brush to grab the paint from the top of the mountain and pull down to complete the entire shape. (The color will automatically mix with the Liquid White and become lighter near the base, creating the illusion of mist.) Before cleaning your brush, use the accumulated paint on the bristles to add the soft mountain in the distance.

Highlight the mountain with Titanium White. Again, pull the paint out very flat on your palette and just "cut" across to load the long edge of the knife with a small roll of paint. Since the light is coming from the right, very gently touch the loaded knife to the right side of the top of the peaks. As you glide the knife down the sides of the peaks, use so little pressure that the paint is allowed to "break". *(Photo 6.)*

The shadows are applied to the left sides of the peaks using a mixture of Titanium White, Prussian Blue, and Midnight Black.

To complete your mountain, use a clean, dry 2" brush to tap and diffuse the base (following the angles) and then gently lift upward to mist. *(Photo 7.)*

BACKGROUND

Load the 2" brush with a mixture of Cadmium Yellow, Sap Green and Midnight Black. Holding the brush horizontally, just tap in the ground areas at the base of the mountain, paying close attention to the lay-of-the-land. *(Photo 8.)*

The small evergreens in the background are made by loading the fan brush with a mixture of Van Dyke Brown, Prussian Blue, Midnight Black and Sap Green. Hold the brush vertically and just touch the canvas to create the center line of the tree. Turn the brush horizontally and begin adding the small branches at the top of the tree by using just one corner of the brush. Working from side to side and forcing the bristles to bend downward, use more pressure as you near the base of the tree allow-

ing the branches to become larger. *(Photo 9.)* Hold the brush vertically and use downward strokes to just indicate the very distant, tiny trees. *(Photo 10.)* Use the point of the knife to scratch in the tree trunks. Add Cadmium Yellow to the same brush (for a lighter value) and touch highlights to the right sides of the branches. Go easy, these trees should remain very dark.

Continue using the 2" brush with various mixtures of all the Yellows, Sap Green and Bright Red to tap in the grassy area of the entire painting. (Photo 11.) Allow the brush to pick up some of the dark tree color, creating shadows and angles. *(Photo 12.)* Work in layers as you form the land contours that extend to the bottom of the canvas. *(Photo 13.)*

CABIN

Use the knife to remove the paint from the canvas in the basic shape of the cabin. Load the knife with a small roll of Van Dyke Brown, by pulling the paint out flat on your palette and just "cutting" across. Touch the knife to the canvas and lay in the back edge of the roof. Paying close attention to angles, pull down the front of the roof and then add the front and the side of the cabin. With a mixture of Bright Red and Dark Sienna on the knife, "bounce" a little color on the front of the roof. Highlight the front of the cabin with a mixture of Titanium White and Midnight Black, using so little pressure that the paint "breaks". Use the same mixture (with less White) on the small knife to highlight the side of the cabin. Still using the small knife and Van Dyke Brown, add the door and the window. Use the knife to remove any excess paint from the bottom of the building. With the knife,

touch a little Titanium White to the very edges of the roof to "sparkle". Tap a little grassy area around the base of the cabin. *(Photo 14.)*

FOREGROUND

Load the fan brush with Van Dyke Brown and Dark Sienna. Use short horizontal strokes to add the path. Watch the perspective (the path should get wider as it comes closer) near the bottom of the canvas. Add Titanium White to the brush to highlight the path, then use the 2" brush to add grassy areas along the edges. *(Photo 15.)*

Use a mixture of Van Dyke Brown and Dark Sienna on the fan brush to pull-in the large tree trunk in the foreground. Holding the brush vertically, start at the top of the canvas and allow the trunk to become wider near the base by using more pressure. (Be sure to give your tree an arm.) Add the small limbs and branches with a mixture of paint thinner and Van Dyke Brown on the liner brush. Use thinned Titanium White on the liner brush to touch highlights to the right side of the trunk. *(Photo 16.)*

Use the 2" brush to add the grassy area to the base of the tree and Van Dyke Brown on the liner brush to add a small fence in the background, long grasses and small sticks and twigs. *(Photo 17.)*

FINISHING TOUCHES

Remove the masking tape from the canvas *(Photo 18)* and *Voila!* a TRIPLE VIEW. Sign and enjoy! *(Photo 19.)*

Triple View

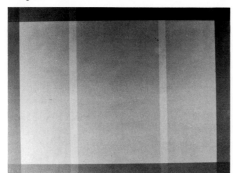

1. Use tape to mask out your design.

2. Criss-cross strokes are used . . .

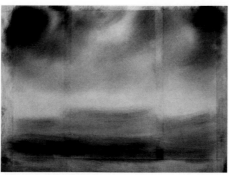

3. to paint the sky.

4. Clouds are made with the top corner of the 2" brush, then blended.

5. The basic mountain shape is painted with the knife.

Triple View

6. The knife is used . . .

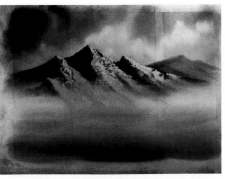

7. . . . to paint highlights and shadows on the mountain, using very little pressure.

8. Tap in foothills using the 2" brush.

9. Evergreens are made by pushing down with corner of the fan brush.

10. Tap down with fan brush to create distant tree shapes.

11. With the 2" brush, tap from the trees outward . . .

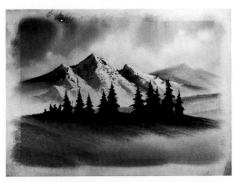

12. . . . to create the hills under the evergreens. Allow the brush to pick up a touch of the tree color.

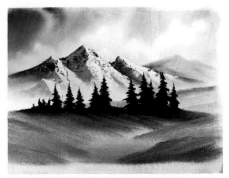

13. Create different planes in your painting.

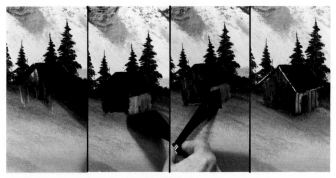

14. Progressional steps used to paint the cabin.

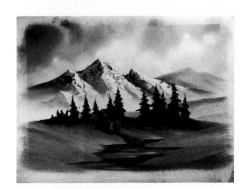

15. Paint a path from the cabin.

16. Pull down with fan brush to paint the large tree trunk.

17. The distant fence is made with the liner brush.

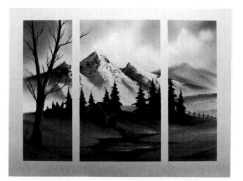

18. Carefully remove the tape . . .

19. . . . to expose your completed painting.

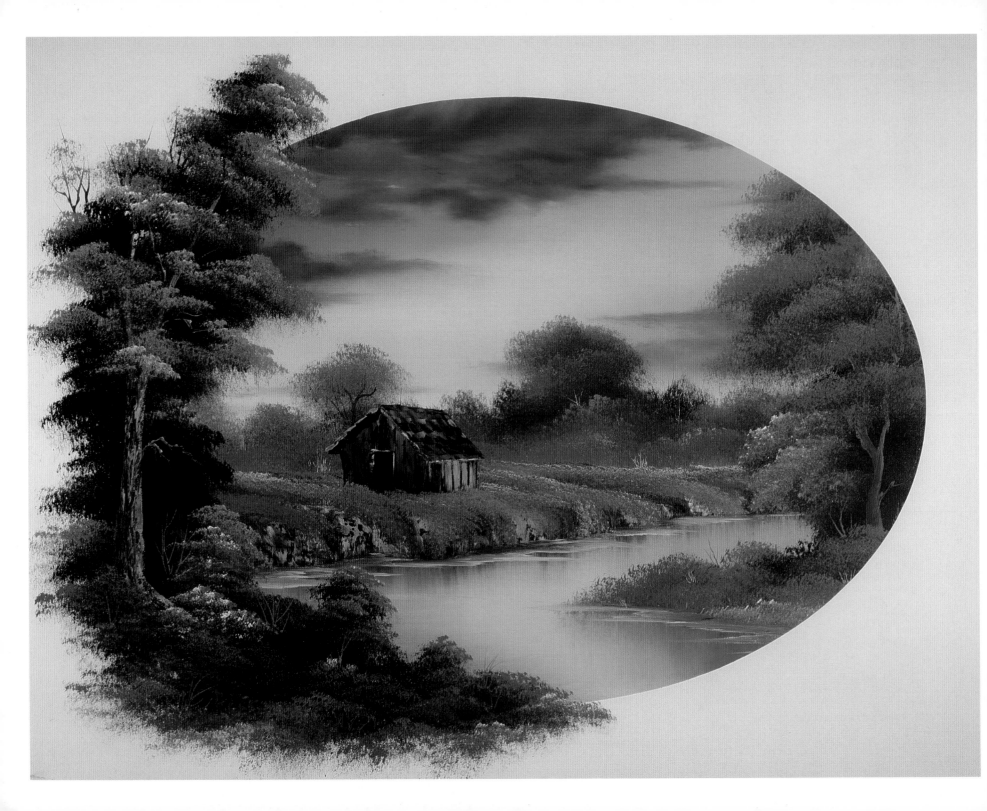

7. TOWARD DAY'S END

MATERIALS

2" Brush	Prussian Blue
Small Round Brush	Midnight Black
#6 Fan Brush	Dark Sienna
#2 Script Liner Brush	Van Dyke Brown
Large Knife	Alizarin Crimson
Small Knife	Sap Green
Adhesive-Backed Plastic	Cadmium Yellow
Liquid White	Yellow Ochre
Titanium White	Indian Yellow
Phthalo Green	Bright Red
Phthalo Blue	

Start by covering the entire canvas with a piece of adhesive-backed plastic (such as Con-Tact Paper) from which you have removed a center oval shape. (A 16 x 20 oval for an 18 x 24 canvas.)

With the 2" brush, cover the exposed area of the canvas with a thin, even coat of Liquid White. Do NOT allow the Liquid White to dry before you begin.

SKY

Load the 2" brush by tapping the bristles into a mixture of Midnight Black, Phthalo Blue and Phthalo Green. Tap firmly against the palette to ensure an even distribution of paint throughout the bristles. Starting at the top of the oval and working downward, use criss-cross strokes paint the sky. (Photo 1.) Allow the center of the sky to remain quite light.

This is a good time to under-paint the water on the lower portion of the canvas. Reload the brush with the same mixture. Starting at the bottom of the oval (and working up towards the horizon) use horizontal strokes to paint the water, pulling from the outside edges of the oval in towards the center. You can create the illusion of shimmering light on the water by allowing the center of the water to remain light.

Load a clean, dry 2" brush with a mixture of Indian Yellow and Cadmium Yellow and use criss-cross strokes to paint the light area of the sky; horizontal strokes to paint the center of the water.

Use a clean, dry 2" brush and criss-cross strokes to blend the sky, then blend the entire canvas (sky and water) with long, horizontal strokes.

Load the fan brush with a mixture of Midnight Black, Prussian Blue and a small amount of Alizarin Crimson. Use the corner of the brush and circular strokes to shape the clouds. Blend the clouds, again with circular strokes, using the top corner of the 2" brush.

Use circular strokes to highlight the cloud edges with a mixture of Titanium White and a very small amount of Bright Red on the fan brush. Again, blend with the top corner of a clean, dry 2" brush. (Photo 2.)

BACKGROUND

Load the small round brush by tapping the bristles into various mixtures of Midnight Black, Prussian Blue, Van Dyke Brown, Alizarin Crimson and Sap Green. Tap downward along the horizon to paint the tiny background trees.

Add the background tree trunks with Van Dyke Brown and the liner brush. (To load the liner brush, thin the Van Dyke Brown to an ink-like consistency by first dipping the liner brush into paint thinner. Slowly turn the brush as you pull the bristles through the paint, forcing them to a sharp point.) Paint the trunks with very little pressure, turning and wiggling the brush, to give your trunks a gnarled appearance.

With the dark tree-mixture already in the small round brush, reload it by tapping the bristles into various mixtures of all of the Yellows, Sap Green and a very small amount of Bright Red. Apply the lacy highlights to the background trees by just tapping downward (Photo 3) carefully forming the individual trees.

Underpaint the grassy area at the base of the trees with the 2" brush and the dark tree-mixture. Use Van Dyke Brown on the knife to shape the steep banks along the water's edge. Highlight the banks with a mixture of Titanium White, Dark Sienna and Van Dyke Brown on the knife, using so little pressure that the paint "breaks". (Photo 4.)

Highlight the soft grassy areas with the 2" brush and various mixtures of the dark tree-color, all of the Yellows and Bright Red. Load the brush by holding it at a 45-degree angle and tapping the bristles into the various paint mixtures. Allow the brush to "slide" slightly forward in the paint each time you tap (this assures that the very tips of the bristles are fully loaded with paint). Hold the brush horizontally and gently tap downward. Working forward in layers, allow the grass to extend over the edges of the banks. If you are careful not to destroy all of the dark color already on the canvas, you can create grassy highlights that look almost like velvet. *(Photo 5.)*

CABIN

Use a clean knife to remove paint from the canvas in the basic shape of the cabin. Load the knife with a small roll of Van Dyke Brown. Paying close attention to angles, paint the back edge of the roof, then add the front of the roof.

With Van Dyke Brown on the small knife, add the front and then the side of the cabin. Use a mixture of Titanium White, Bright Red and Dark Sienna to highlight the side of the cabin with so little pressure that the paint "breaks". Add Van Dyke Brown to the mixture to highlight the darker front of the cabin.

Still using Van Dyke Brown, cut in the indication of boards and add a door. Finish the cabin with roof tiles using a mixture of Midnight Black and Titanium White on the short edge of the knife. Use the Yellow highlight mixtures to add soft grass to the base of the cabin.

MIDDLEGROUND

With a small roll of Liquid White on the edge of the knife, cut in water lines at the base of the steep banks *(Photo 6)* along the water's edge *(Photo 7)*.

Working forward in the painting, load the small round brush with the dark tree-mixture to underpaint the larger trees and bushes on the right side of the painting. Extend the dark color into the water, pull straight down with the 2" brush and lightly brush across for the reflections. *(Photo 8.)*

Use thinned Van Dyke Brown on the liner brush to add the tree trunks. *(Photo 9.)*

Highlight the foliage on the trees and bushes with the small round brush and the Yellow-Red highlight colors. You can thin the highlight mixtures with a small amount of Liquid White. *(Photo 10.)*

Use mixtures of Liquid White and Van Dyke Brown on the knife to add the water's edge at the base of the trees. *(Photo 11.)*

Carefully remove the Con-Tact Paper to expose your painted oval. *(Photo 12.)*

FOREGROUND

With the small round brush and the dark tree-mixture, underpaint the large foreground trees and bushes, allowing them to extend outside the oval. *(Photo 13.)*

With a mixture of Van Dyke Brown and Dark Sienna on the fan brush, add the large foreground tree trunk. *(Photo 14.)* Highlight the right side of the trunk with a small roll of Titanium White on the knife; use so little pressure that the paint "breaks". *(Photo 15.)* Use a small amount of a mixture of Titanium White and Prussian Blue on the left side of the trunk for reflected light.

Highlight the foreground foliage, again using the Yellow highlight mixtures and the small round brush, carefully forming individual leaf clusters and small bushes. *(Photo 16.)*

FINISHING TOUCHES

Use the point of the knife to scratch in the twigs or you can use thinned colors on the liner brush to add small, final details. *(Photo 17.)*

Toward Day's End

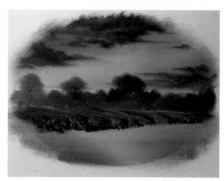

1. Use the 2" brush to paint . . .

2. . . . and blend the sky.

3. Tap in background trees with the small round brush.

4. Add banks with the knife . . .

5. . . . and highlight the grassy areas.

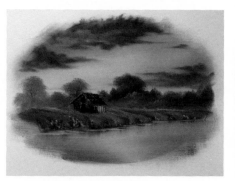

6. Use Liquid White . . .

7. . . . to paint the water's edge.

8. Pull down reflections with the 2" brush . . .

9. . . . and add trunks with the liner brush.

10. Highlight trees with the round brush.

11. Use Liquid White on the knife . . .

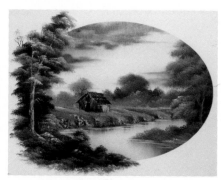

12. . . . to add the water's edge.

13. Extend the tree outside the oval . . .

14. . . . then add the trunk with the fan brush . . .

15. . . . and highlight with the knife.

16. Highlight foliage with the round brush . . .

17. . . . to complete your painting.

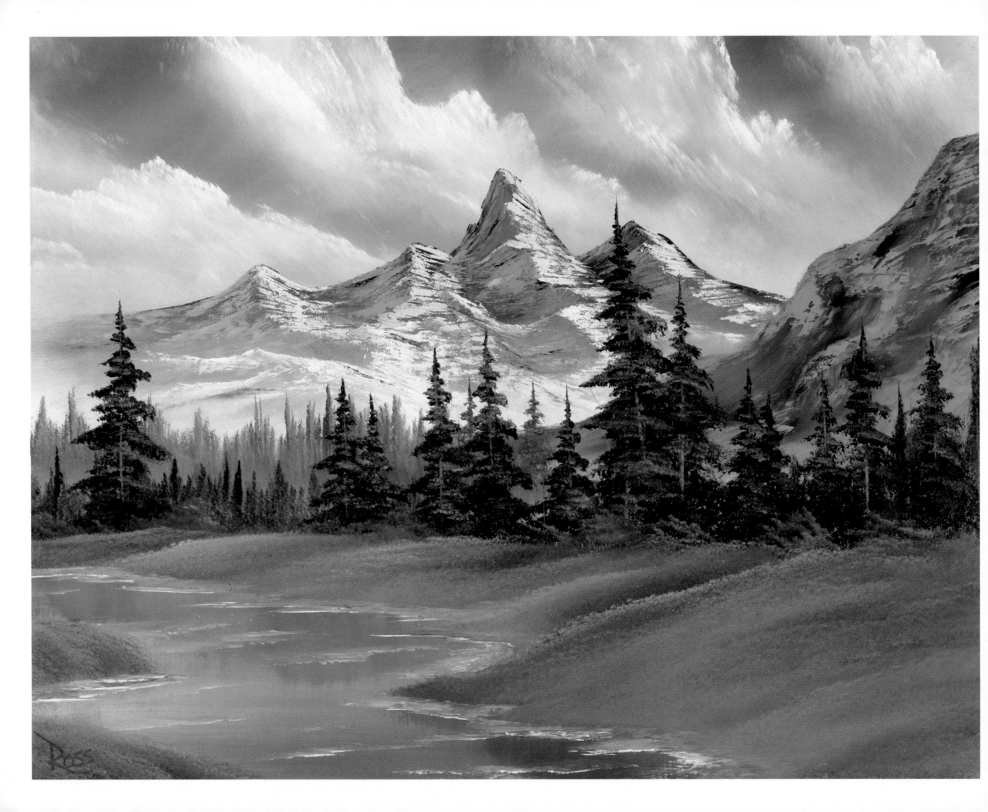

MATERIALS

2" Brush	Midnight Black
1" Brush	Dark Sienna
#6 Fan Brush	Van Dyke Brown
#2 Script Liner Brush	Alizarin Crimson
Large Knife	Sap Green
Small Knife	Cadmium Yellow
Liquid White	Yellow Ochre
Titanium White	Indian Yellow
Phthalo Blue	Bright Red

Start by covering the entire canvas with a thin, even coat of Liquid White using the 2" brush. With long, horizontal and vertical strokes, work back and forth to ensure an even distribution of paint on the canvas. Do NOT allow the Liquid White to dry before you begin.

SKY

Load the 2" brush by tapping the bristles firmly into a mixture of Phthalo Blue and Midnight Black. Starting at the top of the canvas, use criss-cross strokes to paint the sky and long, horizontal strokes to underpaint the water on the lower portion of the canvas. Blend the entire canvas with a clean, dry 2" brush.

The clouds are made with Titanium White on the 2" brush. Use circular strokes with just one corner of the brush to form the shapes. *(Photo 1.)* Being very careful not to touch the top edges, use one corner of a clean, dry 2" brush to blend the base of the clouds and then lift lightly, to "fluff". *(Photo 2.)*

MOUNTAIN

The distant mountain is made with a mixture of Midnight Black and Alizarin Crimson. You can test the color of this mixture by adding a very small amount of some Titanium White. If necessary, add more Black or Crimson, to correct. Pull the mixture out very flat on your palette and cut across to load the long edge of the knife with a small roll of paint.

Use firm pressure on the knife to shape just the top edge of the mountain. *(Photo 3.)* When you are satisfied with the shape,

use the knife to remove any excess paint and then with the 2" brush, pull the paint down to the base of the mountain to complete the entire mountain shape. *(Photo 4.)*

To highlight the mountain, load the long edge of the small knife with a small roll of Titanium White. In this painting, the light is coming from the right. So, starting at the top of the mountain, and carefully following the angles, "bounce" (not glide) the knife down the right side of each peak. *(Photo 5.)* Add the shadows using a mixture of Titanium White and Phthalo Blue on the knife and apply by "bouncing" the knife down the left sides of the peaks. Be sure to give each highlight a shadow! With a clean, dry 2" brush, carefully following the angles, tap to diffuse the base of the mountain *(Photo 6)* and then gently lift upward to create the illusion of mist *(Photo 7)*.

Use the same dark mixture to add the closer, larger mountain. *(Photo 8.)* This mountain is in shadow, so use only the Titanium White-Phthalo Blue mixture to "highlight". *(Photo 9.)*

BACKGROUND

The trees are made with a mixture of Midnight Black, Phthalo Blue, Van Dyke Brown, Alizarin Crimson and Sap Green. To make the tiny background trees, add some Titanium White and Sap Green to a small amount of this dark mixture (to make a "dirty" Green) and load the fan brush. Hold the brush vertically and tap downward to just indicate the small trees at the base of the mountain. *(Photo 10.)* Use a clean, dry 2" brush to tap and diffuse the base of the trees and then lightly lift upward, creating the illusion of mist. *(Photo 11.)* Repeat this procedure to indicate a closer range of small trees using the original dark mixture on the fan brush.

For the more distinct evergreens, load the fan brush full of the dark mixture and then holding the brush vertically, touch the canvas to form the center line of the tree. Turn the brush horizontally (using just one corner of the brush), touch the canvas to begin adding the top branches. Working from side to side, as you move down the tree, use more pressure on the brush (forcing the bristles to bend downward) and automatically the

branches will become larger as you near the base of each tree. *(Photo 12.)* Use a small roll of Van Dyke Brown on the knife to add small tree trunks. Then, with Cadmium Yellow on the fan brush, you can just touch a few highlights to the right side of the tree branches. *(Photo 13.)*

FOREGROUND

Load the 2" brush by tapping the bristles into the dark mixture. Beginning at the base of the background trees, hold the brush horizontally and tap downward to underpaint the ground area. *(Photo 14.)* Continue using the 2" brush to pull the dark color into the water for reflections. *(Photo 15.)* This is where you begin forming the lay-of-the-land. Load the 2" brush with various mixtures of all the Yellows, and working in layers, tap downward to highlight the grassy area. *(Photo 16.)* Pay close attention to the contour of the land (notice how it slopes down towards the water) and be very careful not to completely cover all of your dark base color. You can even pull in some of the dark color from the trees to create shadow effects. *(Photo 17.)*

WATER

Use Van Dyke Brown on the long edge of the knife to add the banks along the water's edge *(Photo 18)* and a small roll of Titanium White on the knife to create the water movement, lines and ripples *(Photo 19)*.

FINISHING TOUCHES

Use the point of the knife to scratch in tiny sticks and twigs or other small details. Step back and admire your painting and then sign with a thinned paint on the liner brush. *(Photo 20.)*

Mountain Exhibition

1. Add the clouds . . .

2. to complete the sky.

3. Use the knife to shape the top of the mountain.

4. Pull the paint down with the 2" brush.

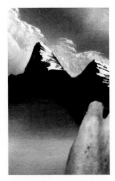
5. Apply highlights with the knife . . .

Mountain Exhibition

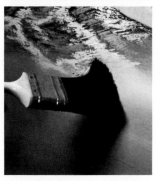

6. . . . and then tap to mist with the 2" brush . . .

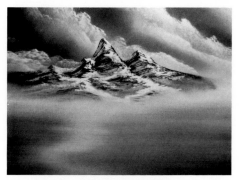

7. . . . to complete the distant mountain.

8. Use the knife . . .

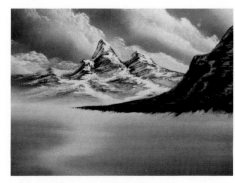

9. . . . to add the closer mountain.

10. Tap down distant trees with the fan brush . . .

11. . . . then mist with the 2" brush.

12. Use one corner of the fan brush . . .

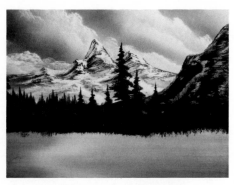

13. . . . to add the more distinct evergreens.

14. Tap down with the 2" brush to underpaint the grassy areas.

15. Pull down with the 2" brush for reflections.

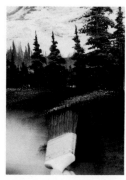

16. Also tap down with the 2" brush . . .

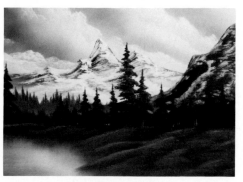

17. . . . to highlight the grassy areas.

18. With the knife, add banks . . .

19. . . . and water lines and ripples . . .

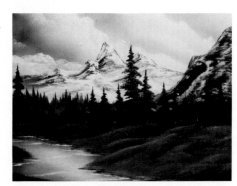

20. . . . to complete the painting.

9. EVENING SEASCAPE

MATERIALS

2" Brush	Dark Sienna
1" Brush	Cadmium Yellow
#6 Fan Brush	Bright Red
#2 Script Liner Brush	Prussian Blue
Large Knife	Phthalo Blue
Liquid White	Phthalo Green
Black Gesso	Titanium White
Alizarin Crimson	Van Dyke Brown

Start with a canvas that has been painted with Black Gesso and allowed to dry completely. Using the 2" brush, paint a narrow band of Dark Sienna across the bottom of the vertical canvas. Without cleaning the brush, blend this color into a band of Van Dyke Brown, then Phthalo Green and then Phthalo Blue. The top half of the canvas is covered with Prussian Blue. Make sure the colors are applied with a very thin layer of paint then use long horizontal and vertical strokes to blend the entire canvas. Do not allow the paint to dry before you begin.

SKY

To make the clouds, load the fan brush with Titanium White. Use the corner of the brush in very small circular patterns to make the basic cloud shapes. *(Photo 1.)* Complete only one cloud at a time, totally finishing the most distant cloud first. After the basic cloud shape is completed, use the top corner of the 2" brush to blend the bottom of the cloud, being careful not to touch the top edge of the cloud. Still using the 2" brush, make gentle, upward, circular strokes to "fluff" the cloud. Blend the entire sky.

ROCKS AND CLIFFS

Mix a Black color by blending together equal parts of Phthalo Green and Alizarin Crimson.

The most distant rock is made using the fan brush and the Black mixture. *(Photo 2.)* Load the brush and lay in the basic shape. *(Photo 3.)* Still using the fan brush and the Black paint, make the evergreen trees by holding the brush vertically and just touching the canvas to create a center line. Turn the brush, and using just one corner, paint in the branches applying more pressure as you near the bottom of the tree. *(Photo 4.)* Highlight the rock shapes with the fan brush using various mixtures of Van Dyke Brown, Titanium White and the Black. Close attention to angles and brush strokes will create the appearance of rocks and steep cliffs. *(Photo 5.)* The misty area at the base of the rock is made with Titanium White and the 2" brush by gently tapping and lifting upward in short strokes. *(Photo 6.)* The final highlights are applied with the liner brush and Bright Red paint, thinned with paint thinner, making sure to complete the most distant rock before beginning the cliffs in the foreground. *(Photo 7.)*

WATER

Start with a very small roll of Titanium White on the long edge of the knife. Begin laying in the water along the horizon between the rocks by gently touching the knife to the canvas and making short back and forth strokes. These lines should be perfectly straight, parallel to the bottom edge of the canvas. *(Photo 8.)* Use the 2" brush, held flat, in light horizontal strokes to blend the water lines. *(Photo 9.)* The waves are a mixture of Titanium White and a little Liquid White applied with the fan brush. *(Photo 10.)* The foam is created by pushing the brush into the canvas, forcing the bristles to bend upward. *(Photo 11.)* The small stones are formed with the fan brush and the Black mixture. Using the same brush with Titanium White, Liquid White and Phthalo Blue, "pull" some water over these stones. *(Photo 12.)* Load the fan brush with Cadmium Yellow and push in some color at the base of the large wave in the foreground. *(Photo 13.)* If the color seems too bright, add a little Titanium White. Using the fan brush with varying mixtures of Titanium White and Phthalo Blue, "pull" the water across, up and over the Yellow paint. *(Photo 14.)* Pay very close attention to brush strokes and angles. *(Photo 15.)* The sandy beach area is made with horizontal strokes using the fan brush and Titanium White. *(Photo 16.)* With the 2" brush, pull this color straight down and then gently brush across to create reflections. *(Photo 17.)* The water line on the beach is made using the fan brush with Titanium White

and some Phthalo Blue. *(Photo 18.)* With very flat, horizontal strokes, pull this water back towards the base of the wave. More small stones can be made with the fan brush and the Black paint; highlights are Van Dyke Brown and Titanium White. *(Photo 19.)* Still using the fan brush and Titanium White, make some water splashing around the rocks by pushing the brush straight into the canvas and bending the bristles upward. *(Photo 20.)*

FINISHING TOUCHES

Use the liner brush with thinned Titanium White and Phthalo Blue to make water dripping over the small stones in the foreground. A thin line of dark color will more clearly define the water on the beach. *(Photo 21.)* Use the liner brush and thinned Black paint. *(Photo 22.)*

Evening Seascape

1. The fan brush is used to paint clouds . . .

2. . . . and to shape rocks and stones.

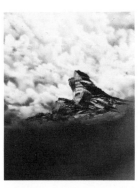
3. Basic shape for background rock.

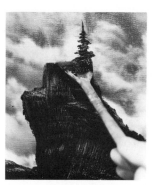
4. Evergreen tree made with a fan brush.

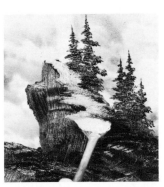
5. Use highlights to give form to the rocks.

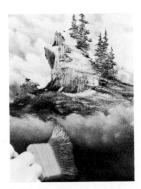
6. Use the 2" brush to create mist . . .

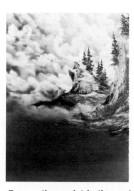
7. . . . then paint in the next rock.

8. Distant water is laid with the knife . . .

9. . . . then blended with the 2" brush.

10. Background waves made with the corner of the fan brush.

Evening Seascape

11. Foam is made with the corner of the fan brush.

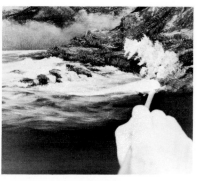

12. Bring the wave in front of the foam.

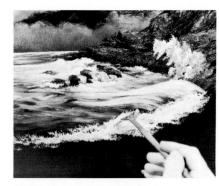

13. Paint in the light area at the base of the wave.

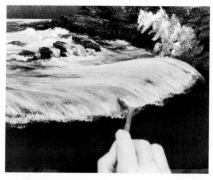

14. Pull the wave over the light areas.

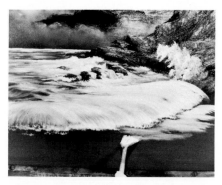

15. Use the fan brush to lay water on the beach.

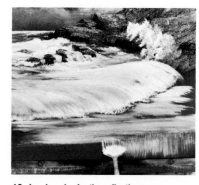

16. Lay in color for the reflections . . .

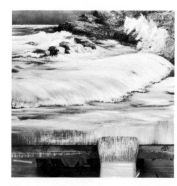

17. . . . and pull downward with the 2" brush.

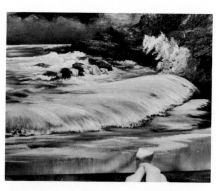

18. Redefine the foam at the edge of the water.

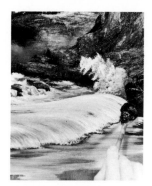

19. Rocks are painted in with the fan brush.

20. Push upward with the corner of the fan brush to create foam.

21. Place a dark shadow under the foam . . .

22. . . . and the painting is complete.

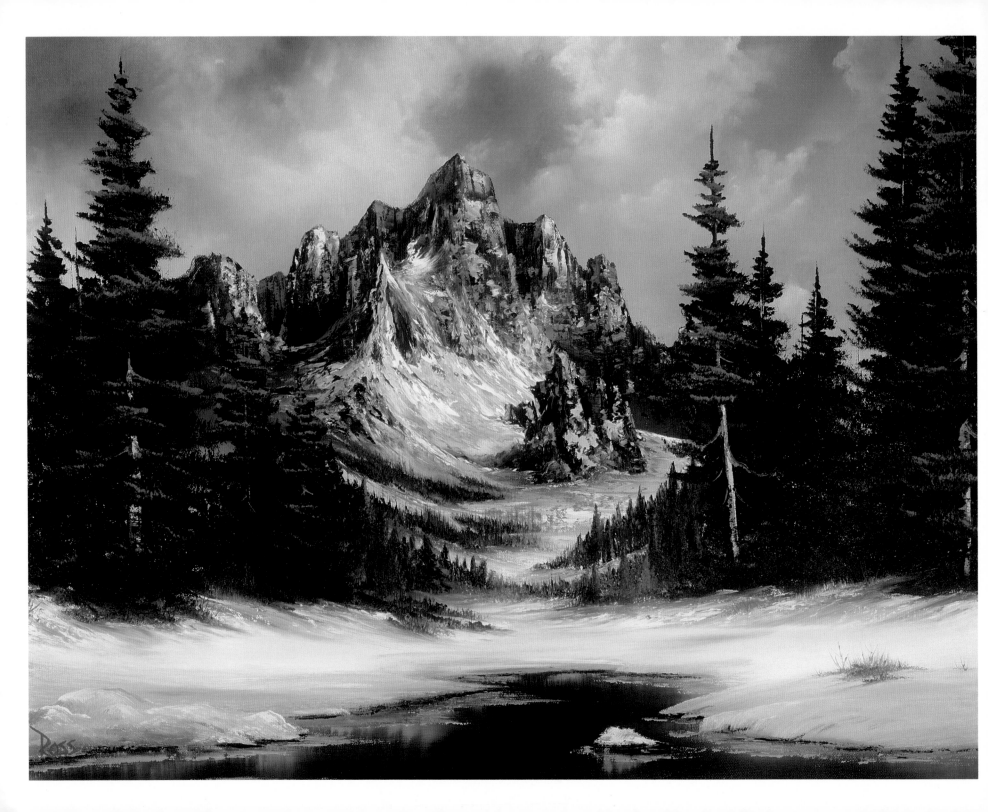

10. NOT QUITE SPRING

MATERIALS

2" Brush	Prussian Blue
#6 Fan Brush	Midnight Black
Large Knife	Dark Sienna
Black Gesso	Van Dyke Brown
Liquid White	Alizarin Crimson
Liquid Clear	Cadmium Yellow
Titanium White	Yellow Ochre

Use a natural sponge and Black Gesso to tap in the dark foliage shapes on lower portions of the canvas, and allow to DRY COMPLETELY. (Photo 1.)

When the Black Gesso is dry, use the 2" brush to apply a VERY thin coat of Liquid Clear to the entire canvas. Then, use the 2" brush to apply a very thin, even coat of Midnight Black to the lower portion of the canvas. Do NOT allow the canvas to dry before proceeding.

SKY

Load a clean, dry 2" brush by tapping the bristles into a very small amount of Prussian Blue. Use criss-cross strokes to begin painting the sky. (Photo 2.) Without cleaning the brush, reload it with various mixtures of Midnight Black and Alizarin Crimson and continue using criss-cross strokes to indicate the darker areas in the sky.

Reload the brush with Titanium White and use just one corner of the brush and circular strokes to swirl in the basic cloud shapes. (Photo 3.)

With the fan brush and various mixtures of Titanium White, Dark Sienna, Alizarin Crimson and Yellow Ochre, use small circular and spinning strokes to further define and outline the cloud shapes. (Photo 4.)

Blend the clouds with a clean, dry 2" brush, using circular and criss-cross strokes, then sweeping upward strokes to "fluff". Blend the entire sky with long horizontal strokes. (Photo 5.)

MOUNTAIN

Use the knife to lightly blend a mixture of Midnight Black, Van Dyke Brown and a small amount of Dark Sienna to paint the mountain. Pull the mixture out very flat on your palette, hold the knife straight up and "cut" across the mixture to load the long edge of the blade with a small roll of paint. (Holding the knife straight up will force the small roll of paint to the very edge of the blade.) With firm pressure, shape just the top edge of the mountain. (Photo 6.) When you are satisfied with the basic shape of the mountain top, use the knife to blend the paint down to the base of the mountain.

Mix three values of color to highlight the mountain: Titanium White and Dark Sienna to make a light Brown, Titanium White and Van Dyke Brown to make a darker Brown and Titanium White, Midnight Black and Van Dyke Brown for a Gray.

Load the long edge of the knife with a small roll of the light-Brown mixture. Starting at the top (and paying close attention to angles) highlight the right side of each peak, using so little pressure that the paint "breaks". (Photo 7.) Use the dark-Brown mixture to highlight the base of the mountain.

Apply the Gray highlight-mixture, in the opposing direction, for the shadowed sides of the peaks. Again, use so little pressure that the paint "breaks".

Use Titanium White with a very small amount of Prussian Blue to add the glacier and also around the base of the mountain. Be sure not to completely cover the darker mountain colors already on the canvas. (Photo 8.)

To create depth to the painting, use the same mixtures to add the smaller mountains at the base of the large mountain. (Photo 9.)

BACKGROUND

Start by mixing a dark-tree color with Midnight Black, Van Dyke Brown, Prussian Blue and Alizarin Crimson. Use the fan brush to push this color into the canvas at the base of the mountains (Photo 10) then use tiny upward strokes to just indicate the most distant evergreens (Photo 11). Be very careful not to completely cover all of the White snowy areas at the base of the mountain. The most distinct background evergreens are made

by holding the fan brush vertically and tapping downward. *(Photo 12.)*

Working forward in layers, use Titanium White on the knife and long horizontal strokes to continue covering the ground area with snow, paying close attention to the lay-of-the-land. *(Photo 13.)*

LARGE EVERGREENS

To paint the large evergreens, load the fan brush to a chiseled edge with the dark tree-mixture. Holding the brush vertically, touch the canvas to create the center line of each tree. Use just the corner of the brush to begin adding the small top branches. Working from side to side, as you move down each tree, apply more pressure to the brush, forcing the bristles to bend upward. Automatically, the branches will become larger as you near the base of each tree. *(Photo 14.)*

Add the trunks with a small roll of the light Brown mixture (originally used to highlight the mountains) on the knife. Hold the knife vertically and make tiny, horizontal strokes. *(Photo 15.)*

Without cleaning the fan brush, reload it with a mixture of Cadmium Yellow and Yellow Ochre and lightly touch Green highlights to the branches of each large tree. *(Photo 16.)* (To maintain the illusion of distance in the painting, do not add the highlight color to the smaller background trees.) Allow the base of the larger trees to remain quite dark, applying less of the highlight color to the lower branches.

FOREGROUND

Continue working forward using Titanium White on the knife to add the snow-covered land areas into the foreground. *(Photo 17.)* Allow the knife to pick up and blend some of the dark color from the base of the trees, automatically creating the illusion of shadows in the snow. *(Photo 18.)*

With a very small amount of Titanium White on the 2" brush, pull straight down to add the foreground water *(Photo 19)* then lightly brush across to create reflections.

Use a small roll of the dark tree-mixture on the knife to add the water's edge. *(Photo 20.)*

Shape and contour the foreground snow with Titanium White on the fan brush. *(Photo 21.)* Again, use a small roll of the dark tree-mixture to add the water's edge.

Cut in water lines and ripples with a small roll of Liquid White on the knife. *(Photo 22.)*

FINISHING TOUCHES

Use the fan brush to shape a small snow-covered stone in the foreground water, then use the 2" brush to pull down its light reflection and brush across. Add the dark shadows under the stone with the dark tree-mixture, then use Liquid White on the knife to add tiny water lines and ripples. Stand back and admire your finished masterpiece! *(Photo 23.)*

Not Quite Spring

1. Underpaint the dark shapes with Black Gesso.

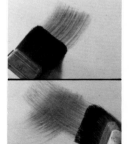

2. Use criss-cross strokes to paint the sky . . .

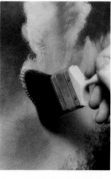

3. . . . and circular strokes to paint the clouds.

4. Use the fan brush and circular strokes . . .

5. . . . to highlight the clouds.

Not Quite Spring

 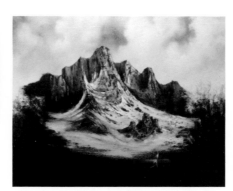

6. Use the knife to shape the mountain . . .

7. . . . then add the highlights . . .

8. . . . and glacier . . .

9. . . . to complete the mountain.

10. Use the fan brush at the base of the mountain . . .

11. . . . and upward strokes to paint tiny trees.

 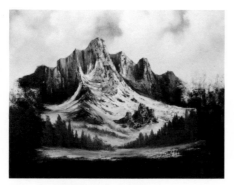

12. Tap down small evergreens . . .

13. . . . at the base of the mountain.

14. Paint large evergreens with the fan brush . . .

15. . . . add trunks with the knife . . .

16. . . . then highlights with the fan brush.

17. Use the knife and horizontal strokes . . .

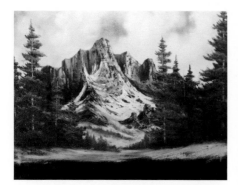 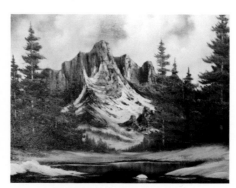

18. . . . to add snow to the base of the evergreens.

19. Pull down reflections with the 2" brush.

20. Use the knife to add the water's edge . . .

21. . . . then continue laying in snow.

22. Add water lines and ripples with Liquid White . . .

23. . . . to complete the painting.

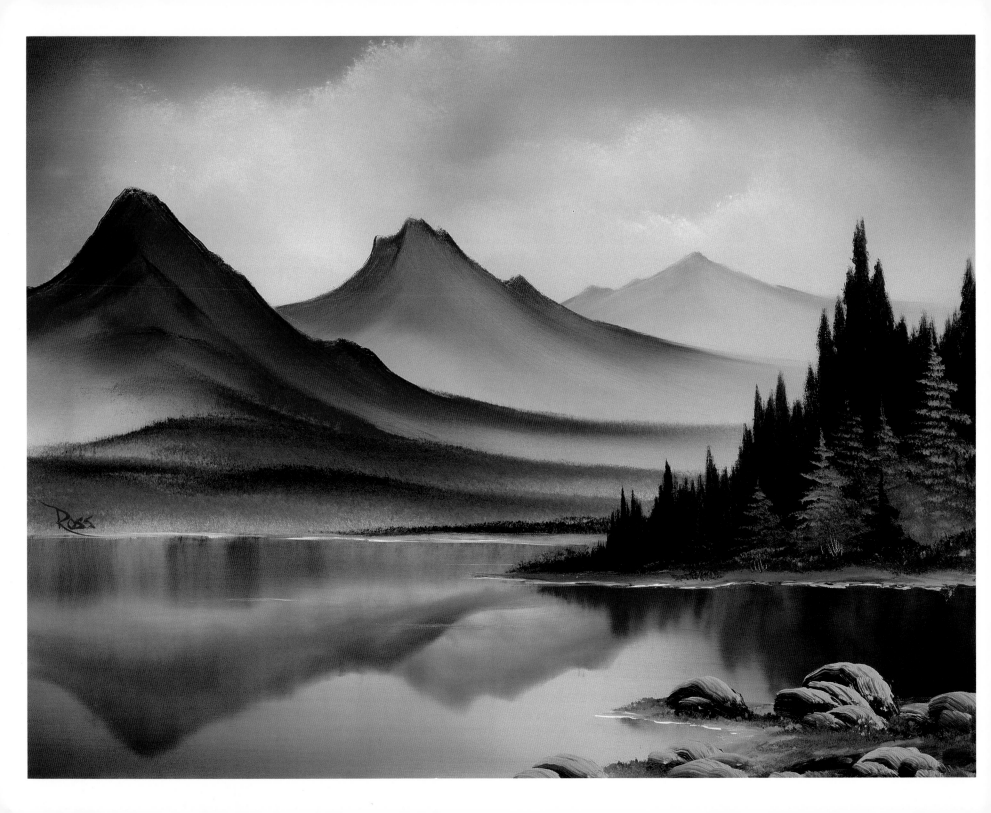

11. MIRRORED IMAGES

MATERIALS

2" Brush	Midnight Black
1" Oval Brush	Dark Sienna
#6 Fan Brush	Van Dyke Brown
#2 Script Liner Brush	Alizarin Crimson
Large Knife	Sap Green
Liquid White	Cadmium Yellow
Titanium White	Yellow Ochre
Phthalo Blue	Indian Yellow

Use the 2" brush to cover the entire canvas with a thin, even coat of Liquid White. Do NOT allow the Liquid White to dry before you begin.

SKY

With a small amount of Phthalo Blue on the 2" brush and starting at the top of the canvas and working downward, use criss-cross strokes to paint the sky. Allow an area near the center of the sky to remain unpainted. (This will become clouds.) Blend with horizontal strokes.

This is a good time to under-paint the water on the lower portion of the canvas. Reload the brush with Phthalo Blue. Starting at the bottom of the canvas (and working up towards the horizon) use horizontal strokes, pulling from the outside edges of the canvas in towards the center. You can create the illusion of shimmering light on the water by allowing the center of the canvas to remain light.

Reload the 2" brush with Prussian Blue to darken just the edges of the canvas; criss-cross strokes in the top corners of the canvas and horizontal strokes on the lower edges. Use a clean, dry 2" brush and criss-cross strokes to blend the sky, then blend the entire canvas with long, horizontal strokes.

Load a clean, dry 2" brush by holding it vertically and tapping the top corner into a small amount of Titanium White. Begin painting the clouds, starting in the light area of the sky, holding the brush vertically and just tapping in cloud shapes with the top corner of the brush. Layer the clouds, adding small amounts of Indian Yellow, Alizarin Crimson and Phthalo Blue to the Titanium White. Tap with a clean, dry 2" brush to blend the clouds, then blend the entire sky with small criss-cross strokes. (Photo 1.)

MOUNTAINS

Load the knife with a mixture of Titanium White, Phthalo Blue and a small amount of Alizarin Crimson. Pull the mixture out very flat on your palette, hold the knife straight up and "cut" across the mixture to load the long edge of the blade with a small roll of paint. With firm pressure, shape just the top edge of the most distant mountain. (Photo 2.) When you are satisfied with the basic shape of the mountain top, use the knife to remove any excess paint. Then, with the 2" brush, blend the paint down to the base of the mountain. (Photo 3.) Use criss-cross strokes to diffuse the entire distant mountain. Working forward in the painting, the second range of mountains should be larger and darker (add a bit more Alizarin Crimson to the mixture). Again, remove the excess paint and blend the remaining color down to the base of the mountain. (Photo 4.)

Paint the third range of mountains larger and darker (add more Alizarin Crimson, Phthalo Blue and Midnight Black to the mountain mixture). (Photo 5.) Remove excess paint and blend the base of the mountain with the 2" brush.

FOOTHILLS

Continue using the 2" brush to tap downward, extending the angles of the closest mountain into foothills. (Photo 6.) Use short, upward strokes to indicate tiny tree tops. As you work forward in layers, you can begin adding a bit of color to the foothills. Use various mixtures of Sap Green and all of the Yellows with the mountain mixture. (Photo 7.)

WATER

With very little paint on the fan brush, use the lightest mixture to reflect the most distant mountain. (Photo 8.) Again, working forward in layers, reflect the larger, darker mountain and finally the third range of mountains.

Reflect the foothill colors with the 2" brush; starting at the base of the hills, just pull straight down. *(Photo 9.)* To give all of the reflections a "watery" appearance, start at the bottom of the canvas and with firm pressure, brush upward with the 2" brush. Then, lightly brush across. *(Photo 10.)* With a mixture of Titanium White, Dark Sienna, Van Dyke Brown and Yellow Ochre on the knife, scrub in the land area at the base of the foothills *(Photo 11),* then use a very small roll of Liquid White on the edge of the knife to "cut" in the water lines and ripples *(Photo 12.)*

EVERGREENS

Load the fan brush with a mixture of Midnight Black, Prussian Blue, Van Dyke Brown, Alizarin Crimson and Sap Green. Hold the brush vertically and tap downward to paint the cluster of evergreens. *(Photo 13.)* Mist the base of the trees by brushing upward with the 2" brush. *(Photo 14.)* With the same dark mixture on the 2" brush, pull down to reflect the trees into the water *(Photo 15)* then brush across.

For the more distinct evergreens, load the fan brush to a chiseled edge with various dark Green mixtures of Sap Green, all of the Yellows and a very small amount of Bright Red. Holding the brush vertically, touch the canvas to create the center line of each tree. Use just the corner of the brush to begin adding the small top branches. Working from side to side, as you move down each tree, apply more pressure to the brush, forcing the bristles to bend downward and automatically the branches will become larger as you near the base of each tree. *(Photos 16 & 17.)* Reflect these trees in the water. With the 2" brush, pull the reflections straight down and lightly brush across. Use the land mixture (Titanium White, Dark Sienna, Van Dyke Brown and Yellow Ochre) on the knife to add the land at the base of the evergreens; use a roll of Liquid White to cut in lines along the water's edge.

FOREGROUND

Working forward in the painting, continue using the land mixture on the knife to block in the foreground. *(Photo 18.)*

Load both sides of the oval brush with a dark mixture of Van Dyke Brown and Midnight Black which has been thinned with a small amount of paint thinner. Then, pull one side of the bristles through a thinned light mixture of Titanium White and Midnight Black, to double-load the brush. With the light side of the bristles up, make single curved strokes to paint each of the larger foreground rocks. By double-loading the brush, with just one stroke, you can paint each rock and its highlight. *(Photo 19.)* Use mixtures of Sap Green and the Yellows on the fan brush to punch in grassy areas at the base of the rocks. *(Photo 20.)*

FINISHING TOUCHES

Use the point of the knife to scratch in small sticks and twigs; then use thinned paint on the liner brush to add your signature and the painting is complete. *(Photo 21.)*

Mirrored Images

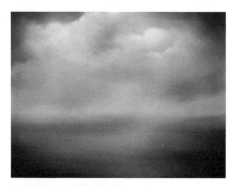

1. Begin by painting the sky.

2. Shape the mountain top with the knife . . .

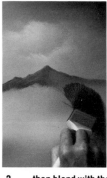

3. . . . then blend with the 2" brush.

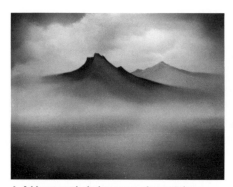

4. Add a second, darker range of mountains.

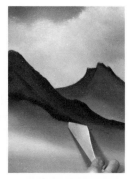

5. Paint the third range of mountains with the knife.

Mirrored Images

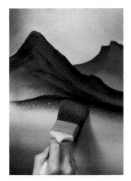 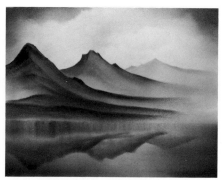

6. Tap down with the 2" brush . . .

7. . . . to paint the foothills.

8. Paint mountain reflections with the fan brush.

9. Use the 2" brush to pull down the foothill reflections . . .

10. . . . then lightly brush across.

 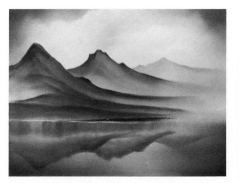 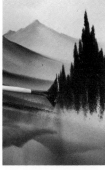 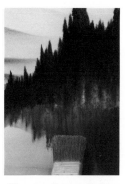 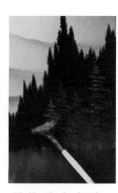

11. Use Liquid White on the knife . . .

12. . . . to cut in water lines and ripples.

13. Tap down with the fan brush to indicate evergreens . . .

14. . . . brush up with the 2" brush to blend . . .

15. . . . then pull down reflections.

16. Use the fan brush . . .

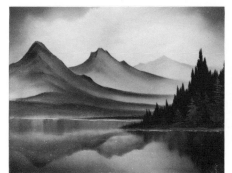

17. . . . to paint more distinct evergreens.

18. Block in the foreground with the knife . . .

19. . . . then use the oval brush to add the rocks.

20. Add grassy areas with the fan brush . . .

21. . . . to complete your painting.

12. DESERT HUES

MATERIALS

2" Brush	Dark Sienna
#6 Filbert Brush	Van Dyke Brown
#2 Script Liner Brush	Alizarin Crimson
Large Knife	Sap Green
Adhesive-Backed Plastic	Cadmium Yellow
Liquid White	Yellow Ochre
Titanium White	Indian Yellow
Prussian Blue	Bright Red
Midnight Black	

Start by covering the entire canvas with a piece of adhesive-backed plastic (such as Con-Tact Paper) from which you have removed a center oval shape. (A 16 x 20 oval for an 18 x 24 canvas.)

Use the 2" brush to cover the exposed oval-area of the canvas with a thin, even coat of Liquid White. With long, horizontal and vertical strokes, work back and forth to ensure an even distribution of paint on the canvas. Do NOT allow the Liquid White to dry before you begin.

SKY

Load the 2" brush with a very small amount of a mixture of Prussian Blue and Midnight Black, tapping the bristles firmly against the palette to ensure an even distribution of paint throughout the bristles. Starting at the top of the canvas, and working downward, use criss-cross strokes to randomly paint the sky, allowing areas to remain light for the addition of clouds. *(Photo 1.)* Notice how the color blends with the Liquid White already on the canvas and automatically the sky becomes lighter as you near the horizon. Use a clean, dry 2" brush and long, horizontal strokes to blend the entire sky. *(Photo 1.)*

Load the 2" brush with a mixture of Titanium White and Yellow Ochre and tap downward to add the basic cloud shapes to the exposed areas of the sky. *(Photo 2.)* Use a clean, dry 2" brush and long, horizontal strokes to blend the entire sky area. *(Photo 3.)*

MOUNTAINS

The mountains are made with the knife and a mixture of Prussian Blue and Alizarin Crimson (to make a Blue-Lavender color). Pull the mixture out very flat on your palette, hold the knife straight up and "cut" across the mixture to load the long edge of the blade with a small roll of paint. (Holding the knife straight up will force the small roll of paint to the very edge of the blade.) Starting with the most distant mountain, use firm pressure to shape just the top edge of the mountain. *(Photo 4.)* When you are satisfied with the basic shape of the mountain top, use the knife to remove any excess paint. Then, with the 2" brush, pull the paint down to the base of the mountain to blend and complete the entire mountain shape. *(Photo 5.)*

With a mixture of Titanium White and Yellow Ochre on the knife, use circular strokes to firmly rub and diffuse the base of the distant mountain *(Photo 6)* creating the illusion of mist *(Photo 7)*.

Working forward, add the larger, closer mountain with the same dark Lavender mixture on the knife. *(Photo 8.)* (Be very careful not to completely cover the misty area at the base of the distant mountain. Use it to separate the mountains, creating depth in your painting.) Again, use the knife to remove excess paint, then use the 2" brush to blend the paint down to the base of the mountain.

Highlight the larger mountain with various mixtures of Titanium White, Dark Sienna, Bright Red, Alizarin Crimson and Yellow Ochre. Begin by loading the long edge of the knife with a small roll of paint. Starting at the top (and paying close attention to angles) apply the highlight colors to the right side of each peak, using so little pressure that the paint "breaks". *(Photo 9.)* Use the original dark Lavender mountain-mixture on the knife to redefine the shadowed sides of the peaks. *(Photo 10.)*

Use the knife and various mixtures of Sap Green, Cadmium Yellow, Yellow Ochre and Van Dyke Brown to firmly rub in the misty Green land-areas *(Photo 11)* at the base of the large mountain *(Photo 12)*.

BACKGROUND

With the filbert brush and various mixtures of Van Dyke Brown, Dark Sienna and Midnight Black, paint the tiny cactus at the base of the mountains. *(Photo 13.)* Use the same dark mixtures on the filbert brush to underpaint the small shrubs and bushes at the base of the cactus. *(Photo 14.)* Highlight the foliage with various mixtures of all of the Yellows and a very small amount of Phthalo Blue (to make Green). Shape the bushes with very subtle highlights, try to not completely cover all of the dark undercolor.

Use the dark Prussian Blue-Alizarin Crimson mixture on the knife *(Photo 15)* to shape the background rock formations *(Photo 16).*

Starting at the base of the small background cactus and working forward *(Photo 17),* add the land area with the mountain highlight mixtures (Titanium White, Dark Sienna, Bright Red, Alizarin Crimson and Yellow Ochre) on the knife *(Photo 18).*

LARGE CACTUS

Use the filbert brush and a thick, textured amount of the Van Dyke Brown-Dark Sienna-Midnight Black mixture to paint the large foreground cactus. *(Photo 19.)* Highlight the large cactus with a mixture of Cadmium Yellow and Sap Green on the same brush.

Reload the filbert brush with the Prussian Blue-Alizarin Crimson mixture to underpaint the bushes at the base of the cactus. *(Photo 20.)* Highlight the bushes with the filbert brush and various mixtures of all of the Yellows, Sap Green, Bright Red and add some bushes with the Blue-White mixture.

Use the knife and the dark Brown mixtures to add the foreground land area at the base of the large cactus. Use horizontal strokes, paying close attention to the lay-of-the-land. Highlight the land area with a mixture of Titanium White and Yellow Ochre on the knife; use so little pressure that the paint "breaks". *(Photo 21.)*

FINISHING TOUCHES

Underpaint tiny foreground bushes with the Prussian Blue-Alizarin Crimson mixture and the filbert brush, then highlight with the Blue-White mixture to complete your painting. *(Photo 22.)* Carefully remove the Con-Tact Paper *(Photo 23)* to expose your finished desert scene *(Photo 24).*

Don't forget to sign your painting. You can just scratch in your name with the point of the knife or use the liner brush with thinned color of your choice. Whatever your choice, have fun, for hopefully with this painting you have truly experienced THE JOY OF PAINTING!

Desert Hues

1. Use the 2" brush to paint the sky . . .

2. . . . and to tap in cloud shapes . . .

3. . . . and to blend the sky.

4. Shape the distant mountain top . . .

5. . . . then blend the paint down with the 2" brush.

6. Firmly rub the base of the mountain . . .

7. . . . to create the misty area.

Desert Hues

8. Shape the mountain top . . .

9. . . . and apply highlights . . .

10. . . . as you work forward.

11. Firmly rub with the knife . . .

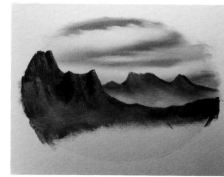

12. . . . to add foliage to the base of the large mountain.

13. Use the filbert brush . . .

14. . . . to shape the distant cactus.

15. Shape rocks with the knife . . .

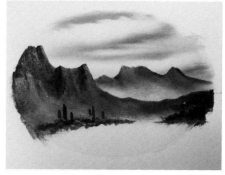

16. . . . at the base of the mountains.

17. Continue using the knife . . .

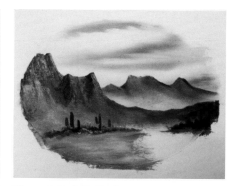

18. . . . to lay in the land area.

19. Shape larger cactuses . . .

20. . . . and add foliage to their feet with the filbert brush.

21. Continue adding desert land . . .

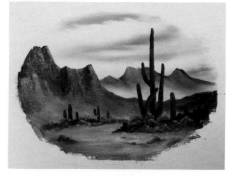

22. . . . paying close attention to the lay-of-the-land.

23. Carefully remove the Con-Tact Paper . . .

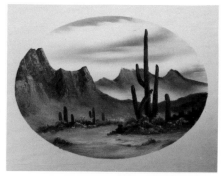

24. . . . and admire your finished masterpiece!

MATERIALS

2" Brush	Phthalo Green
1" Brush	Phthalo Blue
#6 Fan Brush	Prussian Blue
#6 Filbert Brush	Midnight Black
#2 Script Liner Brush	Dark Sienna
Large Knife	Van Dyke Brown
Small Knife	Alizarin Crimson
Liquid White	Cadmium Yellow
Black Gesso	Yellow Ochre
Titanium White	Indian Yellow

The horizon line of this seascape is 14" down from the top of a vertical canvas. Cover the area below the horizon with a thin, even coat of Black Gesso and allow to dry completely.

Cover the area above the horizon with a thin, even coat of Liquid White using the 2" brush. Use a clean, dry 2" brush to apply a mixture of Phthalo Blue and Alizarin Crimson just below the horizon over the dry Black Gesso. Below this Lavender color add a Green mixture of Prussian Blue and Yellow Ochre and across the bottom of the canvas a mixture of Phthalo Blue and Phthalo Green. Do no allow any of these colors to dry before you begin your painting.

SKY

Load a clean, dry 2" brush with a mixture of Phthalo Blue and Midnight Black. Use criss-cross strokes to apply color at random throughout the sky, leaving the cloud areas unpainted. Clean and dry the brush to blend and soften the sky, still using criss-cross strokes.

Without cleaning the brush, pick up a mixture of Bright Red and Midnight Black. Use tiny circular strokes to add just the cloud shadows to the light areas of the sky. *(Photo 1.)* Use Titanium White with a touch of Bright Red on the 1" brush to shape the clouds, still using small circular strokes. Allow the light cloud color to merge with the dark shadow color. *(Photo 2.)* Use the top corner of a clean, dry 2" brush and small circular strokes to

gently blend the clouds, being very careful not to touch the top edges. (Photo 3.) Then, very gently lift upward to fluff. *(Photo 4.)*

BACKGROUND WATER

Use Titanium White on the filbert brush to roughly sketch the major wave. *(Photo 5.)*

Load the fan brush with Titanium White to paint the water along the horizon. Hold the brush horizontally, go straight into the canvas, and make short sweeping strokes. Remember, because the canvas is still covered with wet paint you will be able to create many exciting effects in the background water.

To make the background waves (or swells), again use Titanium White on the fan brush. Paying close attention to angles, paint long horizontal lines across the canvas. *(Photo 6.)* With a clean fan brush, grab the tops of the lines and use a sweeping motion to pull the paint back. *(Photo 7.)* The BOTTOMS of the lines will create the TOPS of the waves. Be very careful not to "kill" all the dark color between the swells. *(Photo 8.)*

LARGE WAVE

Use the same procedure with Titanium White on the fan brush to paint a White line across the top of the major wave and again use short sweeping strokes to pull back and blend.

The transparency or "eye" of the wave is made by using the filbert brush and a mixture of Titanium White with a small amount of Cadmium Yellow. "Scrub" the color into the transparency, allowing a little of it to extend out across the top of the wave. With a clean, dry filbert brush, repeat this procedure until you have achieved the desired lightness. Use the knife to remove any excess paint. *(Photo 9.)*

Use just the top corner of a very clean, dry 2" brush to gently blend the "eye" of the wave using small circular strokes. Then, as you move out across the top of the wave, hold the brush flat and pull down to blend the light transparency color into the dark base of the wave. *(Photo 10.)*

Pull the light over the top of the "breaker" with Titanium White on the fan brush. Again, be very careful of angles. *(Photo 11.)*

Load the bristles of the filbert brush with a dark Lavender mixture of Phthalo Blue, Alizarin Crimson and Titanium White. Using small circular motions, scrub in the base color of the foam. Clean the filbert brush and, with a mixture of Titanium White and a touch of Cadmium Yellow, highlight the foam. Use tiny circular push-up strokes just where the light would strike. *(Photo 12.)* Blend the bottom of the highlight color into the dark shadow color of the foam using just the top corner of a clean, dry 2" brush. *(Photo 13.)* Be very careful not to touch the top edges of the foam highlights. *(Photo 14.)*

Use Titanium White on the fan brush to outline the swell in front of the large wave. With long, sweeping strokes pull the top edge of this line back towards the base of the wave to blend. "Angles" are the name of the game here. Try not to touch the bottom edge of this line and be very careful not to destroy the dark at the base of the large wave.

ROCKS

The major wave is crashing against a large rock. Use a mixture of Dark Sienna and Van Dyke Brown on the long edge of the knife to "build" this rock, extending it up above the horizon line. *(Photo 15.)* Highlight the rock with a mixture of Bright Red and paint thinner loaded on the fan brush or the liner brush.

(Photo 16.) This is where you shape your rock, giving it angles and light and shadow. *(Photo 17.)*

Use Titanium White on the fan brush to "swirl" water along the base of the large rock. At this point you can add some smaller rocks using the same procedure with the small knife. Again, add the highlights and also some foam action at the base of the rock using Titanium White on the filbert brush. *(Photo 18.)* You can add as many rocks as you like, working in layers as you move forward in the painting. *(Photo 19.)*

Use various mixtures of the Blues and Titanium White on the fan brush and the filbert brush to add water movement and foam action to the painting. *(Photo 20.)* This is where you really shape the water. Watch the angles.

FINISHING TOUCHES

With a thinned mixture of Titanium White and Cadmium Yellow on the liner brush, highlight the water along the horizon and across the tops of the swells and waves. Also use this mixture to add foam patterns and other fine details to the water. *(Photo 21.)*

Sign your painting and admire. Truly, you have experienced THE JOY OF PAINTING! *(Photo 22.)*

Ocean Breeze

1. Paint clouds with the 2" brush . . .

2. . . . then use the 1" brush to add highlights.

3. With the top corner of the 2" brush . . .

4. . . . blend the base of each cloud, then use long horizontal strokes to blend the entire sky.

5. Use the filbert brush to draw a basic shape for the major wave.

Ocean Breeze

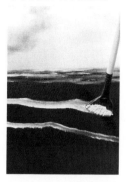 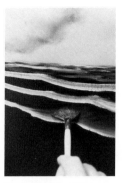 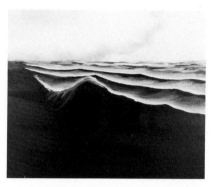 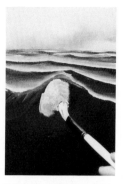

6. Lay in the initial wave shapes with the fan brush . . .

7. . . . then blend back . . .

8. . . . to create the major waves. Pay very close attention to angles.

9. Use the filbert brush to scrub in the transparent portion of the waves . . .

10. . . . then blend with the top corner of the 2" brush.

 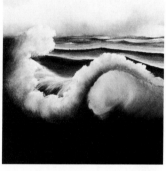

11. Highlights are applied to the crashing wave with a fan brush. Angles are very important.

12. Add foam to the wave with the filbert brush.

13. Small circular strokes with the top corner of the 2" brush . . .

14. . . . are used to blend and soften the foam.

15. Rocks are painted with the knife . . .

16. . . . then highlighted with the corner of the fan brush.

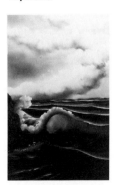 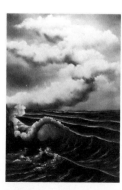

17. Work in layers . . .

18. . . . completing the most distant areas first . . .

19. . . . before moving forward.

20. Large foam shapes can be made with the filbert brush . . .

21. . . . and the script liner brush may be used for fine detail work.

22. Seascape almost ready for your all important signature.

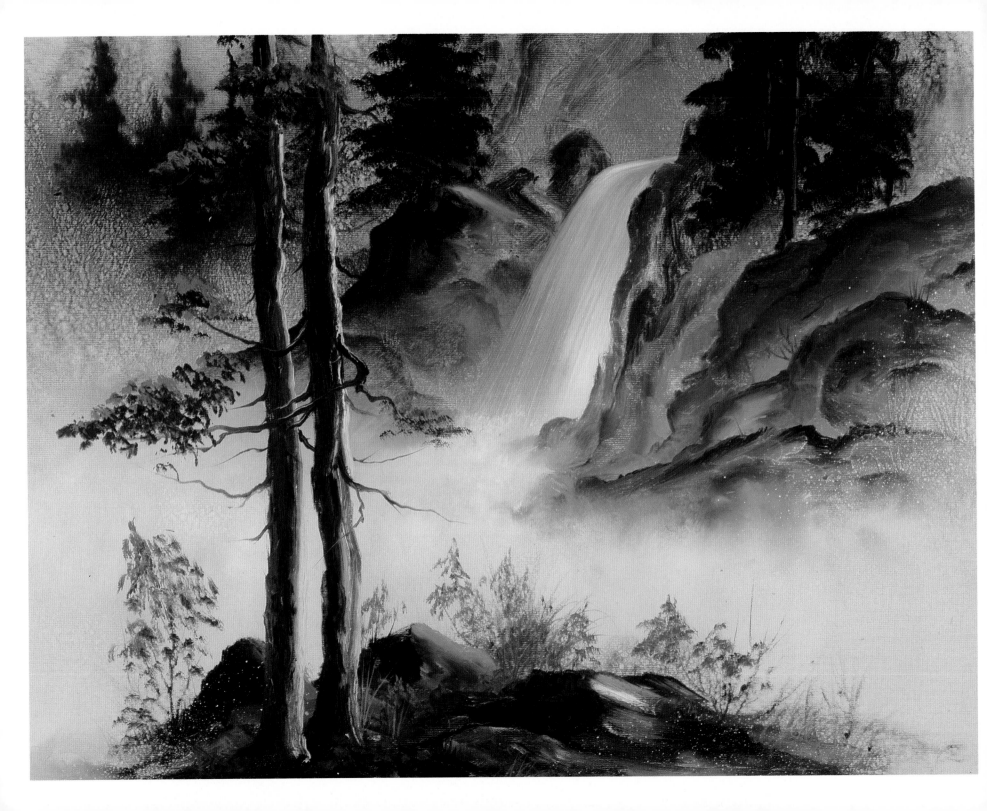

MATERIALS

2" Brush	Dark Sienna
#6 Filbert Brush	Van Dyke Brown
#6 Fan Brush	Alizarin Crimson
#2 Script Liner Brush	Sap Green
Liquid Clear	Cadmium Yellow
Titanium White	Yellow Ochre
Prussian Blue	Indian Yellow
Midnight Black	Bright Red

Start by using the 2" brush to completely cover the entire canvas with a VERY THIN coat of Liquid Clear. (It is important to stress that the Liquid Clear should be applied VERY, VERY sparingly and really scrubbed into the canvas! If necessary, excess Liquid Clear can be removed with a paper towel.) Do NOT allow the canvas to dry before proceeding.

BACKGROUND

Begin by painting the most distant evergreens. Load the fan brush to a chiseled edge with a mixture of Sap Green, Van Dyke Brown, Dark Sienna and Midnight Black. Beginning near the top of the canvas (and, for the moment, concentrating only on the left-hand side of the canvas), hold the brush vertically and touch the canvas to create the center line of each tree. Use just the corner of the brush to begin adding the small top branches. Working from side to side, as you move down each tree, apply more pressure to the brush, forcing the bristles to bend downward (Photo 1) and automatically the branches will become larger as you near the base of each tree.

With a very small amount of paint thinner on the 2" brush, tap the area surrounding the base of the trees creating a mottled, misty effect, caused by the reaction of the paint thinner to the Liquid Clear.

Working forward in layers, continue adding evergreens with the dark tree-mixture and misting the base of the trees by tapping with thinner on the 2" brush. (Photo 2.)

MOUNTAINS AND HILLS

Use the filbert brush with a small amount of a mixture of Sap Green, Van Dyke Brown, Dark Sienna and Midnight Black to outline just the top edge of the most distant hilltop. (Photo 3.) Then, use your finger (or brush) to blend the paint, shaping and misting the side of the hill. (Photo 4.) Allowing these misty areas to separate the hills, continue working forward in layers, outlining hill tops, blending and misting.

To create the interesting, mottled, misty effect in the hills, dip a clean fan brush into paint thinner (shake the brush to remove the excess thinner) then pull the bristles across the blade of the knife allowing a spray of tiny droplets to interact with the Liquid Clear mixture already on the canvas. (Photo 5.)

Still working forward in layers, use the filbert brush (and/or your finger) and various mixtures of Sap Green, Van Dyke Brown, Dark Sienna, Midnight Black and Prussian Blue to shape the darker rocks behind the waterfall. (Photo 6.)

WATERFALL

To add the waterfall, use a thin mixture of Liquid Clear and Titanium White on the fan brush. To paint the falling water, start with a short horizontal stroke at the top of the falls then pull the brush down to the base of the falls (Photo 7). Repeat as often as necessary to achieve the desired width of your falls. (Photo 8.)

Once again, use paint thinner on the fan brush to spray the base of the falls, creating those interesting effects.

Working forward, continue shaping rocks with the various dark mixtures on the filbert brush, blending and contouring with your finger (Photo 9) and spraying with the paint thinner.

LARGE EVERGREENS

Very loosely paint the first large evergreen tree with the filbert brush and a dark tree-mixture of the Browns, Midnight Black, Sap Green, Prussian Blue and Alizarin Crimson. Blend a small amount of this dark mixture into the background and again spray with the paint thinner on the fan brush. (Photo 10.)

With a Lavender mixture (made by mixing small amounts of Prussian Blue and Alizarin Crimson), use the filbert brush (and/or your finger) to blend this color into the base of the first evergreen. Then, spray with paint thinner.

As you work forward in layers, continue using the filbert brush and the dark tree-mixture to add the second large evergreen and the large rocks at the base of the trees. Spray with paint thinner to diffuse and mottle.

Add trunks to the evergreens with a mixture of Titanium White, Dark Sienna and Van Dyke Brown on the filbert brush. *(Photo 11.)*

Reload the filbert brush with a very small amount of the Yellows and lightly touch highlights to the evergreen branches.

Use the filbert brush (or your finger) to continue blending small amounts of color out from the base of the trees.

Dip the fan brush into paint thinner, shake off the excess, and "flick" small amounts of the thinner onto the canvas for the desired "misty" effect. (It is important to sustain this effect throughout the painting.) *(Photo 12.)*

WATER

Load a clean, dry 2" brush with a small amount of Titanium White and even smaller amounts of Alizarin Crimson and Prussian Blue to produce a light Lavender color. Holding the brush vertically, tap downward with the top corner of the brush *(Photo 13)* to add the water at the base of the waterfall *(Photo 14)*.

FOREGROUND

Outline the land mass in the foreground with a mixture of the Browns, Sap Green and Midnight Black on the filbert brush. *(Photo 15.)* Use circular strokes with the brush (and/or your finger) to blend, then spray with thinner.

Starting at the top of the canvas and pulling down, add the large foreground tree trunks with the dark tree-mixture on the filbert brush. *(Photo 16.)* Blend a very small amount of Titanium White with the dark tree-mixture to highlight the trunks and to add large branches. *(Photo 17.)* Add more Sap Green to the tree-mixture before painting the foliage. *(Photo 18.)*

Use the liner brush to add limbs and branches to the foreground trees *(Photo 19)* and thinned dark mixtures on the liner brush to add just the indication of long grasses. With Yellow Ochre and Bright Red on a clean filbert brush, add the last highlights to the bushes and foliage at the base of the foreground trees *(Photo 20)*, and your masterpiece is complete *(Photo 21)*.

Oriental Falls

1. Use the fan brush . . .

2. . . . to paint background evergreens.

3. Shape rocks with the filbert brush . . .

4. . . . blend with your finger . . .

5. . . . then spray with thinner.

6. Shape waterfall rocks . . .

Oriental Falls

7. . . . then use the fan brush . . .

8. . . . to pull water over the rocks.

9. As you work forward in the painting . . .

10. . . . continue shaping rocks . . .

11. . . . and painting evergreens . . .

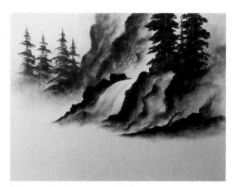

12. . . . with the filbert brush.

13. Firmly tap with the 2" brush . . .

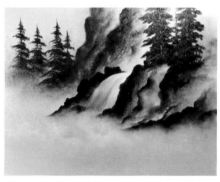

14. . . . to add water to the base of the waterfall.

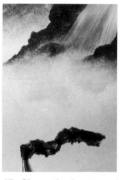

15. Shape the foreground with the filbert.

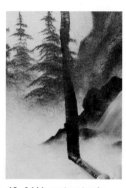

16. Add large tree trunks . . .

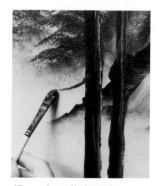

17. . . . large limbs and branches . . .

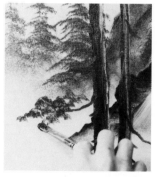

18. . . . and foliage with the filbert brush.

19. Use the liner brush to paint small limbs.

20. Add small bushes with the filbert brush . . .

21. . . . to complete your masterpiece!

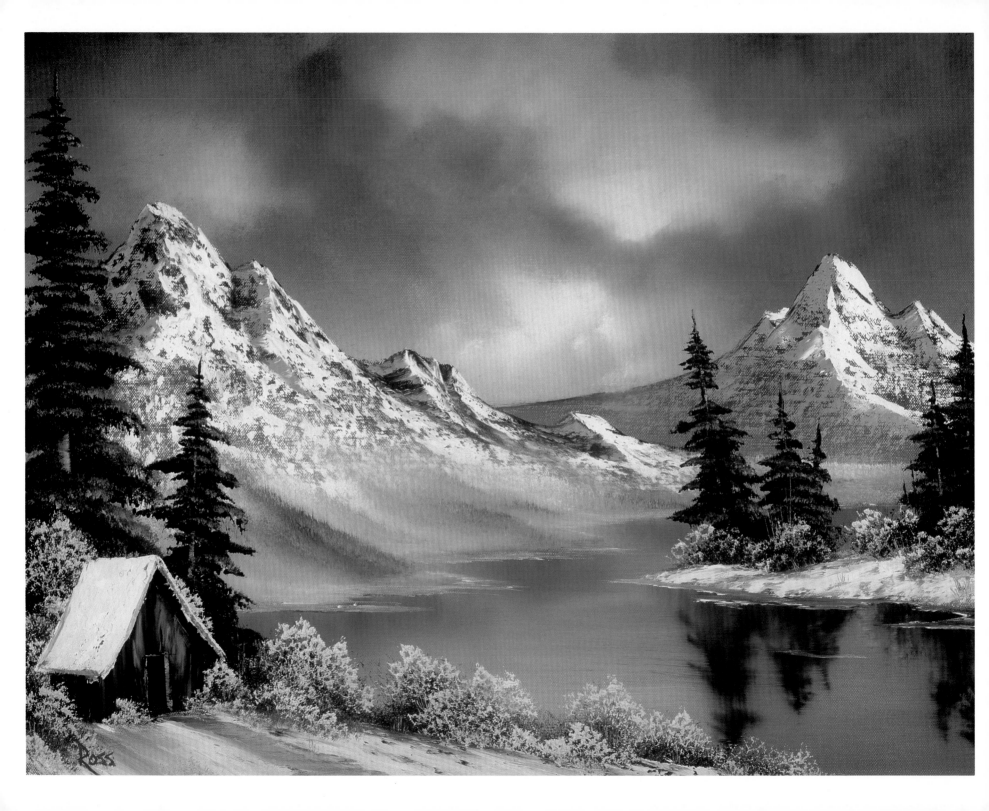

15. AN ARCTIC WINTER DAY

MATERIALS

2" Brush	Titanium White
2" Blender Brush	Prussian Blue
1" Brush	Midnight Black
#6 Fan Brush	Dark Sienna
Large Knife	Van Dyke Brown
Liquid White	Alizarin Crimson

Use the 2" brush to cover the entire canvas with a thin, even coat of Liquid White. Do NOT allow the Liquid White to dry before you begin.

SKY AND WATER

Load the 2" brush with a very small amount of a mixture of Prussian Blue and Midnight Black and use criss-cross strokes to paint the sky, allowing areas to remain light for the addition of clouds. Use a clean, dry 2" brush and long, horizontal strokes to blend the entire sky.

To underpaint the water on the lower portion of the canvas, reload the 2" brush with the same Prussian Blue-Midnight Black mixture. Starting at the bottom of the canvas (and working up towards the horizon) use horizontal strokes, pulling from the outside edges of the canvas in towards the center.

Use a clean, dry 2" brush and criss-cross strokes to blend the sky, then blend the entire canvas (sky and water) with long, horizontal strokes.

Reload the 2" brush with the Prussian Blue-Midnight Black mixture. Hold the brush vertically and use just the top corner of the brush to tap in the basic cloud shapes to the exposed areas of the sky.

Use the soft blender brush and circular strokes to blend out the base of the clouds then long, horizontal strokes to blend the entire sky area.

With Titanium White on the knife, use scrubbing, circular strokes to add the bright areas in the sky. Again, blend this area with the soft blender brush to complete the sky.

MOUNTAIN

Paint the mountain with the knife and a mixture of Prussian

Blue, Midnight Black, Alizarin Crimson and Van Dyke Brown. Pull the mixture out very flat on your palette, hold the knife straight up and "cut" across the mixture to load the long edge of the blade with a small roll of paint. (Holding the knife straight up will force the small roll of paint to the very edge of the blade.) With firm pressure, shape just the top edge of the mountain. (Photo 1.) When you are satisfied with the basic shape of the mountain top, use the knife to remove any excess paint. Then, with the 2" brush, pull the paint down to the base of the mountain to blend and complete the entire mountain shape. (Photo 2.)

Highlight the mountain with Titanium White. Again, load the knife with a small roll of paint. Starting at the top (and paying close attention to angles) glide the knife down the right side of each peak, using so little pressure that the paint "breaks". (Photo 3.) Use a mixture of Titanium White and Prussian Blue, applied in the opposing direction, for the shadow sides of the peaks.

With a clean, dry 2" brush, tap to diffuse the base of the mountain (carefully following the angles) (Photo 4) then gently lift upward to create the illusion of mist (Photo 5).

Use the same mixtures to paint the larger, closer range of mountains. Shape the mountain tops (Photo 6), blend the paint down to the base of the mountains (Photo 7) then apply the highlights (Photo 8). Firmly tap to diffuse and mist the base of the mountains. (Photo 9.)

Reload the 2" brush with a mixture of the mountain color and Titanium White. Carefully following the angles, tap the base of the mountain to add the indication of small trees (Photo 10) then use short upward strokes to create the illusion of tiny tree tops (Photo 11).

Reload the 2" brush with the mountain color, pull straight down into the water for reflections (Photo 12) then brush lightly across.

Add water lines and ripples with a small roll of Liquid White on the knife (Photo 13) to complete the background (Photo 14).

EVERGREENS

Load the fan brush to a chiseled edge with the original mountain-mixture (Prussian Blue, Midnight Black, Alizarin Crimson and Van Dyke Brown). Hold the brush vertically and touch the canvas to create the center line of each tree. Use just the corner of the brush to begin adding the small top branches. Working from side to side, as you move down each tree, apply more pressure to the brush, forcing the bristles to bend downward and automatically the branches will become larger as you near the base of each tree. *(Photo 15.)* Reverse the brush to reflect the trees into the water, pull down with the 2" brush *(Photo 16)* then lightly brush across *(Photo 17)*.

Add the trunks with a small roll of a mixture of Titanium White and Prussian Blue on the knife. *(Photo 18.)* Use the fan brush to very lightly touch highlights to the branches with a mixture of Liquid White, Titanium White and Prussian Blue.

BUSHES AND LAND

The small bushes at the base of the evergreens are underpainted with the dark mountain-mixture on the 1" brush. *(Photo 19.)*

Use Titanium White on the knife to add the snow-covered banks at the base of the bushes, paying close attention to the lay-of-the-land. *(Photo 20.)*

To highlight the bushes, first dip the 1" brush into Liquid White. Then, with the handle straight up, pull the brush (several times in one direction, to round one corner of the bristles) through Titanium White. With the rounded corner of the brush up, force the bristles to bend upward to highlight individual small trees and bushes. Concentrate on shape and form—try not to just "hit" at random. *(Photo 21.)*

Cut in the water lines and ripples with a small roll of Liquid White on the knife. *(Photo 22.)*

CABIN

Use a clean knife to remove paint from the canvas in the basic shape of the cabin. Load the long edge of the knife with a small roll of a mixture of Van Dyke Brown and Dark Sienna by pulling the paint out very flat on your palette and just cutting across. Paying close attention to angles, paint the back of the cabin roof, then the front and the side of the cabin. Use a marbled mixture of Van Dyke Brown, Dark Sienna and Titanium White to highlight the front cabin, holding the knife vertically and using so little pressure that the paint "breaks". Add the roof with Titanium White and the door with Van Dyke Brown. Use Titanium White on the knife to add the snow to the base of the cabin.

Add snow-covered bushes to the base of the cabin with the 1" brush, then use a mixture of Prussian Blue and Titanium White on the knife to add the path. *(Photo 23.)*

FINISHING TOUCHES

Use the point of the knife to scratch in the indication of small sticks and twigs and your painting is complete. *(Photo 24.)*

An Arctic Winter Day

 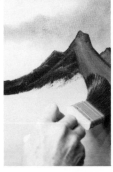 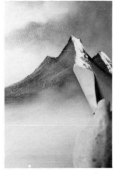 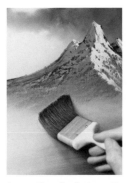 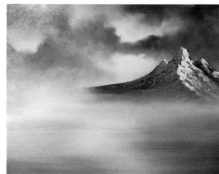

1. Paint the distant mountain top with the knife . . .

2. . . . then blend the paint down with the 2" brush.

3. Add snow with the knife . . .

4. . . . then firmly tap with the 2" brush . . .

5. . . . to create the illusion of mist.

6. Use the knife to paint the closer mountain . . .

An Arctic Winter Day

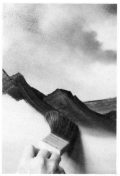

7. . . . then blend down with the 2" brush . . .

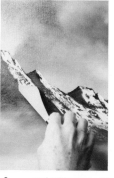

8. . . . and add snow with the knife.

9. Use the 2" brush to mist the base of the mountain . . .

10. . . . and to add foothills . . .

11. . . . and tiny tree tops.

12. Pull straight down to add reflections . . .

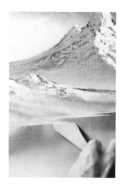

13. . . . then use Liquid White on the knife . . .

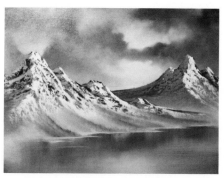

14. . . . to cut in water lines and ripples.

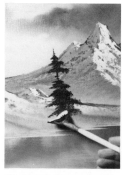

15. Paint the evergreens with the fan brush . . .

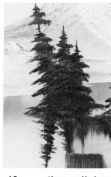

16. . . . then pull down with the 2" brush . . .

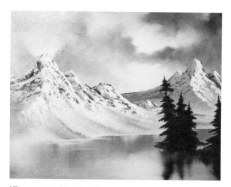

17. . . . to add reflections.

18. Add trunks with the knife . . .

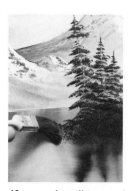

19. . . . and small trees and bushes with the 1" brush.

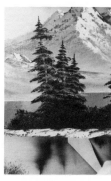

20. Use the knife to add snow to the base of the trees . . .

21. . . . then add snow to the bushes with the 1" brush.

22. Cut in water lines and ripples with the knife.

23. Add a path to the cabin . . .

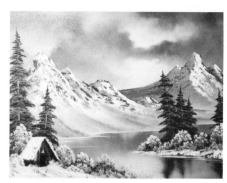

24. . . . to complete the painting.

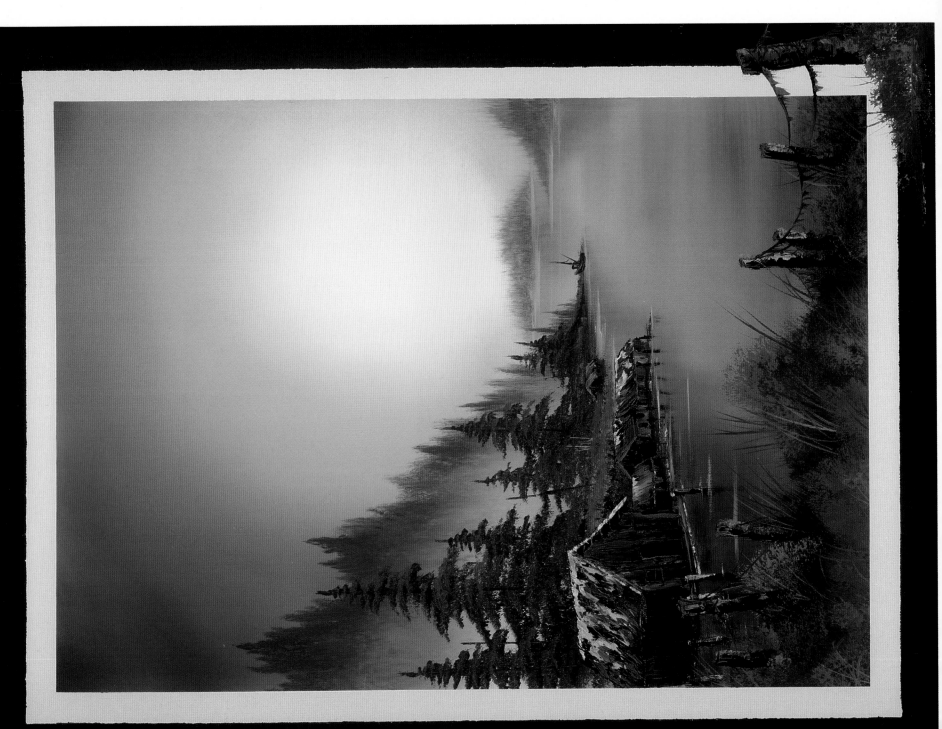

MATERIALS

2" Brush	Titanium White
1" Brush	Prussian Blue
#6 Fan Brush	Midnight Black
#3 Fan Brush	Dark Sienna
#2 Script Liner Brush	Van Dyke Brown
Large Knife	Alizarin Crimson
Small Knife	Cadmium Yellow
Adhesive-Backed Plastic	Yellow Ochre
1/2" Masking Tape	Indian Yellow
Black Gesso	Bright Red
Liquid White	

To create the double-border on this painting, place strips of masking tape about two inches from the outside edges of an 18 x 24 canvas. Cover the borders with a thin, even coat of Black Gesso. Allow the Black Gesso to DRY COMPLETELY before proceeding. Do not remove the masking tape. (Paper strips may be used to protect the Black border, if desired.)

When the Black Gesso is dry, use the 2" brush to cover the exposed area of the canvas with a thin, even coat of Liquid White. Do NOT allow the Liquid White to dry before you proceed.

SKY

Load the 2" brush by tapping the bristles into a very small amount of Indian Yellow. Paint a large Yellow circle in the sky (to the right of center) where the sun will be. Without cleaning the brush, reload it with Cadmium Yellow and work outward from the sunny area with criss-cross strokes. Continue working outward with Yellow Ochre, then Orange (made with Cadmium Yellow and Bright Red).

To paint the darker, left side of the sky, continue working away from the light source with Bright Red, then Dark Sienna and finally Van Dyke Brown. Use a clean, dry 2" brush and criss-cross strokes to lightly blend one color into the next. With a very clean, dry 2" brush, use criss-cross strokes to add Titanium

White to the lightest area of the sky. Blend the entire sky with long, horizontal strokes.

Starting just below the horizon, reflect each sky color into the water with the 2" brush and horizontal strokes. Blend these colors with a clean, dry 2" brush and long, horizontal strokes across the entire water area. (Photo 1.)

BACKGROUND ISLANDS

With a mixture of Titanium White, Dark Sienna and a very small amount of Bright Red (to make Brown) on the fan brush, shape the tiny island in the background then make short, upward strokes to indicate tiny tree tops (Photo 2).

Reverse the fan brush to reflect the island into the water then pull the reflection down with the 2" brush (Photo 3) and lightly brush across. Use a small roll of Liquid White on the top edge of the knife to cut in water lines at the base of the island. (Photo 4.)

Repeat the procedure to add the closer island, or land projection, with a darker Brown-mixture: Van Dyke Brown, Dark Sienna, Titanium White and Bright Red. Again, use a clean, dry 2" brush to blend the reflections, then add water lines and ripples with a mixture of Liquid White and a small amount of Bright Red on the knife. (Photo 5.)

EVERGREENS

Load the fan brush with a darker Brown by adding Alizarin Crimson to the Van Dyke Brown-Dark Sienna-Titanium White-Bright Red mixture. To paint just the indication of evergreens, hold the brush vertically and tap downward. (Photo 6.) With a very small amount of Titanium White and Cadmium Yellow on the 2" brush, firmly tap the base of the evergreens then lift upward to create the illusion of mist (Photo 7).

Use the 2" brush to pull the dark tree-color straight down into the water (Photo 8) then brush lightly across to create shimmering reflections (Photo 9).

Working forward in layers, the more distinct evergreens are made by loading the fan brush with a darker mixture: Van Dyke

Brown, Dark Sienna and Alizarin Crimson. Holding the brush vertically, touch the canvas to create the center line of each tree. Use just the corner of the brush to begin adding the small top branches. Working from side to side, as you move down each tree, apply more pressure to the brush, forcing the bristles to bend downward and automatically the branches will become larger as you near the base of the tree. *(Photo 10.)*

Add the trunks with a small roll of the dark tree-mixture on the knife. *(Photo 11.)*

Reload the fan brush with the dark tree-mixture and a small amount of Yellow Ochre to very lightly touch highlights to the branches.

Continue using the dark tree-mixture on the fan brush to underpaint the grassy area at the base of the evergreen trees. *(Photo 12.)* Reload the brush with various mixtures of Yellow Ochre, Indian Yellow and Bright Red to highlight the grassy area. *(Photo 13.)*

FISHING VILLAGE

Working forward in layers, use the Brown tree-mixture (Van Dyke Brown, Dark Sienna and Alizarin Crimson) and the small knife to shape the tiny houses along the water's edge. Add grassy areas with the fan brush. Apply highlights to the roofs and sides of the houses with various mixtures of Titanium White, Alizarin Crimson, Yellow Ochre, Midnight Black and the Browns on the knife. Finer details—windows, doors and stilts into the water by pulling down with the 2" brush and lightly brushing across. Cut in the water lines at the base of the stilts with a mix-

ture of Liquid White and a very small amount of Bright Red on the knife to complete the fishing village. *(Photo 14.)*

FOREGROUND

Underpaint small trees and bushes in the foreground with a mixture of Midnight Black, Prussian Blue, Alizarin Crimson, Sap Green and the Browns on the 1" brush. *(Photo 15.)* Without cleaning the brush, reload it with various mixtures of all of the Yellows and Bright Red to highlight the small trees and bushes: begin by dipping the 1" brush into Liquid White (or paint thinner). Then, with the handle straight up, pull the brush (several times in one direction, to round one corner of the bristles) through the various highlight mixtures. With the rounded corner of the brush up, touch the canvas and bend the bristles upward, to highlight each individual tree and bush. *(Photo 16.)* Concentrate on shape and form and be very careful to not completely destroy all of the dark undercolor.

Add the foreground fence posts with Brown on the knife *(Photo 17)* then highlight the posts with a mixture of Titanium White and Brown *(Photo 18)*. Use thinned Brown on the liner brush *(Photo 19)* to add wire to the posts *(Photo 20)*.

FINISHING TOUCHES

Carefully remove the masking tape from the canvas *(Photo 21)* to expose the double-border *(Photo 22)*. Add a fence post *(Photo 23)* with grass at the base *(Photo 24)* outside the border to complete the painting *(Photo 25)*. Use thinned color on the liner brush to add wire to the last post and to sign your painting.

Fisherman's Paradise

 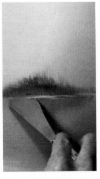 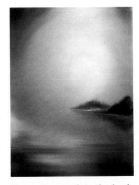 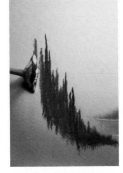 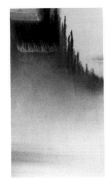

1. Begin by painting the sky.

2. Shape the tiny islands with the fan brush.

3. Pull down the reflections with the 2" brush. . .

4. . . . and cut in water lines with the knife . . .

5. . . . to complete the background islands.

6. Tap down small evergreens with the fan brush . . .

7. . . . then mist with the 2" brush.

Fisherman's Paradise

8. Continue using the 2" brush . . .

9. . . . to pull down dark reflections.

10. Shape large evergreens with the fan brush . . .

11. . . . then add trunks with the knife.

12. Push up with the fan brush . . .

13. . . . to add the grassy area at the base of the trees.

14. When the fishing shacks are complete . . .

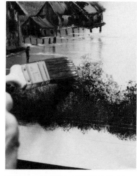

15. . . . use the 1" brush to paint foreground bushes . . .

16. . . . and to add highlights.

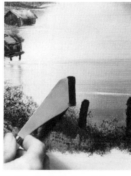

17. Use the knife to paint posts . . .

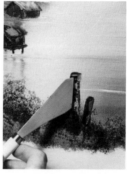

18. . . . and to add highlights.

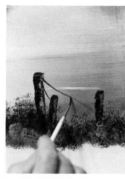

19. Use thinned paint on the liner brush . . .

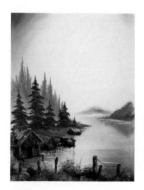

20. . . . to add wire to the posts.

21. Carefully remove the Con-Tact Paper . . .

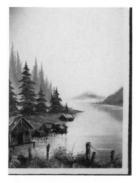

22. . . . to expose the double border.

23. Add the last post outside the border.

24. Paint grass at the base of the post . . .

25. . . . add wire, and the painting is complete.

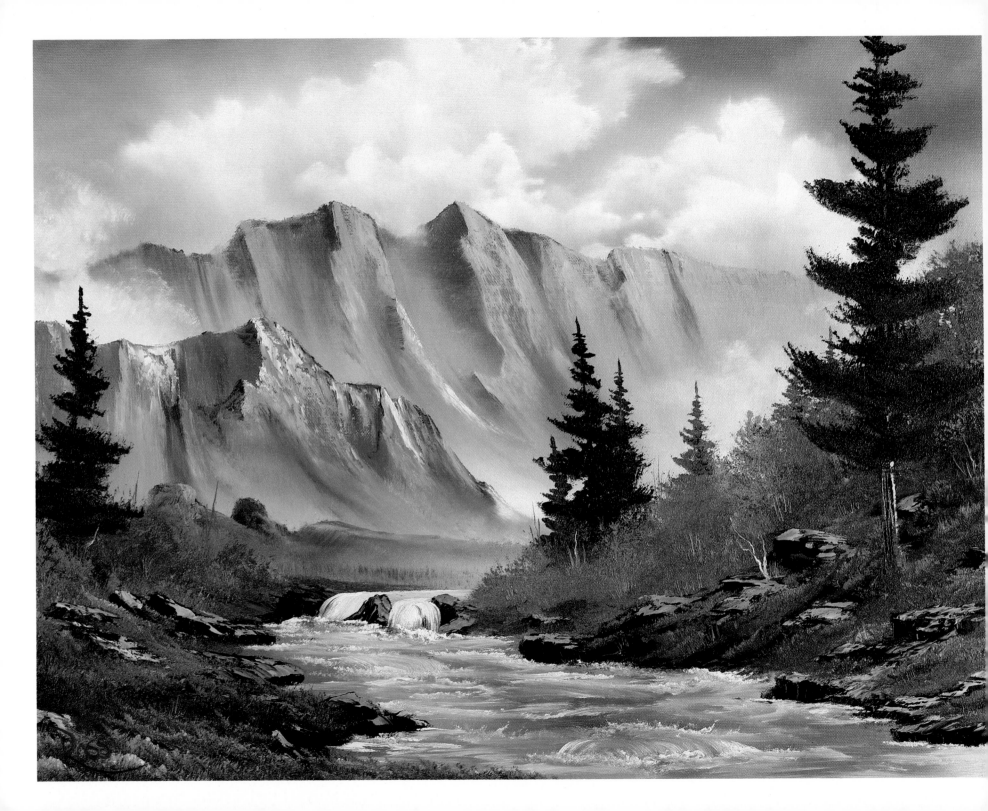

17. BUBBLING MOUNTAIN BROOK

MATERIALS

2" Brush	Midnight Black
1" Brush	Dark Sienna
#6 Fan Brush	Van Dyke Brown
#2 Script Liner Brush	Alizarin Crimson
Large Knife	Sap Green
Small Knife	Cadmium Yellow
Liquid White	Yellow Ochre
Titanium White	Indian Yellow
Phthalo Blue	Bright Red

Start by covering the entire canvas with a thin, even coat of Liquid White, using the 2" brush. Use long horizontal and vertical strokes, working back and forth to assure an even distribution of paint on the canvas. Do NOT allow the Liquid White to dry before you begin. Clean and dry your 2" brush.

SKY

Load your 2" brush with a mixture of Indian Yellow and a little Bright Red. Just brush-mix these colors, tapping the bristles firmly against the palette. Using criss-cross strokes, apply this color unevenly along the horizon, into the sky area. Clean and dry your brush, pick up a little Midnight Black and Phthalo Blue and completely cover the sky area, again using criss-cross strokes. Also add this mixture to the lower portion of the canvas, using horizontal strokes. Later, this will become the water. With a clean, dry 2" brush, blend the entire sky and water. The clouds are made using small circular strokes and the 1" brush loaded with Titanium White and a small amount of Bright Red. Using just the top corner of the 2" brush, blend out the bottoms of the cloud shapes, then gently sweep upward. Work in layers, completely finishing the most distant clouds before moving forward. (Photo 1.)

MOUNTAIN

Load the knife with a mixture of Midnight Black, Alizarin Crimson and Phthalo Blue. Using very little paint, form just the top shape of the mountain by firmly pushing the paint into the canvas. (Photo 2.) With a clean, dry 2" brush, pull down this top ridge of paint to complete the mountain shape. (Photo 3.)

Highlight the mountain with various mixtures of Titanium White, Alizarin Crimson and Phthalo Blue. Load the long edge of the knife with a small roll of paint and very, very gently pull down the right side of the peaks, where the light would strike. (Photo 4.) The shadows are made using the mountain mixture of Titanium White and applied to the left side of the peaks, using the small knife. Use a clean, dry large brush to tap the base of the mountain and lift upward, creating the illusion of mist. You can add clouds to the base of the mountain (Photo 5) using Titanium White and the 1" brush (Photo 6). Working forward in your painting, add another range of mountains using the same mixtures, allowing these mountains to be a little darker and more distinct. Again diffuse and lift upward, using the large brush. A third range can be made using Midnight Black, Phthalo Blue, and Alizarin Crimson on the fan brush. Highlights and shadows are the same mixtures, still using the fan brush. Tap to diffuse the base of the range with a clean, dry 2" brush. (Photo 7.)

BACKGROUND

Still using the fan brush and the same dark mountain mixture, add some small trees to the base of the mountains by pushing the brush straight into the canvas and bending the bristles upward. (Photo 8.) The stones in the background are the same dark mixture, loaded on the long edge of the small knife, then highlighted with a mixture of Dark Sienna and Titanium White. Make sure the stones are highlighted on the same side as the mountains. In this painting, the right side.

The water is made by loading the fan brush with a mixture of Liquid White and Titanium White. Holding the brush horizontally, begin laying in the water, using vertical movements to pull the water down over the rocks. (Photo 9.) Make the water movement at the base of the stones and rocks, by pushing the brush straight into the canvas and bending the bristles upward. (Photo 10.)

FOREGROUND

Load the 2" brush with a mixture of Phthalo Blue, Midnight Black and Alizarin Crimson. Hold the brush vertically and force the bristles to bend upward to form the basic leaf-tree shapes. *(Photo 11.)* Hold the brush horizontally and push upward to add the ground area and bush shapes along the water's edge. *(Photo 12.)* Stones are Van Dyke Brown on the long edge of the knife. Use a mixture of Midnight Black, Phthalo Blue, Alizarin Crimson and Titanium White loaded on the fan brush to paint the evergreen trees. Hold the brush vertically and just touch the canvas to create a center line, turn the brush horizontally and begin pushing the bristles upward to form the branches. Use more pressure near the base of the trees, allowing the branches to become larger. *(Photo 13.)* Highlight the larger trees by adding Cadmium Yellow and Sap Green to the same brush.

To highlight the trees and bushes, load the 1" brush with a mixture of Sap Green, all the Yellows and Bright Red. Pull the brush through the paint in one direction, to round the corner, then, with the rounded corner up, gently push in the highlights to give the trees and bushes form. *(Photo 14.)* Turn the brush horizontally and push upward to highlight the grassy areas, creating the lay-of-the-land.

Working in layers, continue adding rocks *(Photo 15)*, stones, bushes and grassy areas; and then the highlights. Complete the most distant areas before moving forward. *(Photo 16).*

The large tree in the foreground is made using Midnight Black and the fan brush. Hold the brush vertically and tap in the tree trunk. *(Photo 17.)* Turn the brush horizontally and blend the bristles upward to create the branches. *(Photo 18.)* Highlights are made the same way, adding Cadmium Yellow to the brush.

FINISHING TOUCHES

Add small sticks and twigs using the point of the knife or the liner brush loaded with thinned Van Dyke Brown. Add a signature and your painting is complete! *(Photo 19.)*

Bubbling Mountain Brook

1. After completing the sky . . .

2. . . . use the knife to shape the mountain.

3. Blend downward with the 2" brush . . .

4. . . . before highlighting with the knife.

5. Use the 1" brush to add clouds . . .

Bubbling Mountain Brook

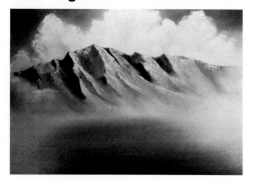

6. . . . and mist to the base of the mountains.

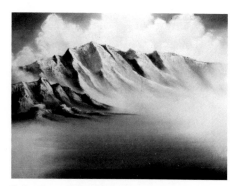

7. Continue adding mountains and rocks.

8. Distant grassy areas made with the fan brush.

9. Pull down the waterfall . . .

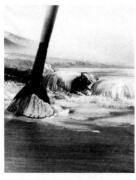

10. . . . and push up water splashes with the fan brush.

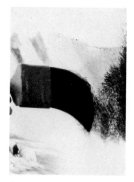

11. Push upward with the 2" brush . . .

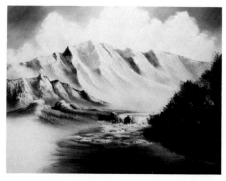

12 . . . to paint in the initial bush and tree shapes.

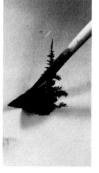

13. The corner of the fan brush, pushed upward, is used to paint evergreens.

14. Individual bushes are highlighted with the 1" brush.

15. Land areas are made and highlighted with the knife.

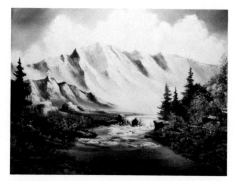

16. Work in layers, completing the most distant areas first.

17. Tap downward with the fan brush to paint tree trunks.

18. Push upward with the fan brush to paint the evergreen.

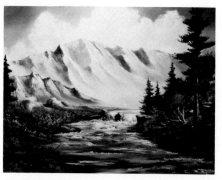

19. Add sticks, twigs and other fine detail, then sign.

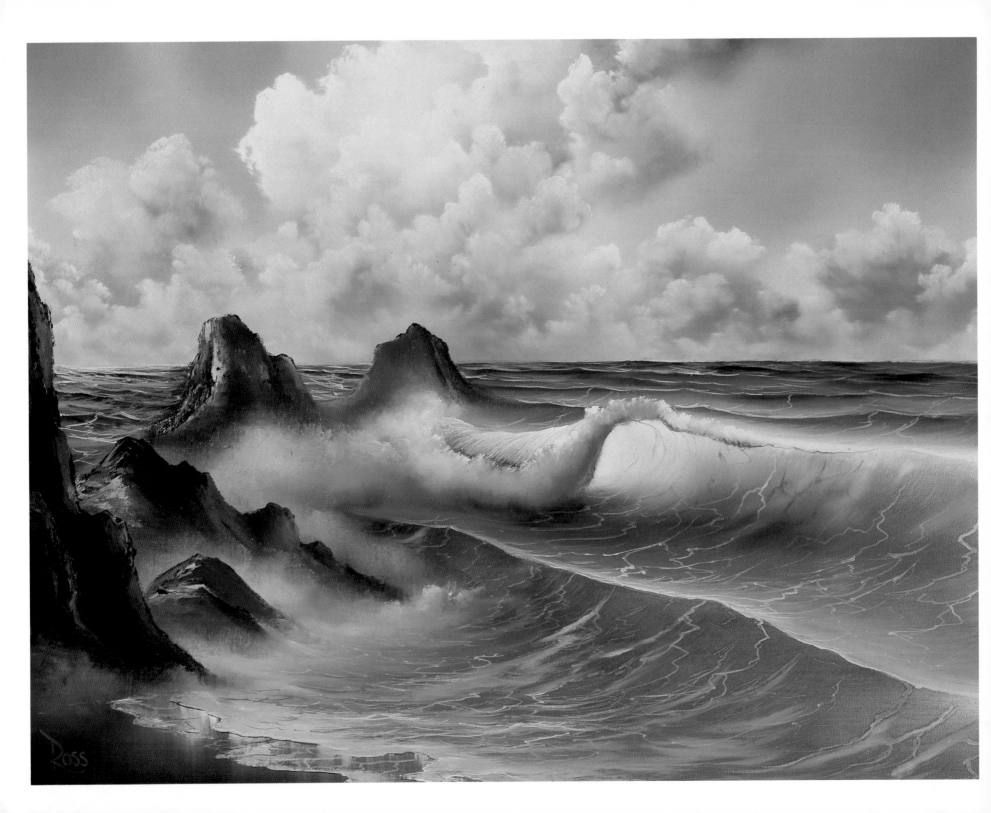

MATERIALS

2" Brush
#6 Filbert Brush
#6 Fan Brush
#2 Script Liner Brush
Small Knife
Liquid White
Liquid Clear
Titanium White
Phthalo Green

Phthalo Blue
Prussian Blue
Midnight Black
Dark Sienna
Van Dyke Brown
Alizarin Crimson
Cadmium Yellow
Yellow Ochre
Bright Red

Begin by applying masking tape (just above center) across the horizontal canvas, to mark the horizon. Use the 2" brush to cover the top portion of the canvas with a thin, even coat of Liquid White. Use long horizontal and vertical strokes, working back and forth to ensure an even distribution of paint on the canvas. Cover the lower portion of the canvas with a VERY THIN coat of Liquid Clear. Do NOT allow the Liquid White and Liquid Clear to dry before you begin!

SKY

Load the 2" brush with a very small amount of Phthalo Blue, tapping the brush firmly against the palette to ensure an even distribution of paint throughout the bristles. Use criss-cross strokes to cover the top corners of the canvas, leaving the center area unpainted for the clouds.

Without cleaning the brush, pick up a small amount of Alizarin Crimson (to make a Lavender) and use small circular strokes with the corner of the brush to add the dark shadows of the clouds. The cloud highlights are made by loading a clean, dry 2" brush with Titanium White and, again use the corner of the brush and circular strokes. With a clean, dry 2" brush, gently blend out the base of the cloud shapes. Lightly lift upward to blend and fluff. Blend the entire sky with long, horizontal strokes. When you are satisfied with your sky, remove the masking tape from the canvas. (Photo 1.)

BACKGROUND

Apply a very small amount of Liquid Clear to the small area left dry by the masking tape.

Use a mixture of paint thinner with Alizarin Crimson and Phthalo Blue on the filbert brush to roughly sketch the major wave and large rocks on the left side of the painting. (Photo 2.)

Load the 2" brush with a dark mixture of Alizarin Crimson and Phthalo Blue. Use horizontal strokes below the horizon to add the small area of background water behind the wave. (Photo 3.) Use the 2" brush with a dark mixture of Alizarin Crimson, Phthalo Blue, Midnight Black and Phthalo Green to just block in the base of the wave and the water beneath the large wave. Be very careful not to paint the wave. It is especially important that the "eye" of the wave remain light and unpainted.

Load a clean, dry 2" brush with a mixture of Van Dyke Brown, Dark Sienna and Yellow Ochre and use long, horizontal strokes to underpaint the sandy beach area at the bottom of the painting. Bring the sand right up to the edge of the water. (Photo 4.)

To paint the swells behind the large wave, make long horizontal strokes with Titanium White on the fan brush. (Photo 5.) Use short, horizontal sweeping strokes to pull the lines of paint back to blend, being very careful not to "kill" all of the dark base color between the swells. Also use the fan brush to pull back and blend some of the Titanium White along the top edge of the large wave. (Photo 6.) Use Titanium White on the fan brush to add additional details to the background water.

LARGE WAVE

To some Titanium White, add a very small amount of Cadmium Yellow. Scrub this mixture into the oval "eye" of the wave with the filbert brush. (Photo 7.) Extend a little of the color out across the top of the wave, allowing it to get progressively darker as it mixes with the Blue base color. Use just the top corner of a clean, dry 2" brush and small circular strokes to very gently blend the "eye". (Photo 8.) Carefully blend the entire wave; this is where you create the angle of the water.

Use the dark mixture of Alizarin Crimson, Phthalo Blue,

Midnight Black and Phthalo Green on the fan brush to underpaint the breaker (the water crashing over the transparency, or "eye" of the wave). Now, with a clean fan brush and Titanium White, highlight the breaker. *(Photo 9.)* Follow the basic angle of the water as you curve the strokes over the top of the wave. *(Photo 10.)*

ROCKS

Working forward in layers, begin shaping the large rock with various mixtures of Van Dyke Brown, Dark Sienna, Alizarin Crimson, Prussian Blue and Phthalo Blue on the small knife, firmly pushing the color into the canvas. Blend the stone into the water using Titanium White on the knife, firmly rubbing with circular strokes to create a churning, misty effect. *(Photo 11.)*

Underpaint the foam at the base of the large wave with a mixture of Phthalo Blue, Alizarin Crimson and a touch of Titanium White on the filbert brush, using tiny circular strokes. Highlight the foam with the Titanium White-Cadmium Yellow mixture on the filbert brush. Make small, circular "push-up" strokes just where the light would strike, along the top edges of the foam. *(Photo 12.)* As your brush picks up the dark undercolor, clean the brush and reload it once again with the light mixture. Use a clean, dry filbert brush and then the top corner of the 2" brush to gently blend and "stir" the base of the highlights into the shadows of the foam. *(Photo 13.)* Use a thinned, dark Lavender mixture on the liner brush to add a tiny shadow under the foam along the edge of the water and other foam details in the "eye" of the wave. *(Photo 14.)*

Use Titanium White on the fan brush to continue painting the wave in front of the rock again using curving strokes. *(Photos 15 & 16).* Still working in layers, continue adding rocks. Highlight the left sides with various mixtures of Titanium White, Dark Sienna and Yellow Ochre, then touch the right sides with the mixture of Phthalo Blue and Titanium White for reflected light. *(Photo 17.)*

FOREGROUND

Load the small knife with a roll of Titanium White to "cut in" the tiny waves and ripples along the shore. Use very firm pressure and reload the knife as needed. Add foam actions to the water on the beach with the Titanium White-Phthalo Blue mixture on the fan brush. Use the liner brush to add small details to the water with Titanium White and Phthalo Blue, thinned with paint thinner. *(Photo 18.)* Make tiny wave shapes in the background water and add small foam patterns to the wave and to the water along the shore.

FINISHING TOUCHES

Use thinned paint on the liner brush to add the final touch to your beautiful seascape masterpiece; your signature! *(Photo 19.)*

Waves of Wonder

1. After completing the sky, remove the tape.

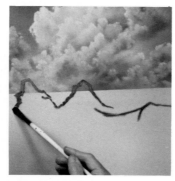

2. Sketch the large wave and rocks . . .

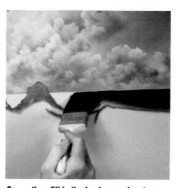

3. . . . then fill in the background water . . .

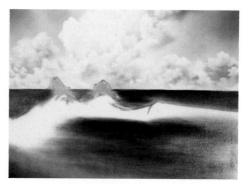

4. . . . and the sandy beach.

Waves of Wonder

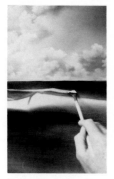

5. Use the fan brush . . .

6. . . . to add the background swells.

7. Paint the eye of the wave . . .

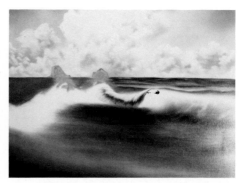

8. . . . and then blend.

9. Highlight the top . . .

10. . . . of the crashing wave, carefully following angles.

11. Use the knife to paint the rocks.

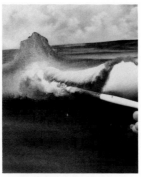

12. Highlight the foam . . .

13. . . . then blend with the 2" brush.

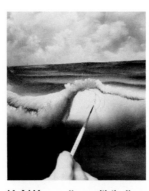

14. Add foam patterns with the liner brush.

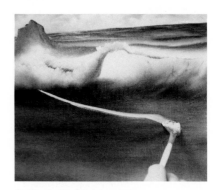

15. Use the fan brush to paint . . .

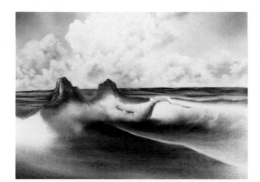

16. . . . the foreground water.

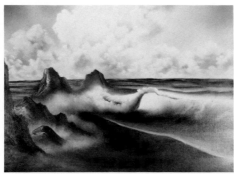

17. Working in layers, continue adding the rocks.

18. Add tiny details with the liner brush . . .

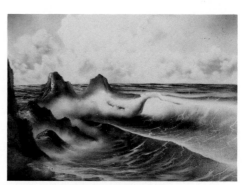

19. . . . to complete your masterpiece.

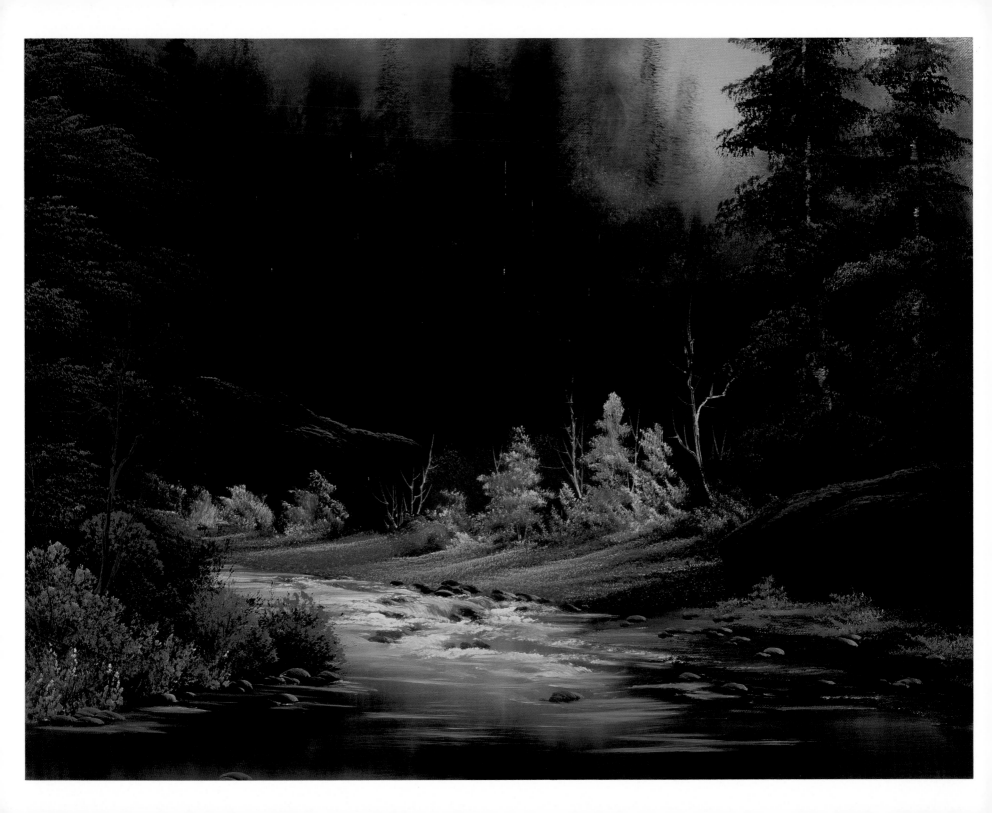

MATERIALS

2" Brush	Prussian Blue
#6 Filbert Brush	Midnight Black
#6 Fan Brush	Dark Sienna
#2 Script Liner Brush	Van Dyke Brown
Large Knife	Alizarin Crimson
Black Gesso	Sap Green
Liquid White	Cadmium Yellow
Liquid Clear	Yellow Ochre
Titanium White	Indian Yellow
Phthalo Blue	Bright Red

Start by using a foam applicator to underpaint the dark areas of the canvas with a thin, even coat of Black Gesso. Allow the Black Gesso to DRY COMPLETELY. (Photo 1.)

When the Black Gesso is dry, use the 2" brush to cover the Black portion of the canvas with a VERY THIN coat of Liquid Clear. (It is important to stress that the Liquid Clear should be applied VERY, VERY sparingly and really scrubbed into the canvas! The Liquid Clear will not only ease with the application of the firmer paint, but will allow you to apply very little color, creating a glazed effect.) Do NOT allow the Liquid Clear to dry.

Still using the 2" brush, cover the Liquid Clear with a very thin, even coat of a mixture of Sap Green and Van Dyke Brown. Apply a thin, even coat of Liquid White to the light, unpainted area of the canvas. Do NOT allow the canvas to dry before you begin.

SKY

Load the 2" brush with a very small amount of Phthalo Blue, tapping the bristles firmly against the palette to ensure an even distribution of paint throughout the bristles. Use criss-cross strokes to suggest a sky in the lightest area of the canvas.

BACKGROUND

The indication of the tall, misty, background evergreens is made using various mixtures of Van Dyke Brown, Sap Green and Titanium White and the 2" brush. To load the brush, pull both sides of the bristles through the mixtures, forcing them to a chiseled edge. Starting at the base of each tree, simply hold the brush vertically and press the side of the brush against the canvas. As you work upward, apply less pressure on the brush, creating the tapered tree top. Complete first one side and then the other of each tree. (Photo 2.)

Continuing with the same mixtures, tap downward with just the top corner of the 2" brush to shape the background leafy trees and the small bushes at the base of the tall evergreens. (Photo 3.) Diffuse the base of the trees by firmly tapping downward with the top corner of the 2" brush, creating the illusion of mist. (Photo 4.)

EVERGREENS

For the more distinct evergreens, load the fan brush to a chiseled edge with a dark-tree mixture of Midnight Black, Van Dyke Brown, Sap Green and Phthalo Blue. Holding the brush vertically, touch the canvas to create the center line of each tree. Use just the corner of the brush to begin adding the small top branches. Working from side to side, as you move down each tree, apply more pressure to the brush, forcing the bristles to bend downward and automatically the branches will become larger as you near the base of each tree. (Photo 5.)

Hold the fan brush vertically and tap downward to paint just the indication of small evergreens. (Photo 6.)

Add the evergreen trunks with a small roll of a mixture of Titanium White and Dark Sienna on the knife. Use the fan brush to very lightly touch highlights to the branches with a mixture of the dark-tree color and the Yellows.

Mist the base of the trees by firmly tapping with a very, very small amount of Titanium White on the 2" brush. (Photo 7.)

To paint the small, bright evergreens, load the fan brush with a very light mixture of Titanium White, Yellow Ochre and Sap Green. Push UP with just the corner of the brush to begin adding the small top branches. Working from side to side, as you move down each tree, apply more pressure to the brush, forcing the

bristles to bend UPWARD and automatically the branches will become larger as you near the base of each tree. *(Photo 8.)*

ROCKS AND BOULDERS

Use a mixture of Midnight Black, Van Dyke Brown and Dark Sienna on the knife to shape the large rocks and boulders. Highlight the rocks by loading the fan brush with a mixture of Titanium White and Prussian Blue. By just tapping downward, you can use the natural curve of the fan brush bristles to shape and contour the rocks. Try not to just tap at random, think about shape and form. *(Photo 9.)* Use a clean, dry 2" brush to lightly blend the rocks.

Continue using the light Yellow mixture on the fan brush to add small bushes at the base of the rocks.

Use a mixture of Titanium White and Van Dyke Brown on the liner brush to add small sticks, twigs, and tiny tree trunks. (To load the liner brush, thin the mixture to an ink-like consistency by first dipping the liner brush into paint thinner. Slowly turn the brush as you pull the bristles through the mixture, forcing them to a sharp point.) Apply very little pressure to the brush as you shape the trunks. By turning and wiggling the brush, you can give your twigs and trunks a gnarled appearance.

To add the grassy area at the base of the trees, load the 2" brush by holding it at a 45-degree angle and tapping the bristles into the various mixtures of Sap Green and all of the Yellows. (Use a very small amount of Titanium White in the lightest area.) Allow the brush to "slide" slightly forward in the paint each time you tap (this assures that the very tips of the bristles are fully loaded with paint.) Hold the brush horizontally and gently tap downward. Work in layers, carefully creating the lay-of-the-land. *(Photo 10.)* If you are careful to load the brush properly and not to destroy all of the dark color already on the canvas, you can create grassy highlights that look almost like velvet.

Re-load the 2" brush with Titanium White and pull straight down to add reflections to the water. *(Photo 11.)* Lightly brush across with a clean, dry 2" brush to give the reflections a "watery" appearance.

To add small rocks and stones to the water, load the filbert brush with a mixture of Van Dyke Brown and Dark Sienna, then pull one side of the bristles through a thin mixture of Liquid White, Van Dyke Brown and Dark Sienna. With the light side of the brush UP, use a single, curved stroke to shape each of the

small rocks and stones. By double-loading the brush, you can highlight and shadow each rock with a single stroke. *(Photo 12.)*

Use a mixture of Liquid White, Titanium White and Phthalo Blue on the fan brush to add the water action *(Photo 13)* and to "swirl" the water forward.

Scrub in the sand bar along the water's edge with a small roll of a mixture of Titanium White and Van Dyke Brown on the knife. Make sure the roll of paint is on the bottom edge of the knife and use firm pressure. *(Photo 14.)*

Continue using the knife with Van Dyke Brown to shape the large, foreground boulder. *(Photo 15.)* Again, use the fan brush to highlight and contour the boulder. *(Photo 16.)*

Underpaint the large foreground trees and bushes with a mixture of Midnight Black, Alizarin Crimson and Sap Green on the 2" brush. *(Photo 17.)* Highlight the trees *(Photo 18)* and bushes *(Photo 19)* with the Yellow highlight mixtures on the 2" brush.

FINISHING TOUCHES

Use the double-loaded filbert brush for additional rocks and stones in the foreground and your painting is complete. *(Photo 20.)*

Country Creek

1. Prepaint the canvas with Black Gesso.

2. Press the 2" brush to paint the evergreens . . .

3. . . . tap down for leaf trees . . .

4. . . . then mist the base of the trees.

5. Paint evergreens with the corner of the fan brush . . .

6. . . . then tap down for tree indications.

7. Create the illusion of mist.

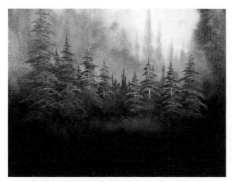

8. Use the fan brush to paint light trees . . .

9. . . . and to highlight the large rocks.

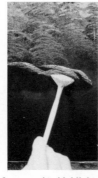

10. Tap down with the 2" brush to paint soft grass . . .

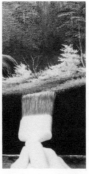

11. . . . pull down to paint reflections.

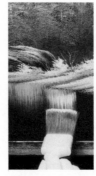

12. Paint small stones with the filbert brush.

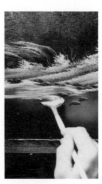

13. Bring the water forward with the fan brush.

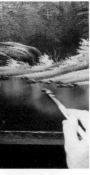

14. Paint the sandbar . . .

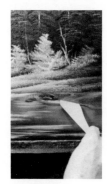

15. . . . and the large boulder with the knife.

16. Highlight the boulder with the fan brush.

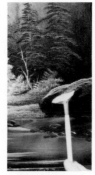

17. Use the 2" brush to paint . . .

18. . . . and highlight foreground trees . . .

19. . . . and bushes . . .

20. . . . to complete the painting.

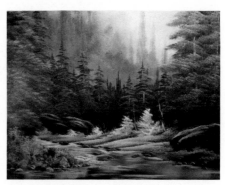

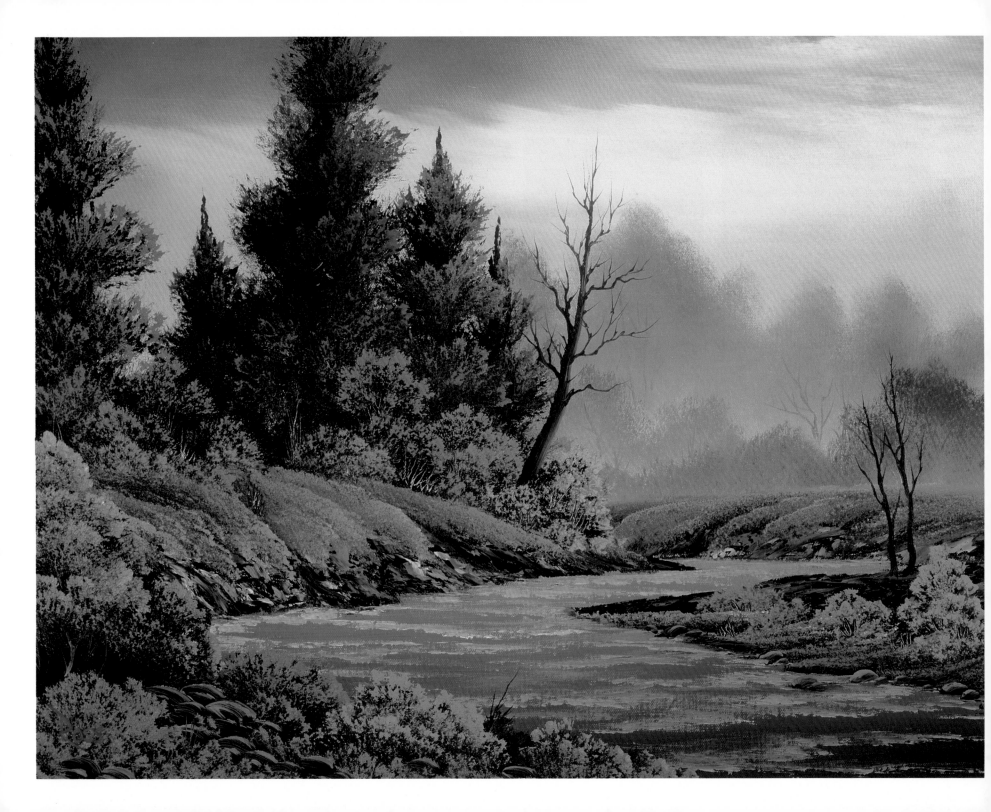

20. A TRACE OF SPRING

MATERIALS

2" Brush	Midnight Black
1" Brush	Dark Sienna
#6 Filbert Brush	Van Dyke Brown
#2 Script Liner Brush	Alizarin Crimson
Large Knife	Sap Green
Liquid White	Cadmium Yellow
Titanium White	Yellow Ochre
Phthalo Green	Indian Yellow
Phthalo Blue	Bright Red
Prussian Blue	

Begin by using the 2" brush to cover the entire canvas with a thin, even coat of Liquid White. Do NOT allow the Liquid White to dry before you begin.

SKY

Load the 2" brush with a small amount of Phthalo Blue. Starting at the top of the canvas and working downward, use criss-cross strokes to paint the sky. *(Photo 1.)* Allow some areas of the sky to remain quite light, for cloud placement.

With a mixture of Titanium White and a very small amount of Bright Red on a clean, dry 2" brush, just tap in the basic cloud shapes. *(Photo 2.)* Lightly blend the clouds with a clean, dry 2" brush using long, horizontal strokes. *(Photo 3.)*

BACKGROUND

Load the 2" brush with a mixture of Alizarin Crimson, Phthalo Blue and a small amount of Titanium White. Holding the brush vertically, tap downward with just the top corner of the brush to indicate the basic shapes of the background trees along the horizon. *(Photo 4.)*

With a clean, dry 2" brush, firmly tap to diffuse the base of the background trees, creating the illusion of mist. *(Photo 5.)*

Working forward in layers, continue using the 2" brush to add the background trees with a darker mixture of Sap Green, Cadmium Yellow and Yellow Ochre. Mist the base of the trees, then add Dark Sienna and Van Dyke Brown to the mixture to add the final layer of the darkest background trees. Again, tap to mist the base of the trees. *(Photo 6.)*

Use a mixture of Midnight Black and Prussian Blue on the 2" brush and long horizontal strokes to underpaint the water on the lower portion of the canvas.

With a thin Brown mixture on the liner brush, add the subtle indication of background tree trunks and branches.

Use a mixture of Van Dyke Brown and Dark Sienna on the knife and horizontal strokes to underpaint the land area at the base of the background trees.

To add the soft grass to the land area, load the 2" brush by holding it at a 45-degree angle and tapping the bristles into the various mixtures of Sap Green and all of the Yellows. Allow the brush to "slide" slightly forward in the paint each time you tap (this assures that the very tips of the bristles are fully loaded with paint). To paint the grass, hold the brush horizontally and gently tap downward. Work in layers, carefully creating the lay-of-the-land. If you are also careful not to destroy all of the dark undercolor, you can create grassy highlights that look almost like velvet.

Rocks and stones are added to the water's edge with a "marbled" mixture of Van Dyke Brown, Midnight Black and Titanium White on the knife.

RIVERBANK

Working forward, underpaint the riverbank on the left side of the painting with the knife and the Brown mixture, then highlight the bank with various mixtures of the marbled rock-color and Bright Red. Apply the highlights with so little pressure that the paint "breaks". *(Photo 7.)*

Again, use the 2" brush and the Yellow highlight mixtures to add the soft grass to the riverbank. *(Photo 8.)*

TREES AND BUSHES

Use a mixture of Prussian Blue, Midnight Black, Phthalo Green, Alizarin Crimson and Van Dyke Brown and the 1" brush to paint the large evergreens. Load the brush to a sharp chiseled edge by wiggling the brush as you pull the bristles through

the mixture. Holding the brush vertically, lightly touch the canvas to create the center line of each tree. Then, still holding the brush vertically and starting at the top of the tree, bend the bristles upward to begin adding the small top branches. Working from side to side, as you move down each tree, apply more pressure to the brush, forcing the bristles to bend upward and automatically the branches will become larger as you near the base of each tree. *(Photo 9.)*

Without cleaning the brush, reload it to a chiseled edge with various mixtures of all of the Yellows and lightly touch highlights to the trees, carefully shaping individual branches.

Use the 1" brush and a Lavender mixture of Alizarin Crimson, Phthalo Blue and Titanium White to add bushes to the base of the evergreens. To load the 1" brush, first dip it into Liquid White, then pull the brush (several times in one direction, to round one corner of the bristles) through the mixture. With the rounded corner of the brush up, force the bristles to bend upward to highlight the individual small trees and bushes. *(Photo 10.)*

You can add small bushes and grassy highlights to the riverbank with Yellow highlight mixtures on the 2" brush. *(Photo 11.)* Again, pay close attention to the lay-of-the-land. *(Photo 12.)*

Use a mixture of Phthalo Blue and Titanium White on the knife and long horizontal strokes to highlight the water at the base of the riverbank, allowing the paint to "break". *(Photo 13.)*

Working forward, underpaint the closer land projection on the right side of the painting with the dark Brown mixture on the knife. Highlight the projection with various mixtures of Van Dyke Brown, Titanium White and a very small amount of Bright Red. *(Photo 14.)* Add the soft grassy area *(Photo 15)* and small bushes with the Yellow highlight mixtures on the 2" brush *(Photo 16)*.

FOREGROUND

Underpaint the foreground trees and bushes with a dark mixture of Sap Green, Prussian Blue and Van Dyke Brown on the 2" brush. Use the Yellow highlight mixtures on the 1" brush to shape and highlight individual trees and bushes. *(Photo 17.)*

To add the small rocks and stones in the foreground, load the filbert brush with a thin dark Brown mixture, then pull one side of the bristles through a thin mixture of Titanium White and Brown, to double-load the brush. With the light side of the bristles up, use curved strokes to shape the small rocks and stones. *(Photo 18.)* By double-loading the brush, you can highlight and shadow each rock and stone with a single stroke. *(Photo 19.)*

Paint the foreground tree trunks with Van Dyke Brown on the filbert brush. *(Photo 20.)* Use the liner brush and thinned Brown to add the limbs and branches to the leafless trees. *(Photo 21.)*

FINISHING TOUCHES

With Phthalo Blue and Titanium White on the knife, add the last of the water lines and ripples to complete the painting. *(Photo 22.)*

A Trace Of Spring

1. Use the 2" brush to paint the sky . . .

2. . . . and to tap in the clouds . . .

3. . . . and to blend the entire sky.

4. Paint background trees with the 2" brush . . .

5. . . . then firmly tap downward . . .

6. . . . to create the illusion of mist.

A Trace Of Spring

7. Working forward, add land with the knife . . .

8. . . . then apply grassy highlights with the 2" brush.

9. Paint evergreens with the 1" brush.

10. Highlight trees and bushes with the 1" brush.

11. Tap in grassy highlights with the 2" brush . . .

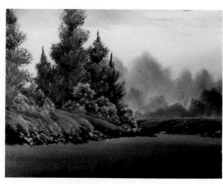

12. . . . paying close attention to the lay-of-the-land.

13. Scrub in water with the knife . . .

14. . . . before moving forward with the land area.

15. Again, tap downward with the 2" brush . . .

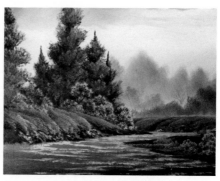

16. . . . to apply the grassy highlights.

17. Use the 1" brush to highlight the bushes.

18. Double-load the filbert brush . . .

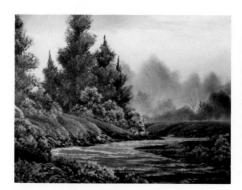

19. . . . to add small rocks and stones . . .

20. . . . and tree trunks.

21. Add tiny limbs and branches with the liner brush . . .

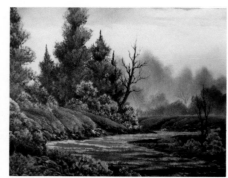

22. . . . to complete the painting.

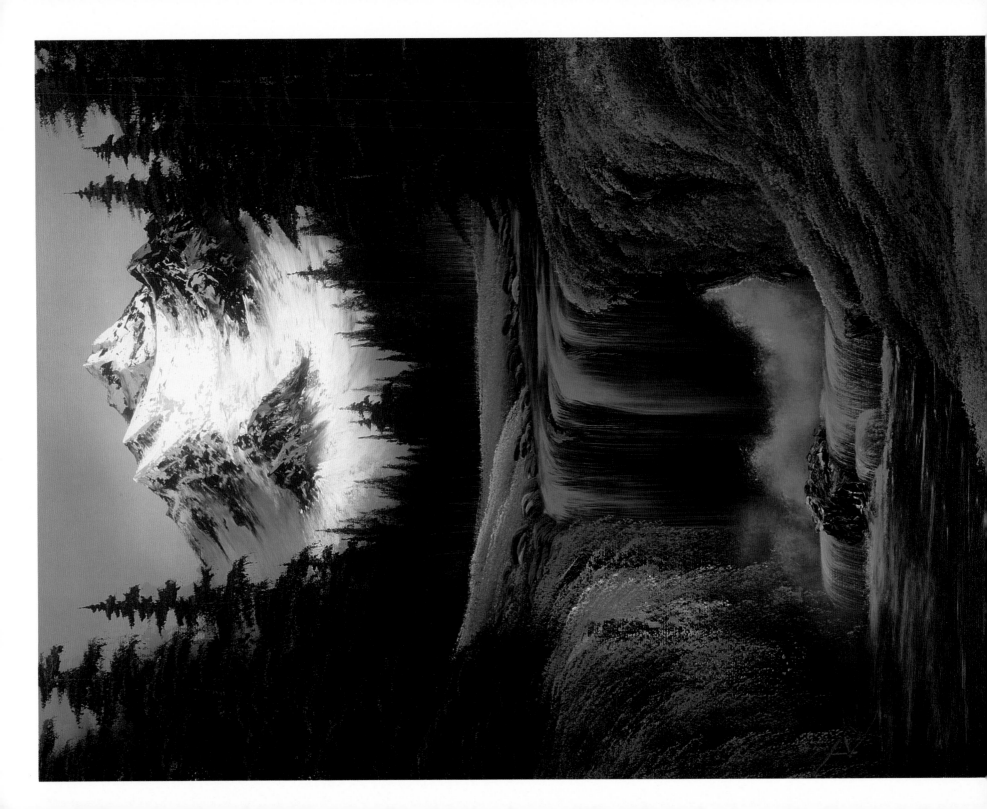

MATERIALS

2" Brush	Phthalo Blue
1" Brush	Prussian Blue
#6 Filbert Brush	Midnight Black
#6 Fan Brush	Dark Sienna
#2 Script Liner Brush	Van Dyke Brown
Large Knife	Alizarin Crimson
Black Gesso	Sap Green
Liquid White	Cadmium Yellow
Liquid Clear	Yellow Ochre
Titanium White	Indian Yellow
Phthalo Green	Bright Red

Start by using a foam applicator to pre-paint the lower portion of the canvas and the basic shape of the tree tops with Black Gesso. Allow the canvas to DRY COMPLETELY before proceeding. *(Photo 1.)*

Use the 2" brush to cover the dark portion of the canvas with a very thin, even coat of a mixture of Liquid Clear, Phthalo Blue and Phthalo Green. Apply a thin, even coat of Liquid White to the light, unpainted sky-area of the canvas. DO NOT allow these colors to dry before you begin.

SKY

With the 2" brush, use criss-cross strokes to extend the Phthalo Blue-Phthalo Green mixture into the sky. Use a clean, dry 2" brush to blend the sky. *(Photo 2.)*

MOUNTAIN

Use the knife and Midnight Black to paint the distant mountain-top. *(Photo 3.)*

Highlight the mountain-top with Titanium White. Again, load the long edge of the knife blade with a small roll of paint. Paying close attention to angles, highlight the right side of the peaks with so little pressure that the paint "breaks". Use a mixture of Titanium White and Phthalo Blue, applied in the opposing direction, for the shadowed sides of the peaks. Again, use so little pressure that the paint "breaks".

Use various mixtures of Titanium White and Phthalo Blue on the knife and horizontal strokes to paint the base of the mountain, again, allowing the paint to "break". *(Photo 4.)* Continue by using Midnight Black to add the shadowed areas at the base of the mountain. *(Photo 5.)* Working in layers, use various mixtures of Titanium White and Phthalo Blue for additional highlights and shadows at the base of the mountain.

Use a clean, dry 2" brush to tap the base of the mountain, carefully following the angles *(Photo 6)* then lightly lift upward to create the illusion of mist *(Photo 7)*.

BACKGROUND

Load the fan brush to a chiseled edge with a dark-tree mixture of Midnight Black, Prussian Blue, Phthalo Green, and Alizarin Crimson. Holding the brush vertically, just tap downward to indicate the small trees at the base of the mountain. *(Photo 8.)* Use just the corner of the brush to add tiny branches to the more distinct trees. With a mixture of Titanium White and Phthalo Blue on the fan brush, use short, upward strokes at the base of the trees to indicate the tiny tree trunks *(Photo 9)*.

To add the soft grassy areas at the base of the trees, use the 2" brush and various mixtures of the dark-tree color, all of the Yellows and Bright Red. Load the brush by holding it at a 45-degree angle and tapping the bristles into the various paint mixtures. Allow the brush to "slide" slightly forward in the paint each time you tap (this assures that the very tips of the bristles are fully loaded with paint). Hold the brush horizontally and gently tap downward to paint the soft grass. *(Photo 10.)* Working forward in layers, carefully creating the lay-of-the-land, use a very small amount of Titanium White to "sparkle" the very lightest areas. If you are careful not to destroy all of the dark color already on the canvas, you can create grassy highlights that look almost like velvet.

WATERFALL

Load the 1" brush by dipping it into Liquid White and then pulling the bristles through a mixture of Liquid Clear, Phthalo

Blue and Phthalo Green. Starting in the distance and working forward, use horizontal strokes to begin scrubbing in the water, then make a series of long, downward strokes to paint the waterfall. *(Photo 11.)*

With a clean, dry 2" brush and firm pressure, lift upward from the base of the falls to blend. Add a small amount of Titanium White to the 2" brush and tap the base of the fall with the top corner of the brush *(Photo 12)* to create the illusion of mist *(Photo 13)*.

Load the filbert brush with a mixture of Midnight Black and Van Dyke Brown, then pull one side of the bristles through a thin mixture of Liquid White, Van Dyke Brown and Dark Sienna, to double-load the brush. With the light side of the bristles up, use curved strokes to paint the rocks and stones at the top of the waterfall. *(Photo 14.)* With just a single stroke, you can paint each rock and its highlight. *(Photo 15.)*

EVERGREENS

To paint the large evergreens, load the fan brush to a chiseled edge with the original dark tree-mixture. Holding the brush vertically, touch the canvas to create the center line of each tree. Use just the corner of the brush to begin adding the small top branches. Working from side to side, as you move down each tree, apply more pressure to the brush, forcing the bristles to bend downward *(Photo 16)* and automatically the branches will become larger as you near the base of each tree. Very lightly

touch highlights to the branches by adding a very small amount of Cadmium Yellow to the brush. *(Photo 17.)*

ROCKS AND CLIFFS

With a mixture of Titanium White, Van Dyke Brown and Dark Sienna on the knife, use very little pressure to shape the large rocks and cliffs at the sides of the waterfall. *(Photo 18.)*

Add foliage to the cliffs with various mixtures of all of the Yellows and Sap Green on the 2" brush. *(Photo 19.)* Work forward in layers, paying close attention to angles and the lay-of-the-land. *(Photo 20.)*

SMALL WATERFALL

Load the fan brush with Liquid White and the Liquid Clear-Phthalo Blue-Phthalo Green mixture. Start with a short horizontal stroke and then pull straight down, as many times as necessary, to paint the left side of the small waterfall. *(Photo 21.)*

Use Van Dyke Brown on the knife to shape the stone at the base of the waterfall and then highlight with a mixture of Titanium White and Van Dyke Brown, allowing the paint to "break". *(Photo 22.)* Continue by painting the waterfall on the right side of the stone. *(Photo 23.)*

FOREGROUND

Continue working forward in layers, adding foliage *(Photo 24)* and rocks and stones to the water's edge *(Photo 25)* and your painting is complete *(Photo 26)*.

Valley Waterfall

1. Pre-paint the canvas with Black Gesso . . . **2. . . . then paint the sky.** **3. Use the knife to shape the mountain top . . .** **4. . . . add highlights . . .** **5. . . . and shadows . . .** **6. . . . before misting . . .**

Valley Waterfall

7. . . . the base of the mountain.

8. Tap down evergreens . . .

9. . . . at the base of the mountain.

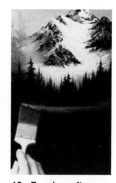

10. Tap in soft grass with the 2" brush.

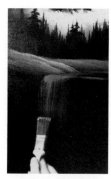

11. Pull down the waterfall with the 1" brush.

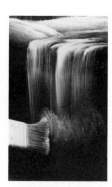

12. Use the top corner of the 2" brush . . .

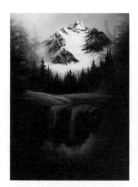

13. . . . to mist the base of the waterfall.

14. Double-load the filbert brush . . .

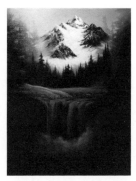

15. . . . to paint small rocks and stones.

16. Use the fan brush . . .

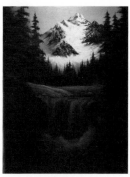

17. . . . to paint the large evergreens.

18. Paint large rocks with the knife . . .

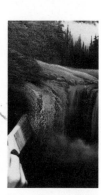

19. . . . then use the 2" brush . . .

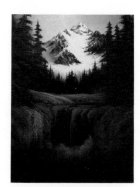

20. . . . to add the foliage.

21. Paint the small waterfall . . .

22. . . . then add the rocks . . .

23. . . . in the foreground.

24. Work forward with soft grass . . .

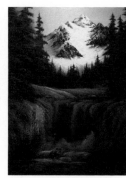

25. . . . and rocks . . .

26. . . . to complete your painting.

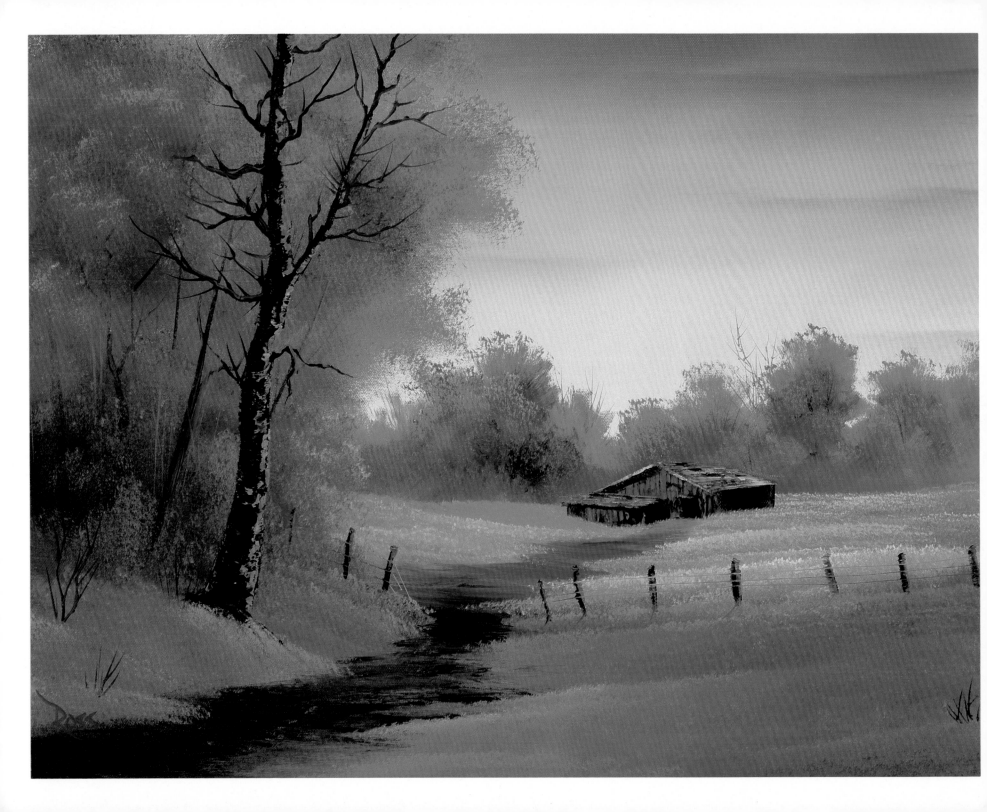

MATERIALS

2" Brush	Prussian Blue
1" Brush	Midnight Black
1" Round Brush	Alizarin Crimson
#3 Fan Brush	Sap Green
#2 Script Liner Brush	Cadmium Yellow
Large Knife	Yellow Ochre
Liquid White	Indian Yellow
Titanium White	Bright Red

Begin by using the 2" brush to cover the entire canvas with a thin, even coat of Liquid White. Do NOT allow the Liquid White to dry before you begin.

SKY

Load the 2" brush with a small amount of Indian Yellow and use criss-cross strokes to create the Golden glow in the sky, just above the horizon. Without cleaning the brush, reload it with Yellow Ochre and continue working upward with criss-cross strokes. *(Photo 1.)*

With a small amount of Midnight Black, continue using criss-cross strokes to add the dark sky-area at the top of the canvas. Lightly blend one color into the other, then blend the entire sky. Use a very small amount of Midnight Black on the 2" brush to tap in the subtle cloud formations. *(Photo 2.)* Use a clean, dry 2" brush to blend the entire sky area with long, horizontal strokes.

BACKGROUND

Use the knife to make a Brown tree-mixture on your palette with equal parts of Alizarin Crimson and Sap Green.

Load the 1" brush with a mixture of the Brown and a very small amount of Midnight Black. Use circular, criss-cross strokes to loosely block in the basic shape of the small background trees just above the horizon.

To highlight the background trees, load the small round brush by first dipping it into Liquid White, then tapping the bristles into various mixtures of the Yellows, Prussian Blue, and small amounts of Midnight Black and Bright Red. Tap downward to apply the highlights, carefully shaping individual trees and bushes. *(Photo 3.)* Pay close attention to lights and darks and try not to just hit at random. *(Photo 4.)*

The tree trunks and branches are added with a thinned mixture of the Brown tree-color on the liner brush. (To load the liner brush, thin the mixture to an ink-like consistency by first dipping the liner brush into paint thinner. Slowly turn the brush as you pull the bristles through the mixture, forcing them to a sharp point.) Paint the trunks with very little pressure, turning and wiggling the brush to give the trunks a gnarled appearance.

SOFT GRASS

Use the 2" brush and various mixtures of the Brown, Midnight Black and Sap Green to underpaint the grassy area at the base of the background trees. *(Photo 5.)*

Use the 2" brush and various mixtures of all of the Yellows and Sap Green to highlight the soft grassy area at the base of the trees. Load the 2" brush by first dipping it into Liquid White, then holding it at a 45-degree angle, tap the bristles into the various highlight mixtures. Allow the brush to "slide" slightly forward in the paint each time you tap (this assures that the very tips of the bristles are fully loaded with paint). To apply the highlights, hold the brush horizontally and gently tap downward. Work in layers, carefully creating the lay-of-the-land. If you are also careful not to destroy all of the dark color already on the canvas, you can create grassy highlights that look almost like velvet. *(Photo 6.)*

BARN

Use the knife to remove paint from the canvas in the basic shape of the barn. With a small roll of the original Brown mixture on the knife and paying close attention to angles, paint the barn roof. Pull down the side and then the front of the barn. Use a mixture of Bright Red, Brown and Titanium White on the knife to highlight the roof, the side and the front of the barn, with so little pressure that the paint "breaks". These same basic steps

can be repeated to add the small shed in front of the barn. Add a door to the barn with the Brown mixture and then use a clean knife to remove excess paint from the base of the buildings. *(Photo 7.)*

Use a Brown-White mixture on the knife and horizontal strokes to add the path leading to the barn–watch your perspective here! *(Photo 8.)*

FENCE

Paint the fence posts with a small roll of the Brown mixture on the knife. *(Photo 9.)* Highlight the left side of each post with Titanium White and the tops of the posts with Bright Red. Add the fence wire with the heel of the knife *(Photo 10)* to complete the fence *(Photo 11)*.

FOREGROUND

Use the Brown mixture on the 2" brush to extend the land area into the foreground. *(Photo 12.)*

Underpaint the cluster of foreground trees with the 2" brush and various mixtures of the Brown color and small amounts of Midnight Black and Bright Red. *(Photo 13.)*

To add the tree trunks, dip the fan brush into paint thinner and load it with a dark Brown mixture, then pull one side of the bristles through a thin light Brown-mixture, to double-load the brush. Holding the brush vertically, with the light side of the bristles on the left, paint the trunks and large branches. *(Photo 14.)*

Add the smaller limbs and branches with thinned Brown on the liner brush. *(Photo 15.)*

Use various mixtures of all of the Yellows, Sap Green and Bright Red on the 2" brush to highlight the cluster of trees. Tap downward with one corner of the brush, carefully shaping individual trees. *(Photo 16.)*

Continue using the Yellow highlight-mixtures on the 2" brush to add the soft grass in the foreground. *(Photo 17.)*

LARGE TREE

With a mixture of the Brown and Midnight Black on the fan brush, pull down the large foreground tree trunks. *(Photo 18.)* Use a mixture of Brown and Titanium White on the knife to highlight the right side of the trunk *(Photo 19)* and a mixture of Titanium White and Prussian Blue on the knife to add reflected light to the left side of the trunk.

Use thinned dark Brown on the liner brush to add the small limbs and branches to the large foreground trees.

FINISHING TOUCHES

Use a thin Brown mixture on the fan brush to extend the path into the foreground, then use the point of the knife to scratch in the indication of tiny sticks and twigs and your painting is complete. *(Photo 20.)*

Delightful Meadow Home

 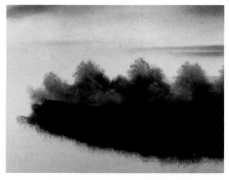

1. Use the 2" brush and criss-cross strokes to paint the sky . . .

2. . . . then tap in the indication of clouds.

3. Tap down with the small round brush . . .

4. . . . to paint the background trees.

5. Tap down with the 2" brush . . .

6. . . . to paint grass at the base of the trees.

Delightful Meadow Home

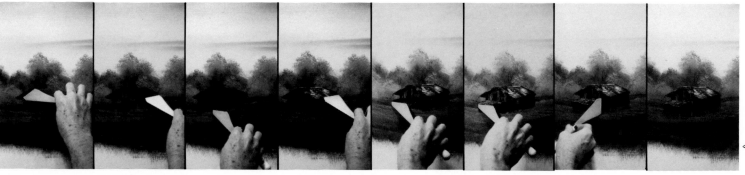

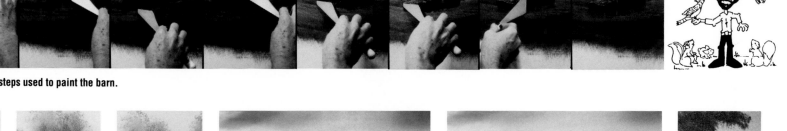

7. Progressional steps used to paint the barn.

8. Use the knife to paint the path . . .

9. . . . and to add the fence posts.

10. Cut in wire with the heel of the knife . . .

11. . . . to complete the fence.

12. Use the 2" brush to underpaint foreground grass . . .

13. . . . and to under-paint foreground trees.

14. Paint small tree trunks with the fan brush . . .

15. . . . then add limbs and branches with the liner brush.

16. Tap down with the 2" brush to highlight the small trees . . .

17. . . . and the soft foreground grass.

18. Paint the large tree trunk with the fan brush . . .

19. . . . then highlight the trunk with the knife.

20. Add limbs and branches with the liner brush to complete the painting.

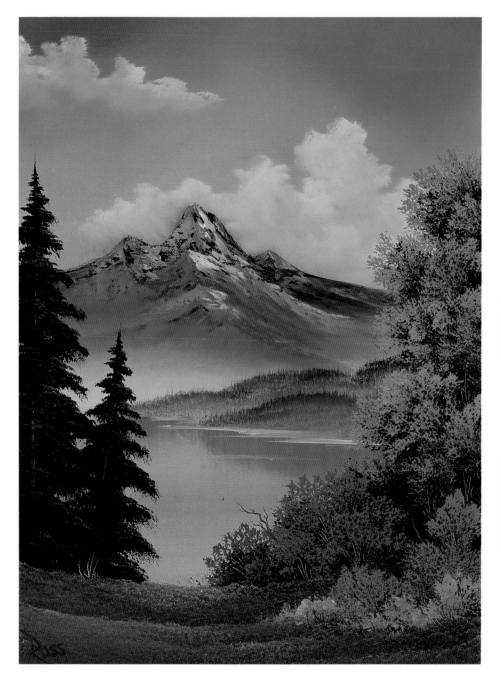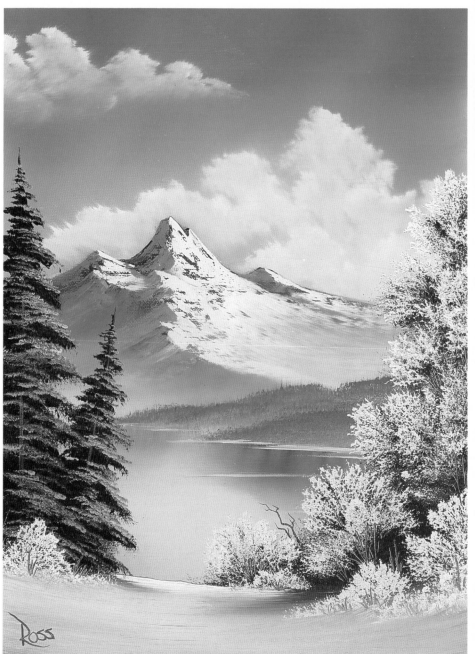

MATERIALS

2" Brush	Midnight Black
1" Brush	Dark Sienna
#6 Fan Brush	Van Dyke Brown
#2 Script Liner Brush	Alizarin Crimson
Large Knife	Sap Green
Liquid White	Cadmium Yellow
Titanium White	Yellow Ochre
Phthalo Green	Indian Yellow
Phthalo Blue	Bright Red
Prussian Blue	

These paintings are done on two small canvases. The scenes are identical, but one represents summer, the other winter. The instructions given here are for the summer painting. Any changes to be made for the winter scene will be in parenthesis. You may find it helpful to use two of each of the brushes, one for the summer colors and the other for the winter colors.

Start by covering both canvases with a thin, even coat of Liquid White. With long horizontal and vertical strokes, work back and forth to ensure an even distribution of paint on the canvases. Do NOT allow the Liquid White to dry before you begin.

SKY

Load the 2" brush with Phthalo Blue (use a mixture of Phthalo Blue and Midnight Black for the winter sky), tapping the bristles firmly against the palette to ensure an even distribution of paint throughout the bristles. Start at the top of the sky, making criss-cross strokes. As you work down the canvas, the color will blend with the Liquid White and automatically get lighter as you near the horizon. Add a Pink glow to the summer sky, just above the horizon, with a small amount of Alizarin Crimson on the brush, still using criss-cross strokes.

This is a good time to add the water to the lower portion of the paintings. With a mixture of Phthalo Blue and Phthalo Green on the 2" brush, use horizontal strokes to pull from the outside edges of the canvas in towards the center. (The water in the winter painting is a mixture of Phthalo Blue and Midnight Black.) Leave a light area in the center of the water, to create a shimmer, but then use long horizontal strokes with a clean brush to blend the entire water-area of the canvas.

The clouds are made with small circular strokes using a mixture of Titanium White with a very small amount of Bright Red on the 1" brush. (Add a very, very small amount of Midnight Black to the cloud mixture for the winter sky.) Use the top corner of a clean, dry 2" brush and circular strokes to blend the base of the clouds and then gently lift upward to "fluff". (Photo 1.)

MOUNTAIN

The mountains are made with a mixture of Midnight Black, Van Dyke Brown, Alizarin Crimson and Prussian Blue. (Use the same mixture for the winter mountain.) Pull the paint out very flat on your palette and just cut across to load the long edge of the knife with a small roll of paint. Use firm pressure to shape just the top edges of both mountains. (Photo 2.) Pull the paint down to the base of the mountains with the 2" brush and automatically the color will mix with the Liquid White already on the canvases, creating a misty appearance. (Photo 3.)

Highlight the summer mountain with a mixture of Titanium White and Dark Sienna; be very careful not to over-mix the colors. (Highlight the winter mountain with a mixture of Titanium White and a very, very small amount of Midnight Black.) Again, load the knife with a small roll of paint and starting at the top, glide the knife down the right side of each peak, using so little pressure on the knife that the paint "breaks." (Photo 4.)

The shadow sides of the peaks are a mixture of Titanium White, Dark Sienna and Prussian Blue (the winter mountain shadows are made with a mixture of Titanium White, Phthalo Blue and Midnight Black), applied to the left sides of the peaks, still with very little pressure on the knife so that the paint "breaks."

Use a clean, dry 2" brush to tap the base of each mountain

to diffuse *(Photo 5)* and then gently lift upward, following the angles, to create the illusion of mist *(Photo 6)*.

FOOTHILLS

The foothills are made with the 2" brush and a mixture of Midnight Black, Van Dyke Brown, Sap Green and Titanium White. (For the winter scene, use a mixture of Titanium White, Midnight Black and Phthalo Blue.) Holding the brush horizontally, use just one corner to tap downward to shape the hills at the base of the mountain. *(Photo 7.)* Extend some of the color down into the water (in both paintings) then pull straight down *(Photo 8)* and lightly brush across to give the reflections a watery appearance.

Use a mixture of Liquid White and Alizarin Crimson on the edge of the knife to cut in the water lines and ripples (use just Liquid White for the winter painting) *(Photo 9)* and the background in both paintings is finished *(Photo 10)*.

FOREGROUND

Use the 2" brush with a mixture of Midnight Black, Prussian Blue, Phthalo Blue, Van Dyke Brown and Alizarin Crimson to underpaint the foreground in both paintings. Pull the big brush through the mixture, to round one corner, and then with the rounded corner up force the bristles to bend upward to underpaint the very basic tree and bush shapes in the foreground. In the summer painting, extend this dark color across the very bottom of the canvas, for grass. *(Photo 11.)*

EVERGREENS

To paint the evergreens in both scenes, load the fan brush to a chiseled edge with the same dark mixture of Midnight Black, Prussian Blue, Phthalo Blue, Van Dyke Brown and Alizarin Crimson. Holding the brush vertically, touch the canvas to create the center line of each tree. Use just the corner of the brush to begin adding the small top branches. Working from side to side, as you move down each tree, apply more pressure to the brush, forcing the bristles to bend downward and automatically the branches will become larger as you near the base of each tree.

HIGHLIGHTING THE FOREGROUND

(For the winter painting, use long, horizontal strokes with Titanium White on the 2" brush to add snow to the base of the foreground trees and bushes. Allow the brush to pick up some of the dark tree color for shadows.) *(Photo 12.)*

Highlight the trees and bushes in both paintings with the 1" brush. Dip the brush into Liquid White and then pull it in one direction, to round one corner, through various mixtures of all of the Yellows, Sap Green and Bright Red for the summer painting. (For the winter painting use mixtures of Liquid White, Titanium White and Phthalo Blue.) With the rounded corner of the brush up, force the bristles to bend upward as you form the individual tree and bush shapes. Try not to just hit at random, think like a tree, create individual limbs and branches. Work in layers and be very careful not to "kill" all of the dark color; use it to separate the individual shapes, in both paintings.

Use the fan brush to highlight the right sides of the evergreen trees with a dark Yellow-Green mixture. (For the winter evergreens, highlight with Titanium White and Phthalo Blue.)

Highlight the grassy area in the summer painting with the 2" brush and various mixtures of Sap Green and all of the Yellows. Load the brush by holding it at a 45-degree angle and tapping the bristles into the various paint mixtures. Allow the brush to "slide" slightly forward in the paint each time you tap (this assures that the very tips of the bristles are fully loaded with paint). Hold the brush horizontally and gently tap downward, carefully creating the lay-of-the-land. If you are also careful not to destroy all of the dark color already on the canvas, you can create grassy highlights that look almost like velvet.

FINISHING TOUCHES

Use the point of the knife to scratch in sticks and twigs and then thinned Dark Sienna on the liner brush for any other small details and you have two paintings for the price of one! *(Photo 13.)*

Two Seasons

1. Complete the sky in both paintings.

2. Shape the mountain top with the knife . . .

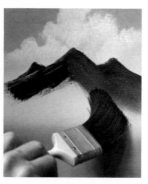

3. . . . then pull the paint down with the 2" brush.

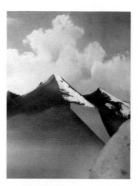

4. Highlight the mountain with the knife . . .

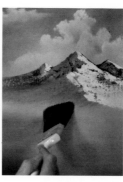

5. . . . and then use the 2" brush . . .

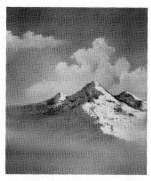

6. . . . to create the illusion of mist.

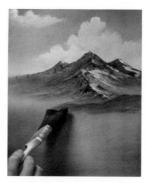

7. Use the 2" brush to tap down the foothills . . .

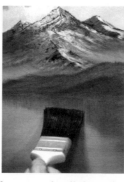

8. . . . and pull down the reflections.

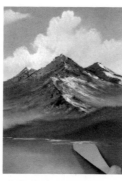

9. Cut in the water lines . . .

10. . . . to complete the backgrounds.

11. Underpaint the foreground in each painting . . .

12. . . . then add highlights. . .

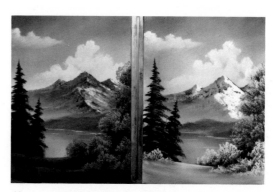

13. . . . and your paintings are finished.

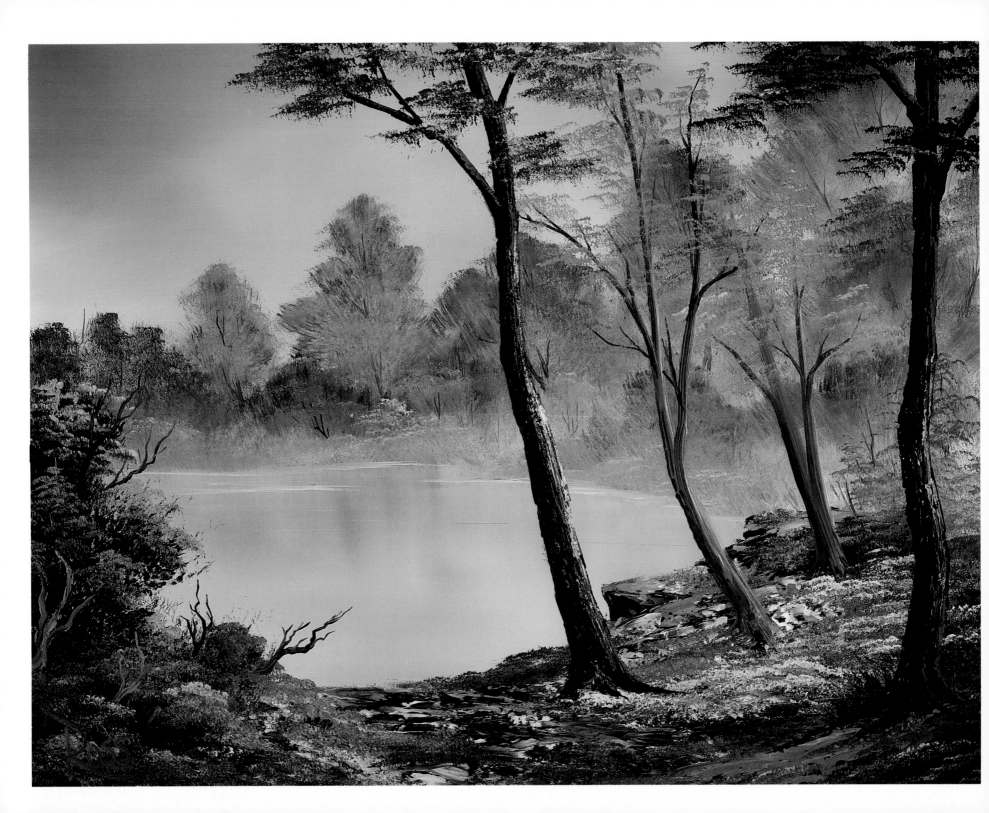

24. WARM SUMMER DAY

MATERIALS

2" Brush	Indian Yellow
1" Brush	Bright Red
Large Knife	Prussian Blue
Liquid White	Phthalo Blue
#6 Fan Brush	Sap Green
#2 Script Liner Brush	Titanium White
Alizarin Crimson	Van Dyke Brown
Dark Sienna	Yellow Ochre
Cadmium Yellow	

Cover the entire canvas with a thin even coat of Liquid White using the 2" brush. Do not allow the Liquid White to dry before you begin.

SKY AND WATER

Start with a small amount of Alizarin Crimson on the 2" brush. Make Pink areas in the sky, here and there, also reflecting some of the same color into the water. Without cleaning the brush, pick up a little Prussian Blue and again brush a little into the sky and water. Repeat with Dark Sienna. After these three colors have been randomly placed in the sky and water areas of the canvas *(Photo 1)*, blend together lightly with a clean, dry 2" brush *(Photo 2)*.

BACKGROUND

Make the trees and bushes in the background using the 2" brush with Van Dyke Brown and Dark Sienna. Holding the brush vertically, tap downward using just the top corner of the brush *(Photo 3)* to create the basic shapes *(Photo 4)*. Pull a little of this dark color into the water and then use horizontal strokes to give these reflections a watery appearance. *(Photo 5.)* Load the 1" brush with various mixtures of Cadmium Yellow, Yellow Ochre, Sap Green and Bright Red and use just one corner to tap the highlights on the basic tree and bush shapes. *(Photo 6.)* These highlights can be softened by tapping with a clean, dry 2" brush. Still using the 2" brush, pull some of the highlight colors into the reflections and gently brush across with horizontal strokes. Use

the liner brush and Van Dyke Brown, which has been thinned with oil *(Photo 7)* to make tree trunks *(Photo 8)*. Water lines are made with Liquid White and a little Van Dyke Brown on the long edge of the knife. *(Photo 9.)*

FOREGROUND

The land area in the foreground is made with the knife loaded with Van Dyke Brown and Dark Sienna. *(Photo 10.)* Apply this paint with a very firm pressure. *(Photo 11.)* The highlights are laid in with Van Dyke Brown, Prussian Blue, Titanium White and Phthalo Blue mixed to a marble appearance. Load a small roll of paint on the long edge of the knife; apply with horizontal strokes, using very little pressure, allowing the paint to "break". Tree trunks are made with the fan brush. Load the brush full of Van Dyke Brown and Dark Sienna, then pull one side through Titanium White. Hold the brush vertically, touch the canvas and pull downward. *(Photo 12.)* Foliage on the trees is made using various mixtures of Cadmium Yellow, Bright Red, Yellow Ochre and Sap Green, again tapping with just one corner of the 1" brush. Use a corner of the 2" brush to soften the effect. Starting with the one that is most distant, be sure to complete each tree before moving forward to the next closer tree.

Use the 1" brush, horizontally, to tap in the grassy area at the base of the trees. *(Photo 13.)* This area is in shadow and should be kept quite dark using various mixtures of Sap Green, Yellow Ochre, Cadmium Yellow and Bright Red. Use a little Titanium White here and there for sunlight. *(Photo 14.)*

The large tree trunks in the foreground are made with Van Dyke Brown. Load a lot of paint on the long edge of the knife and pull in the basic shapes. The branches are also made with the knife. The highlights are made with a mixture of Van Dyke Brown, Titanium White and Bright Red. Load a small roll of paint on the long edge of the knife and just touch the color to the tree trunk where the light would strike. Reflected light is made in the same way, using Prussian Blue on the opposite side of the tree. *(Photo 15.)* The leaves on the large trees are made with various mixtures of Yellow Ochre, Cadmium Yellow, Indian Yellow, Van

Dyke Brown and Sap Green loaded on the 1" brush. *(Photo 16.)* Bushes are made with the 2" brush and Van Dyke Brown and Dark Sienna. Pull the brush through the paint in one direction to round one corner. With the rounded corner up, touch the canvas and push upward, bending the bristles. *(Photo 17.)* Highlight the bushes in the same way, using the 1" brush and Sap Green,

Cadmium Yellow and Bright Red. *(Photo 18.)*

FINISHING TOUCHES

Additional sticks and branches can be made using the liner brush and Van Dyke Brown which has been thinned with a light oil. *(Photo 19.)*

Warm Summer Day

1. Sky and water ready for blending.

2. Blend the entire canvas with the large brush.

3. Use the 2" brush . . .

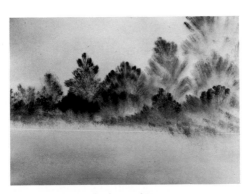

4. . . . to create the background trees.

5. Pull downward to make reflections.

6. Highlights are applied with the 1" brush.

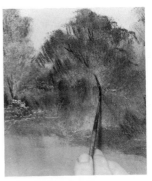

7. Use the liner brush . . .

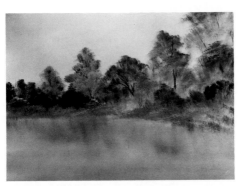

8. to paint tree trunks in distant trees.

Warm Summer Day

9. The knife is used to cut in water lines.

10. Use the knife . . .

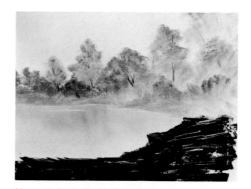

11. . . . to lay in the land areas.

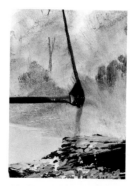

12. Tree trunks made with the fan brush.

13. The corner of the 1" brush is used . . .

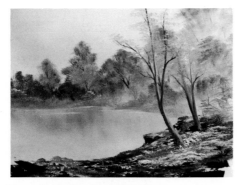

14. . . . to create soft, grassy areas.

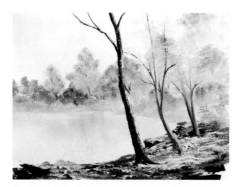

15. Add reflected light to the foreground trunks.

16. Leaves are made with the 1" brush.

17. With the 2" brush . . .

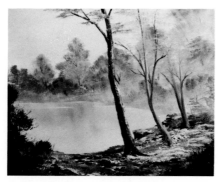

18. . . . paint in the basic bush shapes.

19. Add sticks and twigs with the liner brush.

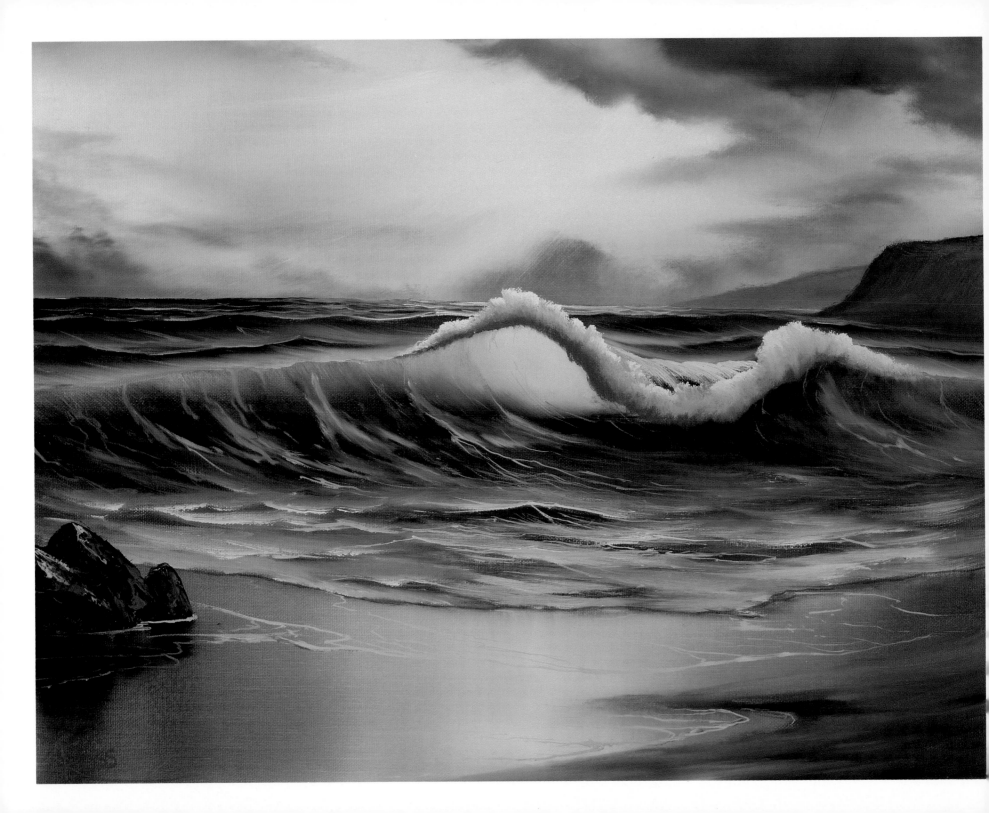

MATERIALS

2" Brush
#6 Fan Brush
#6 Filbert Brush
#2 Script Liner Brush
Large Knife
Small Knife
Liquid White
Liquid Clear
Titanium White

Phthalo Blue
Midnight Black
Dark Sienna
Van Dyke Brown
Alizarin Crimson
Cadmium Yellow
Yellow Ochre
Bright Red

The horizon in this painting is about 7½" down from the top of the canvas. Cover the area above the horizon with a thin, even coat of Liquid White. Cover the canvas below the horizon with a thin, even coat of Liquid Clear. Do not allow these Liquids to dry before you begin.

SKY

Load the 2" brush with a very small amount of Cadmium Yellow and use criss-cross strokes to create a glow in the center of the sky. Without cleaning the brush, pick up some Yellow Ochre and, still using criss-cross strokes, apply to the left side of the Yellow in the center of the sky. Still not cleaning the brush and still using criss-cross strokes, add Bright Red to the left side of the Yellow Ochre and across the canvas, above the horizon. Gently blend all of these colors together.

With a clean, dry 2" brush, use criss-cross strokes to add Titanium White to the upper left portion of the Cadmium Yellow glow. Hold the brush flat against the canvas and use long diagonal strokes to pull the White down and across the sky, creating sun rays.

Add the clouds with a mixture of Alizarin Crimson and Phthalo Blue on a clean, dry 2" brush. Use tiny circular strokes with just the top corner of the brush. Blend the clouds with the corner of a clean brush, still using small circular strokes. Very gently soften the entire sky with horizontal strokes.

Use more Alizarin Crimson and Phthalo Blue on the brush for the closer, darker clouds along the edges. Use the same mixture on the fan brush for the small horizontal "floaters," then blend.

BACKGROUND

Use paint thinner and Phthalo Blue on the filbert brush to roughly sketch the large wave and the shoreline. (Photo 1.)

Load the 2" brush with a dark mixture of Alizarin Crimson and Phthalo Blue. Use long horizontal strokes below the horizon to add the background water. Then, use this same mixture to just block in the base of the wave and the water beneath the large wave. (Photo 2.) Be very careful not to paint the "eye" of the wave. This area should remain light and unpainted. Because you are working over Liquid Clear, the color should remain quite dark and not become diluted as it would if you were using Liquid White. (Photo 3.)

Use Phthalo Blue and Alizarin Crimson to just "scrub-in" the shape of the headlands in the distance. Notice the closer headland is much darker in value. (Photo 4.)

For the background water, load the fan brush with Titanium White. Hold the brush horizontally and use short horizontal strokes to add highlights to the water along the horizon and around the base of the headlands.

Still with Titanium White on the fan brush, make the swells behind the large wave with long horizontal lines. Also add a line of White to the top edge of the major wave. (Photo 5.) To complete the distant swells (or waves) use the fan brush to grab the top edges of the White lines and use a gently sweeping stroke to pull the paint back and blend, paying very close attention to angles. Try not to touch the bottom edges of the White lines and try not to "kill" all the dark base color between the swells. (Photo 6.)

LARGE WAVE

Use the same mixture of Phthalo Blue and Alizarin Crimson on a clean fan brush to underpaint the breaker (the water crashing over the transparency). Follow the basic angle as you curve

the strokes over the top of the breaker. With a clean fan brush and Titanium White, highlight the breaker; again, follow the basic angle. (Photo 7.)

To some Titanium White, add a touch of Cadmium Yellow. Scrub this mixture into the oval "eye" of the wave with the filbert brush. (Photo 8.) Use just the top corner of a clean, dry 2" brush and small circular strokes to blend the "eye". (Photo 9.) Hold the brush flat against the canvas and pull down to blend the entire wave. This is where you create the shape of the wave, so watch the angles of the water.

Underpaint the foam with a mixture of Phthalo Blue and Alizarin Crimson on the filbert brush with tiny circular strokes. (Photo 10.) Highlight the foam with the Titanium White-Cadmium Yellow mixture. Use the filbert brush to make small, circular, "push-up" strokes just where the light would strike along the top edges of the foam. (Photo 11.) Use a clean, dry filbert brush and the top corner of the 2" brush to gently blend together the base of the highlights into the shadows of the foam. (Photo 12.)

Still watching your angles, form the foam patterns that help shape the wave with Titanium White and Phthalo Blue on the liner brush. (Photo 13.)

FOREGROUND

Reflect the sky colors onto the wet sand using the 2" brush. Pull down with Cadmium Yellow directly under the brightest area, then add Yellow Ochre on either side, then Bright Red, Dark Sienna and Van Dyke Brown on the very edges of the canvas where the beach is quite dark. (Photo 14.) With a clean 2" brush, add a little Titanium White over the Cadmium Yellow. Blend the entire beach area with vertical strokes then gently brush across. (Photo 15.)

With Titanium White and Phthalo Blue on the fan brush, add foam patterns to the dark water in front of the large wave. (Photo 16.)

Add the sand in the lower right corner of the painting with the fan brush and Dark Sienna, Van Dyke Brown and Titanium White. (Photos 17 & 18.)

Use the liner brush with thinned dark paint to add a line under the water on the beach. Use the light Blue mixture to add other water lines on the sand.

ROCKS AND STONES

Form the rocks on the beach with Van Dyke Brown on the knife. Use the 2" brush to pull down a little of this dark color (to reflect the rocks on the wet sand) and then gently brush across. Highlight the rocks with the small knife and a mixture of Titanium White, Phthalo Blue and Van Dyke Brown. (Photo 19.)

FINISHING TOUCHES

Add ripples around the base of the rocks, thin lines of light, and other fine details and "sparkles" using thinned mixtures on the liner brush. (Photo 20.)

Ocean Sunset

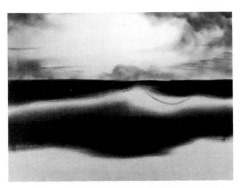
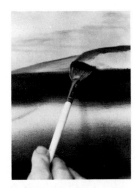

1. After painting the sky, sketch the large wave.

2. The 2" brush is used . . .

3. . . . to apply an initial layer of dark paint to the water.

4. Distant footlands made with the fan brush.

Ocean Sunset

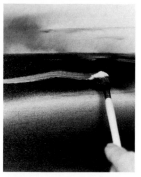

5. Initial wave shapes are made with the fan brush . . .

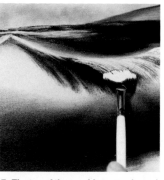

6. . . . then blended back to create the trough between the major waves.

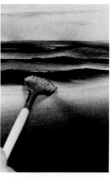

7. The top of the crashing wave is made with the fan brush. Angles are very important.

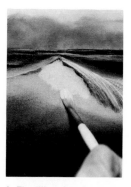

8. The filbert brush is used to scrub in the transparent eye of the wave . . .

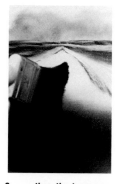

9. . . . then the transparent area is blended with the top corner of the 2" brush.

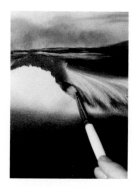

10. Shadows for the foam are painted . . .

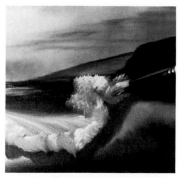

11. . . . and highlighted with the edge of the filbert brush . . .

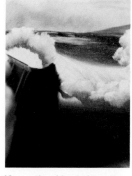

12. . . . then blended together with the top corner of the 2" brush.

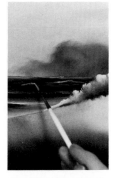

13. The liner brush, loaded with a thin paint, is used for fine detail.

14. Pull a small amount of color straight down . . .

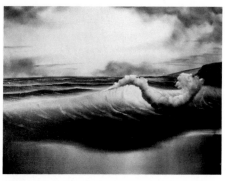

15. . . . then across to create the illusion of wet sand reflecting the colors from the sky.

16. Foam patterns made with the fan brush.

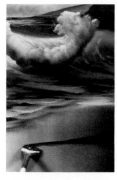

17. Drier, darker sand in the foreground . . .

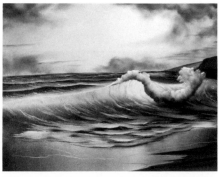

18. . . . is made by pulling across with the fan brush.

19. Rocks are made and highlighted with the knife.

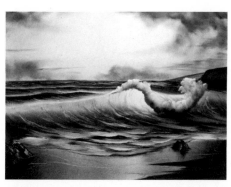

20. You are now ready to stand back and admire your creation.

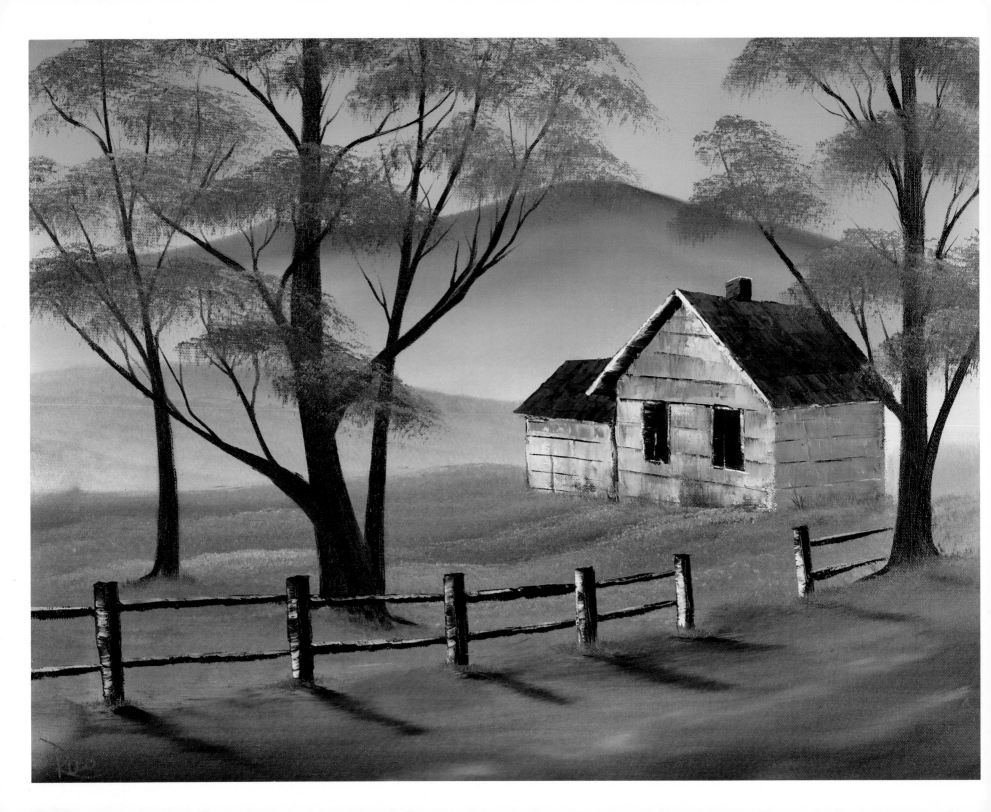

26. LITTLE HOUSE BY-THE-ROAD

MATERIALS

2" Brush	Midnight Black
#6 Fan Brush	Dark Sienna
#2 Script Liner Brush	Van Dyke Brown
Large Knife	Alizarin Crimson
Liquid White	Sap Green
Liquid Black	Cadmium Yellow
Liquid Clear	Indian Yellow
Phthalo Blue	Bright Red

Start by covering the entire canvas with a thin, even coat of Liquid White using the 2" brush. Use long horizontal and vertical strokes, working back and forth to ensure an even distribution of paint on the canvas. Do not allow the Liquid White to dry before you begin. Now, clean and dry your 2" brush.

SKY

Load the 2" brush with a mixture of Phthalo Blue and Midnight Black by just pulling the brush through the paint and tapping the bristles briskly against the palette to ensure an even distribution of paint. Using criss-cross strokes, "drop" in a happy little sky, starting at the top of the canvas and working down towards the horizon. Automatically the sky will get lighter near the horizon as the paint mixes with the Liquid White already on the canvas. Finish with light horizontal strokes to blend. *(Photo 1.)*

BACKGROUND

Using the same 2" brush, pick up a mixture of Phthalo Blue, Alizarin Crimson and Titanium White to just outline the top of the distant hill. Use the brush to pull the paint down towards the base of the hill, allowing it to get lighter as it mixes with the Liquid White near the horizon. This will give your hill a misty appearance. *(Photo 2.)*

Tap the bristles of the same brush into a mixture of Van Dyke Brown and Dark Sienna. Use horizontal strokes to add the dark color base to the ground area at the base of the hill.

Still using the same brush, tap the bristles into a mixture of all the Yellows and Sap Green. Hold the brush horizontally and gently tap highlights onto the ground area, creating small rolling hills at the base of the larger hill. *(Photo 3.)*

Without cleaning the brush, pick up a mixture of all the Browns and moving forward in the painting lay in another closer hill, allowing the dark base color to extend to the bottom of the canvas. *(Photo 4.)*

Use the same highlight mixtures (all the Yellows and Sap Green) on the same 2" brush to shape and contour the land. If you have trouble making your paint stick, add a little paint thinner or Liquid Clear to the mixtures. Remember, a thin paint will stick to a thicker paint. *(Photo 5.)*

HOUSE

Use the knife to scrape in the basic shape of the house. Then, with a mixture of Van Dyke Brown and Dark Sienna on the knife, lay in the back of the roof, then the front of the house, the side, and the little shed. Lastly, use the Browns to complete the shape of the roof. Use a mixture of Bright Red, Van Dyke Brown, Dark Sienna and Titanium White on the small edge of the knife to add little shingles to the roof on the shed. Add a little of this mixture to the back of the roof on the house. Use a mixture of Titanium White and Midnight Black to highlight the side of the shed and the front of the house. Add the board to the sides of the buildings with tiny, horizontal lines of Midnight Black. Give little "pull-downs" to the Black lines to give the impression of very old wood. The side of the house is in shadow, the highlights should be darker, using less Titanium White with the Midnight Black. With Midnight Black on the knife, add the windows; outline with Titanium White. Finally, add the Red shingles to the roof and touch White to the edges for highlighting. Your house is finished.

Go back to the 2" brush with all the Yellows *(Photo 6)* and tap in grass around the base of the house *(Photo 7)*.

FOREGROUND

The large tree trunks are made by dipping the fan brush into

Liquid Clear and picking up some Midnight Black. The Liquid Clear will thin the paint and allow it to glide smoothly on the canvas. Hold the brush vertically, and starting at the top of the canvas, pull in the trunks, using more pressure near the base to allow the trunks to become wider. Don't make telephone poles, give the tree trunks some curves and shape. *(Photo 8.)* Still using the fan brush, add the large limbs and branches. Use Liquid Clear and Midnight Black on the liner brush *(Photo 9)* to add the small limbs and branches *(Photo 10)*.

Tap on the leaf shapes using a mixture of Dark Sienna and Van Dyke Brown on the 2" brush. *(Photo 11.)* At the same time, add a little of this dark color to the base of the trees for shadows. *(Photo 12.)* Without cleaning the brush, highlight the leaf clumps with mixtures of all the Yellows, still just tapping the brush.

Use a clean, dry 2" brush to gently tap and blend the shadow color into the grassy area under the trees. With the same brush, pick up a mixture of Midnight Black and Titanium White and use horizontal strokes to add the road at the bottom of the painting.

The fence posts along the side of the road are made with Van Dyke Brown and the knife. *(Photo 13.)* Notice how the posts get larger and further apart as you move forward in the painting. At the same time, extend a little of this dark color into the road for shadows. *(Photo 14.)* Use a clean, dry 2" brush to very gently pull out the fence post shadows and brush across to blend slightly. *(Photo 15.)*

Highlight the left sides of the posts with a mixture of Titanium White and Van Dyke Brown; add cross bars to the fence, but don't forget to leave an opening for the gate. *(Photo 16.)*

FINISHING TOUCHES

To sign your painting, thin your signature paint with either paint thinner, Liquid Clear or Copal Oil. Twist the liner brush as you pull the bristles through the paint, forcing the bristles to come to a sharp point. Then, use very little pressure, adding more paint when necessary, to sign your masterpiece. Stand back and admire. *(Photo 17.)*

Little House By-The-Road

1. Use the 2" brush to paint the sky . . .

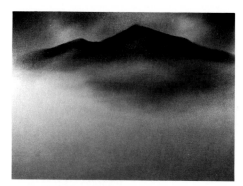

2. . . . and the distant hill.

3. Tap in the highlights . . .

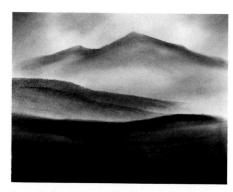

4. . . . before underpainting the dark foreground.

Little House By-The-Road

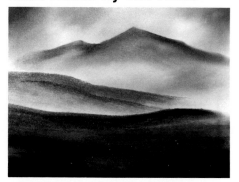

5. Tap downward to highlight the foreground.

6. Tap in grassy areas around the base of the house.

7. Work in layers, completing the most distant areas first.

8. Pull downward with the fan brush to paint tree trunks.

9. With the liner brush, and a thin paint . . .

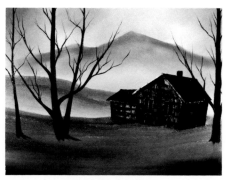

10. . . . paint branches on each tree.

11. Tap downward with the corner of the 2" brush . . .

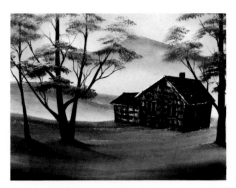

12. . . . to paint leaves on the trees.

13. Fence posts are painted with the knife.

14. Pull the shadows out . . .

15. . . . then across to blend and soften.

16. Rails are painted on the fence with the knife.

17. Add your finishing touches, sign, stand back and admire.

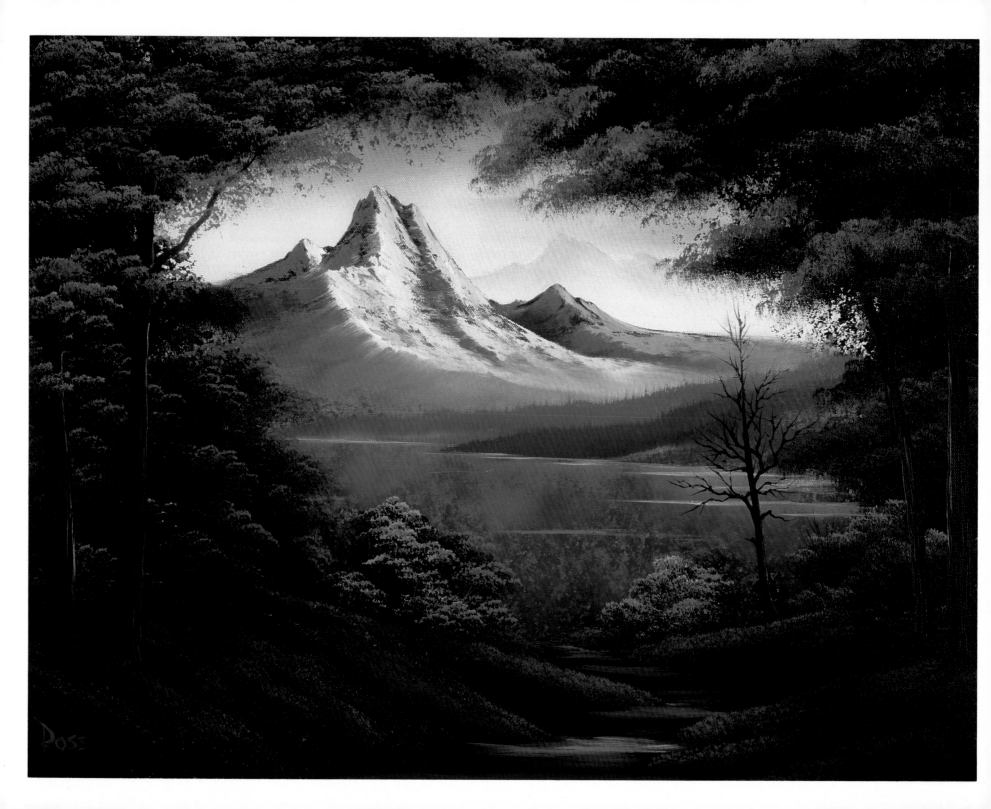

MATERIALS

2" Brush	Prussian Blue
#6 Fan Brush	Midnight Black
#2 Script Liner Brush	Dark Sienna
Large Knife	Van Dyke Brown
Black Gesso	Alizarin Crimson
Liquid White	Sap Green
Liquid Clear	Cadmium Yellow
Titanium White	Yellow Ochre
Phthalo Green	Indian Yellow
Phthalo Blue	Bright Red

Use a natural sponge and Black Gesso to underpaint the basic dark foliage areas of the canvas. The center of the canvas should remain light and unpainted. Allow the Black Gesso to DRY COMPLETELY. (Photo 1.)

When the Black Gesso is dry, cover the canvas with a VERY THIN coat of Liquid Clear. Do NOT allow the Liquid Clear to dry before proceeding.

SKY AND WATER

Load a clean, dry 2" brush with a small amount of Indian Yellow. Starting just above the horizon, begin painting the sky with criss-cross strokes. (Photo 2.) Without cleaning the brush, reload it with Yellow Ochre and continue working upward with criss-cross strokes, then use Alizarin Crimson in the uppermost portion of the sky. Use long, horizontal strokes to blend the entire sky area.

Load a clean, dry 2" brush with a mixture of Phthalo Blue and Phthalo Green. Use long horizontal strokes to underpaint the water on the lower portion of the canvas. (Photo 3.)

MOUNTAINS

The mountains are painted with a dark Lavender mixture of Alizarin Crimson, Prussian Blue and Midnight Black. To paint the small, distant mountain, add a small amount of Titanium White to a portion of the mountain mixture. Pull the mixture out very flat on your palette, hold the knife straight up and "cut" across the mixture to load the long edge of the blade with a small roll of paint. (Holding the knife straight up will force the small roll of paint to the very edge of the blade.) With firm pressure, shape just the top edge of the tiny mountain (Photo 4) then use the 2" brush to blend the paint down to the base of the mountain (Photo 5).

Working forward, shape the larger, darker range of mountains with the knife and the dark Lavender mixture. (Photo 6.) Again, blend the paint down to the base of the mountain with the 2" brush. (Photo 7.)

Highlight the mountain with a mixture of Titanium White, Midnight Black and a small amount of Bright Red. (Don't over mix.) Again, load the long edge of the knife blade with a small roll of paint. Starting at the top (and paying close attention to angles) glide the knife down the right side of each peak, using so little pressure that the paint "breaks". (Photo 8.) Use a mixture of Titanium White and Prussian Blue, applied in the opposing direction, for the shadow sides of the peaks. Again, use so little pressure that the paint "breaks".

With a clean, dry 2" brush, carefully following the angles, tap to diffuse the base of the mountain (Photo 9) then gently lift upward to create the illusion of mist (Photo 10).

BACKGROUND

With a mixture of Titanium White, Phthalo Blue and the mountain color on the 2" brush, shape the foothills at the base of the large mountain by holding the brush horizontally and tapping downward. (Photo 11.) With very short upward strokes you can create the impression of tiny tree tops along the top edges of the hills. Reload the 2" brush with the same mixture, hold the brush flat against the canvas and pull straight down to reflect the foothills into the water and then lightly brush across. (Photo 12.) Watery reflections can be further accented by repeating this step with a small amount of Titanium White on the 2" brush.

Add water lines and ripples with the knife and a mixture of Liquid White blended with a small amount of Bright Red. Push the blade straight into the canvas and use firm pressure to cut

in the water lines and ripples. *(Photo 13.)* Be sure the lines are perfectly straight, parallel to the top and bottom of the canvas. *(Photo 14.)*

FOREGROUND

Use a mixture of the original mountain color and Sap Green on the 2" brush to underpaint the foreground trees and grassy areas. (Notice how the underpainted Black Gesso adds depth and dimension to the painting.) *(Photo 15.)*

Without cleaning the 2" brush, reload it by holding it at a 45-degree angle and tapping the bristles into various mixtures of the Yellows, Sap Green and a small amount of Bright Red. (Paint thinner or Liquid White may be used to thin the mixture.) Allow the brush to "slide" slightly forward in the paint each time you tap (this assures that the very tips of the bristles are fully loaded with paint). Holding the brush horizontally, tap downward with just the corner of the brush to highlight the trees. Working in layers, carefully create individual trees and leaf clusters.

Reload the 2" brush with the Yellow highlight mixtures and tap downward to create the soft grassy highlights *(Photo 16)* paying close attention to the lay-of-the-land *(Photo 17)*.

TREES

Dip the fan brush into paint thinner and load it with a dark mixture of Van Dyke Brown and Dark Sienna, then pull one side of the bristles through a lighter Brown mixture (add Titanium White), to double-load the brush. Holding the brush vertically, with the light side on the right, pull down the foreground tree trunks. *(Photo 18.)*

Use a thinned Brown mixture on the liner brush to add small limbs and branches. (To load the liner brush, thin the Brown to an ink-like consistency by first dipping the liner brush into paint thinner. Slowly turn the brush as you pull the bristles through the mixture, forcing them to a sharp point.) Apply very little pressure to the brush as you shape the trunks. *(Photo 19.)* By turning and wiggling the brush, you can give the branches a gnarled appearance. *(Photo 20.)*

Load the 2" brush with various mixtures of the Yellows, Sap Green and a small amount of Bright Red. Use just the corner of the brush to add foliage to the foreground tree trunks. *(Photo 21.)* Again, carefully shape individual limbs, branches and leaf clusters.

FINISHING TOUCHES

Use a thin Brown mixture on the fan brush and horizontal strokes to add the path *(Photo 22)* and your painting is ready for your signature! *(Photo 23.)*

To sign your masterpiece, use thinned color of your choice on the liner brush. Sign just your initials, first name, last name or all of your names. Sign in the left corner, the right corner or in the middle of the canvas! The choice is yours. You might also consider including the date when you sign your painting.

Lake In The Valley

1. Underpaint the dark foliage with Black Gesso.

2. Use the 2" brush and criss-cross strokes . . .

3. . . . to paint the sky.

4. Shape the distant mountain top . . .

5. . . . then blend with the 2" brush.

Lake In The Valley

6. Paint the closer mountain with the knife . . .

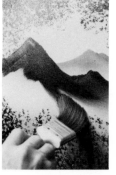

7. . . . then use the 2" brush to blend.

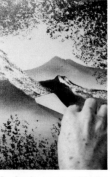

8. Apply snow with the knife . . .

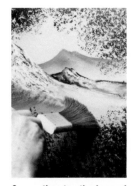

9. . . . then tap the base of the mountain . . .

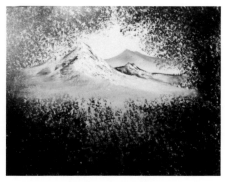

10. . . . to create the illusion of mist.

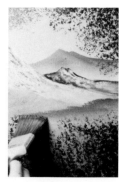

11. Use the 2" brush to tap in foothills . . .

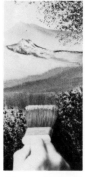

12. . . . then pull the color down into the water.

13. With a small roll of Liquid White on the knife . . .

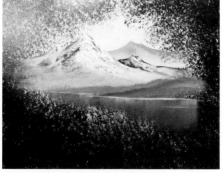

14. . . . cut in water lines and ripples.

15. Tap in small bushes . . .

16. . . . and grassy highlights . . .

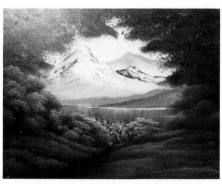

17. . . . paying close attention to the lay-of-the-land.

18. Paint the foreground trunks with the fan brush . . .

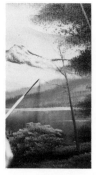

19. . . . then use the liner brush . . .

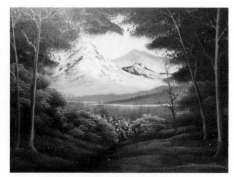

20. . . . to add the limbs and branches.

21. Highlight foliage with the 2" brush . . .

22. . . . then add the path with the fan brush . . .

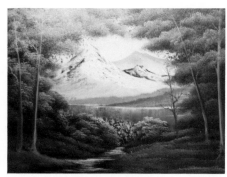

23. . . . to complete the painting.

28. GOLDEN MORNING MIST

MATERIALS

2" Brush
#6 Fan Brush
#2 Script Liner Brush
Large Knife
Black Gesso
Liquid White
Titanium White
Midnight Black

Dark Sienna
Van Dyke Brown
Alizarin Crimson
Sap Green
Cadmium Yellow
Yellow Ochre
Indian Yellow
Bright Red

Start by using a foam applicator to "swirl" a thin coat of Black Gesso on the canvas, keeping a large, circular, sky-area on the upper left portion of the canvas unpainted. Allow the Black Gesso to DRY COMPLETELY. (Photo 1.)

When the Black Gesso is dry, use the 2" brush to cover it with a thin coat of transparent color. Start with Indian Yellow around the light, unpainted sky-area. Working outward and without cleaning the brush, apply a Dark Sienna-Alizarin Crimson mixture and finally Van Dyke Brown around the edges of the canvas.

With a clean, dry 2" brush, apply a thin, even coat of Liquid White to the unpainted sky-area. (Photo 2.) At this stage, your canvas should be completely covered with wet paints of varying colors. Do NOT allow any of these colors to dry before you begin.

SKY

Starting in the lower portion of the sky-area, use the 2" brush and criss-cross strokes to apply Yellow Ochre over the Liquid White. Without cleaning the brush, work outward and upward with a small amount of Alizarin Crimson and then use Dark Sienna in the upper corner of the area. (Photo 3.)

With a clean, dry 2" brush, again use criss-cross strokes to apply Titanium White to the brightest portion of the sky. Finish by blending the entire sky. (Photo 4.)

BACKGROUND

With a very light mixture of Titanium White, Dark Sienna and Alizarin Crimson, use one corner of the fan brush to scrub in the soft, misty trees along the horizon (in the light sky-area). (Photo 5.) Work in layers, adding more Dark Sienna and Van Dyke Brown to the mixture for the larger, darker trees as you move forward. You can allow some of these small trees to extend into the dark area of the canvas. (Photo 6.)

Tree trunks are made by holding the brush vertically and just pulling down from the top to the bottom. (Photo 7.)

Use the same mixture on the liner brush to add the tiny limbs and branches. (Photo 8.) (To load the liner brush, thin the mixture to an ink-like consistency by first dipping the liner brush into paint thinner. Slowly turn the brush as you pull the bristles through the mixture, forcing them to a sharp point.)

Still using the same mixture, add foliage to the larger trees with the corner of the 2" brush. (Photo 9.)

LARGE TREES

Load the 2" brush with a mixture of Dark Sienna, Van Dyke Brown, Alizarin Crimson and Midnight Black. Underpaint the large leafy tree-shapes on the right side of the canvas by just tapping downward. Concentrate on the shape and form of these trees, allowing some of the branches to extend into the light sky-area. (Photo 10.)

Without cleaning the brush, tap the bristles into various mixtures of all of the Yellows. Define and highlight the individual branches, again just tapping. (Photo 11.) Be very careful not to completely cover the dark undercolor, use it to separate the individual shapes and forms. (Photo 12.)

WATER

The water is added with Titanium White on the 2" brush. Starting at the horizon and moving forward, decide where you want your water to be, hold the brush flat against the canvas and firmly pull straight down. (Photo 13.) Very lightly (two hairs and some air) brush across to create reflections. (Photo 14.)

As you continue highlighting the trees and bushes along the water's edge, use the knife with the Dark Sienna-Van Dyke Brown mixture to add the suggestion of a tree trunk. (Photo 15.)

With a very small amount of Titanium White-Dark Sienna-Alizarin Crimson mixture on the fan brush, scrub in the banks *(Photo 16)* along the water's edge *(Photo 17)*.

FOREGROUND

Use mixtures of all of the Yellows, Sap Green and Bright Red on the corner of the large brush to tap in the small trees on the left side of the painting.

Use the same mixtures to highlight the soft grassy area at the base of the trees. Load the 2" brush by holding it at a 45-degree angle and tapping the bristles into the various paint mixtures. Allow the brush to "slide" slightly forward in the paint each time you tap (this assures that the very tips of the bristles are fully loaded with paint). Hold the brush horizontally and gently tap downward. *(Photo 18.)* Work in layers, carefully creating the lay-of-the-land. If you are also careful not to destroy all of the dark color already on the canvas, you can create grassy highlights that look almost like velvet.

Again, use the fan brush with Van Dyke Brown to scrub in the land or a sand bar at the water's edge. Use a mixture of Dark Sienna and Titanium White on the brush and horizontal strokes to highlight the area. Watch your angles here, notice the strokes are perfectly straight, horizontal to the bottom edge of the canvas.

LARGE LEAFLESS TREES

Load the fan brush with Van Dyke Brown. Holding the brush vertically and starting at the top of the canvas, pull down the dead-tree trunks on the left side of the painting. *(Photo 19.)* Use Van Dyke Brown with paint thinner on the liner brush to add the limbs and branches. *(Photo 20.)*

Use the knife to highlight the trunks with a mixture of Dark Sienna and Titanium White. Load the long edge of the knife with a small roll of paint, hold the knife vertically, and just tap. *(Photo 21.)*

FINISHING TOUCHES

You can "sparkle" the lightest area of your painting with a small amount of Titanium White on the 2" brush and then use thinned color on the liner brush to complete the painting with your signature! *(Photo 22.)*

Golden Morning Mist

1. Paint the canvas with Black Gesso . . .

2. . . . then add Liquid White to the light area.

3. Use criss-cross strokes . . .

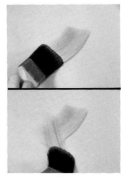

4. . . . to add color to the light area.

5. Use the corner of the fan brush . . .

Golden Morning Mist

6. . . . to tap in background trees.

7. Pull down trunks with the fan brush . . .

8. . . . then add limbs and branches with the liner brush . . .

9. . . . and foliage with the 2" brush.

10. Use the 2" brush to shape . . .

11. . . . and to highlight the foliage . . .

12. . . . on the larger trees.

13. Pull the reflections down . . .

14. . . . then lightly brush across to shimmer.

15. Add the large trunk with the knife . . .

16. . . . and the water's edge with the fan brush . . .

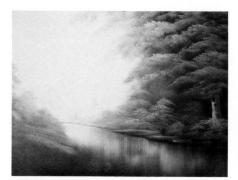

17. . . . to complete the background.

18. Highlight the soft grassy areas.

19. Use the fan brush to paint trunks . . .

20. . . . then add limbs with the liner brush.

21. Highlight the trunks with the knife . . .

22. . . . and your painting is complete.

MATERIALS

2" Brush	Midnight Black
#6 Fan Brush	Dark Sienna
#2 Script Liner Brush	Van Dyke Brown
Large Knife	Alizarin Crimson
Black Gesso	Sap Green
Liquid Clear	Cadmium Yellow
Titanium White	Yellow Ochre
Phthalo Green	Indian Yellow
Phthalo Blue	Bright Red
Prussian Blue	

Start by using a crumpled paper towel to underpaint the basic dark foliage shapes and the waterfall with Black Gesso. (Allow the canvas to remain much lighter near the top than at the bottom.) *(Photo 1.)* When the Black Gesso is dry, use the 2" brush to completely cover the canvas with a VERY THIN coat of Liquid Clear. (It is important to stress that the Liquid Clear should be applied VERY, VERY sparingly and really scrubbed into the canvas!) Immediately apply a very thin, even coat of a mixture of Phthalo Blue and Phthalo Green over the waterfall area and a mixture of Phthalo Blue and Midnight Black in the sky area of the canvas. Do NOT allow the canvas to dry before you proceed.

SKY

Load the 2" brush with a small amount of Titanium White and paint the sky with criss-cross strokes *(Photo 2)* just above the waterfall *(Photo 3)*.

WATERFALL

Dip the fan brush into Liquid Clear and then load it to a chiseled edge with a mixture of Titanium White and a small amount of Phthalo Blue. Holding the brush horizontally and starting at the top of the falls, make a short, horizontal stroke and then pull the brush straight down to the base of the falls. *(Photo 4.)* Paint the falls with a series of these long, "pull down" strokes. With a clean, dry 2" brush, lightly brush upward from the base of the

falls *(Photo 5)* to blend and mist *(Photo 6)*.

Load the 2" brush with a dark-tree mixture of Midnight Black, Prussian Blue, Van Dyke Brown, Alizarin Crimson and Sap Green. Hold the brush horizontally and tap downward to underpaint the large trees at the top of the falls. *(Photo 7.)*

Use a mixture of Dark Sienna and Van Dyke Brown on the knife to block in the large waterfall rocks. *(Photo 8.)* Shape and contour the rocks with a mixture of Titanium White, Dark Sienna, Van Dyke Brown and Yellow Ochre on the knife; use so little pressure that the paint "breaks". *(Photo 9.)*

Working forward in the painting, use the dark-tree mixture and the 2" brush to continue painting the trees and foliage. Allow some of the tree branches to extend right out over the falls. *(Photo 10.)*

Load a clean, dry 2" brush by holding the brush vertically and tapping the top corner into a very small amount of Titanium White. Tap downward with the top corner of the brush to paint the mist at the base of the falls; blend with light, upward strokes. *(Photo 11.)*

TREES AND FOLIAGE

Still working forward in layers, continue adding the dark foliage with the 2" brush. *(Photo 12.)*

Add the tree trunks with the dark-tree mixture and the liner brush. (To load the liner brush, thin the mixture to an ink-like consistency by first dipping the liner brush into paint thinner. Slowly turn the brush as you pull the bristles through the paint, forcing them to a sharp point.) Apply very little pressure to the brush as you shape the trunks. By turning and wiggling the brush, you can give your trunks a gnarled appearance. *(Photo 13.)*

To highlight the trees and foliage, reload the 2" brush with various mixtures of Midnight Black, all of the Yellows and Bright Red. Load the brush by holding it at a 45-degree angle and tapping the bristles into the various paint mixtures. Allow the brush to "slide" slightly forward in the paint each time you tap (this assures that the very tips of the bristles are fully loaded with paint). Hold the brush horizontally and gently tap downward,

carefully layering individual trees and bushes. Be very careful not to completely cover the dark color already on the canvas. *(Photo 14.)*

FOREGROUND

Use a mixture of Van Dyke Brown and Dark Sienna on the knife to shape the rocks and stones at the base of the waterfall. *(Photo 15.)* Again, with very little pressure, use mixtures of Titanium White, Dark Sienna, Van Dyke Brown and Yellow Ochre on the knife to highlight *(Photo 16)* and to shape and contour the rocks *(Photo 17)*.

With a mixture of Liquid Clear, Titanium White and a small amount of Phthalo Blue and Phthalo Green on the fan brush, swirl in the water at the base of the falls. Pull down tiny waterfalls *(Photo 18); push up water splashes.*

FALLEN TREE TRUNK

Use Van Dyke Brown on the knife to shape the fallen tree trunk in the foreground. With very little pressure, highlight the trunk with a mixture of Titanium White and Van Dyke Brown. *(Photo 19.)*

Use thinned Van Dyke Brown on the liner brush to add limbs and branches to the trunk. Highlight the limbs and branches with a thinned mixture of Titanium White and Van Dyke Brown on the liner brush. *(Photo 20.)* Use the fan brush to "pull" the water over the trunk, creating a small waterfall. *(Photo 21.)*

LARGE FOREGROUND TREE

Use a thinned, light mixture on the liner brush to add a final tree trunk in the foreground. *(Photo 22.)* Paint the foliage with the 2" brush and the Midnight Black-Yellows-Bright Red mixtures. By tapping downward with just the corner of the brush, you can carefully create individual leaf clusters. *(Photo 23.)*

FINISHING TOUCHES

You could use various thinned mixtures on the liner brush to add small, final details—small sticks and twigs or tiny tree trunks and your painting is complete. *(Photo 24.)*

Don't forget to sign your painting. Again, load the liner brush with thinned color of your choice. Sign just your initials, first name, last name or all of your names. Sign in the left corner, the right corner or one artist signs right in the middle of the canvas! The choice is yours. You might also consider including the date when you sign your painting. Whatever your choices, have fun, for hopefully with this painting you have truly experienced THE JOY OF PAINTING!

Graceful Waterfall

1. Block in dark shapes with Black Gesso . . .

2. . . . then use the 2" brush and criss-cross strokes . . .

3. . . . to paint the sky.

4. Pull down the waterfall with the fan brush . . .

5. . . . then blend up with the 2" brush . . .

6. . . . to mist the base of the falls.

Graceful Waterfall

7. Block in large trees with the 2" brush.

8. Use the knife to block in large waterfall rocks . . .

9. . . . then use highlights . . .

10. . . . to contour and shape the rocks.

11. Tap down with the 2" brush to continue misting the falls.

12. Apply highlights with the 2" brush . . .

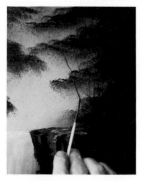

13. . . . then add trunks with the liner brush . . .

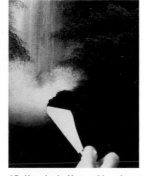

14. . . . and continue adding foliage.

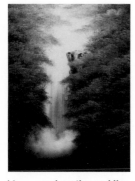

15. Use the knife to add rocks at the base of the falls . . .

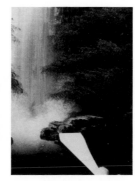

16. . . . then apply highlights . . .

17. . . . to contour the rocks.

18. Create tiny falls with the fan brush.

19. Add a fallen trunk with the knife . . .

20. . . . limbs and branches with the liner brush . . .

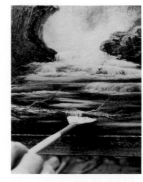

21. . . . then pull the water over the trunk with the fan brush.

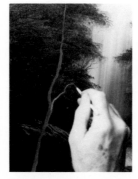

22. Add the foreground tree with the liner brush . . .

23. . . . tap foliage at the base of the tree . . .

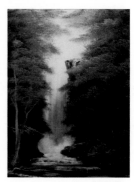

24. . . . to complete the painting.

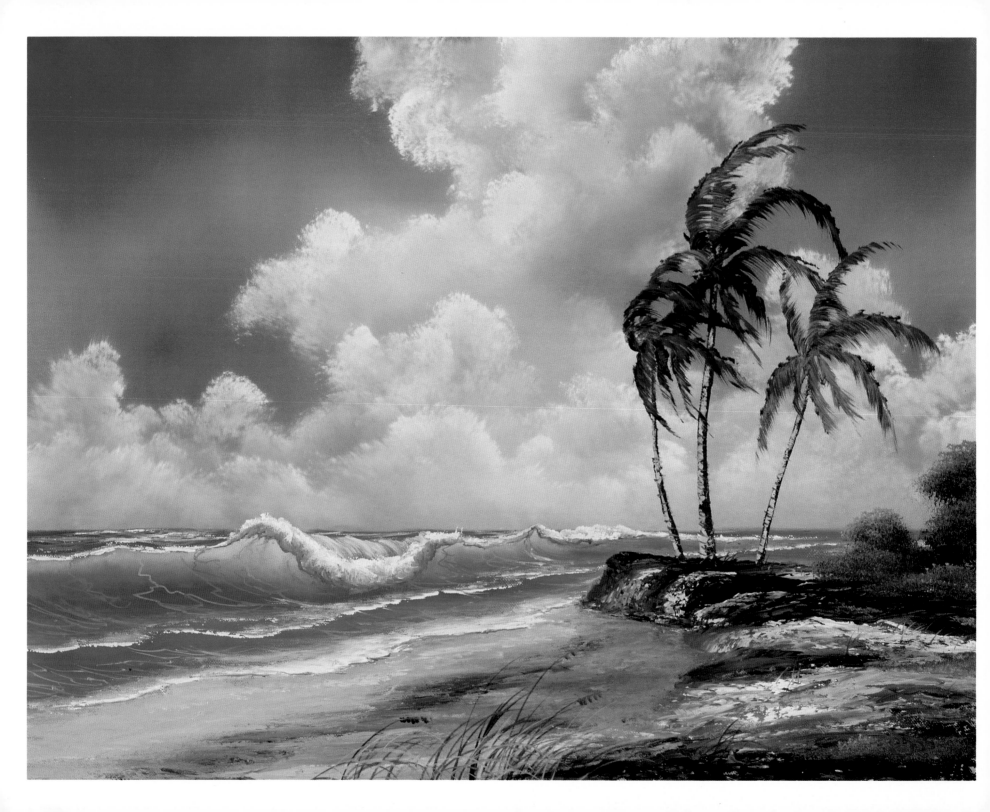

MATERIALS

2" Brush	Phthalo Blue
1" Brush	Prussian Blue
#6 Filbert Brush	Midnight Black
#6 Fan Brush	Dark Sienna
#2 Script Liner Brush	Van Dyke Brown
Large Knife	Alizarin Crimson
Small Knife	Sap Green
Liquid White	Cadmium Yellow
Liquid Black	Yellow Ochre
Titanium White	Indian Yellow
Phthalo Green	Bright Red

Begin by applying masking tape about two-thirds down from the top of the canvas to mark the horizon. Use the 2" brush to cover the entire canvas with a thin, even coat of "Liquid Grey", made from a mixture of equal portions of Liquid White and Liquid Black. Use long horizontal and vertical strokes, working back and forth to ensure an even distribution of paint on the canvas. Do NOT allow the "Liquid Grey" to dry before you begin!

SKY

Load the 2" brush with a very small amount of Prussian Blue and Midnight Black. Using little criss-cross strokes, cover the top corners of the canvas, leaving the center area unpainted for the clouds.

Use a small amount of Alizarin Crimson and small criss-cross strokes to "dance-in" a Lavender glow just above the horizon line. With the same brush, blend the entire sky.

The clouds are made by loading a 1" brush with Titanium White and a small amount of Cadmium Yellow. "Twirl-in" the cloud shapes using circular strokes in the unpainted areas of the sky. Plan where your clouds will be, working in layers; don't just "drop" them in at random. With a clean, dry 2" brush, gently blend out the base of the cloud shapes, then lift upward to fluff. Blend the entire sky with long, horizontal strokes. When you are satisfied, remove the masking tape from the canvas.

BACKGROUND

Using the 1" brush, "scrub" a little Blue color into the small area left dry by the masking tape, working it in to the "Liquid Grey".

Use a mixture of paint thinner with Alizarin Crimson and Phthalo Blue on the filbert brush to roughly sketch the major wave. (Photo 1.)

Load the fan brush with a dark mixture of Prussian Blue and Phthalo Blue. Use horizontal strokes below the horizon to add the small area of background water behind the wave. (Photo 2.)

Remember to keep your horizon line straight! Then, use the 2" brush with a dark mixture of the Blues, Midnight Black and Phthalo Green to just block in the base of the wave and the water beneath the large wave. (Photo 3.) Be very careful not to paint the wave. It is especially important that the "eye" of the wave remain light and unpainted.

Load the same brush with Van Dyke Brown and use long, horizontal strokes to underpaint the sandy beach area at the bottom of the painting. Bring the sand right up to the edge of the water. (Photo 4.)

LARGE WAVE

Use a mixture of Phthalo Blue and Phthalo Green on a clean fan brush to underpaint the breaker (the water crashing over the top of the wave). (Photo 5.)

To some Titanium White, add a very small amount of Cadmium Yellow. Scrub this mixture into the oval "eye" of the wave with the filbert brush. (Photo 6.) Extend a little of the color out across the top of the wave, allowing it to get progressively darker as it mixes with the "Liquid Grey". Use just the top corner of a clean, dry 2" brush and small circular strokes to gently blend the "eye". (Photo 7.) Still "wiggling" the corner of the brush, soften the entire wave, then hold the brush flat against the canvas and pull down to blend. This is where you create the shape of the wave, so watch the angles of the water. (Photo 8.)

Underpaint the foam with a mixture of Phthalo Blue and Alizarin Crimson on the filbert brush, using tiny circular strokes.

With a clean fan brush and Titanium White, use single downward strokes to highlight the water rolling over the top of the wave. *(Photo 9)*. Highlight the foam with the Titanium White-Cadmium Yellow mixture on the filbert brush. Make small, circular, "push-up" strokes just where the light would strike, along the top edges of the foam. *(Photo 10.)* As your brush picks up the dark undercolor, clean the brush and reload it again with the light mixture. Use the top corner of the 2" brush to gently blend the highlights into the shadows of the foam. *(Photo 11.)*

Still watching your angles, form the foam patterns that help shape the body of the wave with Titanium White on the filbert brush.

Load the small knife with a roll of Titanium White to "cut in" the tiny waves along the shore. *(Photo 12.)* Use very firm pressure and reload the knife as needed. Use the liner brush to add small details to the water with Titanium White and Cadmium Yellow, thinned with paint thinner; "sparkle" the top edges of the wave, make tiny wave shapes in the background water and add small foam patterns to the wave and to the water along the shore. (Photo 13.)

FOREGROUND

The land mass in the foreground is shaped using Van Dyke Brown on the knife. *(Photo 14.)* Use a little Titanium White and Dark Sienna on the knife as you shape and form the land mass, and also highlight the sandy beach area with this mixture. *(Photo 15.)* Create some interesting effects by adding various mixtures of Midnight Black, Bright Red, Sap Green, all of the Yellows and Blues, using so little pressure on the knife that the paint "breaks".

PALM TREES

Load the fan brush with Van Dyke Brown. Hold the brush vertically, and pull downward to make the trunks, curving them slightly. *(Photo 16.)* Highlight the trunks with a mixture of Dark Sienna and Titanium White on the knife. *(Photo 17.)* The palm leaves are made with the fan brush and Midnight Black, thinned with paint thinner. Touch the canvas with the fan brush and pull in the same direction as the wind is blowing, releasing pressure on the brush to taper the ends of the leaves. *(Photo 18.)* Use the 1" brush to add the growth to the base of the trees. *(Photo 19.)*

FINISHING TOUCHES

Add the final details with the liner brush *(Photo 20)* and your seascape is finished *(Photo 21)!* Most importantly, don't forget to sign your masterpiece!

Windy Waves

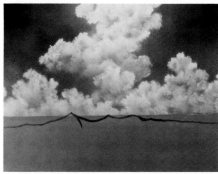

1. Sketch the large wave with the filbert brush.

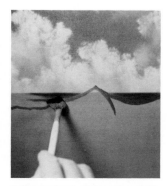

2. Use the fan brush to underpaint the background . . .

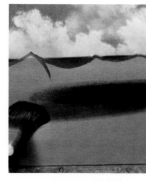

3. . . . and the foreground . . .

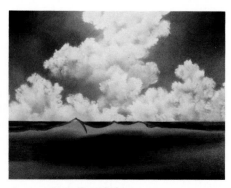

4. . . . water in the painting.

Windy Waves

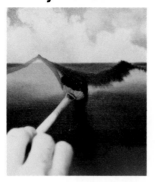

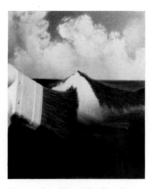
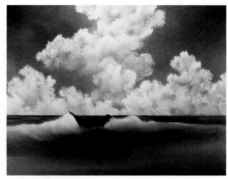
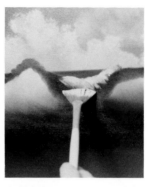

5. Paint the "breaker" with the fan brush . . .

6. . . . the "eye" of the wave with the filbert brush . . .

7. . . . then blend the "eye" . . .

8. . . . and shape the water angles with the 2" brush.

9. Highlight the breaker with the fan brush.

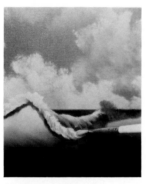
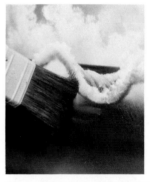
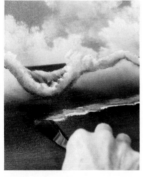
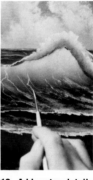

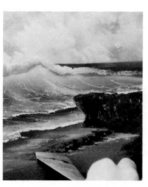

10. Foam highlights are made with the filbert brush . . .

11. . . . and then blended with the 2" brush.

12. Use the small knife to paint water on the beach.

13. Add water details with the liner brush.

14. Use the knife to form the land mass . . .

15. . . . and the sandy beach area.

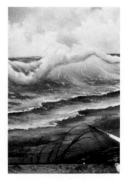
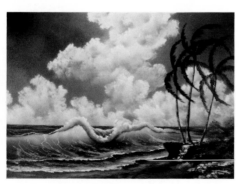

16. Fan brush tree trunks . . .

17. . . . are highlighted with the knife.

18. Add palm leaves with the fan brush . . .

19. . . . undergrowth with the 1" brush . . .

20. . . . final details with the liner brush . . .

21. . . . and the painting is complete.

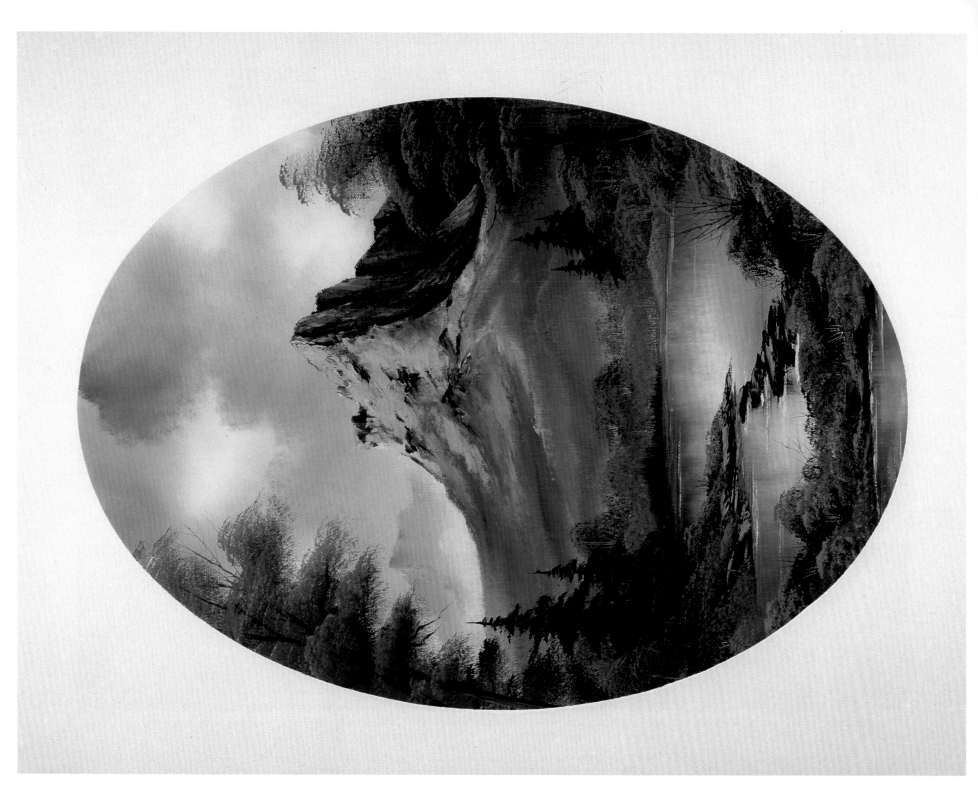

MATERIALS

2" Brush	Phthalo Blue
Small Round Brush	Prussian Blue
#6 Fan Brush	Midnight Black
#3 Fan Brush	Dark Sienna
#2 Script Liner Brush	Van Dyke Brown
2" Blender Brush	Alizarin Crimson
Large Knife	Sap Green
Small Knife	Cadmium Yellow
Adhesive-Backed Plastic	Yellow Ochre
Liquid White	Indian Yellow
Titanium White	Bright Red

Start by covering the entire canvas with a piece of adhesive-backed plastic (such as Con-Tact Paper) from which you have removed a center oval shape. (A 16 x 20 oval for an 18 x 24 canvas.) Use the 2" brush to cover the exposed oval-area of the canvas with a thin, even coat of Liquid White. Do NOT allow the canvas to dry before you proceed.

SKY

With a very small amount of Phthalo Blue on the 2" brush, start at the top of the canvas and work downward with criss-cross strokes to paint the left side of the sky.

Continuing with Phthalo Blue on the 2" brush, underpaint the water on the lower portion of the oval with long, horizontal strokes.

Reload the 2" brush with Phthalo Blue to tap in the basic dark cloud shapes. Blend out the base of the clouds with the 2" blender brush to complete the sky.

MOUNTAIN

The mountain is painted with the knife and a mixture of Midnight Black, Phthalo Blue and Titanium White. Load the knife with a small roll of paint and use firm pressure to shape just the top edge of the small, distant mountain. When you are satisfied with the basic shape of the mountain top, use the knife to remove any excess paint. Then, with the 2" brush, blend the paint down to the base of the mountain to complete the entire mountain shape. Blend to diffuse the entire mountain. *(Photo 1.)*

Use a darker mixture of Midnight Black, Alizarin Crimson and Phthalo Blue on the knife to paint the larger, closer mountain. *(Photo 2.)* Again, after shaping the mountain top, use the 2" brush to blend the paint down to the base of the mountain. *(Photo 3.)*

To highlight the mountain, load the knife with a small roll of a mixture of Titanium White with a very small amount of Midnight Black. Starting at the top (and paying close attention to angles) glide the knife down the left side of each peak, using so little pressure that the paint "breaks". *(Photo 4.)*

Use a mixture of Titanium White, Phthalo Blue, Midnight Black, Van Dyke Brown and Dark Sienna, applied in the opposing direction, for the shadowed sides of the peaks. You can vary the shadow color by adding small amounts of the original dark mountain color. Again, apply the paint with so little pressure that the paint "breaks".

With a clean, dry 2" brush, tap to diffuse the base of the mountain (carefully following the angles) then gently lift upward to create the illusion of mist. *(Photo 5.)*

Reload the 2" brush by tapping the bristles into a mixture of Sap Green and the original mountain mixture. Carefully following the angles of the peaks, tap the base of the mountain to create the tree line, then use short, upward strokes to indicate tiny tree tops. *(Photo 6.)*

FOOTHILLS

Load the small round brush by tapping the bristles into a light mixture of the dark mountain color, Sap Green and Titanium White. Tap downward with the brush to shape the most distant foothills at the base of the mountain. *(Photo 7.)* Again, use short upward strokes to indicate tiny tree tops, then use a clean, dry 2" brush to firmly tap the base of the foothills to create the illusion of mist. *(Photo 8.)*

Working forward in layers, paint the second range of hills with

a darker mixture; use less Titanium White. Again, tap the base of the hills to mist. Add Yellow Ochre to the dark foothill mixture as you work forward.

With the knife, add a mixture of Sap Green and Midnight Black to the base of the foothills, then use short upward strokes with the fan brush to create the illusion of tiny trees. To reflect the foothills into the water, use the 2" brush to pull the color straight down, then lightly brush across.

Reload the knife with a small roll of a mixture of Liquid White and the foothill mixture to scrub in the water lines and ripples in the background.

EVERGREENS

Load the small fan brush to a chiseled edge with a mixture of Midnight Black, Phthalo Blue, Alizarin Crimson and Sap Green. Holding the brush vertically, touch the canvas to create the center line of each of the small background evergreen trees. Use just the corner of the brush to begin adding the small top branches. Working from side to side, as you move down each tree, apply more pressure to the brush, forcing the bristles to bend downward and automatically the branches will become larger as you near the base of each tree. Again, use the Yellow foothill-mixture to add the grassy area at the base of the small trees.

Working forward, use the same dark tree-mixture on the large fan brush to paint the larger evergreens on the left side of the painting. (Photo 9.) Use the dark tree-mixture on the round brush to underpaint the grassy area to the base of the large evergreens (Photo 10), extending the color into the water for reflections. Pull the dark reflections straight down with the 2" brush (Photo 11) then lightly brush across.

Highlight the grassy area at the base of the large evergreens with various mixtures of Sap Green, all of the Yellows and Bright Red on the 2" brush. (Photo 12.)

With a small roll of Van Dyke Brown on the knife, add the banks at the water's edge (Photo 13) then highlight with a mixture of Titanium White and Van Dyke Brown (Photo 14). Use a small roll of Liquid White on the knife (Photo 15) to cut in the water lines (Photo 16).

Use the small knife to shape the rocks and stones in the water. (Photo 17.) Highlights are added with the Titanium White-Van Dyke Brown mixture. (Photo 18.) With a small roll of Liquid White on the knife (Photo 19) add a water line to the base of each of the rocks and stones.

FOREGROUND

Reload the 2" brush with the dark tree-mixture and continue working forward by carefully underpainting the foreground foliage. Again, highlight the foliage with the Yellow mixtures on the 2" brush. (Photo 20.)

Use a clean, dry 2" brush to extend the foliage colors into the water for reflections, then brush across to give the reflections a watery appearance.

Add the evergreen trunks with a small roll of a mixture of Titanium White and Dark Sienna on the knife, then use the fan brush to very lightly touch highlights to the branches with a mixture of the dark tree color and the Yellows.

Use the small knife to add rocks and stones in the foreground and to cut in the water lines and ripples.

Use a mixture of Bright Red, Dark Sienna and Van Dyke Brown on the 2" brush to underpaint the very large foreground trees. (Photo 21.) Add the large tree trunks with a double-loaded fan brush (Van Dyke Brown on one side of the bristles, Titanium White on the other side). (Photo 22.) Use thinned Van Dyke Brown on the liner brush to add limbs and branches. (Photo 23.)

Highlight the large trees with a mixture of Yellow Ochre and Bright Red on the 2" brush. (Photo 24.) Use just the corner of the brush to carefully shape individual branches and leaf clusters.

FINISHING TOUCHES

Carefully remove the Con-Tact Paper to expose your finished oval and your masterpiece is ready for a signature (Photo 25).

Early Autumn

1. After completing the distant mountain . . .

2. . . . shape the large mountain with the knife . . .

3. . . . and again blend down with the 2" brush.

4. Add snow with the knife . . .

5. . . . then firmly tap the base with the 2" brush . . .

6. . . . to create the illusion of mist.

7. Shape foothills with the small round brush . . .

8. . . . then firmly tap to mist with the 2" brush.

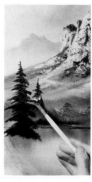

9. Paint the larger evergreens with the fan brush.

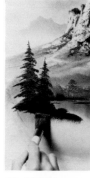

10. Add the grassy area with the round brush . . .

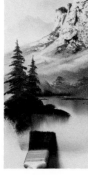

11. . . . then pull down reflections with the 2" brush.

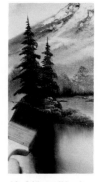

12. Add small bushes with the corner of the 2" brush.

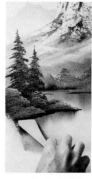

13. Use the knife to underpaint the land area . . .

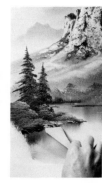

14. . . . then apply highlights . . .

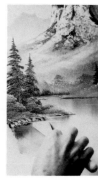

15. . . . and cut in . . .

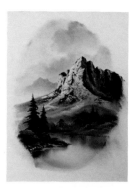

16. . . . water lines and ripples.

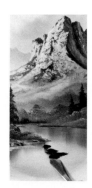

17. Paint small rocks with the small knife . . .

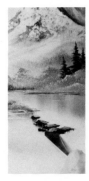

18. . . . then apply highlights . . .

19. . . . and cut in water lines.

20. Add small bushes . . .

21. . . . and large trees with the 2" brush.

22. Paint trunks with the fan brush . . .

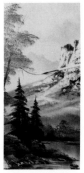

23. . . . then add limbs and branches with the liner.

24. Use the corner of the 2" brush . . .

25. . . . to expose the finished oval.

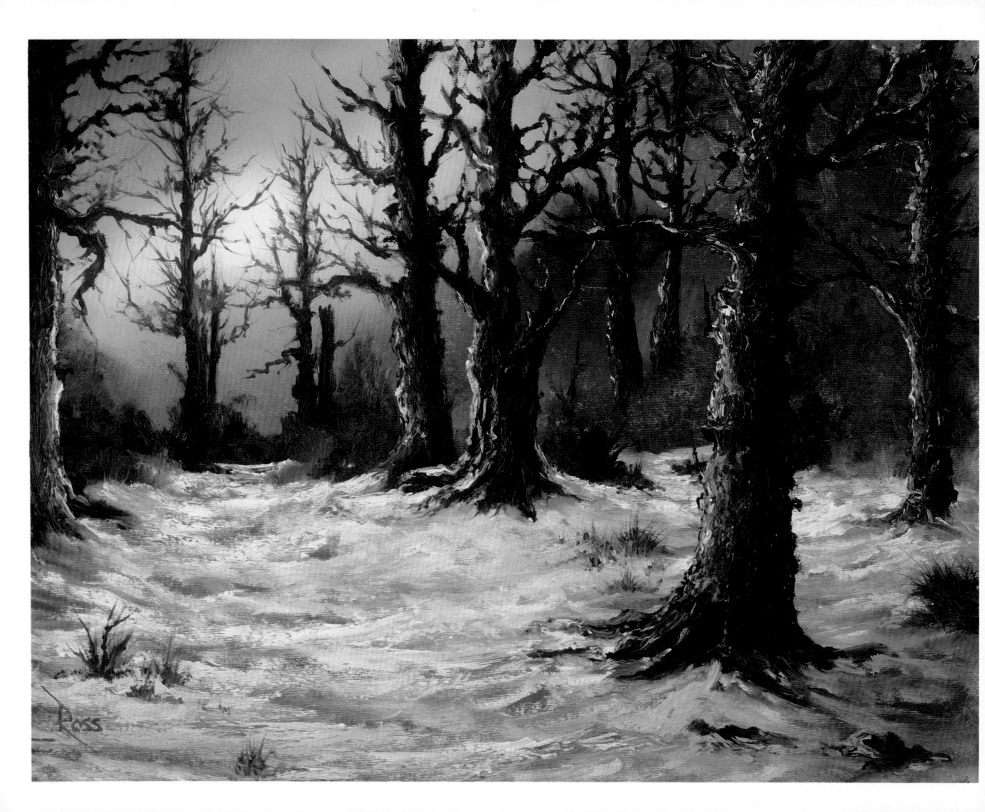

MATERIALS

2" Brush

#6 Filbert Brush

#2 Script Liner Brush

Burnt Sienna Acrylic Paint

Burnt Umber Acrylic Paint

Liquid Clear

Titanium White

Midnight Black

Alizarin Crimson

Sap Green

Cadmium Yellow

Indian Yellow

Prepare the canvas by underpainting the dark foliage shapes with a crumpled paper towel and the Sienna and Umber acrylic paints. Use the filbert brush and the acrylic colors to add the tree trunks. When you are satisfied with the basic underpainting, allow the acrylic colors to DRY COMPLETELY. *(Photo 1.)*

When the canvas is dry, use the 2" brush to completely cover the canvas with a VERY THIN coat of Liquid Clear. (It is important to stress that the Liquid Clear should be applied VERY, VERY sparingly and really scrubbed into the canvas! The Liquid Clear will not only ease with the application of the firmer paint, but will allow you to apply very little color, creating a glazed effect.)

Still using the 2" brush, cover the lower portion of the canvas with a small amount of a Brown mixture made with equal parts of Alizarin Crimson and Sap Green. Do NOT allow the canvas to dry before proceeding.

SKY

Load the 2" brush with a very small amount of Indian Yellow and apply this color with criss-cross strokes to the entire area of the canvas above the horizon.

Reload the 2" brush with the Brown (Alizarin Crimson-Sap Green) mixture and darken just the top corners of the canvas, again with criss-cross strokes. *(Photo 2.)*

Clean and dry the 2" brush and reload it with a small amount of a mixture of Cadmium Yellow and Titanium White. Starting in the lightest area of the sky and working outward, use criss-cross strokes to apply this light mixture, painting right over the tree trunks, lightly diffusing them into the background. *(Photo 3.)*

When you are satisfied with your sky, lightly blend with a clean, dry 2" brush. (Photo 4.)

BACKGROUND

Load the filbert brush with Titanium White. Starting just below the horizon, begin laying in the snow-covered ground area by lightly grazing the canvas with horizontal strokes. *(Photo 5.)* Reload the brush as often as necessary, but allow the White to pick up the wet color already on the canvas to create shadows. Add texture and interest to the snow by varying your strokes, sometimes scrubbing, other times allowing the paint to "break"; paying close attention to the lay-of-the-land. *(Photo 6.)*

LARGE TREES

Working forward in layers, use the Alizarin Crimson-Sap Green (Brown) mixture on the filbert brush to shape the large, more distinct tree trunks. *(Photo 7.)* Paint the trunks, limbs and branches quite roughly *(Photo 8)*, creating texture and character. *(Photo 9.)*

Use the Brown color on the filbert brush to scrub in a few small bushes at the base of the large trees. *(Photo 10.)*

Continue working forward by adding the snow-covered land area to the base of the trees and into the foreground *(Photo 11)* always paying close attention to the lay-of-the-land *(Photo 12)*.

To highlight the large tree trunks, reload the filbert brush with a mixture of Titanium White, the Brown color and Midnight Black. Since the source of light in this painting is in the center, apply the highlight color to the left sides of the trunks on the right side of the painting. *(Photo 13.)* Highlight the right sides of the trunks that are on the left. *(Photo 14.)*

Still working forward in layers, add a final large tree trunk in the foreground. *(Photo 15.)* Use the Titanium White-Brown-Midnight Black mixture on the filbert brush to highlight the rough bark of the trunk. Continue using the filbert brush to add snow to the base of the large tree, then use the Brown mixture on the filbert brush to add small bushes and foliage to the foreground. *(Photo 16.)*

With thinned paint on the liner brush, pull up long grasses in the foreground. *(Photo 17.)* (To load the liner brush, thin the Brown mixture to an ink-like consistency by first dipping the liner brush into paint thinner. Slowly turn the brush as you pull the bristles through the mixture, forcing them to a sharp point.)

Continue using the liner brush to add small twigs, limbs and branches to your trees. Again, give the trees character; by turning and wiggling the brush, you can give the branches a gnarled appearance. *(Photo 18.)*

FINISHING TOUCHES

When you are satisfied with your painting, use the liner brush to add your signature: Again, load the liner brush with thinned color of your choice. Sign just your initials, first name, last name or all of your names. Sign in the left corner, the right corner or one artist signs right in the middle of the canvas! The choice is yours. You might also consider including the date when you sign your painting. Whatever your choices, have fun, for hopefully with this painting you have truly experienced THE JOY OF PAINTING! *(Photo 19.)*

Rustic Winter Woods

1. Begin by underpainting foliage with acrylic paint.

2. Use the 2" brush and criss-cross strokes to paint the sky.

3. Continue using the 2" brush . . .

4. . . . to add the light area in the sky.

5. Use the filbert brush . . .

6. . . . to begin laying in the background snow . . .

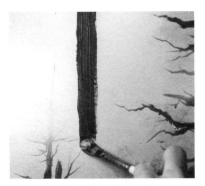

7. . . . and to paint large tree trunks.

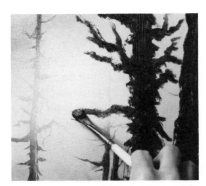

8. Continue using the filbert brush to add limbs and branches . . .

Rustic Winter Woods

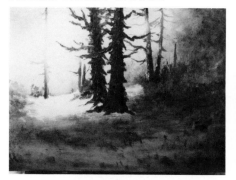

9. . . . to the background trees.

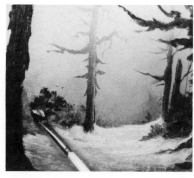

10. Add bushes to the base of the trees with the filbert brush . . .

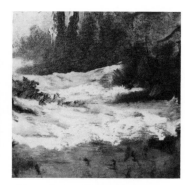

11. . . . then continue adding snow . . .

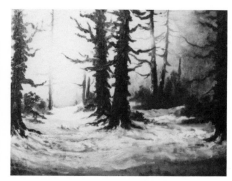

12. . . . into the foreground.

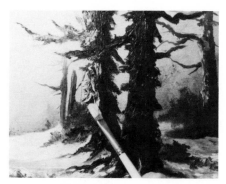

13. Use the filbert brush . . .

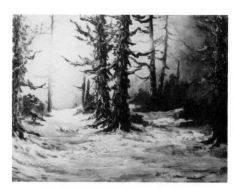

14. . . . to highlight the large tree trunks.

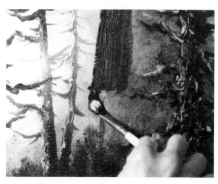

15. Continue working forward with large trunks . . .

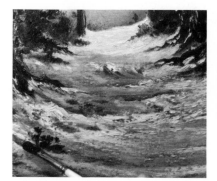

16. . . . and bushes.

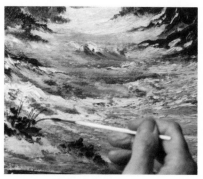

17. Use the liner brush to pull up long grasses . . .

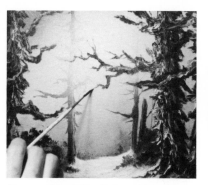

18. . . . and to add tiny limbs and branches . . .

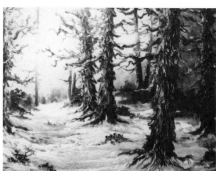

19. . . . and your painting is complete.

33. STORM'S A COMIN'

MATERIALS

2" Brush	Liquid Clear
#6 Filbert Brush	Titanium White
#6 Fan Brush	Phthalo Green
#3 Fan Brush	Phthalo Blue
#2 Script Liner Brush	Midnight Black
2" Blender Brush	Dark Sienna
Large Knife	Van Dyke Brown
Adhesive-Backed Plastic	Alizarin Crimson
Masking Tape	Cadmium Yellow
Black Gesso	Bright Red

Start by covering the entire canvas with a piece of adhesive-backed plastic (such as Con-Tact Paper) from which you have removed a center oval shape. (A 16 x 20 oval for an 18 x 24 canvas.)

Use a foam applicator to apply a thin, even coat of Black Gesso to the exposed oval-area of the canvas and allow to DRY COMPLETELY. (Photo 1.)

When the Black Gesso is dry, mark the horizon with a strip of masking tape, just below the center of the canvas (Photo 2) then use the 2" brush to apply a VERY THIN coat of Liquid Clear to the oval. (It is important to stress that the Liquid Clear should be applied VERY, VERY sparingly and really scrubbed into the canvas! The Liquid Clear will not only ease with the application of the firmer paint, but will allow you to apply very little color, creating a glazed effect.)

Still using the 2" brush, apply a thin, even coat of Phthalo Blue above the horizon and a mixture of Phthalo Blue and Phthalo Green below the horizon. Do NOT allow the canvas to dry before you proceed.

SKY

Load the 2" brush with a very small amount of Titanium White, tapping the bristles firmly against the palette to ensure an even distribution of paint throughout the bristles. Starting at the top of the canvas and working downward, use criss-cross strokes to paint the sky. (Photo 3.) Notice how the color blends with the color already on the canvas and automatically the sky becomes darker as it nears the horizon. Blend the entire sky with long, horizontal strokes.

With Titanium White on a clean, dry 2" brush, use the top corner of the brush and circular strokes to begin painting the most distant clouds. (Photo 4.) Blend out the base of the clouds with the blender brush and circular strokes (Photo 5) then use sweeping upward strokes to "fluff". Continue adding clouds with Titanium White on the 2" brush, then blending with the soft blender brush.

When you are satisfied with your sky, carefully remove the masking tape (Photo 6) to expose a nice, straight horizon (Photo 7). Use a clean, dry 2" brush to extend the Liquid Clear mixture into that small area of the canvas left dry by the masking tape.

HEADLAND

Headlands are ridges of land or rock jutting out into the water. Use a dark Lavender mixture, made with Phthalo Blue and Alizarin Crimson, on the fan brush to shape the background headland above the horizon. (Photo 8.) Use various mixtures of Bright Red, Cadmium Yellow and a very small amount of Titanium White on the fan brush to lightly highlight and contour the headland. (Photo 9.)

BACKGROUND WATER

Begin by using Titanium White on the filbert brush to sketch just the basic shape of the large wave. (Photo 10.)

With Titanium White on the fan brush, sketch the background water lines or swells (Photo 11) then use slight rocking strokes to pull back the top edges of the background swells (Photo 12).

LARGE WAVE

Paying close attention to the angle of the water, use Titanium White on the fan brush to "pull" the water over the top of the large wave. (Photo 13.)

Load the #3 fan brush with a mixture of Titanium White which has been blended with a very small amount of Cadmium Yellow. With firm pressure and circular strokes scrub in the "eye" or

transparency of the wave. *(Photo 14.)* Use just the top corner of the soft blender brush and circular strokes to lightly blend the "eye" of the wave. *(Photo 15.)*

With a mixture of Alizarin Crimson and Phthalo Blue on the filbert brush, use tiny, circular strokes to under-paint the foam. *(Photo 16.)* Highlight the top edges of the foam with Titanium White on the filbert brush, using small, circular, push-up strokes. *(Photo 17.)* With just the top corner of a clean, dry blender brush, use circular strokes *(Photo 18)* to lightly blend these highlights into the underpainted shadowed area *(Photo 19)*.

Use a mixture of Van Dyke Brown and Dark Sienna on the knife to shape the large rocks and stones in the foreground. *(Photo 20.)* Lightly highlight the rocks with various mixtures of Bright Red, Dark Sienna and Titanium White on the knife. *(Photo 21.)*

Use a thin mixture of paint thinner, Titanium White and Phthalo Blue on the #3 fan brush *(Photo 22)* to "drip" water over the rocks and stones *(Photo 23)*.

With Titanium White on the fan brush, use sweeping horizontal strokes to add the foreground water. Again, pay close attention to the angles of the water and be very careful not to destroy the dark undercolor.

Use a thinned mixture of Titanium White and Phthalo Blue on the liner brush to add foam patterns and tiny details to the water.

To load the liner brush, thin the mixture to an ink-like consistency by first dipping the liner brush into paint thinner. Slowly turn the brush as you pull the bristles through the paint, forcing them to a sharp point.) Use very little pressure and just the point of the bristles to paint the small water movements. *(Photo 24.)*

Use a thinned dark mixture on the liner brush to define the base of the large wave foam *(Photo 25)* then use thinned Titanium White and Cadmium Yellow on the liner brush to "sparkle" the water where you think the light would strike *(Photo 26)*.

FOREGROUND

Working forward in layers, use a mixture of Van Dyke Brown, Dark Sienna and Midnight Black on the knife to shape the stone in the foreground. *(Photo 27.)* Again, highlight with the knife *(Photo 28)* then add dripping water with the thinned White and Blue on the fan brush.

FINISHING TOUCHES

Use thinned Midnight Black on the liner brush to add tiny "M" birds *(Photo 29)* then use various thinned mixtures on the liner brush to add final details to the water.

When you are satisfied with your painting *(Photo 30)* carefully remove the Con-Tact Paper *(Photo 31)* to expose your finished seascape *(Photo 32)*.

Storm's A Comin'

1. Prepaint the oval with Black Gesso and allow to dry.

2. Mark the horizon with masking tape.

3. Paint the sky with criss-cross strokes . . .

4. . . . then add clouds with the 2" brush.

5. Blend the clouds with the soft blender brush.

6. Remove the masking tape . . .

7. . . . to expose the horizon line.

8. Use the fan brush to shape . . .

Storm's A Comin'

9. . . . and highlight the headlands.

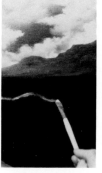
10. Sketch the wave with the filbert brush . . .

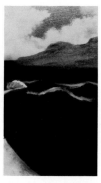
11. . . . and the background water with the fan brush.

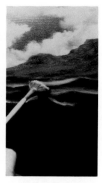
12. Pull back the tops of the swells . . .

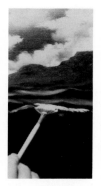
13. . . . and pull water over the wave . . .

14. . . . and scrub in the "eye" with the fan brush.

15. Blend the "eye" with the blender brush.

16. Underpaint the foam . . .

17. . . . and add highlights with the filbert brush.

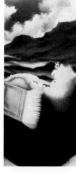
18. Use the soft blender brush . . .

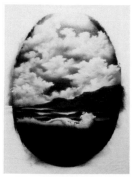
19. . . . to lightly blend the foam.

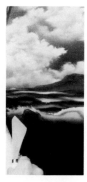
20. Shape rocks . . .

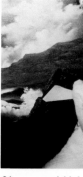
21. . . . and highlight with the knife.

22. Use thinned paint on the fan brush . . .

23. . . . to drip water over the rocks.

24. Add highlight details to the water . . .

25. . . . and shadowed areas . . .

26. . . . with thinned paint on the liner brush.

27. Shape foreground rocks . . .

28. . . . and add highlights with the knife.

29. Use the liner brush to add birds . . .

30. . . . to complete the seascape.

31. Remove the Con-Tact Paper . . .

32. . . . to expose the finished oval.

MATERIALS

2" Brush	Cadmium Yellow
1" Brush	Indian Yellow
Large Knife	Bright Red
Liquid White	Phthalo Blue
Black Gesso	Phthalo Green
#6 Fan Brush	Sap Green
#2 Script Liner Brush	Titanium White
Alizarin Crimson	Van Dyke Brown
Dark Sienna	Yellow Ochre

Start with a canvas that has been painted with Black Gesso and allowed to dry completely. With the 2" brush, cover the entire canvas with a mixture of Phthalo Blue and Sap Green. Use long horizontal and vertical strokes to blend the paint evenly. Do not allow the color to dry before you begin.

BACKGROUND

The fan brush, loaded with Titanium White, is used to paint in the basic light areas in the background. Hold the brush vertically *(Photo 1)* and scrub in your light areas *(Photo 2)*. The 2" brush, held flat *(Photo 3)* is used to blend the background area using long up and down strokes *(Photo 4)*.

TREES

Start with a mixture of Alizarin Crimson and Phthalo Green to create a Black color. Load the fan brush full of paint and tap downward with the brush held vertically to make the tree trunks. *(Photo 5.)* To make tree trunks that look further away, use the fan brush with very little paint, so the color is lighter. *(Photo 6.)* The indication of leaves on these trees is made with the same Black color and the brush held horizontally. Go straight into the canvas and bend the bristles slightly downward. A few highlights may be applied in the same manner using Sap Green and Cadmium Yellow. *(Photo 7.)* Highlights on the trunks are applied with a small roll of paint on the top edge of the knife. *(Photo 8.)* The highlight colors are Titanium White, Alizarin Crimson and Bright Red and the shadows are made from Phthalo Blue and

Titanium White. With a small roll of paint, hold the knife vertically and just touch the canvas wherever you want the highlight or shadow to be. To make the edge of the highlights really shine, add a touch of straight Titanium White to just the edge of the tree. Be careful not to add too much of this very bright color. *(Photo 9.)* Tree limbs can be painted on using the liner brush, fully loaded, with a very thin Black color. *(Photo 10.)* Thin the paint to a watery consistency with paint thinner and turn the liner brush in the paint to load it. *(Photo 11.)* Some of the larger tree limbs may be painted on with the fan brush, if desired. *(Photo 12.)*

FOLIAGE

The base color of Black for the bushes in the background is applied with the fan brush. Hold the brush vertically and tap in your basic shapes. Highlights are applied with the 2" brush loaded with Cadmium Yellow and Sap Green. Hold the brush vertically and tap downward, allowing just the top corner of the brush to strike the canvas. *(Photo 13.)* The grassy areas are made by holding the large brush horizontally and tapping downward. The highlight colors are varying mixtures of Cadmium Yellow, Sap Green, Yellow Ochre, Indian Yellow and a touch of Bright Red. Work in layers to create the lay of the land, totally finishing the most distant areas first. *(Photo 14.)*

WATER

The small pools of water are made with the 2" brush loaded with Titanium White and a touch of Phthalo Blue. Decide where you want your water. Hold the brush horizontally, touch the canvas and pull straight down. *(Photo 15.)* A few very light horizontal strokes will complete your water. This step may be repeated to create brighter water, if desired. Land areas are used to separate the water from the grassy areas. These areas are made with a small roll of Van Dyke Brown and Dark Sienna on the long edge of the knife. Use very little pressure, allowing the paint to "break" and pay close attention to the lay of the land. *(Photo 16.)* Highlights are applied in the same manner using a

mixture of Phthalo Blue, Van Dyke Brown and Titanium White. *(Photo 17.)* Waterlines are cut in with the knife loaded with a small amount of Titanium White and Phthalo Blue. *(Photo 18.)* Complete one pool of water at a time *(Photo 19)* then work forward *(Photo 20)*. Use the grassy effects to cover any sharp edges and tie everything together. *(Photo 21.)*

Working forward, use the knife to extend some of the background tree trunks into the foreground. *(Photo 22.)* Tap downward with the fan brush *(Photo 23)* to paint the large foreground tree trunk *(Photo 24)*. Touch highlights to the large trunk with a small roll of paint on the knife. *(Photo 25.)* Use the fan brush

(Photo 26) to add limbs and branches to the large foreground tree *(Photo 27)*.

FINISHING TOUCHES

The large tree is reflected in the water with the same technique used to paint it. The 2" brush is then used to pull the reflection straight down, using no pressure *(Photo 28.)* A few horizontal strokes will complete your reflections. A thin paint on the liner brush is used to sign your masterpiece. Try this painting using different transparent colors on the Black background. You will be pleased with the beautiful results.

Secluded Forest

1. Hold the fan brush vertically . . .

2. . . . to scrub in basic light areas in the background.

3. Use the 2" brush . . .

4. . . . to blend the background area.

5. Tap downward with the fan brush . . .

6. . . . to make tree trunks . . .

7. . . . then hold the brush horizontally to indicate leaves.

8. Use a small roll of paint on the knife . . .

9. . . . to highlight and shadow the tree trunks.

10. Use a thin paint on the liner brush . . .

11. . . . to paint in the tree limbs . . .

12. . . . then add leaves using the fan brush.

13. The 2" brush is used to highlight trees and bushes . . .

Secluded Forest

14. . . . tap in the grassy areas . . .

15. . . . and pull in small pools of water.

16. Use the knife to lay in land areas . . .

17. . . . highlights . . .

18. . . . and to cut in waterlines.

19. Complete each pool of water . . .

20. . . . before moving forward . . .

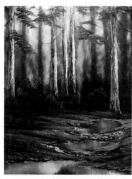

21. . . . working in layers.

22. Use the knife to extend some of the background trees into the foreground.

23. Tap downward with the fan brush . . .

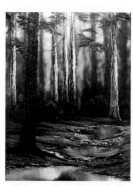

24. . . . to create the large foreground tree . . .

25. . . . and then highlight with a small roll of paint on the knife.

26. Also use the fan brush . . .

27. . . . to paint the limbs . . .

28. . . . and reflect the tree into the water.

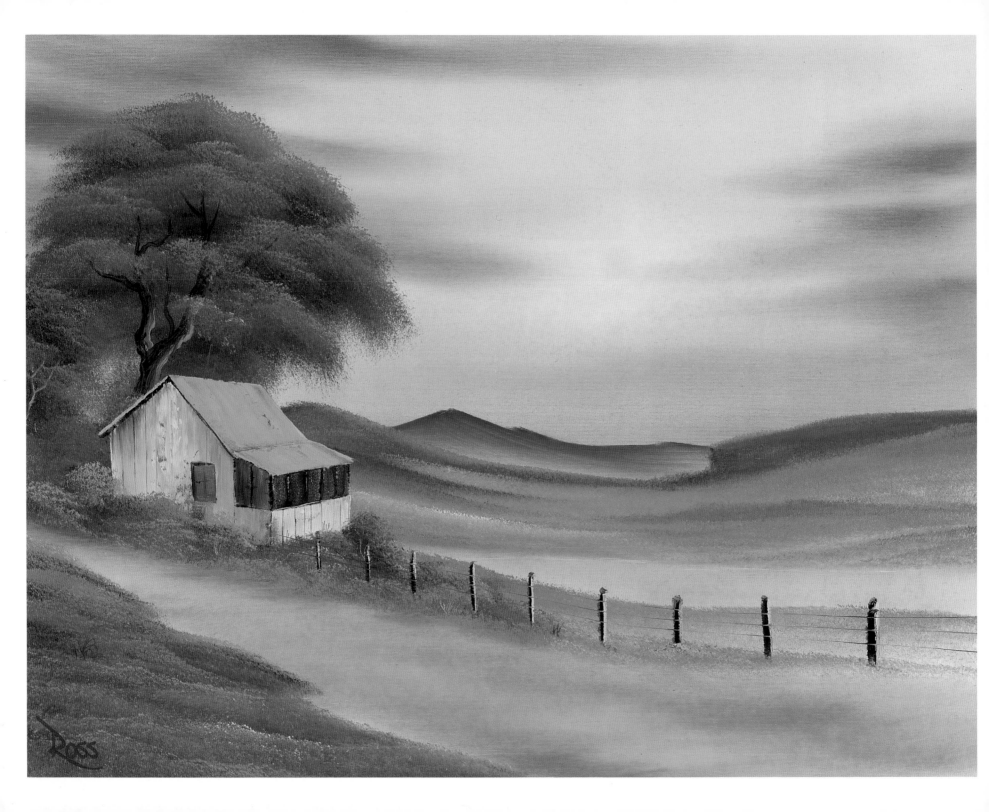

35. THE OLD HOME PLACE

MATERIALS

2" Brush	Van Dyke Brown
#2 Script Liner Brush	Alizarin Crimson
Large Knife	Sap Green
Liquid White	Cadmium Yellow
Titanium White	Yellow Ochre
Phthalo Blue	Indian Yellow
Midnight Black	Bright Red
Dark Sienna	

Start by covering the entire canvas with a thin, even coat of Liquid White using the 2" brush. Use long, horizontal and vertical strokes, working back and forth to ensure an even distribution of paint on the canvas. Do NOT allow the Liquid White to dry before you begin.

SKY

Load the 2" brush with a small amount of Cadmium Yellow, tapping the bristles firmly against the palette to ensure an even distribution of paint throughout the bristles. Use criss-cross strokes to add this color across the center of the sky. Without cleaning the brush, use criss-cross strokes to add Yellow Ochre, and then Alizarin Crimson below the Cadmium Yellow. You can also add small areas of these colors to the top portion of your sky. *(Photo 1.)* With Alizarin Crimson on your finger, make a small circle in the sky to indicate the sun *(Photo 2)* and then blend the entire sky with a clean, dry 2" brush.

With Alizarin Crimson and a very small amount of Phthalo Blue on the 2" brush, tap in the cloud shapes. *(Photo 3.)* Use a clean, dry 2" brush and long, horizontal strokes to blend the clouds *(Photo 4)* and your sky is finished *(Photo 5).*

BACKGROUND

Still using the Lavender mixture of Alizarin Crimson and Phthalo Blue on the 2" brush, tap in the shape of the background hills. *(Photo 6.)* With a clean, dry 2" brush, tap to diffuse the base of the hills *(Photo 7)* creating the illusion of mist *(Photo 8).*

Add a small amount of Van Dyke Brown and Midnight Black to the Lavender mixture and still using the 2" brush, tap down *(Photo 9)* to underpaint the grassy area at the base of the hills *(Photo 10).*

To highlight the grassy area, use the 2" brush and various mixtures of all of the Yellows, Bright Red, Dark Sienna and Sap Green. Load the brush by holding it at a 45-degree angle and allowing the brush to slide slightly forward each time you tap into the mixtures. This assures that the very tips of the bristles are fully loaded with paint. Holding the brush horizontally, tap downward to highlight the grassy area. *(Photo 11.)* Pay close attention to the lay-of-the-land and be careful not to "kill" all of the dark undercolor. Working forward in layers, you can create grass that looks almost like velvet. Add a small amount of Titanium White to the brush, just where you think the light would strike.

WATER

Decide where you would like your pond to be and then with Phthalo Blue on the 2" brush, pull straight down to add reflections. *(Photo 12.)* Again, you can add the smallest amount of Titanium White to the brush for "sparkle", then lightly brush across to give the reflections a water appearance. The banks of the pond are made with the knife, using a mixture of Titanium White and Dark Sienna. *(Photo 13.)* Use a small amount of Liquid White on the knife to cut in the water lines and your pond is finished. *(Photo 14.)*

FOREGROUND

Moving forward in the painting, underpaint the grassy areas in front of the pond with the 2" brush and the Alizarin Crimson-Phthalo Blue-Van Dyke Brown-Midnight Black mixture, still just tapping downward. *(Photo 15.)* Add Dark Sienna and Titanium White to the same brush and use long, horizontal strokes *(Photo 16)* to underpaint the road on the lower portion of the canvas and then continue underpainting the foreground grass *(Photo 17.)* Highlight all of the grass with the same Yellow mixtures on the 2" brush.

TREE

Use the dark mixture on the 2" brush to underpaint the large tree, again just tapping downward. *(Photo 18.)* To add the trunk, dip the liner brush into paint thinner and load the bristles with Van Dyke Brown, then pull one side of the bristles through a thin mixture of Liquid White, Yellow Ochre and Dark Sienna, to double-load the brush. With the light side of the bristles on the right (the light source) slightly "wiggle" the brush as you paint the trunk and branches. *(Photo 19.)*

Highlight the tree with mixtures of all of the Yellows and Sap Green on the 2" brush. Use just one corner of the brush to tap in the individual leaf clusters—don't just hit at random, think about form and shape and be careful not to destroy all of the dark base color. *(Photo 20.)* At the same time, you can also shape the small bushes at the base of the tree. With the point of the knife, scratch in small sticks and twigs. *(Photo 21.)*

OLD HOUSE

Use the knife to remove paint from the canvas in the basic shape of the house. Load the knife with a mixture of Titanium White, Dark Sienna, Phthalo Blue and Midnight Black. Pull the paint out very flat on your palette, hold the knife straight up and just cut across to load the long edge of the knife with a small roll of paint. Being very careful of angles, paint the roof of the house.

Use Van Dyke Brown to add the porch and then a mixture of Titanium White, Midnight Black and Dark Sienna for the side of the house. With Van Dyke Brown, add the windows and board indications and the old house is finished.

Use the Yellow highlight mixtures on the 2" brush to add small bushes and grass to the base of the house.

FENCE

Add the fence along the road with a small roll of Van Dyke Brown on the knife. Highlight with Titanium White and then use Liquid White on the heel of the knife to cut in the wire and the fence is finished.

FINISHING TOUCHES

Use the 2" brush to blend the road and to add the grassy highlights at the base of the fence and in the foreground.

Your masterpiece is ready for a signature. *(Photo 22.)*

The Old Home Place

1. Use criss-cross strokes to paint the sky . . .

2. . . . and then add the sun with your finger.

3. Use the 2" brush to tap in the cloud shapes.

4. Blend the clouds . . .

5. . . . and the entire sky is complete.

6. Use the 2" brush to add the background hills . . .

The Old Home Place

7. . . . then tap the base of the hills . . .

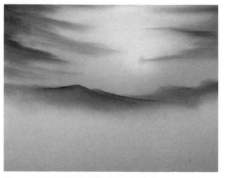

8. . . . to create the illusion of mist.

9. Tap downward with the 2" brush . . .

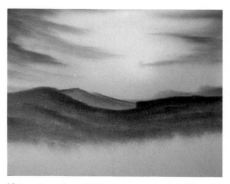

10. . . . to underpaint the grassy area at the base of the hills.

11. Use the 2" brush to highlight the grassy area . . .

12. . . . and to pull down the reflections in the pond.

13. Use the knife to add the banks . . .

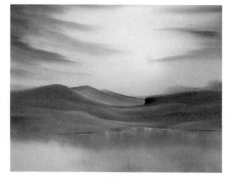

14. . . . to the water's edge.

15. With the 2" brush, add the grassy area . . .

16. . . . and underpaint the road.

17. Underpaint the grassy areas . . .

18. . . . and the large tree with the 2" brush.

19. Add trunks, limbs and branches with the liner brush.

20. Tap down with the 2" brush . . .

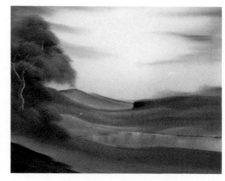

21. . . . to highlight and shape the large tree . . .

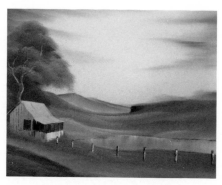

22. . . . and your masterpiece is finished!

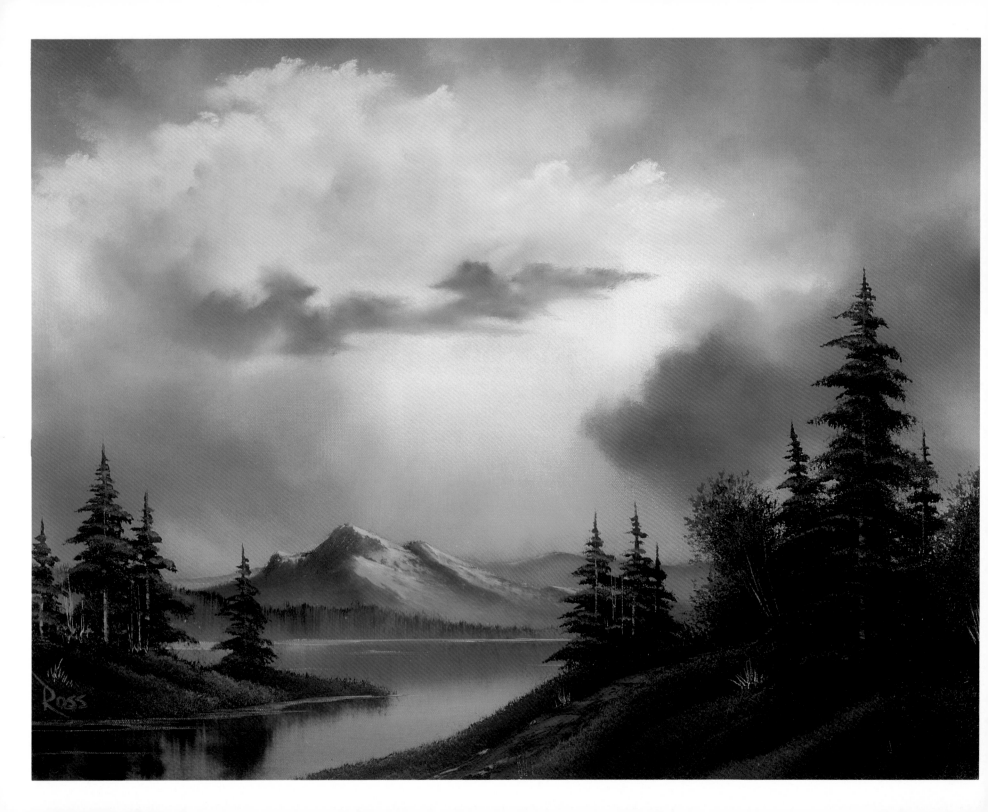

MATERIALS

2" Brush	Midnight Black
1" Brush	Van Dyke Brown
#6 Fan Brush	Alizarin Crimson
2" Blender Brush	Sap Green
Large Knife	Cadmium Yellow
Liquid White	Yellow Ochre
Titanium White	Indian Yellow
Prussian Blue	Bright Red

With the 2" brush, cover the entire canvas with a thin, even coat of Liquid White. Use long horizontal and vertical strokes to ensure an even distribution of paint on the canvas. Do NOT allow the Liquid White to dry before you begin.

SKY

Load the 2" brush with a very small amount of Indian Yellow, tapping the bristles firmly against the palette to ensure an even distribution of paint throughout the bristles. Use criss-cross strokes to paint the golden glow in the center of the sky. Reload the brush with the Yellow Ochre and continue working downward, towards the horizon, with criss-cross strokes. Add a very, very small amount of Bright Red to the brush and continue with criss-cross strokes over the Yellow Ochre.

Brush-mix a dark Lavender color by tapping the bristles into Alizarin Crimson and a very small amount of Phthalo Blue. Use criss-cross strokes to swirl-in the upper portion of the sky, then use a clean, dry 2" brush and criss-cross strokes to lightly blend the sky.

Load the fan brush with a mixture of Titanium White and a very small amount of Bright Red. With just the corner of the brush, make circular strokes to shape the clouds. Use the top corner of the blender brush and tiny circular strokes to blend out the base of the clouds, then sweeping upward strokes to "fluff". Working in layers, use various mixtures of Titanium White, Bright Red, the dark Lavender mixture and Phthalo Blue on the soft blender brush to continue adding clouds.

The dark clouds are shaped with the corner of the fan brush and the dark Lavender mixture. (Photo 1.) Again, blend with the blender brush and circular strokes. Highlight the dark clouds with a mixture of Titanium White and Bright Red on the fan brush–again, blend with the corner of the blender brush.

Use Titanium White on the knife to firmly scrub in the lightest area of the sky (Photo 2) then lightly blend with the blender brush (Photo 3).

Add the fluffy, dark clouds with various mixtures of the Lavender color, Bright Red and Titanium White, using the blender brush and circular strokes to complete the sky. (Photo 4.)

Use the 2" brush and the Lavender mixture to underpaint the lower portion of the canvas with long, horizontal strokes. (Photo 5.)

MOUNTAIN

To paint the distant mountain, use the knife and a mixture of Titanium White and the Lavender color. With firm pressure, shape the small, distant mountain top. (Photo 6.) Use the 2" brush to blend the paint down (Photo 7) to the base of the mountain (Photo 8).

Shape the larger, closer mountain top with a mixture of Prussian Blue, Alizarin Crimson, Midnight Black and Van Dyke Brown on the knife. (Photo 9.) When you are satisfied with the basic shape of the mountain top, use the knife to remove any excess paint, then use the 2" brush to blend the paint down to the base of the mountain. (Photo 10.)

Lightly highlight the closer mountain with various mixtures of Titanium White and a very small amount of Bright Red. Again, load the long edge of the knife blade with a small roll of paint. Starting at the top (and paying close attention to angles) glide the knife down the right side of each peak (Photo 11) using so little pressure that the paint "breaks" (Photo 12).

BACKGROUND

With the dark mountain mixture on the 2" brush, tap in the foothills at the base of the mountain (Photo 13) then pull the dark color straight down and lightly brush across to reflect the

foothills into the water *(Photo 14)*. Use a small roll of Liquid White (blended with a very small amount of Bright Red) on the edge of the knife to cut in water lines and ripples *(Photo 15)* at the base of the foothills *(Photo 16)*.

EVERGREENS

Working forward in the painting, add the evergreen trees by loading the fan brush to a chiseled edge with a dark-tree mixture of Midnight Black, Prussian Blue, Van Dyke Brown and Alizarin Crimson. Holding the brush vertically, touch the canvas to create the center line of each evergreen tree. Use just the corner of the brush to begin adding the small top branches. Working from side to side, as you move down each tree, apply more pressure to the brush, forcing the bristles to bend downward–automatically the branches will become larger as you near the base of each tree. *(Photo 17.)*

Extend the dark-tree color into the water for reflections. *(Photo 18.)* Use the 2" brush to pull the color down *(Photo 19)* then lightly brush across the reflections *(Photo 20)*.

FOREGROUND

Add the grassy area at the base of the trees on the left side of the painting with the dark-tree mixture on the fan brush, forcing the bristles to bend upward. On the right side of the painting, use the same dark mixture on the 2" brush to underpaint the large bushes at the base of the evergreen trees *(Photo 21)*

and to tap in the grassy land area *(Photo 22)*.

Use a mixture of Titanium White and the dark-tree color on the 1" brush to highlight the large bushes at the base of the evergreens. *(Photo 23.)*

Use various mixtures of Sap Green, all of the Yellows and Midnight Black on the 2" brush to highlight the soft grassy area at the base of the trees. Load the 2" brush by holding it at a 45-degree angle and tapping the bristles into the various paint mixtures. Allow the brush to "slide" slightly forward in the paint each time you tap (this assures that the very tips of the bristles are fully loaded with paint). Hold the brush horizontally and gently tap downward. Work in layers, carefully creating the lay-of-the-land. If you are also careful not to destroy all of the dark color already on the canvas, you can create grassy highlights that look almost like velvet. *(Photo 24.)*

Cut in water lines and ripples with a small roll of Liquid White on the knife. *(Photo 25.)*

Use the fan brush to very lightly touch highlights to the evergreens with a mixture of the dark tree color and the Yellow highlight mixture.

FINISHING TOUCHES

Paint the foreground path with the dark-Lavender mixture on the knife, then highlight with Titanium White—use very little pressure, allowing the paint to "break". *(Photo 26.)* Add final grassy highlights *(Photo 27)* to complete the painting *(Photo 28)*.

Sunset Aglow

1. Shape dark clouds with the fan brush . . .

2. . . . then add light with the knife.

3. Use the blender brush . . .

4. . . . to blend the entire sky.

5. Underpaint the water with the 2" brush.

6. Shape the distant mountain top with the knife . . .

7. . . . then blend down with the 2" brush . . .

Sunset Aglow

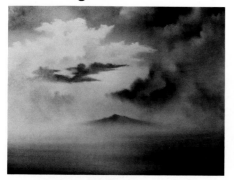

8. . . . to complete the shape.

9. Paint the closer mountain with the knife . . .

10. . . . then blend with the 2" brush.

11. Apply snow with the knife . . .

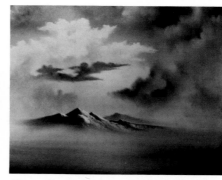

12. . . . then firmly tap to mist with the 2" brush.

13. Tap in foothills with the 2" brush . . .

14. . . . then pull down reflections.

15. Use Liquid White on the knife . . .

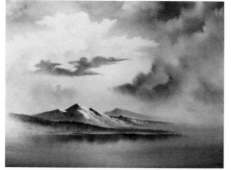

16. . . . cut in water lines and ripples.

17. Paint the evergreens . . .

18. . . . and their reflections.

19. Pull the reflections down . . .

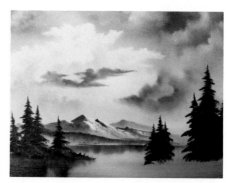

20. . . . and lightly brush across with the 2" brush.

21. Underpaint bushes . . .

22. . . . and grassy area with the 2" brush.

23. Highlight bushes with the 1" brush . . .

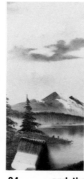

24. . . . and the grassy area with the 2" brush.

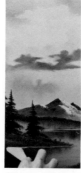

25. Use the knife to cut in water lines . . .

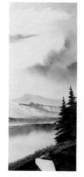

26. . . . and to add the path.

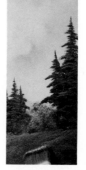

27. Paint the soft foreground grass . . .

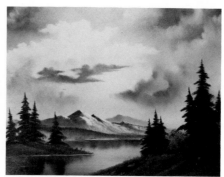

28. . . . to complete the painting.

37. HALF-OVAL VIGNETTE

MATERIALS

2" Brush	Midnight Black
1" Brush	Dark Sienna
#6 Fan Brush	Van Dyke Brown
#2 Script Liner Brush	Alizarin Crimson
Large Knife	Sap Green
Adhesive-Backed Plastic	Cadmium Yellow
Liquid White	Yellow Ochre
Titanium White	Indian Yellow
Phthalo Blue	Bright Red
Prussian Blue	

Cover one half (the right side) of the canvas with a piece of adhesive-backed plastic (such as Con-Tact Paper) from which you have removed a half-oval shape.

Apply a thin, even coat of Liquid White to the exposed area of the canvas and do NOT allow this paint to dry before you begin.

SKY

Load the 2" brush with a very small amount of Phthalo Blue. Starting at the top of the canvas, use criss-cross strokes to paint the sky. As you work down the canvas, notice how the color blends with the Liquid White, and automatically the sky becomes lighter as you near the horizon. Re-load the brush with Phthalo Blue and use horizontal strokes to add the water at the bottom of the canvas.

Use Titanium White with a very small amount of Bright Red and the fan brush to shape the clouds, making small circular strokes with just the corner of the brush.

With the top corner of a clean, dry 2" brush and small, circular strokes, blend out just the base of the clouds. Gently lift upward to "fluff". (Photo 1.)

MOUNTAIN

Use a mixture of Midnight Black, Van Dyke Brown, Alizarin Crimson and Prussian Blue for the mountain. Pull the mixture out very flat on your palette and just cut across to load the long

edge of the knife with a small roll of paint. With very firm pressure, shape the top edge of this small distant mountain. (Photo 2.) Use the 2" brush to pull the paint down to the base of the mountain, to blend and complete the entire shape. (Photo 3.) With careful brush strokes alone, you can create the highlights and shadows on the mountain. (Photo 4.)

FOOTHILLS

Tap the bristles of the 2" brush into Titanium White, Phthalo Blue and the mountain mixture. Shape the foothills at the base of the mountain by holding the brush horizontally and tapping downward. (Photo 5.) With the same color, pull straight down to reflect the foothills into the water and then lightly brush across. (Photo 6.) With very short upward strokes (Photo 7) you can create the impression of tiny tree tops along the top edges of the hills (Photo 8).

BACKGROUND

Load the 2" brush by tapping the bristles into the mountain mixture and a small amount of Sap Green. Working forward in layers, tap downward to underpaint the land areas at the base of the foothills. (Photo 9.) Pull the reflections straight down (Photo 10) completing each land projection before moving forward (Photo 11).

Use a mixture of Cadmium Yellow, Sap Green and Yellow Ochre on the fan brush to lighten the ground areas. Holding the brush horizontally, force the bristles to bend upward to apply the grassy highlights. Again, work forward in layers and be very careful not to completely cover all of your dark, base color. (Photo 12.)

Load the fan brush with Midnight Black, Van Dyke Brown, Alizarin Crimson, Sap Green and Prussian Blue. To indicate the tiny, distant evergreens, hold the brush vertically and just tap downward. (Photo 13.)

Use Liquid White with a very small amount of Bright Red, for the water lines. Pull the mixture out very flat on your palette and just cut across to load the long edge of the knife with a small roll

of paint. Cut in the water lines with firm pressure, making sure they are perfectly straight *(Photo 14);* you don't want your water to run right off the canvas.

LARGE TREES

For the larger evergreens, load the fan brush to a chiseled edge with the Midnight Black-Van Dyke Brown-Alizarin Crimson-Sap Green-Prussian Blue mixture. Holding the brush vertically, touch the canvas to create the center line of each tree. Use just the corner of the brush to begin adding the small top branches. Working from side to side, as you move down each tree, apply more pressure to the brush, forcing the bristles to bend downward and automatically the branches will become larger as you near the base of each tree. *(Photo 15.)*

Add the tree trunks with a small roll of a mixture of Titanium White and Dark Sienna on the knife. Use the fan brush to very lightly touch highlights to the right sides of the branches with a dark Green mixture of Midnight Black and Cadmium Yellow. But, allow the evergreens to remain quite dark. *(Photo 16.)*

FOREGROUND

Working forward in the painting, underpaint the foreground with the same dark Midnight Black-Van Dyke Brown-Alizarin Crimson-Sap Green-Prussian Blue mixture on the 2" brush. *(Photo 17.)*

Use the point of the knife to scratch in the indication of small sticks and twigs.

Use various mixtures of all of the Yellows with Midnight Black and Bright Red to highlight the small bushes in the foreground. Dip the 1" brush into Liquid White and then pull it several times (in one direction) through the mixtures, to round one corner. With the rounded corner up, touch the canvas and force the bristles to bend upward as you create the individual bush shapes. *(Photo 18.)* Try not to just hit at random, work on one bush at a time. Again, working in layers, highlight the most distant bushes first, along the water's edge.

With a mixture of Van Dyke Brown and Dark Sienna on the knife, use short, horizontal strokes to add the path. Highlight the path with a mixture of Titanium White, Dark Sienna and Bright Red on the knife using so little pressure that the paint "breaks". *(Photo 19.)* Continue by highlighting the closer bushes, along the edge of the path. *(Photo 20.)*

FINISHING TOUCHES

Carefully remove the Con-Tact Paper from the canvas *(Photo 21)* and extend the foreground bushes outside the oval, to the lower edge of the canvas *(Photo 22).*

At the top of the canvas, use a clean, dry 2" brush to blend out the remaining harsh Blue line in the sky and then use Titanium White on the fan brush to "float" some clouds beyond the borders of the oval. Use the liner brush to add final small details *(Photo 23)* and to sign your masterpiece *(Photo 24)!*

Half-Oval Vignette

1. Begin by painting the sky.

2. Shape the top edge of the mountain.

3. Pull the paint down . . .

4. . . . to mist and blend.

5. Tap to add oothills . . .

6. . . . then reflect them into the water.

Half-Oval Vignette

 7. Lift up with the 2" brush . . .

 8. . . . to create tiny tree tops.

 9. Complete each . . .

 10. . . . land projection . . .

 11. . . . before moving forward.

 12. Use the fan brush to highlight . . .

 13. . . . and add tiny evergreens.

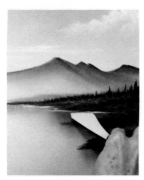 14. Use the knife to cut in water lines and ripples.

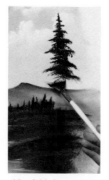 15. Add large evergreens with the fan brush . . .

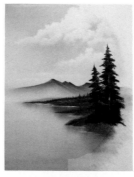 16. . . . to the foreground.

 17. Use the 2" brush to underpaint the foreground . . .

 18. . . . then highlight with the 1" brush.

 19. Use the knife to paint and highlight . . .

 20. . . . the foreground path.

 21. Remove the Con-Tact Paper from your canvas.

 22. Extend the foreground outside the oval . . .

 23. . . . add finishing touches . . .

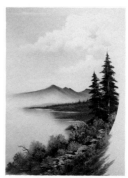 24. . . . and your painting is complete.

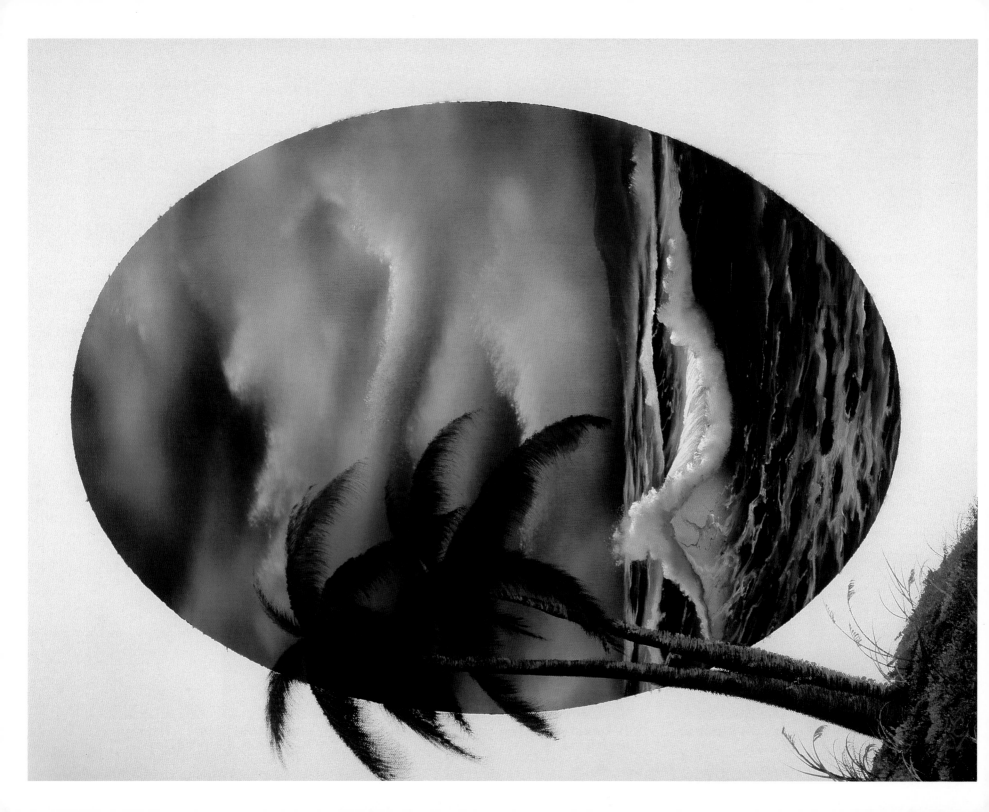

38. JUST BEFORE THE STORM

MATERIALS

2" Brush	Liquid Clear
#6 Filbert Brush	Titanium White
#6 Fan Brush	Prussian Blue
#3 Fan Brush	Midnight Black
#2 Script Liner Brush	Dark Sienna
Adhesive-Backed Plastic	Van Dyke Brown
Large Knife	Alizarin Crimson
Masking Tape	Sap Green
Black Gesso	Cadmium Yellow

Start by covering the entire canvas with a piece of adhesive-backed plastic (such as Con-Tact Paper) from which you have removed a center oval shape. (A 16 x 20 oval for an 18 x 24 canvas.)

Use a foam applicator to cover the exposed area of the canvas with a thin, even coat of Black Gesso and allow to DRY COMPLETELY. *(Photo 1.)*

When the Black Gesso is dry, mark the horizon with a strip of masking tape, then use the 2" brush to cover the oval with a VERY THIN coat of Liquid Clear.

Continue using the 2" brush to apply a thin, even coat of a mixture of Prussian Blue and Midnight Black above the horizon and a mixture of Prussian Blue, Midnight Black and Sap Green below the horizon. Do NOT allow the canvas to dry before proceeding.

SKY

Load the 2" brush with a very small amount of Titanium White and begin painting the cloud shapes with tiny criss-cross strokes. *(Photo 2.)* Notice how the White blends with the colors already on the canvas. With a clean, dry 2" brush, blend with criss-cross strokes, then make sweeping upward strokes to "fluff" the clouds. Repeat as often as necessary to achieve the desired degree of lightness. *(Photo 3.)*

When you are satisfied with the sky, carefully remove the masking tape to expose a nice, straight horizon line. *(Photo 4.)* Use the 2" brush and a small amount of the Prussian Blue-Sap Green-Midnight Black mixture to cover the tiny area of the canvas left dry by the masking tape.

BACKGROUND WATER

Before painting the background water, use Titanium White on the filbert brush to sketch just the basic shape of the large wave. *(Photo 5.)*

With Titanium White on the #3 fan brush, use rocking strokes to paint the background swells. *(Photo 6.)* Use a clean, dry fan brush to blend back the tops of the swells. *(Photo 7.)* Be very careful not to destroy all of the dark color already on the canvas; you need this dark to separate the individual swells of water. *(Photo 8.)*

LARGE WAVE

Load the filbert brush with a mixture of Titanium White and a very small amount of Cadmium Yellow. Use circular strokes to scrub in the "eye" or transparency of the large, foreground wave. *(Photo 9.)* Use just the top corner of a very clean, dry 2" brush and circular strokes to lightly blend the "eye" of the wave. *(Photo 10.)*

Paying close attention to the angle of the water, use Titanium White on the #6 fan brush to "pull" water over the top of the large wave. *(Photo 11.)*

With a mixture of Titanium White, Prussian Blue, Midnight Black and Alizarin Crimson (to make a Blue-Lavender) on the filbert brush, use tiny, circular strokes to under-paint the foam. This dark color will be the shadowed areas of the foam. *(Photo 12.)*

Use Titanium White on the filbert brush and small, circular, push-up strokes to highlight the top edges of the foam, just where the light would strike. *(Photo 13.)* Blend the bottom of the foam highlights into the shadows with the top corner of a clean, dry 1" or 2" brush. *(Photo 14.)*

HEADLANDS

Shape the background headlands with a mixture of Van Dyke Brown, Dark Sienna and Midnight Black on the fan brush. Add Titanium White to the mixture to highlight. *(Photo 15.)*

Add water to the base of the headlands with Titanium White on the fan brush *(Photo 16)* to complete the background *(Photo 17)*.

FOREGROUND

Paint the foam patterns at the base of the large wave with Titanium White on the filbert brush. *(Photo 18.)* Again, pay close attention to the angle of the water.

Use a mixture of Titanium White and Prussian Blue on the liner brush to highlight the top edges of the swells and waves and to add tiny details to the water. (To load the liner brush, thin the mixture to an ink-like consistency by first dipping the liner brush into paint thinner. Slowly turn the brush as you pull the bristles through the mixture, forcing them to a sharp point.)

The brightest highlights are added very sparingly with a thinned mixture of Titanium White and Cadmium Yellow in the liner brush. *(Photo 19.)*

Another technique used to character the water is to "punch holes" in the foam patterns. Use a mixture of Prussian Blue, Midnight Black and Sap Green on the filbert brush to shape the dark holes in the light foreground water. *(Photo 20.)*

When you are satisfied with your sea *(Photo 21)*, carefully remove the Con-Tact Paper *(Photo 22)* to expose the unpainted edges of the canvas *(Photo 23)*.

PALM TREES

Load the fan brush with a mixture of Van Dyke Brown and Midnight Black. Hold the brush vertically and pull down each large tree trunk, allowing the trunks to extend outside the painted oval. *(Photo 24.)*

Add Sap Green to the dark mixture already on the fan brush to underpaint the grassy land area at the base of the trees. *(Photo 25.)*

Subtle highlights are added to the tree trunks with a mixture of Midnight Black, Titanium White and a small amount of Dark Sienna on the fan brush. Holding the brush vertically, just touch the right edges of the trunks and pull the Gray color inward with light, rounded strokes. *(Photo 26.)*

Load the fan brush with a thin mixture of paint thinner and Midnight Black to underpaint the palm-tree foliage. (This paint should have a very thin consistency.) Shape the curved branches *(Photo 27)* then pull the color away to indicate the feathery, palm leaves *(Photo 28)*. Touch highlights sparingly with small amounts of Titanium White and Sap Green added to the brush.

Highlight the grass at the base of the palm trees with various mixtures of Sap Green, Cadmium Yellow and Dark Sienna on the fan brush. *(Photo 29.)*

FINISHING TOUCHES

Use thinned mixtures on the liner brush to pull up long grasses and sea oats *(Photo 30)* and your seascape is complete *(Photo 31)*.

Just Before The Storm

1. Start by covering the oval with Black Gesso.

2. Use the 2" brush and tiny criss-cross strokes . . .

3. . . . to paint the sky . . .

4. . . . then remove the masking tape from the horizon.

5. Sketch the large wave with the filbert brush.

6. Paint water with the fan brush . . .

7. . . . then blend with rocking strokes . . .

Just Before The Storm

8. . . . to create background swells.

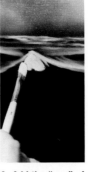

9. Add the "eye" of the wave with the filbert brush . . .

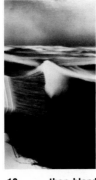

10. . . . then blend with the corner of the 2" brush.

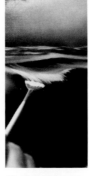

11. Pull water over the wave with the fan brush.

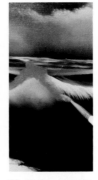

12. Underpaint the foam . . .

13. . . . then highlight with the filbert brush . . .

14. . . . and blend with the 2" brush.

15. Use the fan brush to paint the headlands . . .

16. . . . and to add the water . . .

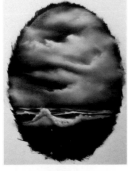

17. . . . at the base of the background hills.

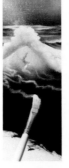

18. Shape foam patterns with the filbert brush . . .

19. . . . then highlight with the liner brush.

20. Continue using the filbert brush . . .

21. . . . to punch in dark foam shapes.

22. Remove the Con-Tact Paper . . .

23. . . . to expose the painted oval.

24. Extend palm trunks outside the oval . . .

25. . . . then add grass to the base of the trunks.

26. Highlight the trunks . . .

27. . . . and add branches . . .

28. . . . and feathery foliage with the fan brush.

29. Highlight the grassy area . . .

30. . . . pull up a few long grasses . . .

31. . . . and the seascape is complete.

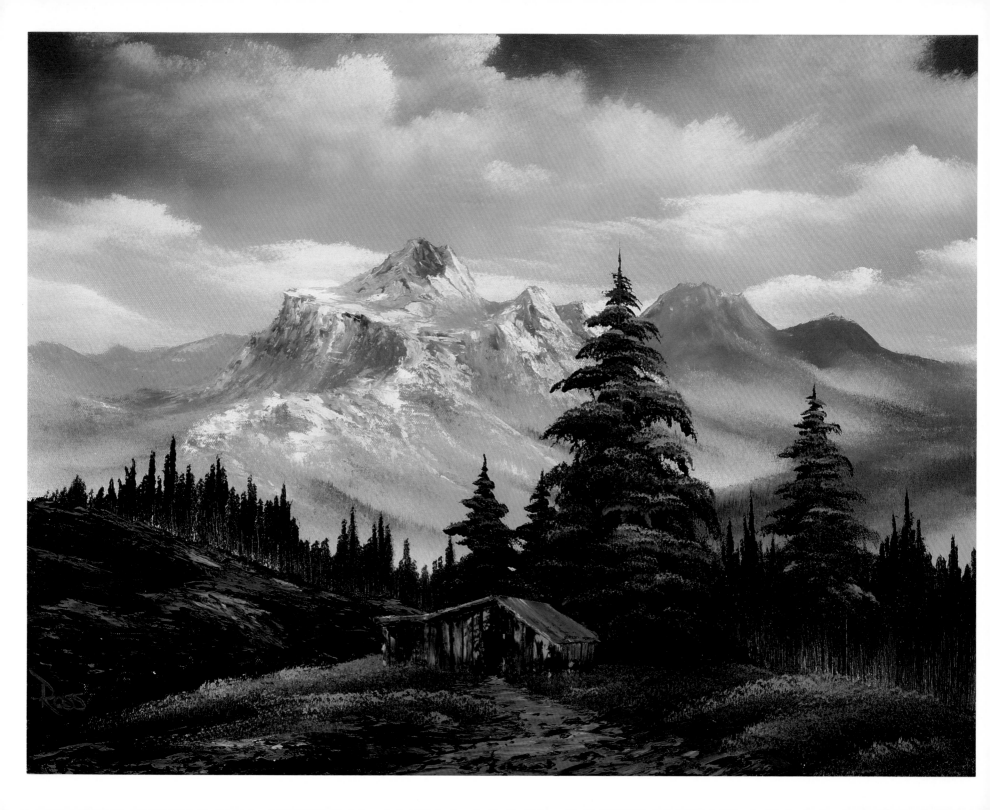

MATERIALS

2" Brush	Midnight Black
1" Oval Brush	Dark Sienna
#6 Fan Brush	Van Dyke Brown
2" Blender Brush	Alizarin Crimson
Large Knife	Sap Green
Small Knife	Cadmium Yellow
Liquid White	Yellow Ochre
Titanium White	Indian Yellow
Prussian Blue	Bright Red

Use the 2" brush to cover the entire canvas with a thin, even coat of Liquid White. With long horizontal and vertical strokes, work back and forth to ensure an even distribution of paint on the canvas. Do NOT allow the Liquid White to dry before you proceed.

SKY

Load the 2" brush with a small amount of Prussian Blue, tapping the bristles firmly against the palette to ensure an even distribution of paint throughout the bristles. Starting at the top of the canvas and working downward, use criss-cross strokes to paint the sky. *(Photo 1.)* Notice how the color blends with the Liquid White already on the canvas and automatically the sky becomes lighter near the horizon.

Reload the brush by tapping the bristles into a small amount of Midnight Black and continue using criss-cross strokes to darken the top corners of the canvas. Blend the entire sky with long, horizontal strokes.

With Titanium White on a clean, dry 2" brush, tap in the basic cloud shapes. *(Photo 2.)* Lightly blend the clouds with the soft, blender brush. *(Photo 3.)* Blend the entire sky with long, horizontal strokes. *(Photo 4.)*

MOUNTAIN

Load the knife with a small roll of a mixture of Midnight Black, Prussian Blue, Van Dyke Brown and Alizarin Crimson. With firm pressure, shape just the top edge of the mountain. *(Photo 5.)* Blend the paint down to the base of the mountain with the 2" brush. *(Photo 6.)* Paying close attention to angles, tap the base of the mountain with a very small amount of Cadmium Yellow on the brush. *(Photo 7.)*

Use a small roll of Titanium White on the knife to highlight the mountain. To load the knife, pull the Titanium White out very flat on your palette, hold the knife straight up and "cut" across the paint to load the long edge of the blade with a small roll of Titanium White. (Holding the knife straight up will force the small roll of paint to the very edge of the blade.)

Starting at the top (and paying close attention to angles) glide the knife down the right side of each peak, using so little pressure that the paint "breaks". *(Photo 8.)* Use a mixture of Titanium White and Prussian Blue, applied in the opposing direction, for the shadow sides of the peaks. Again, use so little pressure that the paint "breaks". Use the small knife for small, hard-to-reach areas.

With a clean, dry 2" brush, tap to diffuse the base of the mountain, again carefully following angles. *(Photo 9.)* Reload the 2" brush by tapping the bristles into various mixtures of all of the Yellows and the mountain color (to make Green) and continue tapping the base of the mountain. *(Photo 10.)* With very short upward strokes, still following the angles of the mountain, you can indicate tiny tree tops. *(Photo 11.)*

BACKGROUND

Load the fan brush with a mixture of Prussian Blue, Midnight Black, Alizarin Crimson and Sap Green. Holding the brush vertically, just tap downward to indicate the small trees at the base of the mountain. *(Photo 12.)* Reload the fan brush with a small amount of Titanium White, hold the brush horizontally and brush upward from the base of the trees *(Photo 13)* to indicate tiny tree trunks *(Photo 14)*.

Add the land at the base of the small trees with the same dark tree mixture on the knife and long, horizontal strokes. *(Photo 15.)* Extend this dark color to the bottom of the canvas. Highlight

the land areas with a small roll of a mixture of Titanium White, Midnight Black and Prussian Blue on the knife. Again, use so little pressure that the paint "breaks". *(Photo 16.)* Pay close attention to the lay-of-the-land. *(Photo 17.)*

EVERGREENS

For the larger, more distinct evergreens, load the oval brush to a chiseled edge with the dark tree mixture. Holding the brush vertically, touch the canvas to create the center line of each tree. Use just the corner of the brush to begin adding the small top branches. Working from side to side, as you move down each tree, apply more pressure to the brush, forcing the bristles to bend downward *(Photo 18)* and automatically the branches will become larger as you near the base of each tree. With the dark-tree mixture still in the brush, reload the brush with various mixtures of the Yellows to lightly highlight the evergreen trees. *(Photo 19.)*

CABIN

Use a clean knife to remove paint from the canvas in the basic shape of the cabin. Load the long edge of the knife with a small roll of a mixture of Van Dyke Brown and Dark Sienna. Paying close attention to angles, block in the side and the front of the cabin. Use a mixture of the Browns, Titanium White and Bright Red to add the roof. Highlight the cabin by adding more Titanium White to the mixture. Add Prussian Blue to the mixture for the shadowed side of the cabin. Cut in slabs with the point of the knife, then finish the cabin with a door made of Van Dyke Brown. *(Photo 20.)*

FOREGROUND

Use various mixtures of all of the Yellows and Bright Red to add the soft grassy area at the base of the cabin. Load the 2" brush by first dipping it into Liquid White, then holding it at a 45-degree angle, tap the bristles into the various paint mixtures. Allow the brush to "slide" slightly forward in the paint each time you tap (this assures that the very tips of the bristles are fully loaded with paint). Hold the brush horizontally and gently tap downward. Work in layers, carefully creating the lay-of-the-land. If you are also careful not to destroy all of the dark color already on the canvas, you can create grassy highlights that look almost like velvet. *(Photo 21.)*

Use a mixture of Titanium White, Dark Sienna and Bright Red on the knife and horizontal strokes to add the path. *(Photo 22.)*

FINISHING TOUCHES

Add the indication of rocks and stones to your painting with a mixture of Titanium White and Midnight Black on the knife and your masterpiece is ready for a signature. *(Photo 23.)*

A Spectacular View

 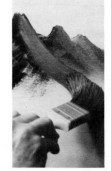 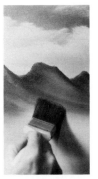

1. Begin by painting the sky with criss-cross strokes . . .

2. . . . then tapping in cloud shapes with the 2" brush.

3. Use the soft blender brush . . .

4. . . . to blend the clouds and complete the sky.

5. Paint the mountain top with the knife . . .

6. . . . then blend the paint down with the 2" brush.

7. Tap in the tree line at the base of the mountain.

A Spectacular View

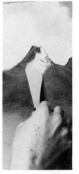 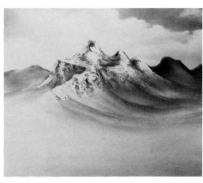 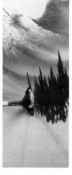 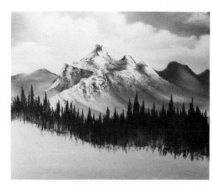

8. Use the knife to add snow to the mountain . . .

9. . . . then tap to mist and diffuse the base of the mountain.

10. Continue using the 2" brush . . .

11. . . . to add tiny trees at the base of the mountain.

12. Tap down with the fan brush to indicate evergreens . . .

13. . . . then use upward strokes . . .

14. . . . to add the indication of trunks.

 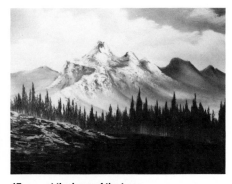 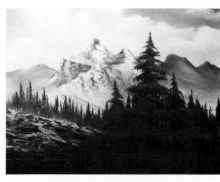

15. Use the knife to add the land area . . .

16. . . . and highlights . . .

17. . . . at the base of the trees.

18. The oval brush . . .

19. . . . is wonderful for painting evergreens!

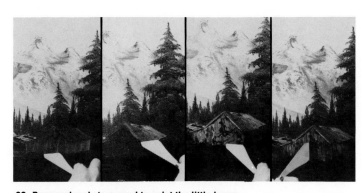 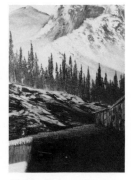 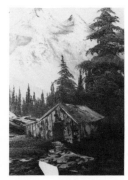 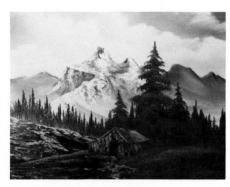

20. Progressional steps used to paint the little house . . .

21. Tap in grass at the base of the house . . .

22. . . . and add a path . . .

23. . . . to complete your painting.

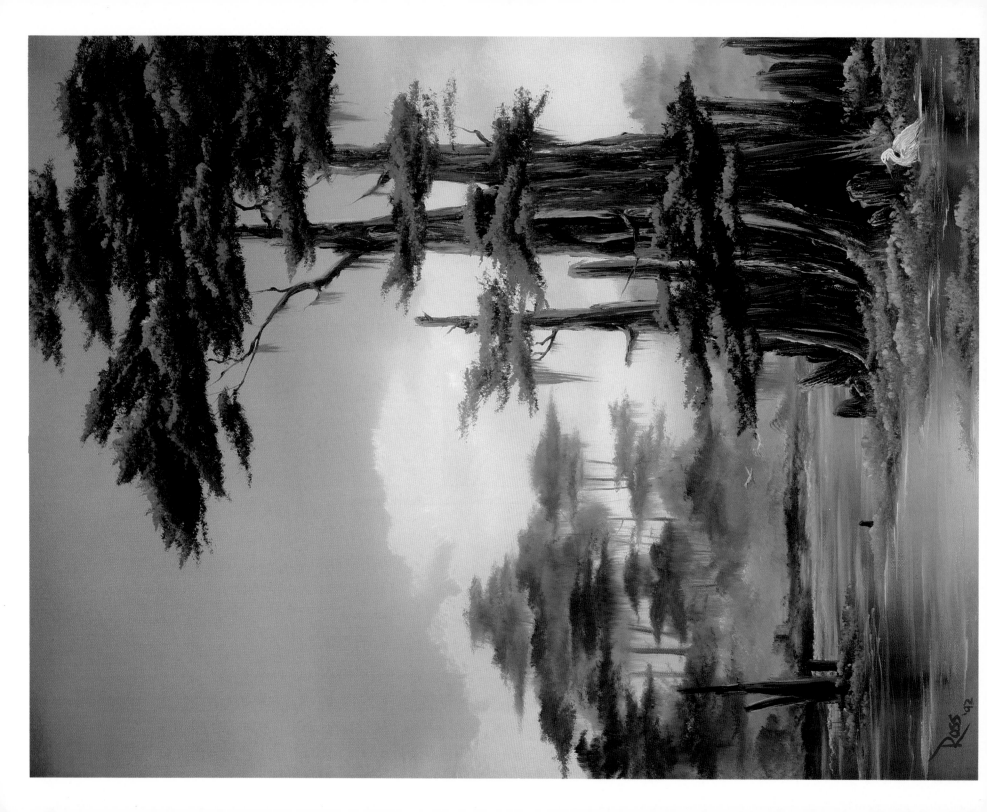

40. CYPRESS SWAMP

MATERIALS

2" Brush	Midnight Black
#6 Filbert Brush	Dark Sienna
#6 Fan Brush	Van Dyke Brown
#2 Script Liner Brush	Alizarin Crimson
Large Knife	Sap Green
Liquid White	Cadmium Yellow
Titanium White	Yellow Ochre
Phthalo Blue	Indian Yellow
Prussian Blue	Bright Red

Begin by using the 2" brush to cover the entire canvas with a thin, even coat of Liquid White. With long, horizontal and vertical strokes, work back and forth to ensure an even distribution of paint on the canvas. Do NOT allow the Liquid White to dry before proceeding.

SKY

Load the 2" brush with Phthalo Blue, tapping the bristles firmly against the palette to ensure an even distribution of paint throughout the bristles. Starting at the top of the canvas and working downward, use criss-cross strokes to paint the sky. Notice how the color blends with the Liquid White already on the canvas and automatically the sky becomes lighter as it nears the horizon. Reload the 2" brush with a mixture of Midnight Black and Prussian Blue and continue using criss-cross strokes to darken just the top corners of the canvas. Blend with long, horizontal strokes.

To underpaint the water on the lower portion of the canvas, reload the 2" brush with Phthalo Blue and Alizarin Crimson. Starting at the bottom of the canvas and working upward, use horizontal strokes, pulling from the outside edges of the canvas in towards the center. You can create a sheen on the water by allowing the center of the canvas to remain light.

Again, darken the lower corners of the canvas. With a clean, dry 2" brush, add a very small amount of Alizarin Crimson to the center, light area of the water. Blend the entire canvas with long, horizontal strokes.

CLOUDS

Load the fan brush with a mixture of Titanium White and a very, very small amount of Bright Red. Shape the clouds with just one corner of the fan brush and tight, circular strokes. Blend out the base of the clouds with the top corner of a clean, dry 2" brush and circular strokes, then use sweeping upward strokes to "fluff". Lightly brush across, using long, horizontal strokes to blend the entire sky. (Photo 1.)

BACKGROUND

Load the 2" brush with a mixture of Prussian Blue and Alizarin Crimson (to make a dark Blue-Lavender). Tap downward with just the corner of the brush to shape the subtle background Cypress trees along the horizon. (Photo 2.) Reload the brush with various mixtures of the Yellows to lightly highlight the trees.

Add the background tree trunks with the dark Blue-Lavender mixture and the liner brush. (To load the liner brush, thin the Lavender mixture to an ink-like consistency by first dipping the liner brush into paint thinner. Slowly turn the brush as you pull the bristles through the mixture, forcing them to a sharp point.) Apply very little pressure to the brush as you shape the trunks.

Load a clean fan brush with the dark Lavender tree-mixture. Hold the brush horizontally and push firmly into the canvas (forcing the bristles to bend upward) to underpaint the small trees and bushes at the base of the background trees.

Reload the fan brush with Sap Green and all of the Yellows to shape and highlight the small trees and bushes. Add a small amount of Phthalo Blue and Titanium White for the cool color. (Photo 3.)

With a small amount of the dark Lavender color on the 2" brush and starting at the base of the background trees and bushes, pull the dark color straight down into the water. Brush lightly across to create the illusion of reflections. (Photo 4.)

Use the knife to mix Liquid White and a very small amount of Phthalo Blue. Pull the mixture out very flat on the palette and "cut" across the mixture to load the top of the long edge of the blade with a small roll of paint. Use firm pressure to rub in water

lines and ripples. *(Photo 5.)* Be sure the lines are straight and parallel to the top and bottom of the canvas. *(Photo 6.)*

CYPRESS TREES

Shape the Cypress tree trunks with the filbert brush and a mixture of Van Dyke Brown and Dark Sienna. Holding the brush vertically, start at the top of each tree and pull the trunk down into the water. *(Photo 7.)* Notice that Cypress tree trunks are very wide at the base. Add Titanium White to the filbert brush and highlight the left side of each trunk.

Underpaint the grassy area at the base of the Cypress trees with the fan brush and a mixture of all of the dark colors: Midnight Black, Prussian Blue, Sap Green, Alizarin Crimson and the Browns. Again, hold the brush horizontally and push firmly into the canvas, forcing the bristles to bend upward. Reload the brush with Cadmium Yellow to highlight the grassy area. *(Photo 8.)*

Use the dark Lavender-mixture on the 2" brush to pull down reflections *(Photo 9),* then use a mixture of Liquid White and Phthalo Blue on the knife to add water lines to the base of the grassy area *(Photo 10).*

LARGE FOREGROUND CYPRESS TREES

Shape the large cluster of Cypress tree trunks in the foreground with the filbert brush and a thick, textured mixture of Van Dyke Brown and Dark Sienna. *(Photo 11.)* Paint the base of each trunk thick and wide. The indication of "knees" and other details can also be added.

Use a clean, dry 2" brush to pull color from the base of the trees straight down into the water and brush lightly across for reflections. *(Photo 12.)*

Use the liner brush and a thinned mixture of Titanium White, Dark Sienna and a very small amount of Alizarin Crimson to highlight the tree trunks. Starting at the top left-hand edge of each trunk (the light source in this painting is on the left), just "graze" the thick paint as you pull the brush downward, gradually working more of the highlight color into the center of each trunk. Use a thinned mixture of Titanium White and Phthalo Blue on the liner brush to indicate reflected light on the right-hand side of the trunks.

Underpaint the Cypress tree foliage with a mixture of Midnight Black, Prussian Blue and Sap Green on the fan brush, again forcing the bristles to bend upward.

Add limbs and branches with a thinned Brown color on the liner brush. *(Photo 13.)* Highlight the foliage with a mixture of the dark undercolor, Sap Green and all of the Yellows on the fan brush, carefully forming individual leaf clusters. *(Photo 14.)*

Underpaint the grassy area at the base of the large foreground trees with the dark foliage mixture and the fan brush. Again, highlight with the Yellow mixtures *(Photo 15)* and add water lines with Liquid White on the knife.

FINISHING TOUCHES

Use the knife to remove paint from the canvas in the basic shape of the bird and allow the painting to dry.

When the painting is dry, use Liquid White on the liner brush to shape the Egret, add his feet with a Yellow-Red mixture (to make Orange) and then paint his eye with Midnight Black *(Photo 16)* and your masterpiece is complete *(Photo 17).*

Cypress Swamp

1. Begin by painting the sky.

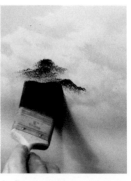

2. Tap in background trees with the 2" brush . . .

3. . . . then highlight with the fan brush.

4. Pull down dark reflections . . .

5. . . . then use the knife . . .

6. . . . to cut in water lines and ripples.

7. Paint small cypress trunks with the filbert.

8. Push in the grassy area at the base of the trunks.

9. Use the 2" brush to pull down . . .

10. . . . the dark reflections in the water.

11. Paint large cypress trunks with the filbert . . .

12. . . . then add reflections with the 2" brush.

13. Add small limbs and branches . . .

14. . . . before highlighting the foliage with the fan brush.

15. Push in the grassy areas with the fan brush . . .

16. . . . then use the liner brush to paint the bird . . .

17. . . . and your swampy masterpiece is complete.

MATERIALS

2" Brush	Midnight Black
#6 Filbert Brush	Dark Sienna
#2 Script Liner Brush	Van Dyke Brown
Large Knife	Alizarin Crimson
Black Gesso	Sap Green
White Gesso	Cadmium Yellow
Liquid Clear	Yellow Ochre
Cadmium Yellow (acrylic)	Indian Yellow
Titanium White	Bright Red
Phthalo Blue	

Begin by using a foam applicator to cover the entire canvas with a thin, even coat of a mixture of the Yellow Acrylic and White Gesso. Allow the canvas to DRY COMPLETELY.

With a natural sponge and Black Gesso, apply the basic dark foliage shapes to the lower portion of the canvas. *(Photo 1.)* Allow the canvas to DRY COMPLETELY.

When the canvas is dry, use the 2" brush to cover the entire canvas with a VERY THIN coat of Liquid Clear. Continue using the 2" brush to apply a small amount of Indian Yellow to the lower portion of the canvas. Do NOT allow the canvas to dry before you proceed.

SKY

Load a clean, dry 2" brush by tapping the bristles into a very small amount of Phthalo Blue and use criss-cross strokes to begin painting the sky. Reload the brush with a small amount of Alizarin Crimson (to vary the color of the sky) and continue with criss-cross strokes.

Reload the 2" brush with a very small amount of Titanium White. Still using criss-cross strokes, add the misty glow to areas just above the horizon. With a clean, dry 2" brush, use criss-cross strokes to blend the various colors, then use horizontal strokes to blend the entire sky.

BACKGROUND

Load the 2" brush by tapping the bristles into various mixtures of all the Yellows. Tap downward with just the top corner of the brush *(Photo 2)* to shape the subtle, light background trees along the horizon *(Photo 3)*.

Use the knife to mix equal parts of Alizarin Crimson and Sap Green (to make Brown). Load a clean, dry 2" brush with this Brown mixture and working forward in layers, continue tapping downward to add the small dark trees and bushes in the background. Use a very small amount of Titanium White and Yellow Ochre on the brush and firmly tap downward to mist the base of the dark trees *(Photo 4)*.

Add the final layer of background trees and bushes with Midnight Black on the 2" brush. Be very careful to not completely cover the light misty area, use it to separate the layers of background trees and bushes.

Add the background tree trunks with the Sap Green-Alizarin Crimson mixture and the liner brush. (To load the liner brush, thin the mixture to an ink-like consistency by first dipping the liner brush into paint thinner. Slowly turn the brush as you pull the bristles through the mixture, forcing them to a sharp point.) Apply very little pressure to the brush as you shape the trunks. *(Photo 5.)* By turning and wiggling the brush, you can give the trunks a gnarled appearance.

Use a blend of the Brown mixture and Titanium White on the knife to add the land area to the base of the background trees and bushes. *(Photo 6.)* Then, very lightly blend and soften this land into the base of the trees and bushes with the knife and small circular strokes. *(Photo 7.)*

LARGE TREES

With a liberal amount of a mixture of Van Dyke Brown and Dark Sienna on the filbert brush, add the large foreground tree trunks and large branches. *(Photo 8.)*

Use a thin mixture of Titanium White and the Brown on the liner brush to highlight the left sides of the trunks. *(Photo 9.)* Smaller limbs and branches can be added with thinned Brown on the liner brush. *(Photo 10.)* Again, turn and wiggle the brush to give the limbs a gnarled appearance. *(Photo 11.)*

Underpaint the foliage on the large leafy tree with a mixture of the dark Brown tree-color, Yellow Ochre and Bright Red on the 2" brush *(Photo 12)* concentrating on shape and form. For a "shadowy" effect, try to not completely cover the under-painted Black Gesso.

Use the liner brush and a thin mixture of the dark tree-color to add the trunk and branches to the tree. *(Photo 13.)*

Reload the 2" brush with small amounts of Cadmium Yellow and Titanium White to highlight the foliage. *(Photo 14.)* Try not to just hit at random, carefully form individual leaf clusters.

Add the land area at the base of the large tree with the knife, a mixture of the Brown tree-color and Titanium White *(Photo 15)* paying close attention to the lay-of-the-land *(Photo 16)*.

FOREGROUND

Use the 2" brush with various mixtures of the dark Brown and Midnight Black to underpaint the foreground bushes. *(Photo 17.)* Add a very small amount of Cadmium Yellow to the 2" brush to very lightly highlight and shape the foreground bushes.

FENCE

To paint the fence, load the filbert brush with the dark Brown mixture, then pull one side of the bristles through a thin mixture of Liquid White and Brown, to double-load the brush. With the light side of the brush on the left, and paying close attention to perspective, paint each fence post. *(Photo 18.)* By double-loading the brush, you can highlight and shadow each post and rail.

Use a mixture of the Brown and Titanium White on the knife and short horizontal strokes to add just the indication of a path in the foreground. *(Photo 19.)*

Continue working forward with the light mixture on the knife to add the land area, and the dark mixtures on the 2" brush to underpaint foreground bushes. *(Photo 20.)*

FINISHING TOUCHES

With thinned mixtures on the liner brush, pull up long grasses *(Photo 21)* and your painting is complete *(Photo 22)*.

Don't forget to sign your painting: Again, load the liner brush with thinned color of your choice. Sign just your initials, your first name, your last name or all of your names. Sign in the left corner, the right corner or one artist we know signs right in the middle of the canvas! The choice is yours. You might also consider including the date when you sign your painting. Whatever your choices, have fun, for hopefully with this painting you have truly experienced THE JOY OF PAINTING!

Autumn Palette

1. Underpaint the foliage shapes with Black Gesso.

2. Tap down with the 2" brush . . .

3. . . . to add subtle light background trees . . .

4. . . . and to create the illusion of mist.

5. Add trunks with the liner brush.

Autumn Palette

6. Add land areas with the knife . . .

7. . . . paying close attention to the lay-of-the-land.

8. Shape large trunks with the filbert brush . . .

9. . . . then use the liner brush to highlight . . .

10. . . . and add limbs . . .

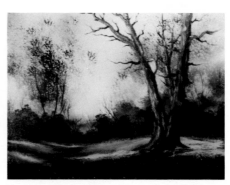
11. . . . to the large tree.

12. Underpaint leafy foliage with the 2" brush . . .

13. . . . before painting trunks with the liner brush.

14. Highlight foliage with the 2" brush.

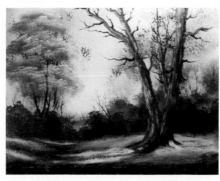
15. Use the knife . . .

16. . . . to continue adding land area to the base of the tree.

17. Add foreground bushes with the 2" brush.

18. Paint the fence with the filbert brush.

19. Use the knife and horizontal strokes . . .

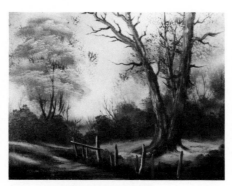
20. . . . to add the foreground path.

21. Pull up long grasses with the liner brush . . .

22. . . . and your painting is complete.

MATERIALS

2" Brush
2" Blender Brush
#6 Filbert Brush
#6 Fan Brush
Large Knife
Black Gesso

Liquid Clear
Titanium White
Prussian Blue
Midnight Black
Sap Green
Cadmium Yellow

Start by using a foam applicator to apply a thin, even coat of Black Gesso to your entire canvas and allow to DRY COMPLETELY.

When the Black Gesso is dry, use the 2" brush to completely cover the canvas with a VERY THIN coat of Liquid Clear. (It is important to stress that the Liquid Clear should be applied VERY, VERY sparingly and really scrubbed into the canvas! The Liquid Clear will not only ease with the application of the firmer paint, but will allow you to apply very little color, creating a glazed effect.)

Still using the 2" brush, cover the Liquid Clear with a very thin, even coat of a mixture of Midnight Black and Prussian Blue. Do NOT allow the canvas to dry before you proceed.

SKY

Load the 2" brush with a small amount of Titanium White, tapping the bristles firmly against the palette to evenly distribute the paint throughout the bristles. Starting at the top of the canvas, and working down towards the horizon, paint the sky with sweeping, horizontal strokes. *(Photo 1.)* (Notice how the White blends with the Blue-color already on the canvas.) Use a clean, very dry 2" brush to blend the entire sky. *(Photo 2.)*

BACKGROUND

Load the fan brush with a mixture of Midnight Black and Prussian Blue. Hold the brush vertically and tap downward to begin painting just the indication of tiny background evergreen trees on the right side of the painting. *(Photo 3.)* Add a very small amount of Titanium White to the left side of the brush to create the light areas in the trees.

With a very, very small amount of Titanium White on the 2" brush, firmly tap downward to diffuse and mist the base of the trees. *(Photo 4.)* Use just the top corner of the 2" blender brush and circular strokes to create the misty cloud effect at the base of the tiny background evergreens *(Photo 5)* before indicating the tiny trees on the left side of the background *(Photo 6)*.

Working forward in layers, add the larger, more distinct background evergreens by loading the fan brush to a chiseled edge with the Midnight Black-Prussian Blue mixture. Holding the brush vertically, touch the canvas to create the center line of each tree. Use just the corner of the brush to begin adding the small top branches. Working from side to side, as you move down each tree, apply more pressure to the brush, forcing the bristles to bend downward and automatically the branches will become larger as you near the base of each tree. *(Photo 7.)*

Load the knife with a mixture of Titanium White, Midnight Black and Prussian Blue: pull the paint out very flat on your palette and "cut" across to load the knife with a very small roll of paint. Holding the knife horizontally, scrub in the land area at the base of the larger evergreens. *(Photo 8.)* Use a clean fan brush and tiny upward strokes *(Photo 9)* to add the grassy patches to the land area *(Photo 10)*.

WATERFALL

Add more Titanium White to the White-Black-Blue mixture and again with a small roll of paint on the knife, begin scrubbing in the background water at the base of the land area. *(Photo 11.)* Still using the knife, make a series of long downward strokes to underpaint the large waterfall. *(Photo 12.)* Add tiny, sparkling highlights with additional Titanium White. *(Photo 13.)*

Over-paint the large waterfall (still using the knife) with pure Titanium White and long, vertical strokes. *(Photo 14.)* (Be very careful not to completely cover the underpainting.) With a clean, very dry 2" brush, brush upward from the base of the falls to lightly blend. *(Photo 15.)*

Tap the base of the falls with a very small amount of Titanium White on the 2" brush *(Photo 16)* and again blend with tiny cir-

cular strokes using the top corner of the blender brush *(Photo 17)*. You can add a very small amount of Titanium White to the blender brush and continue with circular strokes to create the layers of mist at the base of the falls.

Working forward in layers, shape the rocks and stones at the base of the falls with the Midnight Black-Prussian Blue mixture on the fan brush. *(Photo 18.)* Continue by misting the base of the rocks with a very small amount of Titanium White on the top corner of the blender brush. Use a mixture of Liquid Clear and Titanium White on the fan brush to shape the water and small waterfalls *(Photo 19)* at the base of the rocks and stones *(Photo 20)*.

FOREGROUND

Working forward in layers, use the fan brush and the Black-Blue mixture to add the large, foreground evergreens on the right side of the painting. *(Photo 21.)* Mist the base of the large evergreens with a small amount of Titanium White on the 2" brush. *(Photo 22.)*

On the left side of the painting, shape the large rocks with the knife and the dark Black-Blue mixture. *(Photo 23.)* Highlight the rocks by adding a small amount of Titanium White to the mixture, using so little pressure on the knife that the paint "breaks". Again, use the blender brush and circular strokes to mist the base of the large rocks.

Paint the large evergreens at the top of the rocks with the fan brush and the Black-Blue mixture, then add smaller evergreens

at the base of the rocks and at the base of the large evergreens on the right side of the painting.

With the White-Black-Blue mixture on the knife, add just a suggestion of tree trunks. *(Photo 24.)* Use a mixture of the dark tree color and a small amount of Sap Green and Cadmium Yellow on the fan brush to very lightly touch highlights to the evergreens.

FOREGROUND WATER

Use a mixture of Titanium White, Midnight Black and Prussian Blue on the fan brush and continue swirling the water forward at the base of the foreground trees. With a small amount of Titanium White on the 2" brush, pull straight down then lightly brush across to shimmer the foreground water. *(Photo 25.)*

To add small rocks and stones to the foreground water, dip the filbert brush into paint thinner before loading both sides of the bristles with the Black-Blue mixture. Then, pull one side of the bristles through Titanium White, to double-load the brush. With the light side of the bristles up, use curved strokes to shape the small rocks and stones. By double-loading the brush, you can highlight and shadow each rock and stone with a single stroke. *(Photo 26.)*

FINISHING TOUCHES

You can add water lines to the base of the small rocks and stones with a small roll of thinned White on the knife *(Photo 27)* to complete your masterpiece *(Photo 28)*.

Evening At The Falls

 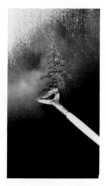

1. Use 2" brush and criss-cross strokes. . .

2. . . . to paint and blend the sky.

3. Indicate evergreens with the fan brush . . .

4. . . . then firmly tap with the 2" brush . . .

5. . . . to create mist.

6. Working in layers . . .

7. . . . continue adding evergreens.

Evening At The Falls

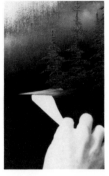

8. Scrub in land with the knife . . .

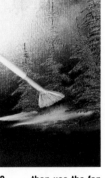

9. . . . then use the fan brush . . .

10. . . . to pull up grassy areas.

11. Begin scrubbing in the water . . .

12. . . . then use a series of . . .

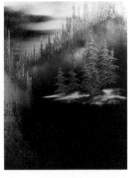

13. . . . downward strokes with the knife . . .

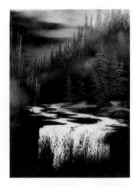

14. . . . to paint the water fall.

15. Brush up the base of the falls . . .

16. . . . then use circular strokes to mist.

17. Blend misty areas with the blender brush.

18. Shape rocks with the fan brush . . .

19. . . . then use thin paint . . .

20. . . . to add the swirling water.

21. Continue painting evergreens . . .

22. . . . and adding mist to the base of the trees.

23. Working forward, add rocks . . .

24. . . . and evergreen trunks.

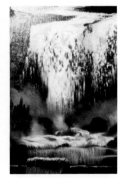

25. Pull down foreground water with the 2" brush.

26. Shape rocks with the filbert brush.

27. Cut in water lines . . .

28. . . . to complete the painting.

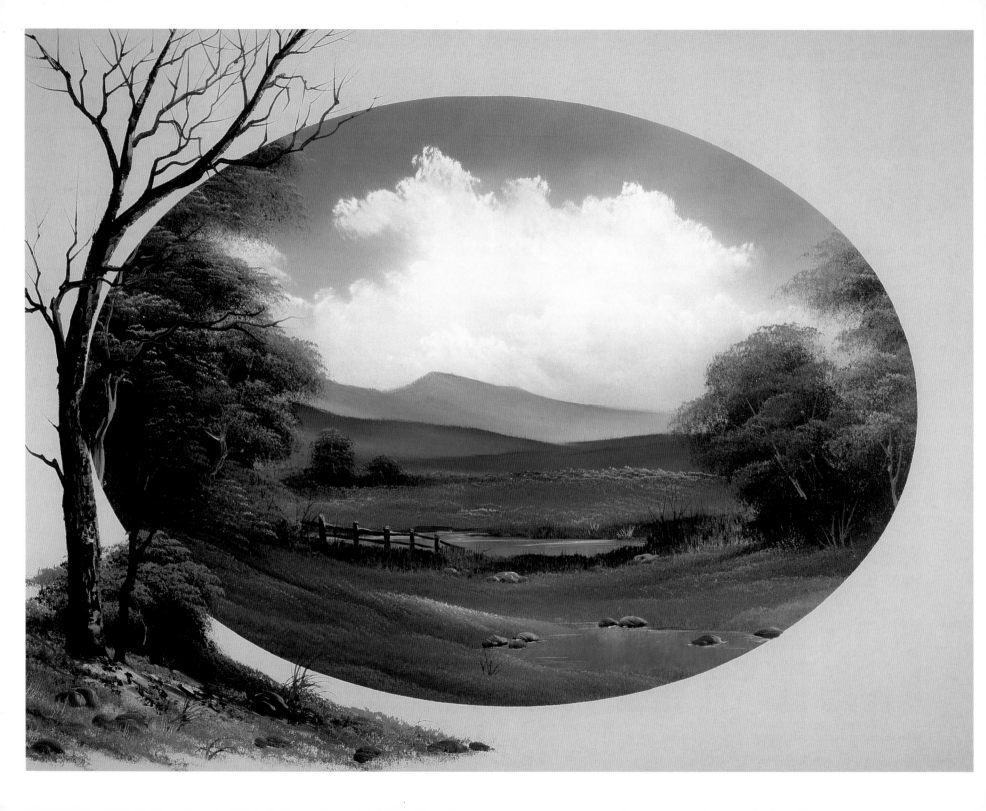

43. COUNTRYSIDE OVAL

MATERIALS

2" Brush	Prussian Blue
1" Brush	Midnight Black
#6 Filbert Brush	Dark Sienna
#6 Fan Brush	Van Dyke Brown
#2 Script Liner Brush	Alizarin Crimson
Large Knife	Sap Green
Adhesive-Backed Plastic	Cadmium Yellow
Liquid White	Yellow Ochre
Titanium White	Indian Yellow
Phthalo Blue	Bright Red

Start by covering the entire canvas with a piece of adhesive-backed plastic (such as Con-Tact Paper) from which you have removed a center oval shape. (A 16 x 20 oval for an 18 x 24 canvas.)

Use the 2" brush to cover the exposed area of the canvas with a thin, even coat of Liquid White. With long horizontal and vertical strokes, work back and forth to ensure an even distribution of paint on the canvas. Do NOT allow the Liquid White to dry before you begin.

SKY

Load the 2" brush with a very small amount of Phthalo Blue, tapping the bristles firmly against the palette to ensure an even distribution of paint throughout the bristles.

Starting at the top of the canvas and working downward, use criss-cross strokes to paint the sky. Notice how the color blends with the Liquid White already on the canvas and automatically the sky becomes lighter as it nears the horizon. Vary the color, leaving some areas of the sky quite light, to indicate cloud placement.

Use a mixture of Titanium White with a very small amount of Bright Red on the 1" brush to shape the clouds with tiny, circular strokes.

With the top corner of a clean, dry 2" brush, again make circular strokes to blend out just the base of the clouds, then light-ly lift upward to "fluff". Blend the entire sky. (Photo 1.)

ROLLING HILLS

Start by making a Lavender color, mixing a small amount of Phthalo Blue with some Alizarin Crimson. To a portion of this dark mixture, add a small amount of Titanium White to make a light Lavender color.

Load the long edge of the knife with a small roll of the lightest Lavender mixture and with firm pressure, shape just the top edge of the most distant hill. (Photo 2.) Remove any excess paint with the knife, then firmly pull the paint down to the base of the hill with a clean, dry 2" brush. (Photo 3.) The color will blend and mix with the Liquid White to create a misty appearance at the base of the distant hill.

Use the knife and the darker Lavender color to shape the closer hill. After removing the excess paint, again use the 2" brush to blend the paint down to the base of the mountain, creating the illusion of mist.

BACKGROUND

Use the dark Lavender mixture with Midnight Black, Van Dyke Brown, Alizarin Crimson and Sap Green on the 2" brush to tap in the soft grassy area at the base of the hills.

To highlight the grassy area, load the 2" brush by holding it at a 45-degree angle and tapping the bristles into various mixtures of all of the Yellows and Sap Green. Allow the brush to "slide" slightly forward in the paint each time you tap (this assures that the very tips of the bristles are fully loaded with paint.)

To apply the highlights, hold the brush horizontally and gently tap downward. Work in layers, carefully creating the lay-of-the-land. If you are also careful not to destroy all of the dark color already on the canvas, you can create grassy highlights that look almost like velvet.

Use the dark Lavender-Black-Brown-Crimson-Green mixture on the 1" brush to block in the basic shape of the small background trees. Highlight the small trees by again fully loading the

tips of the 2" brush with the Yellow highlight mixtures plus Bright Red and just tapping downward with the corner of the brush to shape each tree. *(Photo 4.)*

BACKGROUND WATER

Re-load the 2" brush with the dark tree mixture and just pull straight down to add the water in the background. Sparkle the water by adding a small amount of Titanium White to the brush. *(Photo 5.)*

Use a mixture of Van Dyke Brown and Dark Sienna on the fan brush to scrub in the banks along the water's edge. *(Photo 6.)* With a small roll of Liquid White on the knife *(Photo 7)* cut in the water lines and ripples.

FOREGROUND

Working forward in the painting, continue using the dark tree mixtures on the 2" brush to underpaint the large trees and bushes. *(Photo 8.)* Extend this dark mixture to the bottom of the oval.

Use a mixture of Titanium White and Dark Sienna on the liner brush to add the tree trunks. (To load the liner brush, thin the mixture to an ink-like consistency by first dipping the liner brush into paint thinner. Slowly turn the brush as you pull the bristles through the mixture, forcing them to a sharp point.) Apply very little pressure to the brush as you shape the trunks. By turning and wiggling the brush, you can give your trunks a gnarled appearance. *(Photo 9.)*

Highlight the large trees and bushes with the Yellows and Sap Green on the 2" brush. *(Photo 10.)*

Use thinned Van Dyke Brown on the liner brush to paint the small fence posts. *(Photo 11.)* Highlight the fence with thinned Titanium White on the liner brush.

Create soft grassy areas in the foreground with the Yellow highlight mixtures on the 2" brush. *(Photo 12.)*

Pull in the foreground water with a mixture of Titanium White and Phthalo Blue on the 2" brush. *(Photo 13.)*

Working forward in layers, use the Yellow highlight mixtures on the 2" brush to continue adding the soft grassy areas *(Photo 14)* and to highlight the large trees and bushes *(Photo 15)*.

To add small rocks and stones to the water, load the filbert brush with a mixture of Van Dyke Brown and Dark Sienna, then pull one side of the bristles through a thin mixture of Liquid White, Van Dyke Brown and Dark Sienna. With the light side of the brush UP, use a single, curved stroke to shape each of the

small rocks and stones. *(Photo 16.)* Use Liquid White on the fan brush to add ripples to the base of the rocks.

Carefully remove the Con-Tact Paper to expose the painted oval. *(Photo 17.)*

LARGE TREE

Use Van Dyke Brown on the fan brush to paint the large tree trunk outside the oval. *(Photo 18.)* Add the small bushes at the base of the tree with the 2" brush. *(Photo 19.)*

Use thinned Van Dyke Brown on the liner brush to add the small tree trunk and limbs and branches. *(Photo 20.)*

With a small roll of Van Dyke Brown on the edge of the knife, add the land area at the base of the tree and then highlight with a mixture of Titanium White and Dark Sienna, using so little pressure that the paint "breaks". *(Photo 21.)*

FINISHING TOUCHES

Use the Yellow highlight mixtures on the fan brush and push-up strokes to add the grassy areas at the base of the large tree and your painting is complete. *(Photo 22.)*

Don't forget to sign your name with pride: Again, load the liner brush with thinned color of your choice. Sign just your initials, first name, last name or all of your names. Sign in the left corner, the right corner or one artist signs right in the middle of the canvas! The choice is yours. You might also consider including the date when you sign your painting. Whatever your choices, have fun, for hopefully with this painting you have truly experienced THE JOY OF PAINTING.

Countryside Oval

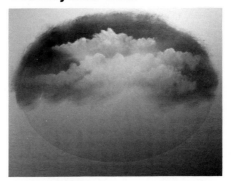

1. After painting the sky . . .

2. . . . shape rolling hills with the knife . . .

3. . . . then blend with the 2" brush.

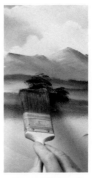

4. Use the 2" brush to apply highlights . . .

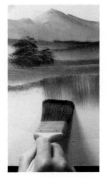

5. . . . and to paint reflections.

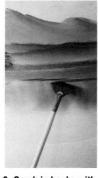

6. Scrub in banks with the fan brush . . .

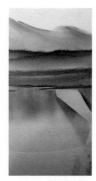

7. . . . then cut in water lines with the knife.

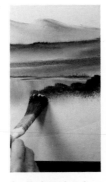

8. Underpaint foreground trees and bushes with the 1" brush.

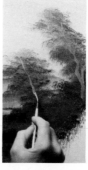

9. Use thinned paint on the liner brush to add trunks.

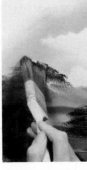

10. Apply tree highlights with the corner of the 2" brush.

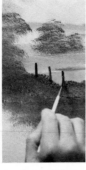

11. Paint tiny fence posts with the liner brush.

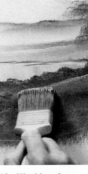

12. Working forward in layers, add soft grass . . .

13. . . . reflections . . .

14. . . . then more soft grass in the foreground.

15. Highlight the foreground trees . . .

16. . . . then add rocks with the filbert brush.

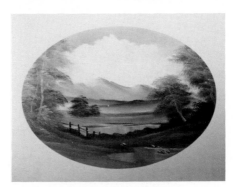

17. After removing the Con-Tact Paper . . .

18. . . . use the fan brush to paint the tree trunk . . .

19. . . . then add bushes to the base with the 2" brush . . .

20. . . . and limbs and branches with the liner brush.

21. Add land to the base of the tree . . .

22. . . . and your painting is complete.

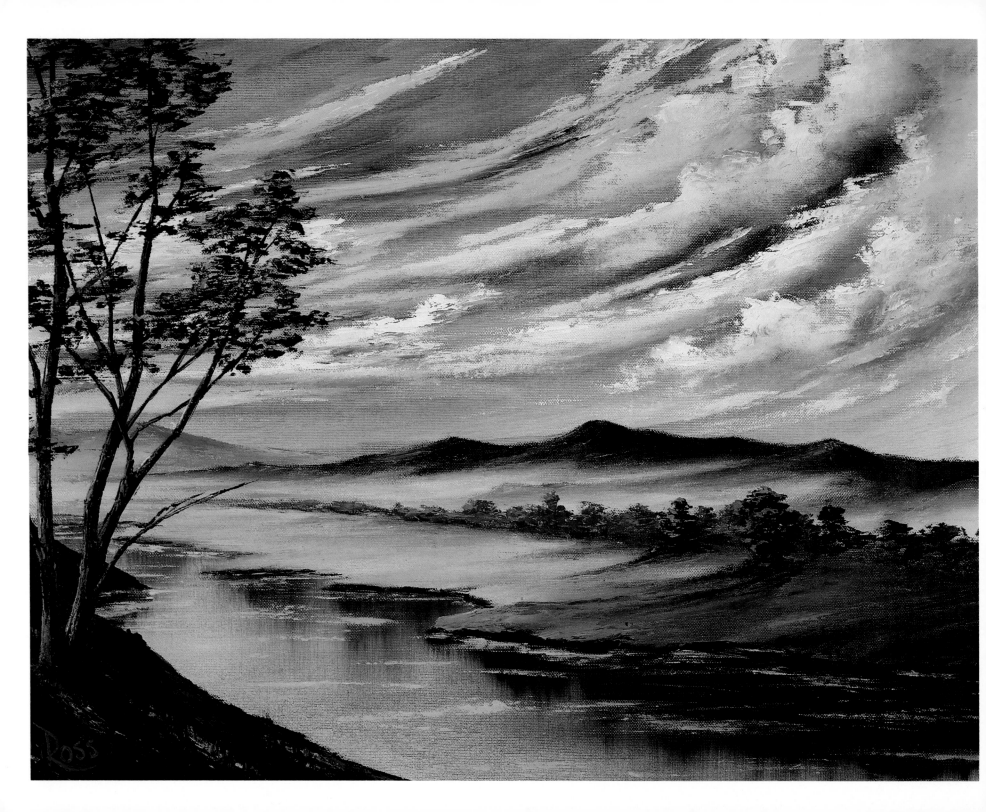

MATERIALS

2" Brush	Phthalo Blue
Large Knife	Phthalo Green
Alizarin Crimson	Sap Green
Dark Sienna	Titanium White
Cadmium Yellow	Van Dyke Brown
Indian Yellow	Yellow Ochre
Bright Red	

SKY

This painting begins with a dry canvas. With the 2" brush, cover the entire canvas with a wash made with Phthalo Blue and paint thinner. Thin the color to a watery consistency and scrub it onto the canvas. This is only background color and will dry very rapidly. The clouds are made with a small roll of Titanium White on the long edge of the knife. Work back and forth with the knife, paying close attention to angles. For shadows, add a small amount of Alizarin Crimson and Phthalo Blue. With the knife, blend the highlight and shadow colors together to form your clouds. Be careful not to cover all of the Blue wash in the background. *(Photo 1.)*

BACKGROUND

The distant hills are made with a Purple color created by mixing Alizarin Crimson and Phthalo Blue. Load a roll of paint on the long edge of the knife and, with a very firm pressure, paint the basic shapes. *(Photo 2.)* Very little color is required. A small amount of Bright Red and Titanium White is used to highlight the hills. Place your highlights where you think light would strike your mountains. *(Photo 3.)* A small amount of Titanium White, blended very firmly, in small circular strokes of the knife *(Photo 4)* will give the feeling of mist at the base of the mountain *(Photo 5)*. As the hills get closer to you, they should get progressively darker in color.

The distant trees under the hills are made with a mixture of Cadmium Yellow, Sap Green, Dark Sienna and Yellow Ochre. Keep this color quite dark so it will stand out against the light mist at the base of the hills. *(Photo 6.)* Hold the knife horizontally and just touch the canvas to make the trees. *(Photo 7.)* The grassy area under these trees is made with the same colors plus Titanium White. A touch of Bright Red and Indian Yellow may be added for highlights. The darker areas are created by adding a small amount of Sap Green to your color. This is another area where angles play a very important part, so be very careful. *(Photo 8.)* The individual trees in the background are made with the small edge of the knife loaded with Sap Green. *(Photo 9.)* The trees are highlighted the same way with Cadmium Yellow. *(Photo 10.)*

WATER

Both the land and water are made with a Black color created by mixing Alizarin Crimson and Phthalo Green. *(Photo 11.)* Use the knife to lay in the land areas and the basic reflections in the water. Use a very firm pressure when applying the color for the reflections. *(Photo 12.)* Pull straight down with the 2" brush *(Photo 13)* held flat, to complete the reflections *(Photo 14)*. The ripples on the water are made with the knife held horizontally, loaded with Phthalo Blue and Titanium White. *(Photo 15.)* Load the knife with a small roll of paint and use short, back and forth strokes, to create ripples on the water. *(Photo 16.)*

FOREGROUND

The basic foreground shape is laid in with the knife and Black made from Alizarin Crimson and Phthalo Green. *(Photo 17.)* The highlights are applied the same way using Sap Green and all the Yellows.

The large tree is made with Van Dyke Brown and Dark Sienna. *(Photo 18.)* Load a roll of paint, hold the knife vertically, touch the canvas and pull sideways. *(Photo 19.)* A touch of highlight color made from Bright Red, Dark Sienna and Yellow Ochre is applied with the knife. *(Photo 20.)* Leaves on the tree are a mixture of Sap Green and Van Dyke Brown. Hold the knife horizontally and allow it to bounce back and forth. Highlights are Cadmium Yellow and Sap Green applied in the same manner. *(Photo 21.)*

FINISHING TOUCHES

Spend some time blending with the knife and you can create some soft, beautiful effects that are almost unbelievable. A signature is all that is required to finish this painting. *(Photo 22.)*

Western Expanse

1. Paint the sky area of the painting.

2. Use firm pressure . . .

3. . . . to paint the distant hills.

4. White paint at the base of the mountain . . .

5. . . . will create a misty area.

6. Just touch the knife to the canvas . . .

7. . . . to make distant tree indications.

8. Close attention to angles will create the illusion of grassy areas under the distant trees.

Western Expanse

9. Individual trees in the background are made . . .

10. . . . and highlighted with the small edge of the knife.

11. Use the knife to lay in the land areas . . .

12. . . . and the reflections in the water.

13. Pull straight down with the 2" brush . . .

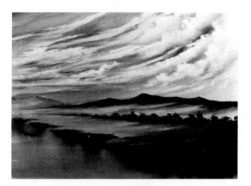

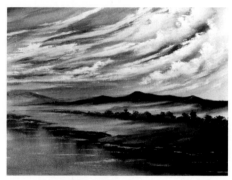

14. . . . to complete the reflections.

15. With a small roll of paint on the long edge of the knife . . .

16. . . . add ripples to the water.

17. The foreground is laid in with the knife.

18. Use the long edge of the knife . . .

19. . . . to make and highlight . . .

20. . . . the large tree in the foreground.

21. A few leaves can be tapped on with the knife . . .

22. . . . and your painting is ready to sign.

45. ENCHANTED FALLS OVAL

MATERIALS

2" Brush	Liquid White
1" Oval Brush	Liquid Clear
#6 Fan Brush	Titanium White
#2 Script Liner Brush	Alizarin Crimson
Large Knife	Sap Green
Adhesive-Backed Plastic	Yellow Ochre
Black Gesso	Indian Yellow

Begin by covering the entire canvas with a piece of adhesive-backed plastic (such as Con-Tact Paper) from which a center oval shape has been removed. (A 16 x 20 oval for an 18 x 24 canvas.)

Use a sponge (preferably a natural sponge) and Black Gesso to tap in the dark, foliage shapes, allowing the center of the canvas to remain quite light. Allow the canvas to DRY COMPLETELY. (Photo 1.)

When the Black Gesso is dry, use the 2" brush to cover the exposed area of the canvas with a VERY THIN coat of Liquid Clear. (It is important to stress that the Liquid Clear should be applied VERY, VERY sparingly and really scrubbed into the canvas; excess Liquid Clear can be removed with a paper towel, if necessary. The Liquid Clear will not only ease the application of the firmer paint, but will allow you to apply very little color, creating a glazed effect.) Do NOT allow the Liquid Clear to dry.

Still using the 2" brush, cover the canvas with a very small amount of a Brown mixture made with equal parts of Sap Green and Alizarin Crimson. Do NOT allow the canvas to dry before you begin your painting.

SKY

Load a clean, dry 2" brush by tapping the bristles into a small amount of a mixture of Titanium White and Indian Yellow. Starting in the center of the oval and working outward, make circular strokes with the corner of the brush to paint the sky, repeating as often as necessary to achieve the desired lightness. (Photo 2.) Blend the entire sky with long, horizontal strokes. (Photo 3.)

BACKGROUND

Load the oval brush with Titanium White and the Alizarin Crimson-Sap Green mixture. Tap downward to shape the background trees. (Photo 4.) Allow the trees to become darker (by using less Titanium White in the mixture) as you work away from the light source.

Add just the indication of background tree trunks with the Alizarin Crimson-Sap Green mixture. (To load the liner brush, thin the paint to an ink-like consistency by first dipping the brush into paint thinner. Slowly turn the handle of the brush as you pull the bristles through the mixture, forcing them to a sharp point.) Apply very little pressure to the brush when shaping these branches and trunks (Photo 5) to maintain the illusion of distance (Photo 6).

As you work forward in layers, the trees and tree trunks should become larger and quite dark, especially along the edges of the oval where the deepest shadows are created. (Photo 7.)

WATERFALL

Load the fan brush with a mixture of Liquid Clear, Titanium White and a small amount of Indian Yellow. Holding the brush horizontally and beginning at the top of the falls, make a short, horizontal stroke (Photo 8) then pull the brush straight down (Photo 9) to the base of the falls (Photo 10).

Use the Brown mixture on the knife to shape the waterfall rock. (Photo 11.) Add the highlight to the rock with a mixture of the Brown and Titanium White, with so little pressure that the paint "breaks".

Continue using the fan brush with the Liquid Clear-White-Yellow mixture to complete the waterfall. (Photo 12.) With a clean, dry 2" brush, gently brush upward from the base of the falls, to blend and mist. (Photo 13.)

Dip a clean fan brush into paint thinner (shake the brush to remove the excess thinner) then pull the bristles across the blade of the knife (or the edge of your palette) directing the spray

of thinner towards the base of the waterfall. *(Photo 14.)* As the tiny droplets of thinner interact with the Liquid Clear already on the canvas, you can create very interesting water actions at the base of the falls. *(Photo 15.)*

FOREGROUND

Add the large stone at the edge of the waterfall with the knife and the Alizarin Crimson-Sap Green mixture. *(Photo 16.)* Shape the contour of the stone by adding a small amount of Titanium White to the mixture and using so little pressure that the paint "breaks". *(Photo 17.)*

Continue adding trees, rocks and foliage with the oval brush and the Alizarin Crimson-Sap Green mixture. Allow some of the bushes to hang over the waterfall. (This will "push" the waterfall "into" the painting.)

With a very small amount of Titanium White on a clean, dry 2" brush, create the mist at the base of the waterfall by softly tapping with the top corner of the brush. *(Photo 18.)* Still using Titanium White on the 2" brush, pull straight down to add reflections to the water at the base of the falls *(Photo 19)* then lightly brush across.

Continue using the Brown mixture and the oval brush to add small trees and bushes along the water's edge.

Highlight the trees and bushes with the oval brush and a mixture of the Brown and Yellow Ochre. *(Photo 20.)* Again, work in layers and allow the dark under-color to separate individual tree and bush shapes. *(Photo 21.)*

Add the banks along the water's edge with the Brown mixture and the knife, then highlight by adding a small amount of Titanium White. *(Photo 22.)*

Use thinned light mixtures on the liner brush to add tiny sticks and twigs, long grasses *(Photo 23)* and ripples in the water *(Photo 24)*.

FINISHING TOUCHES

When you are satisfied with your painting *(Photo 25)* carefully remove the Con-Tact Paper *(Photo 26)* to expose your finished masterpiece *(Photo 27)*.

Don't forget to sign your painting: Load the liner brush with thinned color of your choice. Sign just your initials, first name, last name or all of your names. Sign in the left corner, the right corner or one artist we know signs right in the middle of the canvas! The choice is yours. You might also consider including the date when you sign your painting. Whatever your choices, have fun, for hopefully with this painting you have truly experienced THE JOY OF PAINTING.

Enchanted Falls Oval

1. Use Black Gesso to underpaint the basic dark shapes.

2. Use the 2" brush and circular strokes . . .

3. . . . to paint the sky.

4. Paint background trees by tapping down with the oval brush.

5. Use thin paint on the liner brush . . .

6. . . . to add the background tree trunks.

7. Continue layering background trees.

Enchanted Falls Oval

8. Start with a short horizontal stroke . . .

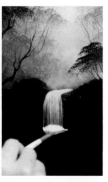

9. . . . then pull straight down with the fan brush . . .

10. . . . to paint the waterfall.

11. Shape rocks with the knife . . .

12. . . . then continue painting the falling water.

13. Brush up with the 2" brush to diffuse the base of the falls.

14. Lightly spray the canvas with paint thinner . . .

15. . . . to add tiny details to the waterfall.

16. Use the knife to shape large rocks . . .

17. . . . and then contour with highlights.

18. Use the 2" brush to mist the base of the falls . . .

19. . . . and to pull down reflections in the water.

20. Tap down with the oval brush . . .

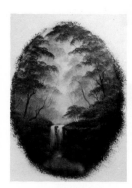

21. . . . to highlight trees and bushes.

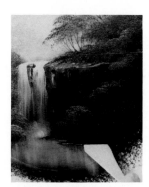

22. Use the knife to add banks to the water's edge.

23. Pull up long grasses . . .

24. . . . and add ripples to the water with the liner brush.

25. When you are satisfied with your painting . . .

26. . . . carefully remove the Con-Tact Paper . . .

27. . . . to expose your finished masterpiece.

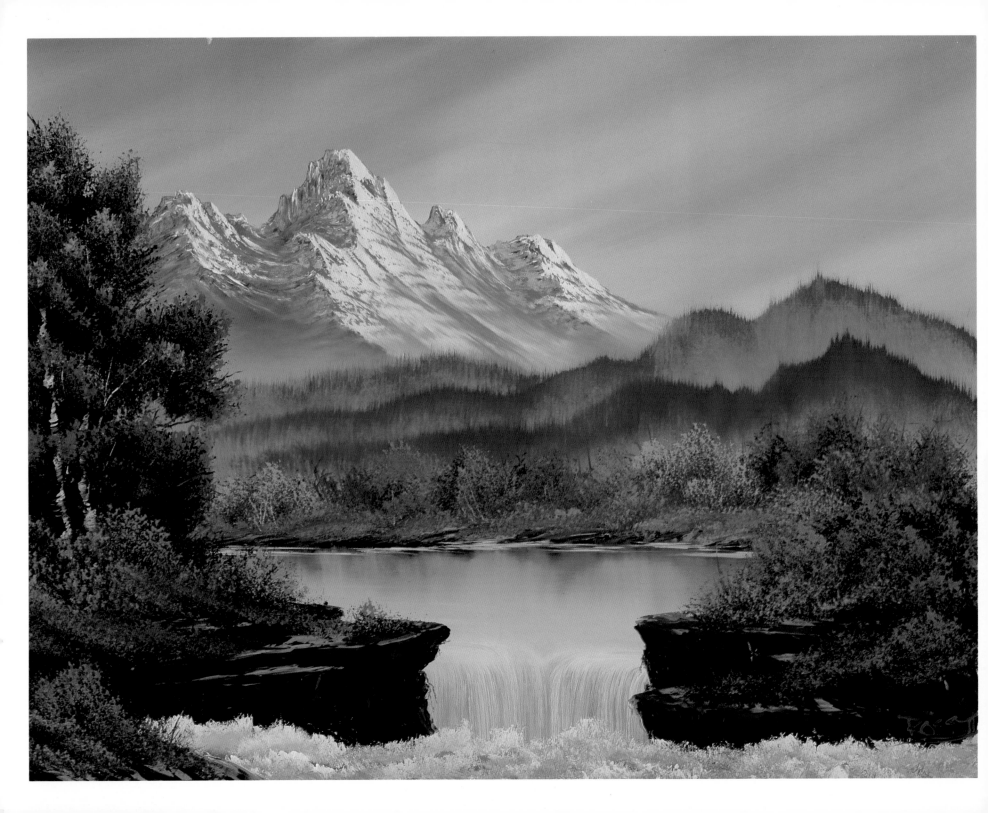

46. SURPRISING FALLS

BY STEVE ROSS

MATERIALS

2" Brush	Midnight Black
1" Brush	Dark Sienna
#6 Fan Brush	Van Dyke Brown
#2 Script Liner Brush	Alizarin Crimson
Large Knife	Sap Green
Liquid White	Cadmium Yellow
Titanium White	Yellow Ochre
Phthalo Green	Indian Yellow
Phthalo Blue	Bright Red
Prussian Blue	

Start by covering the entire canvas with a thin, even coat of Liquid White, using the 2" brush. Do NOT allow the Liquid White to dry before you begin.

SKY

Load the 2" brush with Phthalo Blue and starting at the top of the canvas, use criss-cross strokes to paint in the sky. (Photo 1.) Be sure to leave open, unpainted areas for the indication of clouds. Without cleaning the brush, use horizontal strokes and Phthalo Green to add the water to the lower portion of the canvas. Pull from the outside edges of the canvas, leaving the center unpainted to create the illusion of shimmering light. Use a clean, dry 2" brush to blend the entire canvas. (Photo 2.)

MOUNTAINS

The mountains are made with a mixture of Midnight Black, Van Dyke Brown, Prussian Blue and Alizarin Crimson on the long edge of the knife. Use firm pressure to shape just the top portion of the mountain. (Photo 3.) With a clean, dry 2" brush, pull the color down to the base of the mountain to complete the entire shape. (Photo 4.)

For the highlights, load the long edge of the knife with a small roll of Titanium White. In this painting, the light is coming from the right. So, starting at the top of the mountain, glide the knife down the right side of each peak, using so little pressure that the paint "breaks". (Photo 5.) The shadows are applied to the left sides of the peaks using a mixture of Prussian Blue and Titanium White. With a clean, dry 2" brush, tap to diffuse the base of the mountain, carefully following the angles. (Photo 6.) Finally, lift upward to create a misty appearance. Your mountain should be more distinct at the top than at the bottom. (Photo 7.)

BACKGROUND

Load the 1" brush by tapping the bristles into a mixture of Sap Green, Van Dyke Brown and Titanium White. Holding the brush horizontally, just tap in basic foothill shapes, following the lay-of-the-land. (Photo 8.) With a clean, dry 1" brush, grab just the top edges of the hills and make tiny, upward strokes. This will give the impression of small trees in the distance. Use the corner of a clean, dry 2" brush to tap and diffuse the base of the hills, creating a misty appearance. (Photo 9.) Paint a closer range of hills, using a darker mixture by adding more Sap Green and Van Dyke Brown. The closest row of foothills is made with an even darker mixture of Sap Green and Van Dyke Brown. (Photo 10.)

Still using the same dark mixture and the 1" brush, move forward in the painting and tap in the indication of distant leafy tree shapes. (Photo 11.) Extend this dark color into the water area. With a clean, dry 2" brush, pull down the reflections and gently brush across to create the water.

The shoreline is made by loading the knife edge with a small roll of Van Dyke Brown, forming land shapes by just touching the canvas. (Photo 12.) The highlights are a mixture of Van Dyke Brown, Dark Sienna and Titanium White, applied with so little pressure that the paint "breaks". (Photo 13.) Use the 2" brush to pull down reflections of the shore-line into the water and brush gently across.

To highlight the leafy tree shapes, dip the 1" brush into Liquid White and then pull the brush (in one direction to round one corner) through various mixtures of Sap Green, all of the Yellows and Bright Red. With the rounded corner up, gently touch the canvas forcing the bristles to bend upward, creating the individual tree and bush shapes. (Photo 14.)

Water lines are made with Liquid White loaded on the long edge of the knife. Hold the knife horizontally and cut straight into the canvas with a firm pressure. *(Photo 15.)*

WATERFALL

Use the 2" brush with Prussian Blue and Phthalo Blue to underpaint the waterfall area. *(Photo 16.)* Load the fan brush with a mixture of Liquid White and Titanium White. To make the waterfall, hold the fan brush horizontally, make a short horizontal stroke and then pull straight down. *(Photo 17.)* Start with the most distant part of the waterfall and work forward, overlapping your strokes. Use short, horizontal strokes to continue making water movements at the top of the waterfall using Liquid White and Titanium White on the fan brush.

With Van Dyke Brown on the long edge of the knife, lay in the cliff shapes on either side of the waterfall. Highlights are applied using the knife with so little pressure that the paint is allowed to "break". *(Photo 18.)* Use various mixtures of the Browns and Titanium White.

Load the fan brush with a mixture of Liquid White and Titanium White and "push in" some little water splashes at the base of the waterfall and cliffs. *(Photo 19.)*

With the 1" brush and the Sap Green-Van Dyke Brown paint mixture, underpaint the bushes and grasses on the cliffs *(Photo 20),* then pop in and highlight individual bush shapes using the 1" brush and various mixtures of all of the Yellows, Sap Green and Bright Red; be careful not to "kill" all of your dark base color.

LARGE TREE

The large tree on the left is made with the 1" brush and the same dark mixture of Sap Green and Van Dyke Brown. Just tap in the basic tree shape. *(Photo 21.)*

Load the knife with a small roll of Van Dyke Brown, touching it to the canvas to lay in the tree trunk. Highlight the trunk with a mixture of Van Dyke Brown and Titanium White on the long edge of the knife. *(Photo 22.)* Hold the knife vertically, touch the paint to the bright side of the trunk and give a little sideways pull. Branches are scratched in with the point of the knife.

Highlight the leaf clusters, again using the various Yellows and Bright Red on the 1" brush.

FINISHING TOUCHES

Indicate small sticks and twigs using the point of the knife, and don't forget to add your signature with thinned paint on the liner brush. *(Photo 23.)*

Surprising Falls

 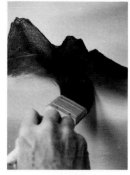 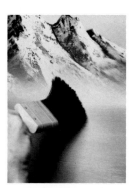

1. Use criss-cross strokes to paint the sky . . .

2. . . . and horizontal strokes to paint the water.

3. Shape the mountain top with the knife . . .

4. . . . and then pull the color down to the base with the 2" brush.

5. Apply highlights with the knife . . .

6. . . . and then use the 2" brush . . .

Surprising Falls

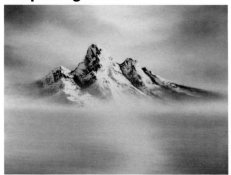

7. . . . to mist the base of the mountain.

8. Shape the foothills with the 1" brush . . .

9. . . . and then tap firmly with the 2" brush . . .

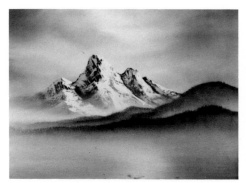

10. . . . to create the illusion of mist.

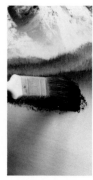

11. Background trees are made with the 1" brush.

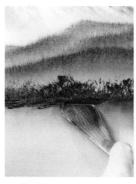

12. Make the banks along the water's edge . . .

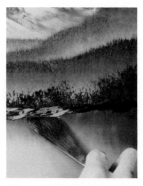

13. . . . and highlight them with the knife.

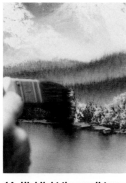

14. Highlight the small trees with the 1" brush . . .

15. . . . and cut in water lines with the knife.

16. Use the 2" brush to underpaint the falls.

17. Single downward strokes . . .

18. . . . and then highlight them.

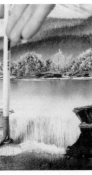

19. "Bubble" water at the base of the falls.

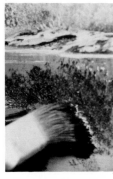

20. Use the 1" brush to add foliage.

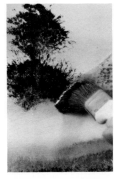

21. Use the 1" brush for the trees . . .

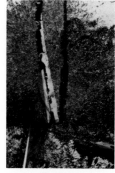

22. . . . the knife for the trunks . . .

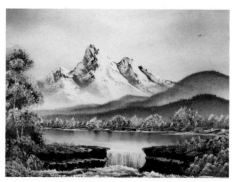

23. . . . and the painting is finished.

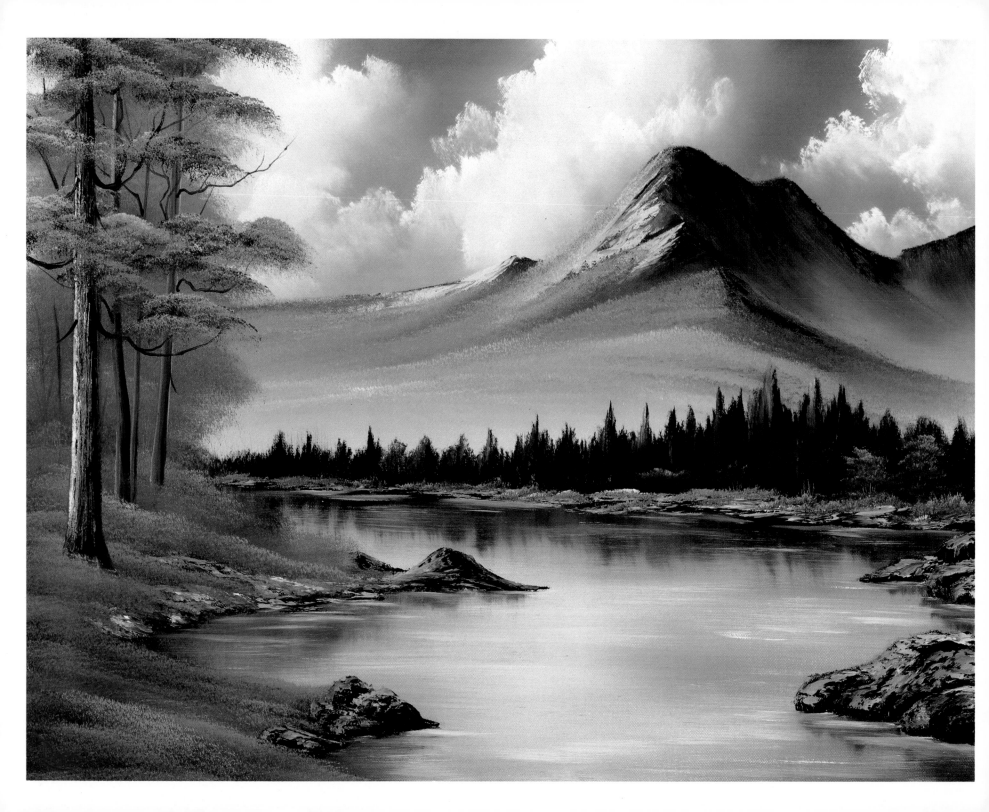

MATERIALS

2" Brush	Midnight Black
1" Oval Brush	Dark Sienna
#6 Fan Brush	Van Dyke Brown
#2 Script Liner Brush	Alizarin Crimson
Large Knife	Sap Green
Liquid White	Cadmium Yellow
Titanium White	Yellow Ochre
Phthalo Green	Indian Yellow
Phthalo Blue	Bright Red
Prussian Blue	

Start by covering the entire canvas with a thin, even coat of Liquid White using the 2" brush. With long horizontal and vertical strokes, work back and forth to ensure an even distribution of paint on the canvas. Do NOT allow the Liquid White to dry before you begin.

SKY AND WATER

Load the 2" brush with a mixture of Prussian Blue and Midnight Black, tapping the bristles firmly against the palette to ensure an even distribution of paint throughout the bristles. Starting at the top of the canvas and working toward the horizon, use small criss-cross strokes to paint the sky. Leave some areas of the sky open and unpainted.

Add Phthalo Blue, Midnight Black and Phthalo Green to the brush and use long, horizontal strokes to add the water to the lower half of the canvas. Pull the strokes from the outside edges of the canvas in towards the center. If you leave the center area of the water unpainted, you can create the illusion of shimmering light.

Use the 2" brush to add the clouds to the sky with Titanium White mixed with a very small amount of Bright Red. Use the corner of the brush and tiny circular motions to make the clouds. When you are satisfied with your cloud shapes, use just the top corner of a clean, dry 2" brush to blend out the bottoms of the clouds (carefully not touching the top edges) and then sweep-

ing, upward strokes to further blend and "fluff". Complete the sky with very light, long, horizontal strokes to blend. (Photo 1.)

MOUNTAIN

The mountain is made with Midnight Black, Prussian Blue, Alizarin Crimson and Yellow Ochre. The Ochre will give your mountain a Greenish hue which you can test by mixing a small amount of the mixture with some Titanium White. When you are satisfied with your mountain mixture color, pull it out very flat on your palette and just cut across to load the long edge of the knife with a small roll of paint. Use firm pressure (really pushing the paint into the canvas) to shape the mountain. At this point, you should be concerned only with the shape of the top edge of your mountain. (Photo 2.) Use the 2" brush to pull the paint down to the base of the mountain, thereby completing the entire shape. (Photo 3.)

These are soft grass-covered mountains and even though there is no snow on them, we will touch some highlight color to the left sides of the peaks. Use Titanium White on the knife to which you have added a very small amount of Bright Red. Highlight the top portions of the peaks, using so little pressure that the paint "breaks". (Photo 4.)

Load the 2" brush by tapping it into various mixtures of Yellow Ochre, Sap Green, Midnight Black, Cadmium Yellow and Indian Yellow. Add grass to the sunny (left) side of the mountain using a tapping motion. (Photo 5.) Start at the base and work towards the top, being very careful to follow the angles. You can add a little Titanium White here and there for sun "sparkles". (Photo 6.)

Use the original mountain mixture on the knife to just define the edges of the peaks and add other small details to the shadow sides of the mountain.

Again, being very careful to follow angles, use a clean, dry, 2" brush to tap (to diffuse) the base of the mountain, creating the illusion of mist.

BACKGROUND

The small evergreens at the base of the mountain are made

with the fan brush and a mixture of Midnight Black, Prussian Blue, Van Dyke Brown, Alizarin Crimson and Sap Green. (You will need quite a large amount of this dark mixture.)

Load the fan brush full of paint, hold it vertically and just tap downward to indicate the small, distant trees at the base of the mountain. (Photo 7.) Watch your perspective! The closer trees should be larger and more distinct than the more distant trees. Reflect this dark color into the water and then with a clean, dry 2" brush, pull the reflections straight down and lightly brush across. (Photo 8.)

Use a small roll of Van Dyke Brown on the knife to add the land under the distant trees. Pay close attention to angles and perspective. Highlight the land using the knife with a mixture of Dark Sienna and Titanium White; use very little pressure, forcing the paint to "break". (Photo 9.)

Add Cadmium Yellow to the dark mixture on the fan brush used to make the trees and force the bristles to bend upward as you add little patches of grass to the land area. A touch of Titanium White here and there will create sun "sparkles". Use Cadmium Yellow on the brush to add a few highlights to some of the evergreen trees.

Load a clean fan brush with a mixture of Liquid White and Titanium White and then barely grazing the canvas, use short, sweeping, horizontal strokes to create the water's edge, ripples and a sheen of light playing across the water. (Photo 10.)

FOREGROUND

Load the 2" brush by tapping it firmly into a mixture of Van Dyke Brown and Dark Sienna. Beginning on the left side of the painting, use a tapping motion to paint the large leaf trees and bushes. (Photo 11.) Start at the dark base of each tree and then add Yellow Ochre to the brush near the tree tops to lighten. Reverse the brush and add this dark base color to the water, for reflections. Decide just where the reflections will be and use the brush to pull straight down and then brush across to begin creating a "watery" effect. (Photo 12.)

Use a small roll of Van Dyke Brown on the knife to add the land under the trees and bushes. Also use the knife and Van Dyke Brown to shape the rocks and stones along the water's edge on both the left and right sides of the painting. (Photo 13.) Use the knife to pull a little of the Van Dyke Brown down into the water for the rock reflections. With a mixture of Liquid White and Titanium White on the fan brush (Photo 14), add water lines and ripples (Photo 15).

Use a mixture of Titanium White, Midnight Black and Dark Sienna on the knife to highlight the left sides of the rocks, using so little pressure that the paint "breaks". Add Prussian Blue to the mixture for the right sides of the rocks, which are in shadow.

To paint the tree trunks, load both sides of the fan brush with a mixture of Van Dyke Brown and Dark Sienna and then add Titanium White to one side of the brush. Hold the double-loaded brush vertically (with the light side to the left) and, starting at the top of the canvas, just pull down to add the large tree trunks. (Photo 16.) Use more pressure as you near the base, allowing the trunks to become wider. Add the limbs and branches with a mixture of paint thinner and Van Dyke Brown on the liner brush.

Use the oval brush, with the same dark mixture of Van Dyke Brown and Dark Sienna, to underpaint the leaf clusters on the large trees. Tap on the highlights with Cadmium Yellow added to the same brush; be very careful not to "kill" all of the dark undercolor. (Photo 17.)

Load the 2" brush by tapping it firmly into various mixtures of all the Yellows, Sap Green and Bright Red. Carefully following the lay-of-the-land (and working in layers) hold the brush horizontally and just tap to highlight the grass at the base of the trees. If you have trouble making the paint stick, add a little paint thinner to your mixtures. You can load the fan brush with the same mixtures, and forcing the bristles to bend upward, add little grassy "things" along the edge of the water. Again, use Titanium White on the fan brush to add the water's edge.

FINISHING TOUCHES

Use the point of the knife to add small sticks and twigs; you can also use a thinned paint on the liner brush for other small details. Sign your masterpiece, stand back and admire! (Photo 18.)

Secluded Mountain

1. After painting the sky . . .

2. . . . use the knife to paint the mountain top . . .

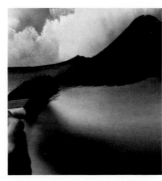

3. . . . and the 2" brush to complete the shape.

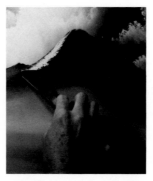

4. Highlight the mountain with the knife.

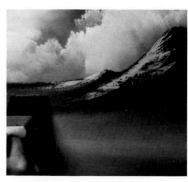

5. Use the 2" brush to add grass . . .

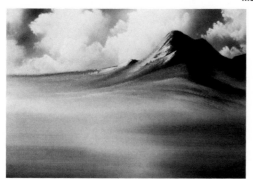

6. . . . to the base of the mountain.

7. Tap downward with the fan brush for distant trees.

8. Pull down with the 2" brush for reflections.

9. Add the banks with the knife . . .

10. . . . then add water lines with the fan brush.

11. With the 2" brush paint the large trees . . .

12. . . . then pull down to make reflections.

13. Use the knife to shape rocks and stones.

14. The fan brush is used . . .

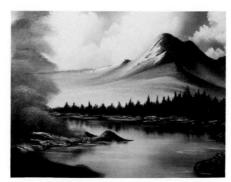

15. . . . to add water lines and ripples.

16. Double-load the fan brush to make tree trunks . . .

17. . . . then add leaves with the oval brush . . .

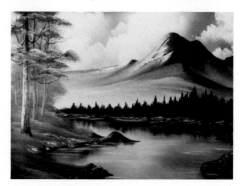

18. . . . to complete the painting.

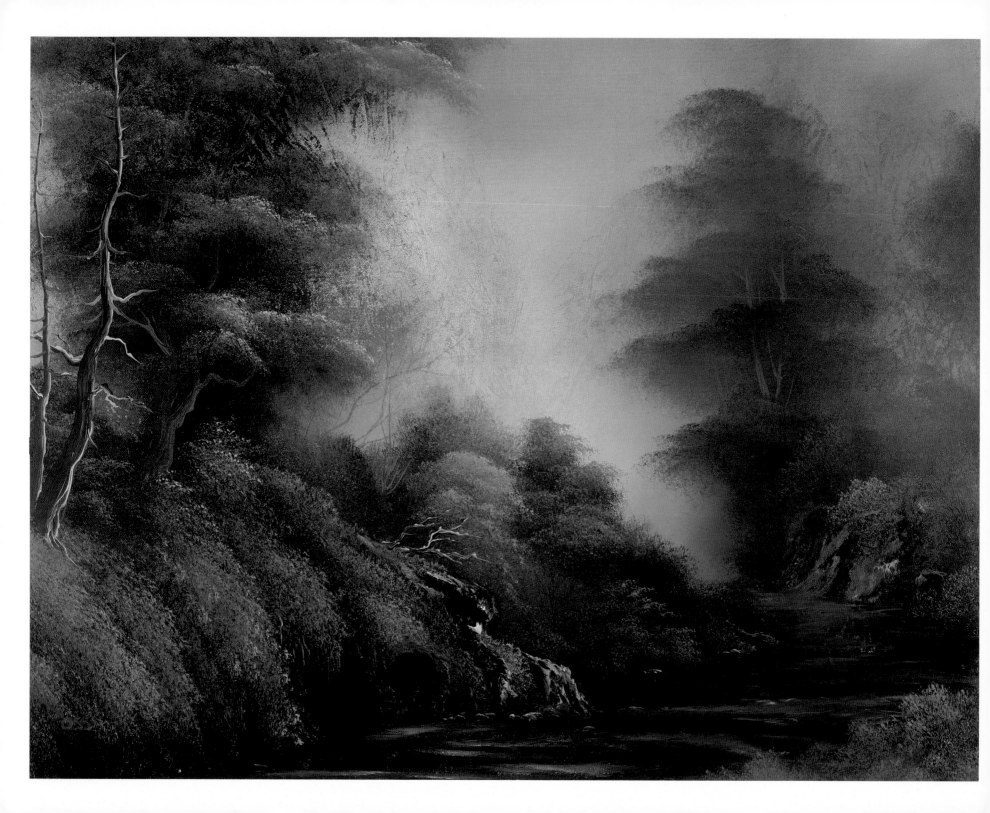

48. BACK COUNTRY PATH

MATERIALS

2" Brush	Phthalo Blue
1" Round Brush	Prussian Blue
Small Round Brush	Midnight Black
#2 Script Liner Brush	Alizarin Crimson
Large Knife	Sap Green
Black Gesso	Cadmium Yellow
Liquid White	Yellow Ochre
Liquid Clear	Indian Yellow
Titanium White	Bright Red

Start by using a crumpled paper towel to underpaint the basic dark foliage shapes with Black Gesso. (Allow the canvas to remain much lighter near the top than at the bottom.) Allow the Black Gesso to DRY COMPLETELY. *(Photo 1.)*

When the Black Gesso is dry, use the 2" brush to cover the entire canvas with a VERY THIN coat of a thin mixture of Liquid Clear, Liquid White and Midnight Black, to make a Gray. (It is important to stress that the mixture should be applied VERY, VERY sparingly and really scrubbed into the canvas!) Do NOT allow the canvas to dry before you begin. Clean and dry the 2" brush.

SKY

Paint the sky by loading the 2" brush with a very, very small amount of Alizarin Crimson and making criss-cross strokes, just above the horizon. *(Photo 2.)* As you work up towards the top of the canvas, vary the color by reloading the brush with a very small amount of Sap Green and then Phthalo Blue.

Reload the 2" brush with Titanium White and create a misty effect, just above the horizon, still using criss-cross strokes. (Photo 3.)

BACKGROUND

Use the knife to make a dark Lavender mixture on your palette by mixing a small amount of Prussian Blue with some Alizarin Crimson. Load the small round brush with this dark mixture and underpaint the background trees by just tapping down-ward. *(Photo 4.)*

Add the background tree trunks with the Lavender mixture and the liner brush. (To load the liner brush, thin the Lavender mixture to an ink-like consistency by first dipping the liner brush into paint thinner. Slowly turn the brush as you pull the bristles through the mixture, forcing them to a sharp point.) Apply very little pressure to the brush, as you shape the trunks. By turning and wiggling the brush, you can give your trunks a gnarled appearance. *(Photo 5.)*

Reload the small round brush by tapping the bristles into various mixtures of Midnight Black, all of the Yellows and Bright Red. Begin highlighting the background foliage by just tapping downward with the brush, carefully forming individual trees and bushes.

MIDDLEGROUND

Use the knife to make a Brown color on your palette by mixing equal parts of Sap Green and Alizarin Crimson. Begin blocking in the rocky land masses with this Brown mixture on the knife. *(Photo 6.)* Use various highlight mixtures of Titanium White, the Brown and Bright Red on the knife to carefully contour these large rocks, using so little pressure that the paint "breaks".

Working forward in layers, continue using the small round brush and the Yellow highlight mixtures to add foliage *(Photo 7)*; the Brown mixture on the knife to add the land areas *(Photo 8)*.

With firm pressure on the knife, use the Brown mixture and horizontal strokes to add the path *(Photo 9)* then highlight with the White-Brown-Ochre-Red mixture *(Photo 10)*.

Working forward in layers, use the dark-tree mixture on the large round brush to continue blocking in larger trees and bushes. *(Photo 11.)* Apply the highlights with various mixtures of Sap Green, the Yellows and Bright Red on the small round brush. *(Photo 12.)*

Tree trunks are added with various thinned mixtures on the liner brush; some are light and some are dark. *(Photo 13.)*

Highlight the foreground foliage by tapping with the 2" brush,

using various mixtures of Midnight Black, Sap Green, all of the Yellows and Bright Red. *(Photo 14.)* Working in layers, continue adding banks, rocks and stones with mixtures of the dark Lavender, the Brown and Titanium White *(Photo 15)* then use the 2" brush to extend grassy areas over the banks *(Photo 16)*.

Underpaint the large foreground trees with the dark tree mixture on the large round brush *(Photo 17)* then use a thinned mixture of Titanium White and the Brown on the liner brush to paint the trunks *(Photo 18)*.

Highlight the foreground trees and bushes with the small round brush and the Yellow highlight mixtures. *(Photo 19.)*

Double-load the liner brush to add the large, foreground tree trunk. (To double-load the liner brush, fill the bristles with a very thin mixture of paint thinner, and Van Dyke Brown, then pull *one* side of the bristles through very thinned Titanium White.) With single strokes you can paint the tree with highlights and shadows. *(Photo 20.)*

FINISHING TOUCHES

Use thinned mixtures on the liner brush to add final details, not the least of which is your signature! *(Photo 21.)*

Back Country Path

1. Block in foliage shapes with Black Gesso . . .

2. . . . then use the 2" brush and criss-cross strokes . . .

3. . . . to paint the sky.

4. Tap down with the round brush to paint background trees.

5. Add the trunks with the liner brush.

6. Use the knife to shape the land areas . . .

7. . . . then use the round brush to highlight foliage.

8. Use the knife and horizontal strokes . . .

9. . . . to begin painting the path.

Back Country Path

10. Apply highlights to the path...

11.... with so little pressure the paint "breaks".

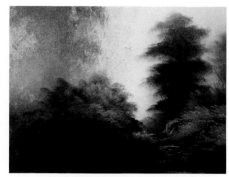

12. Continue using the round brush...

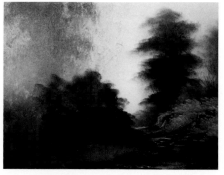

13.... to highlight the foliage.

14. Highlight foreground foliage with the 2" brush...

15.... continue using the knife...

16.... to shape the foreground land areas.

17. Block in the trees with the large round brush...

18.... then add the trunks with the liner brush.

19. Highlight the trees with the liner brush...

20.... then continue adding trunks with the liner brush...

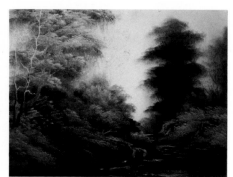

21.... to complete the painting.

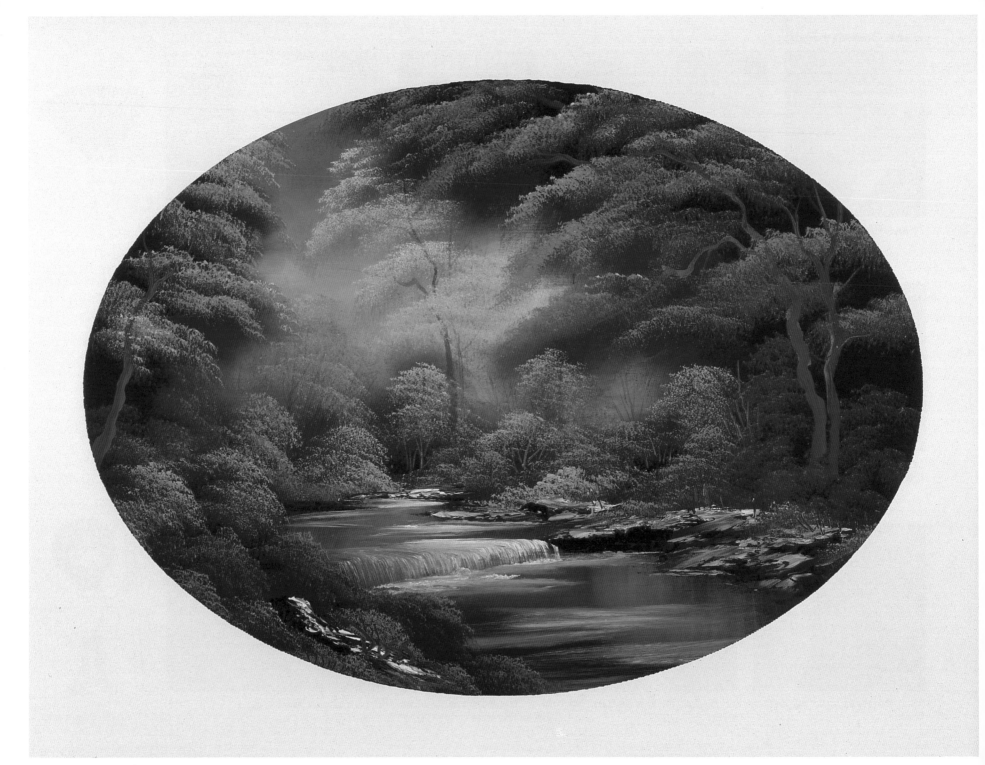

49. WOODED STREAM OVAL

MATERIALS

2" Brush	Midnight Black
1" Brush	Dark Sienna
#6 Fan Brush	Van Dyke Brown
#2 Script Liner Brush	Alizarin Crimson
Large Knife	Sap Green
Adhesive-Backed Plastic	Cadmium Yellow
Black Gesso	Yellow Ochre
Liquid White	Indian Yellow
Titanium White	Bright Red
Phthalo Blue	

Cover the entire canvas with adhesive-backed plastic (such as Con-Tact Paper) from which you have removed a center oval. On an 18 x 24 canvas, the oval I use is 16 x 20. Using a foam applicator, apply Black Gesso to the exposed oval area of the canvas, allowing a light, irregular-shaped portion of the sky to remain unpainted. (Photo 1.) Allow the Black Gesso to dry completely before you begin.

When the Black Gesso is dry, use the 2" brush to cover it with a thin, even coat of a mixture of Phthalo Blue and Alizarin Crimson. Cover the White, unpainted portion of the canvas with a thin coat of Liquid White. Do NOT allow these paints to dry before you begin.

SKY

Load a clean, dry 2" brush with a very, very small amount of Phthalo Blue. Use criss-cross strokes to add the color to the top of the light portion of the sky. (Photo 2.) As you work down the canvas, the color will mix with the Liquid White and become quite light as you near the horizon.

BACKGROUND

Use the 2" brush to tap into the dark color already on the canvas, extending tree shapes into the light portion of the sky. (Photo 3.) Use a very thin mixture of paint thinner and the Phthalo Blue-Alizarin Crimson mixture on the liner brush to add the small, background tree trunks. (Photo 4.)

The lighter trees in the background are made with the 1" brush and a mixture of Titanium White, Phthalo Blue and Alizarin Crimson. Use just one corner of the brush to tap in the foliage. (Photo 5.) Don't just hit at random; think about form and shape, tap in individual leaf clusters. Working in layers, you can vary the colors of the trees by using mixtures of all of the Yellows and Sap Green. (Photo 6.)

WATER

With Titanium White on the 2" brush, hold the brush flat against the canvas and pull down for the water (Photo 7) and then lightly brush across for a watery appearance. Notice how the White mixes with the color already on the canvas and Presto! you have Lavender water. (Photo 8.)

The banks along the water's edge are made with Van Dyke Brown on the edge of the knife (Photo 9) and then highlighted with a mixture of Titanium White and Dark Sienna (Photo 10). Add little grassy areas to the banks with the Yellow-Green mixtures on the 1" brush. You can cut in the distant water lines and ripples with Liquid White and the Lavender mixture on the very edge of the knife. (Photo 11.)

WATERFALL

With Titanium White and a very small amount of Phthalo Blue on the fan brush, start in the background and use swirling strokes to bring the water forward. (Photo 12.) Create the waterfall with a series of short pull down strokes. (Photo 13.) Continue using swirling, horizontal strokes as you bring the water forward in the painting. (Photo 14.)

FOREGROUND

Use the Phthalo Blue-Alizarin Crimson mixture on the 2" brush to underpaint the foreground bushes and land area. Again, use the 1" brush with the various Yellow mixtures to highlight the bushes. Working in layers, be careful not to completely destroy all of the dark undercolor, use it to separate the individual bush shapes. (Photo 15.)

Add rocks and stones to the foreground with Van Dyke Brown

on the knife. Use a mixture of Titanium White and Dark Sienna *(Photo 16)* to shape and contour the rocks *(Photo 17)*.

LARGE TREES

Load the liner brush with a very, very thin mixture of paint thinner, Titanium White, Van Dyke Brown and Dark Sienna. Starting at the top of each tree trunk, turn the brush as you pull it down *(Photo 18)* to give your trees a gnarled appearance. If you have trouble making the paint flow, chances are the paint is too thick and you should add more thinner to your mixture.

Add the foliage to the trees with the Yellow-Green mixtures or highlight colors of your choice. Use just one corner of the 1" brush to tap in the individual leaf clusters. *(Photo 19.)*

FINISHING TOUCHES

Use the point of the knife to scratch in tiny sticks and twigs. *(Photo 20.)* And now, the fun part! Remove the Con-Tact Paper from the canvas *(Photo 21)* to expose the finished painting *(Photo 22)*. Sign your masterpiece with pride, for hopefully, today you have truly experienced THE JOY OF PAINTING.

Wooded Stream Oval

1. Start by painting the canvas with Black Gesso.

2. Use criss-cross strokes to paint the sky.

3. Tap in tree shapes with the 2" brush . . .

4. . . . then add trunks with the liner brush.

5. Use the 1" brush . . .

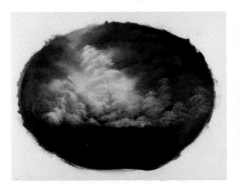

6. . . . to highlight the background trees.

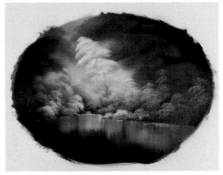

7. Pull down with the 2" brush . . .

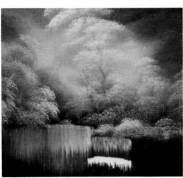

8. . . . to create a watery appearance.

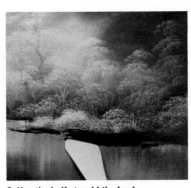

9. Use the knife to add the land . . .

Wooded Stream Oval

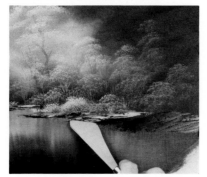

10. . . . and highlights . . .

11. . . . to the water's edge.

12. Swirl in background water . . .

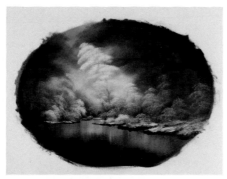

13. . . . then pull down tiny falls . . .

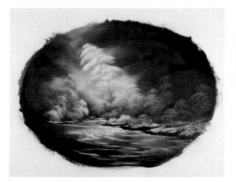

14. . . . to add the stream.

15. Highlight bushes . . .

16. . . . and add land areas . . .

17. . . . to the foreground.

18. Tree trunks are made with the liner brush . . .

19. . . . then foliage is added with the 1" brush.

20. Scratch in tiny sticks and twigs . . .

21. . . . then remove the Con-Tact Paper . . .

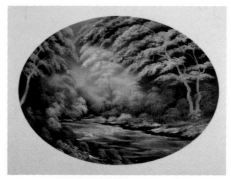

22. . . . from your finished oval.

50. CRIMSON TIDE

MATERIALS

2" Brush	Liquid Clear
1" Brush	Titanium White
#6 Filbert Brush	Phthalo Blue
#6 Fan Brush	Midnight Black
#3 Fan Brush	Dark Sienna
#2 Script Liner Brush	Van Dyke Brown
Large Knife	Alizarin Crimson
Small Knife	Cadmium Yellow
Black Gesso	Yellow Ochre
Liquid White	

Use a foam applicator to cover the entire canvas with a thin, even coat of Black Gesso. Allow the canvas to DRY COMPLETELY before you proceed. When the Black canvas is dry, mark the horizon with a strip of masking tape. *(Photo 1.)*

When the Black Gesso is dry, use the 2" brush to completely cover the canvas with a VERY THIN coat of Liquid Clear. (It is important to stress that the Liquid Clear should be applied VERY, VERY sparingly and really scrubbed into the canvas! The Liquid Clear will ease the application of the firmer paint.)

Still using the 2" brush, cover the Liquid Clear with a very thin, even coat of Alizarin Crimson above and below the horizon. Apply a thin even coat of Phthalo Blue at the top and bottom of the canvas, allowing it to blend into the Alizarin Crimson. Do NOT allow the canvas to dry.

SKY

Load the small round brush by tapping the bristles into Titanium White. Starting just above the horizon and working upward, paint the clouds in the sky with circular strokes. *(Photo 2.)* Clean and dry the small round brush and reload it with a mixture of Titanium White, Cadmium Yellow and Yellow Ochre. Use circular strokes to create a Golden glow in the clouds just above the horizon.

Use the top corner of a clean, dry 2" brush and circular strokes to blend the entire sky. *(Photo 3.)* When you are satis-

fied with your sky, carefully remove the masking tape from the horizon. *(Photo 4.)* Be sure to cover the area of the canvas left dry by the masking tape with a small amount of Alizarin Crimson.

BACKGROUND WATER

Use Titanium White on the #3 fan brush to sketch the basic shape of the large wave *(Photo 5)* then, make a series of long, horizontal strokes to place the background swells *(Photo 6)*.

Still with Titanium White on the small fan brush, use short, horizontal, rocking strokes to paint the lightest background water, just below the horizon. Clean the fan brush and again, with short rocking strokes, blend back the tops of the long swells. *(Photo 7.)* Be very careful not to touch the bottoms of these long horizontal strokes and to retain the dark area between the swells. *(Photo 8.)*

LARGE WAVE

Load the filbert brush with a mixture of Titanium White and a very small amount of Cadmium Yellow. Use firm pressure and circular strokes to scrub in the "eye" or transparency of the large wave, allowing the color to extend out and fade across the top of the wave. *(Photo 9.)*

Use the Titanium White-Cadmium Yellow mixture on the fan brush to "pull" the water over the top of the crashing wave. *(Photo 10.)*

With a mixture of Phthalo Blue, Alizarin Crimson and Midnight Black on the fan brush, use circular strokes with one corner of the brush to paint the shadowed area of the foam at the base of the large wave. Highlight the foam with the Titanium White-Cadmium Yellow mixture on the filbert brush using circular push-up strokes. *(Photo 11.)* Again, allow the foam to extend up and fade out across the top of the large wave. Use the top corner of the 1" brush to carefully blend and soften the foam highlights into the shadowed area. *(Photo 12.)*

With the top corner of a clean, very dry 2" brush, use circular strokes to carefully blend the "eye" of the wave *(Photo 13)*

creating the illusion of transparency *(Photo 14)*.

Add foam patterns and tiny details to the water with the liner brush and the Titanium White and Cadmium Yellow mixture. *(Photo 15.)* (To load the liner brush, thin the mixture to an ink-like consistency by first dipping the liner brush into paint thinner. Slowly turn the brush as you pull the bristles through the mixture, forcing them to a sharp point.) With just the tips of the bristles and very little pressure, you can shape foam patterns in the large wave and add bright highlights to the background water. *(Photo 16.)*

ROCKS

With a mixture of Van Dyke Brown, Midnight Black and Dark Sienna on the large fan brush, block in the basic shape of the large rocks, at the same time extending some of this Brown color onto the beach.

Reload the fan brush with a mixture of Titanium White and Dark Sienna to shape and highlight the rocks. *(Photo 17.)* Because of the bright sunset sky, these rocks are almost in silhouette, so be very careful to allow them to remain quite dark. *(Photo 18.)*

EVERGREENS

Use a mixture of Phthalo Blue, Van Dyke Brown and Alizarin Crimson on the fan brush to paint the tiny evergreens on the large rocks. Hold the brush vertically and just touch the canvas to place the trees, then use one corner of the brush to add the branches. *(Photo 19.)* Use more pressure on the brush near the base of the trees for the larger branches. *(Photo 20.)*

BEACH

With a small roll of a mixture of Titanium White and Phthalo Blue on the underside of the small knife blade, use firm pressure to shape the water line under the large wave. (Photo 21.) Use a clean, dry fan brush to carefully blend the water back to the wave. *(Photo 22.)*

Use a very small amount of Titanium White on the 2" brush and vertical strokes to add reflections to the beach *(Photo 23)* then lightly brush across to create a sheen *(Photo 24)*.

Continue using the small knife to add water lines to the beach *(Photo 25)* each time blending back with the fan brush.

To add the small stones on the beach, load the filbert brush with a mixture of Midnight Black and Van Dyke Brown, then pull one side of the bristles through a thin mixture of Liquid White, Van Dyke Brown and Dark Sienna, to double load the brush. With the light side of the bristles up, use a curved stroke to paint each stone on the beach. *(Photo 26.)* With just a single stroke, you can paint each rock and its highlight.

FINISHING TOUCHES

Use thinned mixtures on the liner brush to add water lines at the base of the stones *(Photo 27)* and other final details of the water and your masterpiece is complete *(Photo 28)*.

Crimson Tide

1. Mark the horizon with masking tape. . .

2. . . . then use the round brush to paint the sky.

3. Blend the sky with the 2" brush . . .

4. . . . before removing the masking tape.

5. Sketch the large wave . . .

6. . . . before painting the background water.

7. Use the fan brush to blend back . . .

Crimson Tide

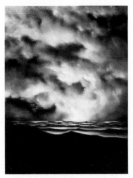

8. . . . the tops of the back-ground swells.

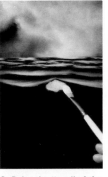

9. Paint the "eye" of the wave . . .

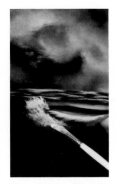

10. . . . then the top of the wave . . .

11. . . . before adding the foam.

12. Blend the foam with the 1" brush . . .

13. . . . then use the 2" brush . . .

14. . . . to blend the "eye" of the wave.

15. Use the liner brush . . .

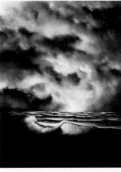

16. . . . to add highlights to the water.

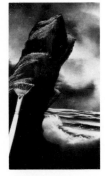

17. Use the fan brush . . .

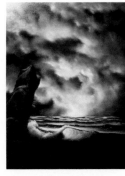

18. . . . to shape the large rock . . .

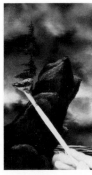

19. . . . and to add the evergreens . . .

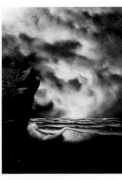

20. . . . before painting the foreground.

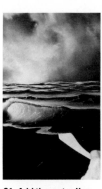

21. Add the water line . . .

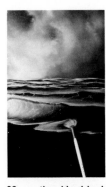

22. . . . then blend back with the fan brush.

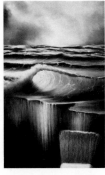

23. Use the 2" brush . . .

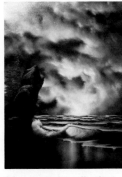

24. . . . to paint reflections on the beach.

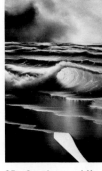

25. Continue adding water lines . . .

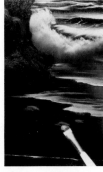

26. . . . and small rocks . . .

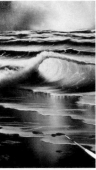

27. . . . and tiny details . . .

28. . . . to complete your painting.

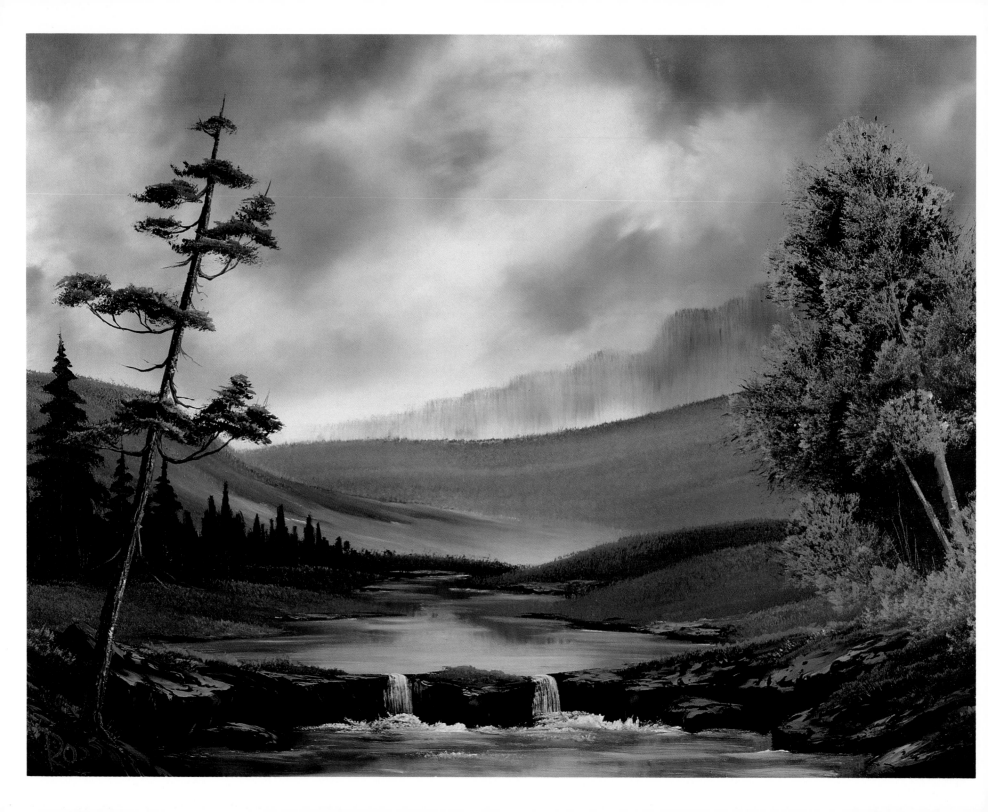

MATERIALS

2" Brush	Prussian Blue
1" Brush	Midnight Black
#6 Fan Brush	Dark Sienna
#2 Script Liner Brush	Van Dyke Brown
Large Knife	Alizarin Crimson
Small Knife	Sap Green
Liquid White	Cadmium Yellow
Liquid Black	Yellow Ochre
Titanium White	Indian Yellow
Phthalo Blue	Bright Red

Start by covering the entire canvas with a thin, even coat of Liquid White using the 2" brush. Use long horizontal and vertical strokes, working back and forth to assure an even distribution of paint on the canvas. Do not allow the Liquid White to dry before you begin.

SKY AND WATER

Load the 2" brush with a mixture of Midnight Black and Phthalo Blue. Using just the corner of the brush and small circular strokes, "dance-in" this Blue-Gray color into the sky, leaving some openings, allowing some of the Liquid White to show through. Add a TOUCH of Alizarin Crimson to the same brush and, still using circular strokes, add a little color to the White areas in the sky. Clean and dry the 2" brush then lightly blend the entire sky area.

Add some Phthalo Blue and Midnight Black to the same brush and just use long horizontal strokes to add the water to the bottom half of the canvas.

Load the fan brush with Titanium White. Using firm pressure, "bounce-in" the cloud shapes into the sky. Use the knife to remove any excess paint. With a clean, dry 2" brush blend the clouds using criss-cross strokes. Blend the entire sky using long horizontal strokes. *(Photo 1.)*

BACKGROUND

Load the 2" brush with Phthalo Blue, Midnight Black and Alizarin Crimson. With just one corner of the brush, touch the canvas and pull down to shape the distant hill. Allow the base of the hill to remain very soft and misty. *(Photo 2.)*

Load the same 2" brush with Midnight Black, Van Dyke Brown and Dark Sienna. Hold the brush horizontally and tap in the dark base color of the ground area under the distant hill. Pay close attention to the lay-of-the-land and be careful not to "kill" the misty area at the base of the hill. Use the same brush to pick up Cadmium Yellow and some Midnight Black (to make Green) and highlight the ground area still using a tapping motion. *(Photo 3.)*

Again using the same brush, pick up Midnight Black, Van Dyke Brown, Dark Sienna and Alizarin Crimson. Working forward in your painting, tap in the base color of the small hill on the left. Highlight this grassy hill with all the Yellows and a touch of Bright Red. With Titanium White on the fan brush, use small, sweeping, horizontal strokes to create a sandy area at the base of the hill. Extend the grassy area over the edges of the sand using the highlight colors on the 2" brush. With a clean, dry 2" brush tap the base of this small hill to diffuse and mist.

TREES

The small evergreens in the background are made by loading the fan brush with a mixture of Midnight Black, Van Dyke Brown, Sap Green and Prussian Blue. Hold the brush vertically and just tap downward to indicate the small trees. *(Photo 4.)* The very tiny, distant trees can be made by holding the brush vertically and bending the bristles upward.

For larger, more distinct trees, hold the brush vertically and just touch the canvas to create the center line of each tree. Turn the brush horizontally and begin adding the small branches at the top of the tree by using just one corner of the brush. Working from side to side and forcing the bristles to bend downward, use more pressure as you near the base of the tree allowing the branches to become larger. Use the point of the knife to scratch in small trunk indications.

Use the same dark tree mixture on the 2" brush to extend the

land area under the evergreen trees and also to lay in the land area on the right side of the painting. This will be the beginning of the water so, still using the 2" brush, grab the dark color of the land and pull straight down (to create reflections) and gently brush across. Use a clean, dry 2" brush to highlight grassy areas with a mixture of Midnight Black, all of the Yellows, Dark Sienna and Bright Red. (Photo 5.)

With Titanium White on the fan brush, use short horizontal strokes to add the water's edge to the base of these land areas.

The large leaf-tree and bushes on the right are underpainted with the same dark mixture of Midnight Black, Van Dyke Brown, Sap Green and Prussian Blue. Pull the 2" brush through the mixture in one direction to round one corner. With the rounded corner up, touch the canvas forcing the bristles to bend upward as you form the tree and bushes. (Photo 6.)

Use a mixture of Dark Sienna and Titanium White on the long edge of the knife to make the leaf-tree trunk. (Photo 7.) Highlight the trees and bushes with various mixtures of all the Yellows, Sap Green and Bright Red. Pull the 1" brush in one direction through the paint to round one corner. With the rounded corner up, touch the canvas forcing the bristles to bend upward. Try not to just hit at random, this is where you shape each tree and bush. Working in layers, be careful not to "kill" all the dark base color.

FOREGROUND

With Van Dyke Brown on the long edge of the knife, extend the land area across the water and along its edges. Use a clean, dry 2" brush and pull this dark color down to create a reflection; gently brush across. (Photo 8.) Highlight this rocky land area with a mixture of Van Dyke Brown and Titanium White. Use a small roll of paint on the long edge of the knife and barely graze the canvas as you shape the rocks in the water. (Photo 9.)

Use a mixture of Liquid White, Yellow Ochre, Bright Red and Dark Sienna on the fan brush to highlight the grassy areas along the banks of the water. Holding the brush horizontally, push it into the canvas forcing the bristles to bend upward. Again, pay close attention to the lay-of-the-land, allowing the grass to extend down over the edges of the land at the water's edge. (Photo 10.)

WATERFALLS

Load a clean fan brush with a mixture of Liquid White and

Titanium White. Hold the brush horizontally and pull straight down as you spill the water over the rocks in the center of the painting. (Photo 11.) Push up and bend the bristles to create little splashes at the base of the falls. (Photo 12.) Use sweeping, horizontal strokes along the water's edge to add ripples to the water. (Photo 13.)

LARGE EVERGREEN TREE

To load the long edge of the knife with a small roll of Van Dyke Brown, pull the paint out flat and just "cut" across. Hold the knife vertically and apply the paint to the base of the tree, allowing the trunk to become much narrower as you near the top. Highlight with a mixture of Bright Red, Dark Sienna and Titanium White on the knife and just touched to the right side of the tree trunk. Add branches with Liquid Black on the liner brush.

The foliage is a mixture of Midnight Black and Sap Green on the fan brush. Hold the brush horizontally, this time forcing the bristles to bend upward. Highlights are made the same way by adding Cadmium Yellow to the dark mixture already on the fan brush. (Photo 14.)

FINISHING TOUCHES

You can add some little grassy spots to the tops of the rocks in the water using the fan brush, also scratch in sticks and twigs with the point of the knife. Add your signature with thinned paint on the liner brush. Good job! Well done! (Photo 15.)

Twin Falls

1. After completing the sky . . .

2. . . . use the 2" brush to add background hills . . .

3. . . . and grassy areas.

4. Tap down with the fan brush . . .

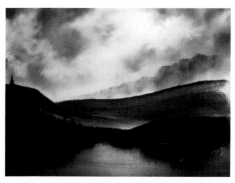

5. . . . to add background evergreens.

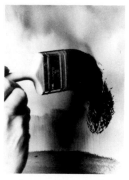

6. Push upward with the 2" brush to paint the basic tree and bush shapes.

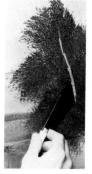

7. Add trunks with the edge of the knife.

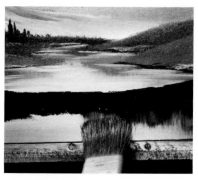

8. Underpaint the waterfalls . . .

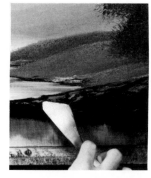

9. then add rocks with the knife.

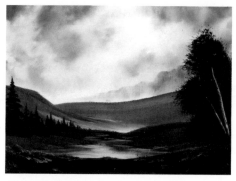

10. Use the fan brush to paint grassy areas . . .

11. to pull down the waterfalls . . .

12. and to push up the splashing water . . .

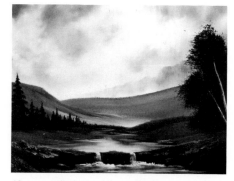

13. at the base of the waterfalls.

14. Add trees to the foreground . . .

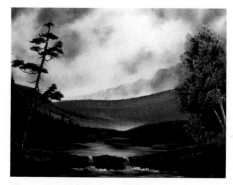

15. to complete your painting.

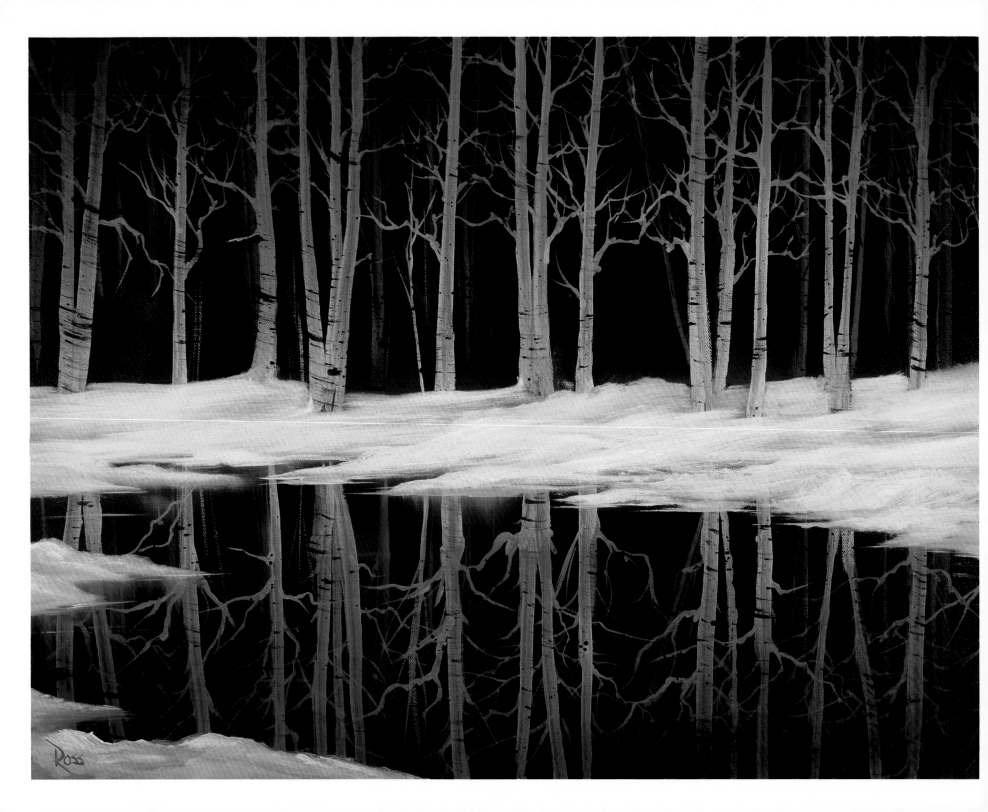

MATERIALS

2" Brush	Foam Applicator
#6 Fan Brush	Liquid Clear
#2 Script Liner Brush	Titanium White
Large Knife	Phthalo Blue
White Gesso	Prussian Blue
Black Gesso	Indian Yellow
Gray Gesso	

(Note: Please do not use your Bob Ross brushes when working with Gesso or other water-based paints.)

Start by using a foam applicator to apply a thin, even coat of Black Gesso to your entire canvas and allow to DRY COMPLETELY.

UNDERPAINTING THE BACKGROUND

When the Black Gesso is dry, use the foam applicator with Gray Gesso to under-paint just the basic shapes of the subtle background birch tree trunks *(Photo 1)* and also the reflections of the trunks *(Photo 2)*. Use the liner brush with thinned Gray Gesso to add limbs and branches to the trunks. *(Photo 3.)* (To load the liner brush, thin the Gray Gesso to an ink-like consistency by first dipping the liner brush into water. Slowly turn the brush as you pull the bristles through the Gray Gesso, forcing the bristles to a sharp point.) Use just the tips of the bristles and very little pressure to shape individual limbs and branches. By turning and wiggling the brush, you can give the limbs and branches a gnarled appearance.

Again, be sure to reflect the branches into the water. *(Photo 4.)* When you are satisfied with the background trunks, allow the Gray Gesso to DRY COMPLETELY.

When the background trunks are dry, use White Gesso on the foam applicator to add the closer, more distinct trunks. *(Photo 5.)* Try to give the trunks a little "character". Maybe some are falling over, others could be growing in clumps, which is so characteristic of birch trees. Reflect these closer trunks into the water with mirrored images. Again, use the liner brush with thinned White Gesso to add the gnarled limbs and branches to the closer tree trunks and to the reflections. *(Photo 6.)* Allow the trees to DRY COMPLETELY.

To create the dark rings on the trunks, you may prefer working with your canvas on a flat, horizontal surface. Load the fan brush with Black Gesso which has been thinned with water. Pass the blade of the knife across the bristles of the fan brush, directing dark droplets of Gesso onto the dried tree trunks. *(Photo 7.)* (Since the canvas has been prepainted with Black Gesso, it is not necessary to be concerned with those dark droplets which may inadvertently be sprayed onto the black background.) Before the dark droplets dry, use a clean foam applicator and short, slightly curved strokes to pull the tiny spots of dark color across the trunks *(Photo 8)* creating those dark rings that are so characteristic of birch tree trunks *(Photo 9)*. Allow the canvas to DRY COMPLETELY.

When the canvas is completely dry, use the Bob Ross 2" brush to completely cover the dry canvas with a VERY SMALL AMOUNT of Liquid Clear. (It is important to stress that the Liquid Clear should be applied VERY, VERY sparingly and really scrubbed into the canvas! The Liquid Clear will not only ease with the application of the firmer paint, but will allow you to apply very little color, creating a glazed effect.) DO NOT allow the canvas to dry before you proceed.

SKY

Load a clean, dry 2" brush with a very small amount of Indian Yellow, tapping the bristles firmly against the palette to ensure an even distribution of paint throughout the bristles. Starting just above the horizon, and working upward, begin painting the sky area with criss-cross strokes, right over the trees. *(Photo 10.)* Be sure to reflect this color into the water; start just below the horizon and work downward with criss-cross strokes.

Load a clean, dry 2" brush with a small amount of Phthalo Blue and continue with criss-cross strokes, at the top and at the bottom of the canvas—above and below the Indian Yellow. Use criss-cross strokes to softly merge one color into the other.

Reload the 2" brush with a small amount of Prussian Blue and use criss-cross strokes to darken the four corners of the canvas. Because all of these colors are transparent, you can paint right over the tree trunks, creating a glazed effect. *(Photo 11.)*

BACKGROUND

Use a very small amount of Titanium White on the fan brush and horizontal strokes to suggest snow at the base of the most distant trees. *(Photo 12.)* Softly blend and diffuse this snow into the sky colors already on the canvas.

FOREGROUND

Reload the fan brush with Titanium White and continue using horizontal strokes to shape the foreground snow *(Photo 13)* paying close attention to the lay-of-the-land *(Photo 14)*. You could also create tiny snow drifts at the base of some of the trees.

Working forward in layers, use a clean, dry 2" brush to pull the White paint straight down into the water, creating shimmering reflections, then lightly brush across. *(Photo 15.)*

Continue by using Titanium White on the fan brush to shape the foreground snow-covered peninsulas. Again, pay close attention to angles and the lay-of-the-land. *(Photo 16.)*

FINISHING TOUCHES

Use a small roll of a mixture of Liquid White and Titanium White on the knife to scrub in water lines and ripples *(Photo 17)* and your painting is complete *(Photo 18)*.

Don't forget to sign your masterpiece with pride: Again, load the liner brush, this time with thinned oil color of your choice. Sign just your initials, first name, last name or all of your names. Sign in the left corner, the right corner or one artist signs right in the middle of the canvas! The choice is yours. You might also consider including the date when you sign your painting. Whatever your choices, have fun, for hopefully with this painting you have truly experienced THE JOY OF PAINTING!

If you enjoyed this painting, try it with other transparent colors—let your imagination be your guide!

Snow Birch

1. After painting the canvas Black use a foam applicator and Gray Gesso to paint the distant birch tree trunks.

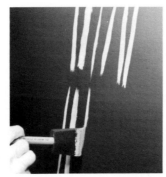

2. Reflect the birch tree trunks into the water.

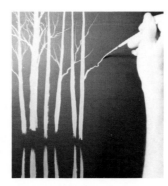

3. Use thinned Gray Gesso on the liner brush to paint the distant tree limbs and branches.

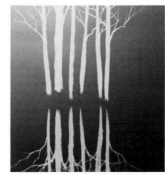

4. Be sure to include the limbs and branches in the reflections.

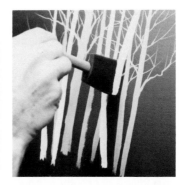

5. Use the foam applicator and White Gesso to paint the closer birch tree trunks.

Snow Birch

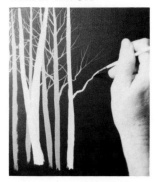

6. Add foreground limbs and branches with thinned White Gesso and the liner brush.

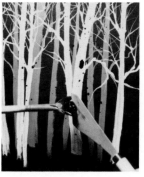

7. When the birch trees are dry, "flick" with Black Gesso droplets . . .

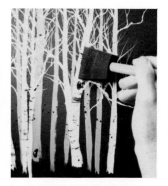

8. . . . then pull the droplets across the trunks with a foam applicator . . .

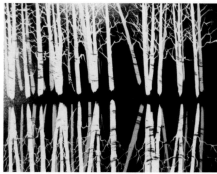

9. . . . to complete the birch tree trunks.

10. Use the 2" brush and criss-cross strokes with transparent paint . . .

11. . . . to glaze the canvas.

12. Add background snow with a small amount of Titanium White on the fan brush.

13. Continue using Titanium White on the fan brush . . .

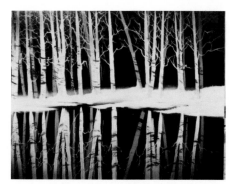

14. . . . to contour the foreground snow.

15. Working forward in layers, reflect the snow into the water by pulling down with the 2" brush.

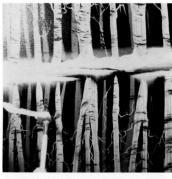

16. Use the fan brush and Titanium White to add the snow covered peninsulas in the foreground.

17. Scrub in water lines and ripples with White on the knife . . .

18. . . . to complete the painting.

MATERIALS

2" Brush
#6 Fan Brush
#2 Script Liner Brush
Black Gesso
Liquid Clear
Titanium White
Phthalo Blue
Midnight Black

Dark Sienna
Van Dyke Brown
Alizarin Crimson
Sap Green
Cadmium Yellow
Yellow Ochre
Indian Yellow
Bright Red

To prepare the canvas, use a foam brush and Black Gesso to pre-paint the basic shape of the large tree, the ground and also the shadow areas of the canvas. Allow the Black Gesso to DRY COMPLETELY. *(Photo 1.)*

When the Black Gesso is dry, use the 2" brush to cover the entire canvas with a VERY THIN, even coat of Liquid Clear. Immediately cover the Liquid Clear with a very small amount of Phthalo Blue. Do NOT allow these paints to dry before you begin.

SKY

Load the 2" brush with Titanium White and use criss-cross strokes to paint the lightest areas of the sky (under the tree). *(Photo 2.)* Even though the Titanium White will blend with the Phthalo Blue already on the canvas, the sky should remain quite light. *(Photo 3.)*

BACKGROUND

Re-load the 2" brush with a Bluish-Lavender mixture made with Alizarin Crimson and Phthalo Blue. Hold the brush vertically and tap downward to indicate the subtle background tree shapes. *(Photo 4.)* Be very careful not to completely cover the light sky area.

Add the background tree trunks with the same mixture and the liner brush. (To load the liner brush, thin the mixture to an ink-like consistency by first dipping the liner brush into paint thinner. Slowly turn the brush as you pull the bristles through the mixture, forcing them to a sharp point.) Paint the trunks with very little pressure on the brush. *(Photo 5.)*

Use the 2" brush and various mixtures of Titanium White, the Lavender and Phthalo Blue to highlight the background trees. Load the brush by holding it at a 45-degree angle and tapping the bristles into the mixture. Allow the brush to "slide" slightly forward in the mixtures each time you tap (this assures that the very tips of the bristles are fully loaded with paint).

Apply subtle highlights to the small trees by just tapping downward with one corner of the brush. *(Photo 6.)* Pay close attention to shape and form–try to create individual tree and bush shapes, don't just hit at random. *(Photo 7.)*

Working in layers, continue adding trees with the dark mixtures *(Photo 8)*, tree trunks with the liner brush *(Photo 9)* and highlights with the lighter mixtures *(Photo 10)*. As you work forward use various mixtures of all of the Yellows, Sap Green and Midnight Black to highlight the trees. *(Photo 11.)*

LARGE TREE TRUNK

Paint the large tree trunk (right over the Black Gesso) with the fan brush and a mixture of Van Dyke Brown and Dark Sienna. *(Photo 12.)* Shape and contour the trunk by adding Titanium White to the mixtures on the brush. *(Photo 13.)*

SOFT GRASSY AREAS

Again, fully load the 2" brush by tapping the bristles into various mixtures of Sap Green, all of the Yellows and Bright Red. Highlight the soft grassy area at the base of the trees by holding the brush horizontally and gently tapping downward. *(Photo 14.)*

Work in layers, carefully creating the lay-of-the-land. If you are also careful not to destroy all of the dark color already on the canvas, you can create grassy highlights that look almost like velvet. *(Photo 15.)*

PATH

Add the path with Dark Sienna and Van Dyke Brown on the fan brush, using short, horizontal strokes. Watch the perspective here! Highlight the path with a very small amount of

Titanium White and Phthalo Blue on the fan brush. *(Photo 16.)*

TREE TRUNKS

Use thinned Midnight Black on the liner brush to add the more distinct tree trunks *(Photo 17),* turning and wiggling the brush to give the trunks a gnarled appearance *(Photo 18).*

LARGE TREE FOLIAGE

Highlight the foliage on the large tree with dark Green mixtures of Midnight Black and all of the Yellows on the 2" brush.

Fully load the bristles of the brush and then just tap downward with the corner of the brush to shape the individual leaf clusters. Don't just throw the paint on at random, think about shape and form and be very careful not to completely cover all of the dark base color already on the canvas. *(Photo 19.)*

FINISHING TOUCHES

Use thinned colors on the liner brush to add small sticks and twigs and to also sign your name. *(Photo 20.)*

The Old Oak Tree

1. Use Black Gesso to underpaint the large tree.

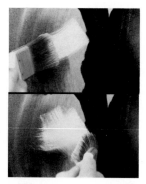

2. Make criss-cross strokes with the 2" brush . . .

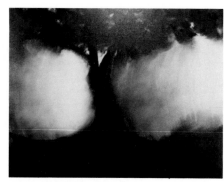

3. . . . to paint the sky.

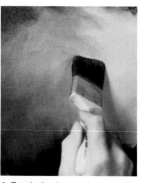

4. Tap in background trees with the 2" brush . . .

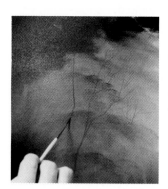

5. . . . then add trunks with the liner brush.

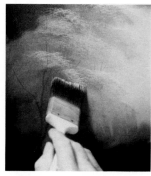

6. Use one corner of the 2" brush . . .

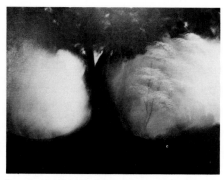

7. . . . to highlight the background trees.

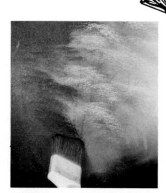

8. Continue underpainting trees with the 2" brush . . .

The Old Oak Tree

9. . . . adding trunks with the liner brush . . .

10. . . . highlights with the corner of the 2" brush . . .

11. . . . as you work forward in layers.

12. Use the fan brush . . .

13. . . . to shape and contour the large tree trunk.

14. Tap downward with the 2" brush . . .

15. . . . to create soft, velvet grass.

16. Add the path with horizontal strokes using the fan brush.

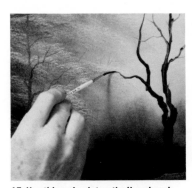

17. Use thinned paint on the liner brush . . .

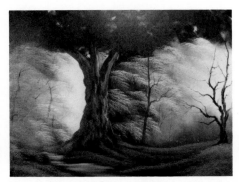

18. . . . to paint gnarled tree trunks.

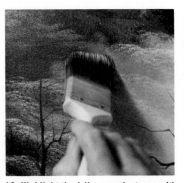

19. Highlight the foliage on the trees with the 2" brush . . .

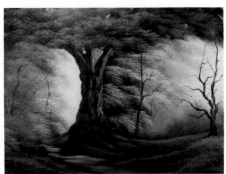

20. . . . and your painting is complete.

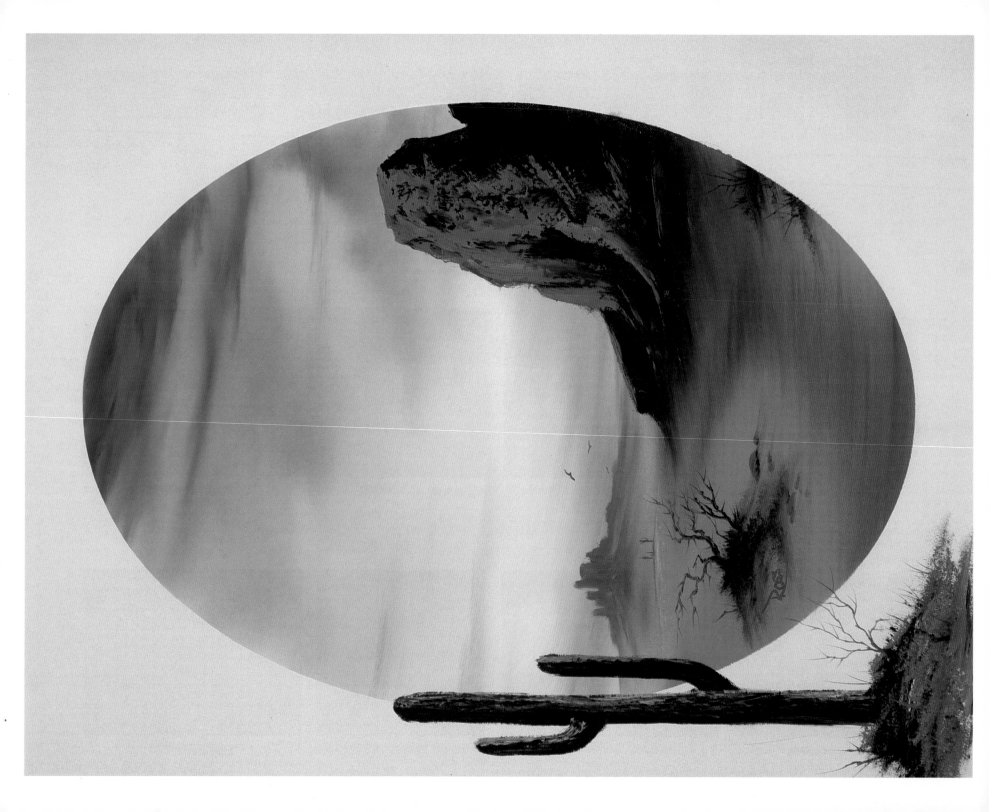

MATERIALS

2" Brush	Titanium White
#6 Fan Brush	Phthalo Blue
Filbert Brush	Midnight Black
Script Liner Brush	Alizarin Crimson
Large Knife	Sap Green
Small Knife	Yellow Ochre
Adhesive-Backed Plastic	Indian Yellow
Liquid White	Bright Red

Start by covering the entire canvas with a piece of adhesive-backed plastic (such as Con-Tact Paper) from which you have removed a center oval shape. (A 16 x 20 oval for an 18 x 24 canvas.) (Photo 1.)

Use the 2" brush to cover the entire exposed area of the canvas with a thin, even coat of Liquid White. With long horizontal and vertical strokes, work back and forth to ensure an even distribution of paint on the canvas. Do NOT allow the Liquid White to dry before you begin.

SKY

With a very small amount of Indian Yellow on the 2" brush, start in the lightest area of the sky, just above the horizon, with criss-cross strokes. Re-load the brush with a small amount of Yellow Ochre and continue working upward with criss-cross strokes. Paint the top of the sky with a very small amount of Alizarin Crimson. (Photo 2.) Blend the entire sky with long, horizontal strokes.

Use a Lavender mixture of Alizarin Crimson and Phthalo Blue on the 2" brush and sweeping, upward strokes to suggest clouds above the horizon. (Photo 3.) Use the same Lavender mixture on the fan brush and horizontal, rocking strokes to add the clouds at the top of the oval. (Photo 4.) Make circular strokes with one corner of the fan brush to shape the fluffy clouds. (Photo 5.) With the top corner of a clean, dry 2" brush, blend the base of the cloud shapes (Photo 6) then upward strokes to "fluff" (Photo 7).

BACKGROUND

Shape the distant mountain top with the fan brush and the same Lavender mixture plus a small amount of Phthalo Blue. (Photo 8.) Use the 2" brush to blend the paint down to the base of the mountain (Photo 9) creating a misty appearance (Photo 10).

FOREGROUND

Load the 2" brush with a mixture of equal parts of Alizarin Crimson and Sap Green (to make Brown). Use long horizontal strokes (Photo 11) to paint the lower portion of the oval (Photo 12).

With a small roll of the Alizarin Crimson-Sap Green mixture on the knife, block in the basic shape of the large foreground rock. (Photo 13.) Use a mixture of the Brown color, Bright Red and Titanium White on the knife to highlight and contour the large rock. (Photo 14.) Use so little pressure on the knife that the paint "breaks". (Photo 15.)

Blend out the base of the rock with the 2" brush (Photo 16) carefully creating the lay-of-the-land (Photo 17).

Starting in the distance and working forward, use the Brown mixture on the fan brush and short, horizontal rocking strokes to paint the path. (Photo 18.) Pay close attention to perspective here, the path should be wider in the foreground. Lightly blend with a clean, dry 2" brush.

Re-load the fan brush with the Alizarin Crimson-Sap Green (Brown) mixture. Hold the brush horizontally and force the bristles to bend upward to add the small grassy patches. (Photo 19.) Blend out the base of these grassy patches with the fan brush, adding a small amount of Titanium White to the Brown mixture on the fan brush. (Photo 20.)

Add the bush with the Brown mixture and the liner brush. (To load the liner brush, thin the mixture to an ink-like consistency by first dipping the liner brush into paint thinner. Slowly turn the brush as you pull the bristles through the mixture, forcing them to a sharp point.) Apply very little pressure to the brush, as you shape the bush. By turning and wiggling the brush, you can give the bush a gnarled appearance. (Photo 21.)

To paint the small rocks and stones at the base of the bush, load the filbert brush with the Brown mixture; then, pull one side of the bristles through a thin mixture of Liquid White and the Brown, to double-load the brush. With the light side of the brush up, make a single, curved stroke *(Photo 22)* to paint each stone and its highlight *(Photo 23)*.

CACTUS

Carefully remove the Con-Tact Paper from the canvas *(Photo 24)* to expose the painted oval *(Photo 25)*. Use the Brown mixture on the fan brush to shape the cactus outside the oval *(Photo 26)* then, push up on the bristles to add the grass at the base of the cactus *(Photo 27)*.

With a small roll of a mixture of Titanium White, Midnight Black and the Brown on the long edge of the small knife, tap highlights onto the cactus *(Photo 28)* then use a small roll of Sap Green to paint the shadowed areas of the cactus.

Add the land area at the base of the cactus with a mixture of the Brown and Titanium White on the knife. *(Photo 29.)* Push in grassy highlights with the Brown and Yellow Ochre on the fan brush. *(Photo 30.)*

FINISHING TOUCHES

Add tall grasses with the thinned Brown mixture on the liner brush, and your painting is ready for a signature. *(Photo 31.)*

Desert Glow

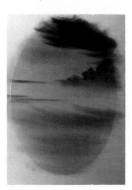
1. Cover the canvas with Con-Tact Paper.

2. Paint the entire sky with criss-cross strokes.

3. Sweep up clouds with the 2" brush.

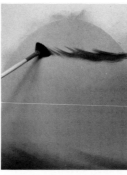
4. Use the fan brush and rocking strokes . . .

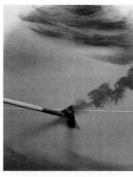
5. . . . and circular strokes to add clouds.

6. Use the 2" brush . . .

7. . . . to blend the clouds.

8. Paint the mountain top with the fan brush . . .

9. . . . then blend the paint down with the 2" brush . . .

10. . . . to create a misty appearance.

11. Use horizontal strokes with the 2" brush . . .

12. . . . to underpaint the foreground.

Desert Glow

13. Use the knife to block-in . . .

14. . . . and highlight . . .

15. . . . the large foreground rock.

16. Use the 2" brush to pull out the base of the rock . . .

17. . . . to blend.

18. With the fan brush, add the path . . .

19. . . . and grassy patches.

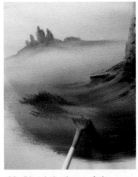

20. Blend the base of the grass with the fan brush.

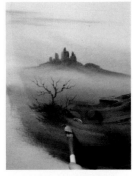

21. Paint the bush with the liner brush . . .

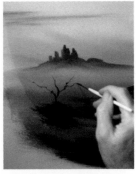

22. . . . then use the filbert brush . . .

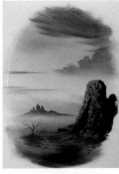

23. . . . to add small rocks and stones.

24. Carefully remove the Con-Tact Paper . . .

25. . . . to expose the painted oval.

26. Shape the cactus . . .

27. . . . and add grass with the fan brush.

28. Highlight the cactus with the knife . . .

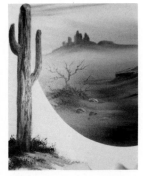

29. . . . then add the land area.

30. Highlight grass with the fan brush . . .

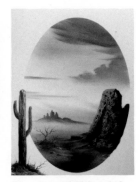

31. . . . to complete the painting.

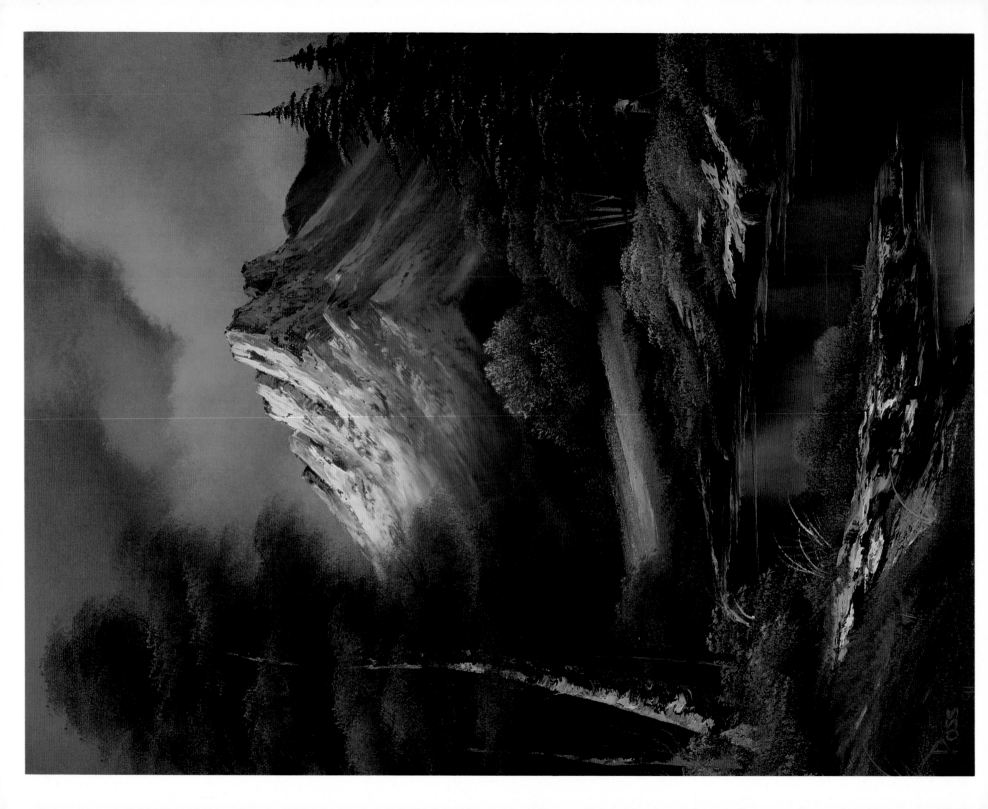

MATERIALS

2" Brush	Phthalo Blue
1" Round Brush	Prussian Blue
Small Round Brush	Midnight Black
#6 Fan Brush	Alizarin Crimson
#2 Script Liner Brush	Sap Green
Large Knife	Cadmium Yellow
Black Gesso	Yellow Ochre
Liquid White	Indian Yellow
Liquid Clear	Bright Red
Titanium White	

Use a foam applicator to cover the entire canvas with a thin, even coat of Black Gesso and allow to DRY COMPLETELY before you begin.

When the Black Gesso is dry, use the 2" brush to completely cover the canvas with a VERY SMALL AMOUNT of Liquid Clear. Then use a paper towel to firmly scrub the canvas, removing as much of the Liquid Clear from the canvas as possible. The remaining Liquid Clear will be sufficient to proceed with the painting. Do NOT allow the canvas to dry before you begin.

SKY

With a mixture of Titanium White and Phthalo Blue on the 2" brush, paint the upper left corner of the sky with criss-cross strokes. Load a clean, dry 2" brush by holding it vertically and tapping the top corner into Titanium White with a very small amount of Yellow Ochre. Begin painting cloud shapes by holding the brush vertically and just tapping downward with the top corner of the brush. As you continue layering the clouds, vary the color by adding a small amount of a Lavender mixture (made with Alizarin Crimson and Phthalo Blue) to the brush. Use a clean, dry 2" brush and very small criss-cross strokes to blend the base of the clouds; then sweeping upward strokes to "fluff". Continue layering clouds, adding small amounts of Dark Sienna and Phthalo Blue to the Titanium White and then blend with a clean, dry 2" brush. *(Photo 1.)*

MOUNTAIN

Use the knife to make a Brown mixture on your palette with equal parts of Sap Green and Alizarin Crimson. Pull the mixture out very flat on your palette, hold the knife straight up and "cut" across the mixture to load the long edge of the blade with a small roll of paint. (Holding the knife straight up will force the small roll of paint to the very edge of the blade.) With firm pressure, shape just the top edge of the mountain. *(Photo 2.)* When you are satisfied with the basic shape of the mountain top, use the 2" brush to blend paint down to the base of the mountain.

Highlight the mountain with a mixture of Titanium White, your Brown mixture and Yellow Ochre. Again, load the long edge of the knife blade with a small roll of paint. Starting at the top (and paying close attention to angles) glide the knife down the left side of each peak, using so little pressure that the paint "breaks". *(Photo 3.)*

Use a mixture of Titanium White, Phthalo Blue and Alizarin Crimson, applied in the opposing direction, for the shadowed sides of the peaks. Again, use so little pressure that the paint "breaks".

Use a clean, dry 2" brush to tap to diffuse the base of the mountain (carefully following the angles) and then gently lift upward to create the illusion of mist. *(Photo 4.)*

BACKGROUND

Use the knife to make a dark Lavender mixture on your palette with Alizarin Crimson and Prussian Blue. Load the small round brush by tapping the bristles into the Lavender color. Just tap downward to block in the dark undercolor of the tiny trees at the base of the mountain.

Use various mixtures of Sap Green and Cadmium Yellow on the small round brush and again, just tap downward *(Photo 5)* to highlight the small trees at the base of the mountain *(Photo 6)*.

To add the soft grassy areas at the base of the trees, use the 2" brush and various mixtures of Sap Green, all of the Yellows and Bright Red. Load the brush by holding it at a 45-

degree angle and tapping the bristles into the various paint mixtures. Allow the brush to "slide" slightly forward in the paint each time you tap (this assures that the very tips of the bristles are fully loaded with paint). Hold the brush horizontally and gently tap downward to paint the soft grass. *(Photo 7.)* Working forward in layers, carefully creating the lay-of-the-land, use a very small amount of Titanium White to "sparkle" the lightest areas. If you are careful not to destroy all of the dark color already on the canvas, you can create grassy highlights that look almost like velvet.

Working forward in layers, continue highlighting trees and bushes with the small round brush and various mixtures of Sap Green, all of the Yellows and Bright Red.

Add the background tree trunks with the light Blue mixture and the liner brush. (To load the liner brush, thin the mixture to an ink-like consistency by first dipping the liner brush into paint thinner. Slowly turn the brush as you pull the bristles through the paint, forcing them to a sharp point.) Apply very little pressure to the brush *(Photo 8)* as you shape the trunks.

EVERGREENS

To paint the evergreens, load the fan brush to a chiseled edge with the dark tree mixture. Holding the brush vertically, touch the canvas to create the center line of each tree. Use just the corner of the brush to begin adding the small top branches. Working from side to side, as you move down each tree, apply more pressure to the brush, forcing the bristles to bend downward and automatically the branches will become larger as you near the base of each tree. *(Photo 9.)*

MIDDLEGROUND

Working forward in the painting, use the same dark color and the small round brush to block in the small trees and bushes at the base of the evergreens, then highlight with the Yellow mixtures. *(Photo 10.)*

With careful attention to angles, add the land area with the Brown mixture on the knife. *(Photo 11.)* Highlight the land with a mixture of Titanium White, the Brown, Bright Red and Yellow Ochre, using so little pressure that the paint "breaks".

STREAM

With the dark Lavender mixture on the 2" brush, use vertical strokes to underpaint the stream. Reload the brush with a small amount of Titanium White, hold the brush horizontally and use downward strokes to paint reflections in the stream, then lightly brush across. *(Photo 12.)*

FOREGROUND

Use a mixture of the dark Lavender color and Midnight Black on the large round brush to underpaint the large tree and bushes in the foreground. *(Photo 13.)*

With the Brown mixture on the knife, add the land area at the base of the foreground trees–the banks at the water's edge. Again, highlight the land with the Titanium White-Brown-Bright Red-Yellow Ochre mixture on the knife, using very little pressure and paying close attention to angles. *(Photo 14.)*

Highlight the small trees and bushes with the small round brush using various mixtures of Sap Green, all of the Yellows and Bright Red. *(Photo 15.)* Highlight the grassy area with the 2" brush. *(Photo 16.)*

Add a trunk to the large tree with the fan brush and the Brown mixture. Highlight the trunk with Titanium White on the knife. *(Photo 17.)*

Highlight the large tree with the small round brush. Load the brush by first dipping it in Liquid White and then tapping the bristles into various mixtures of Brown and Yellow Ochre. Paying close attention to shape and form, highlight individual leaf clusters by just tapping downward. *(Photo 18.)*

FINISHING TOUCHES

Use Liquid White on the knife to cut in additional water lines and ripples *(Photo 19)* and your painting is complete *(Photo 20)*.

A Pretty Autumn Day

1. Begin by painting the sky.

2. Shape the mountain with the knife . . .

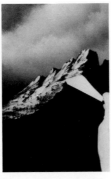
3. . . . then apply highlights.

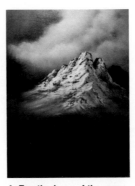
4. Tap the base of the mountain to mist.

5. Continue using the small round brush . . .

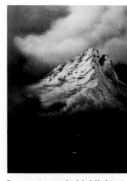
6. . . . to apply highlights to the background trees.

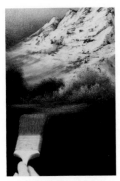
7. Use the 2" brush to paint the soft grass . . .

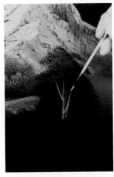
8. . . . and the liner brush to paint the tree trunks.

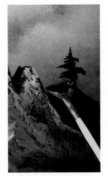
9. Paint large evergreens with the fan brush.

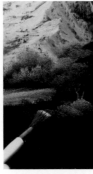
10. After highlighting bushes with the small round brush . . .

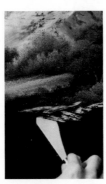
11. . . . use the knife to add the land areas.

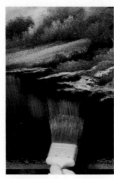
12. Paint the water with the 2" brush.

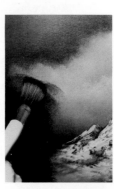
13. Block in foreground trees with the round brush . . .

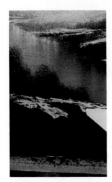
14. . . . then use the knife to add the land areas.

15. Use the round brush to highlight the bushes . . .

16. . . . and the 2" brush to highlight grassy areas.

17. Highlight the tree trunk with the knife . . .

18. . . . and the foliage with the round brush.

19. Use Liquid White on the knife . . .

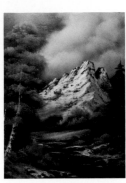
20. . . . to add water lines to your finished painting.

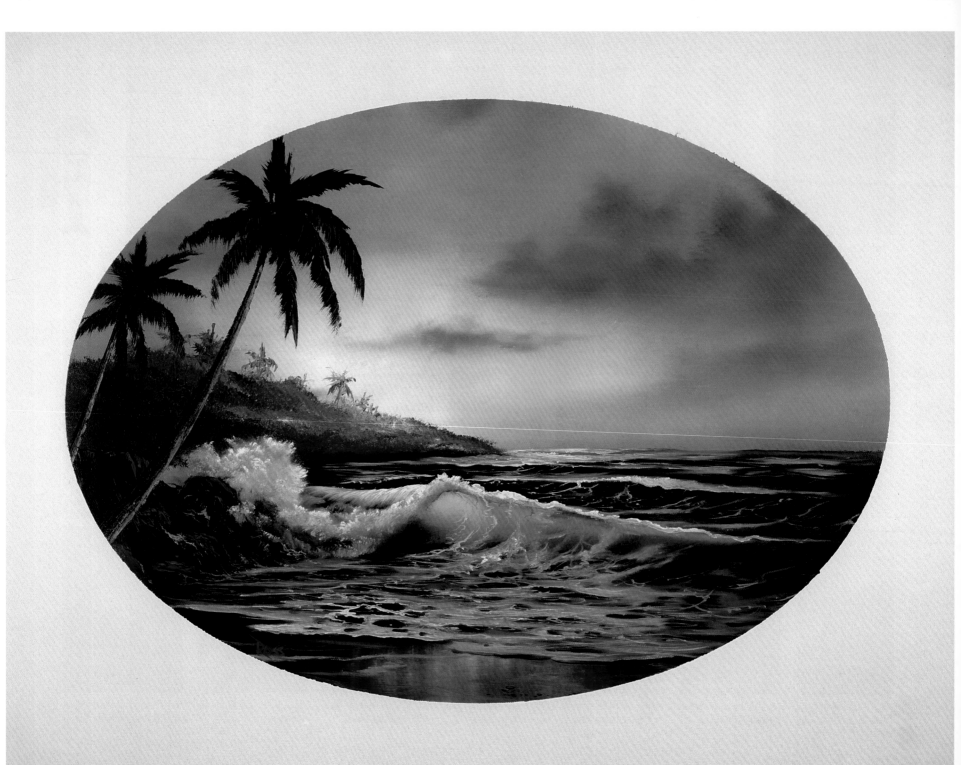

MATERIALS

2" Brush	Titanium White
#6 Filbert Brush	Phthalo Green
#6 Fan Brush	Phthalo Blue
#2 Script Liner Brush	Midnight Black
2" Blender Brush	Dark Sienna
Large Knife	Van Dyke Brown
Small Knife	Alizarin Crimson
Adhesive-Backed Plastic	Cadmium Yellow
Black Gesso	Yellow Ochre
Gray Gesso	Indian Yellow
Liquid Clear	Bright Red

Start by covering the entire canvas with a piece of adhesive-backed plastic (such as Con-Tact Paper) from which you have removed a center oval shape. (A 16 x 20 oval for an 18 x 24 canvas.)

Use a foam applicator to apply a thin, even coat of Black Gesso to the area of the oval below the horizon. Apply a thin, even coat of Gray Gesso to the area above the horizon. Allow the canvas to DRY COMPLETELY before proceeding. (Photo 1.)

When the Gessos are dry, use the 2" brush to completely cover the entire oval with a VERY THIN coat of Liquid Clear. (It is important to stress that the Liquid Clear should be applied VERY, VERY sparingly and really scrubbed into the canvas! The Liquid Clear will not only ease with the application of the firmer paint, but will allow you to apply very little color, creating a glazed effect.)

Still using the 2" brush, cover the Liquid Clear, below the horizon, with a very thin, even coat of a mixture of Phthalo Blue and Phthalo Green. At the bottom of the oval, apply a small amount of Van Dyke Brown to underpaint the sandy beach. Do NOT allow the canvas to dry before you proceed.

SKY

Load the 2" brush with a very small amount of Indian Yellow, tapping the bristles firmly against the palette to ensure an even distribution of paint throughout the bristles. Starting just above the horizon, use criss-cross strokes to begin painting the sky. As you work upwards, reload the 2" brush with a very small amount of Yellow Ochre and continue with criss-cross strokes near the top of the oval. Reload the brush with a small amount of Titanium White and use criss-cross strokes near the center of the canvas, just above the horizon, to create the lightest area of the sky. (Photo 2.) You can add a very, very small amount of Bright Red to the edges of the oval, just above the horizon. With a very small amount of Phthalo Blue of the 2" soft blender brush, continue with criss-cross strokes at the top of the oval.

Use the knife to make a Lavender mixture on your palette by adding a small amount of Phthalo Blue to some Alizarin Crimson. (You can test the color by adding a small amount of the mixture to some Titanium White. Adjust the color if necessary by adding more Blue or Crimson.) When you are satisfied with your color, load the 2" brush by tapping the bristles into a small amount of the Lavender mixture. Hold the brush vertically and use the top corner of the brush and circular strokes to shape the dark clouds. (Photo 3.) Blend out the base of the clouds with the soft blender brush and circular strokes. (Photo 4.) Add the small cloud shapes with the Lavender color on the fan brush (Photo 5) and then blend the entire sky with the soft blender brush. (Photo 6.)

HEADLANDS

Use the knife to make a mixture on your palette of Dark Sienna, Bright Red and Titanium White. To a portion of the mixture, add more Titanium White to make a lighter color. With the lightest mixture on the fan brush, begin shaping the lightest area of the background headlands. (Photo 7.) Use the darker mixture to create the shadowed areas of the headlands. With a mixture of paint thinner and the darker color on the liner brush (Photo 8) shape the tiny palm trees on the headlands (Photo 9).

WATER

With Titanium White on the fan brush, outline the basic shape

of the large wave *(Photo 10)* and the background swells. Use slight rocking, horizontal strokes to add the background water, just below the horizon. *(Photo 11.)* (Notice how the White blends with the color already on the canvas, creating Blue-Green water!) Continue using rocking strokes with the fan brush to blend back the top edges of the large wave *(Photo 12)* and the background swells. Reload the fan brush with Titanium White to pull the water over the top of the large wave. Be very careful of the angle of the falling water. *(Photo 13.)*

Scrub in the transparent "eye" of the large wave with a mixture of Titanium White and Cadmium Yellow on the filbert brush. *(Photo 14.)* Use the top corner of a clean, dry soft blender brush and circular strokes *(Photo 15)* to lightly blend the "eye" of the large wave *(Photo 16)*.

With a mixture of Alizarin Crimson and Phthalo Blue on the filbert brush, make circular strokes to underpaint the foam of the large crashing wave. Use Titanium White on the filbert brush and small circular strokes to highlight the top edges of the wave. *(Photo 17.)* Also use the filbert brush and Titanium White to begin adding the foam patterns in the wave. *(Photo 18.)*

With Titanium White on a clean, dry filbert brush, use tiny, circular, push-up strokes to highlight the top edges of the foam, where the light would strike. *(Photo 19.)* Lightly blend the bottom edges of the highlights into the dark undercolor with the top corner of a clean, dry blender brush and circular strokes. *(Photo 20.)*

ROCKS

Shape the foreground rocks with a mixture of Van Dyke Brown, Dark Sienna and Midnight Black on the filbert brush. *(Photo 21.)* Highlight and contour the rocks, adding a small amount of Bright Red to the mixture on the filbert brush. Use a thin mixture of paint thinner, Titanium White and Phthalo Blue on the liner brush to add dripping water to the foreground rocks. *(Photo 22.)*

FOREGROUND

Load a small amount of Titanium White on the 2" brush. Hold the brush horizontally, touch the canvas and pull straight down then lightly brush across to add reflections to the beach. *(Photo 23.)* (Remember, this area was underpainted with Van Dyke Brown.)

Add the water line to the beach with a mixture of Titanium White and Phthalo Blue on the small knife. *(Photo 24.)*

Continue adding foam patterns and tiny details to the water with the filbert brush and thinned mixtures on the liner brush. *(Photo 25.)*

PALM TREES

Use Midnight Black on the fan brush to shape the palm tree trunks. *(Photo 26.)* Highlight the trunks with the knife and a mixture of Van Dyke Brown and Titanium White. *(Photo 27.)* Use thinned Midnight Black on the fan brush to paint the palm tree branches. *(Photo 28.)*

FINISHING TOUCHES

Remove the Con-Tact Paper from your canvas to expose your oval, seascape, masterpiece! *(Photo 29.)*

Island Paradise

 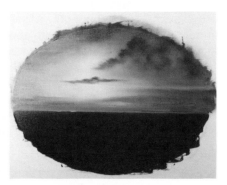

1. Start by covering the canvas with Black and Gray Gesso.

2. . . . then tap in the light area . . .

3. . . . and add large dark clouds to the sky.

4. Blend the clouds with the soft blender brush.

5. Paint small clouds with the fan brush . . .

6. . . . to complete the sky.

Island Paradise

 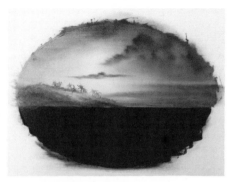

7. Shape headlands with the fan brush . . .

8. . . . then use the liner brush . . .

9. . . . to add tiny palm trees.

10. Use the fan brush to sketch the wave . . .

11. . . . and to add background water.

12. Blend the tops of the swells back . . .

13. . . . then pull the water over the top of the wave.

14. Scrub in the "eye" with the filbert brush . . .

15. . . . then use the top corner of the blender . . .

16. . . . to blend the transparent eye of the wave.

17. Highlight the wave . . .

18. . . . and add foam with the filbert brush.

19. Highlight foam with the filbert brush . . .

20. . . . then blend with the soft blender brush.

21. Shape the foreground rock with the filbert . . .

22. . . . then add water with the liner brush.

 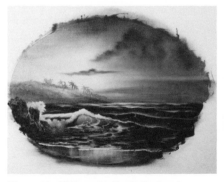 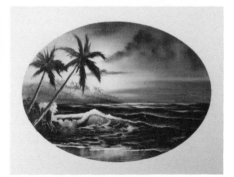

23. Pull down beach reflections with the 2" brush.

24. Use the small knife . . .

25. . . . to add the water line to the beach.

26. Paint the palm tree trunks with the fan brush.

27. Highlight trunks with the knife.

28. Add palm branches with the fan brush . . .

29. . . . to complete your painting.

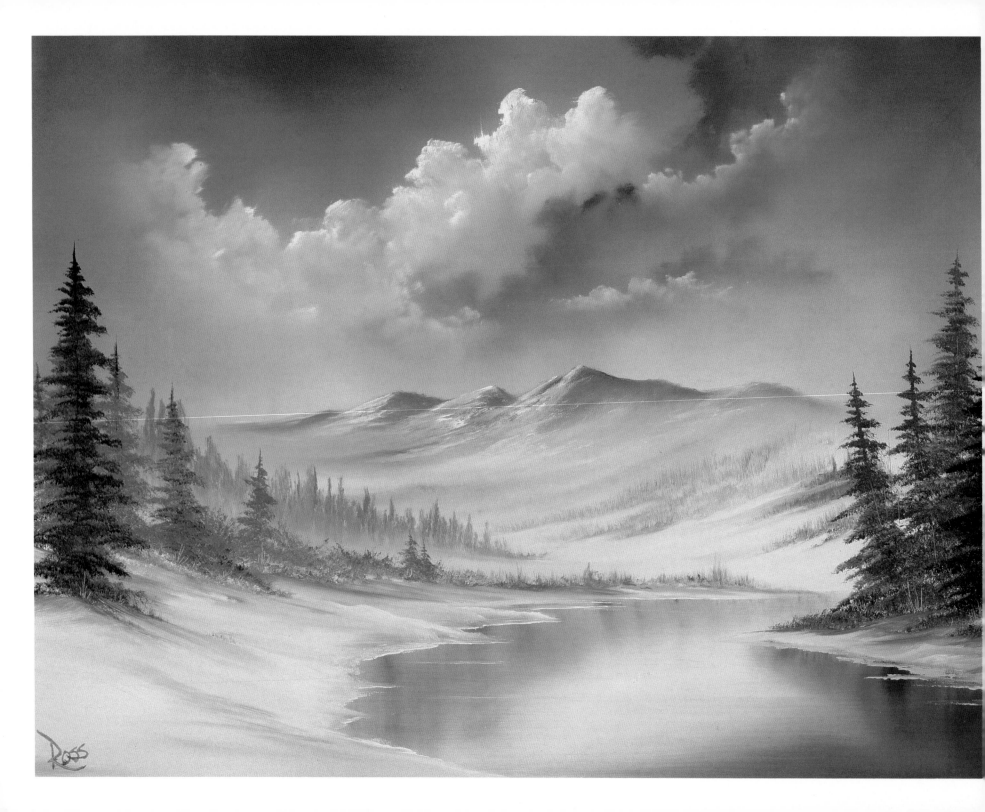

MATERIALS

2" Brush	Liquid White
1" Brush	Titanium White
#6 Fan Brush	Prussian Blue
Large Knife	Midnight Black
Small Knife	

Use the 2" brush to cover the entire canvas with a thin, even coat of Liquid White. With long horizontal and vertical strokes, work back and forth to ensure an even distribution of paint on the canvas. Do NOT allow the Liquid White to dry before you begin.

SKY

Load the 2" brush with a mixture of Midnight Black and Prussian Blue, tapping the bristles firmly against the palette to ensure an even distribution of paint throughout the bristles. Starting at the top of the canvas and working downward, use criss-cross strokes to paint the sky. *(Photo 1.)* Notice how the color blends with the Liquid White already on the canvas and automatically the sky becomes lighter as it nears the horizon. Blend the entire sky with long, horizontal strokes.

Use the same Midnight Black-Prussian Blue mixture on the 2" brush to underpaint the water on the lower portion of the canvas. Starting at the bottom of the canvas and working upward, use horizontal strokes, pulling from the outside edges of the canvas in towards the center. You can create a sheen on the water by allowing the center of the canvas to remain light. *(Photo 2.)*

Load the fan brush with Titanium White and use one corner of the brush to shape the clouds with small circular strokes. *(Photo 3.)* Blend the base of the clouds with the top corner of a clean, dry 2" brush, still using circular strokes *(Photo 4)* then gentle, sweeping upward strokes to "fluff".

Use a mixture of Titanium White with Midnight Black and Prussian Blue on the fan brush to add the layers of darker clouds. *(Photo 5.)* Again blend the base of the clouds with the

2" brush *(Photo 6)* and make upward strokes to "fluff". Very lightly blend the entire sky. *(Photo 7.)*

MOUNTAIN

Use a mixture of Midnight Black and Prussian Blue on the fan brush to shape just the top edge of the mountain. *(Photo 8.)* When you are satisfied with the basic shape of the mountain top, use the 2" brush to blend the paint down to the base of the mountain. *(Photo 9.)*

To highlight the mountain, load the small knife with a very small roll of Titanium White. Starting at the top (and paying close attention to angles) lightly rub the knife down the left side of each peak. *(Photo 10.)* Use the original, dark, mountain-mixture, applied in the opposing direction, for the shadow sides of the peaks.

With a mixture of the mountain color and Titanium White on the 1" brush, and again carefully following the angles of the peaks, make very short upward strokes to add the tiny trees at the base of the mountain. *(Photo 11.)* Diffuse the trees by again making short upward strokes, this time with a clean, dry 1" brush.

Working forward in layers, add snow to the base of the tiny trees with Titanium White on the knife. *(Photo 12.)* Pay close attention to angles and the lay-of-the-land. *(Photo 13.)*

BACKGROUND

Load the fan brush with the Midnight Black-Prussian Blue-Titanium White mixture. Holding the brush vertically, just tap downward to indicate small evergreen trees at the base of the mountain. *(Photo 14.)*

Use a clean, dry 2" brush to firmly tap the base of the evergreens, then upward strokes, creating the illusion of mist. *(Photo 15.)*

Use Titanium White on the knife to add snow to the base of the small evergreens. *(Photo 16.)* Again, watch the angle here. Use a darker mixture of Midnight Black, Prussian Blue and Titanium White on the fan brush to pop in the distant grassy area. *(Photo 17.)*

EVERGREENS

For the larger evergreens, load the fan brush to a chiseled edge with a very dark mixture of Midnight Black, Prussian Blue and Titanium White. Holding the brush vertically, touch the canvas to create the center line of each tree. Use just the corner of the brush to begin adding the small top branches. Working from side to side, as you move down each tree, apply more pressure to the brush, forcing the bristles to bend downward *(Photo 18)* and automatically the branches will become larger as you near the base of each tree.

With Titanium White on the 2" brush, use long horizontal strokes to add the snow to the base of the evergreens *(Photo 19)* allowing the brush to pull in some of the dark tree color for shadows.

WATER

Use the darker mixture on the 2" brush, hold the brush horizontally and just pull straight down to add the water. Allow the brush to pull in a small amount of the White snow along the water's edge, for reflections. *(Photo 20.)* Lightly brush across to create a watery appearance.

With a mixture of Liquid White and Titanium White on the knife, cut in the water lines. *(Photo 21.)* Make sure these lines are perfectly straight, parallel to the top and bottom of the canvas. *(Photo 22.)*

FOREGROUND

Working forward in layers, use Titanium White on the 2" brush and long horizontal strokes to add the snow-covered ground area on the left side of the painting *(Photo 23)* then use the dark mixture on the fan brush to paint the large foreground evergreen *(Photo 24)*. Again, use the 2" brush to pull the dark tree color *(Photo 25)* into the snow for shadows *(Photo 26)*.

Use various mixtures of the dark tree color on the fan brush to paint the large evergreens on the right side of the painting. Extend the dark tree color into the water for reflections, pull straight down with the 2" brush and lightly brush across to give the reflections a watery appearance. Add snow to the base of the trees with Titanium White on the knife. *(Photo 27.)* Again, use a mixture of Liquid White and Titanium White on the knife to cut in the water lines and ripples and the painting is complete. *(Photo 28.)*

FINISHING TOUCHES

Use the point of the knife to scratch in the indication of small sticks and twigs and your masterpiece is ready for a signature. Sign just your initials, first name, last name or all of your names. Sign in the left corner, the right corner or one artist signs right in the middle of the canvas! The choice is yours. You might also consider including the date when you sign your painting. Whatever your choices, have fun, for hopefully with this painting you have truly experienced THE JOY OF PAINTING!

Blue Winter

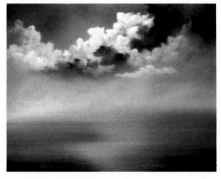

1. Paint the sky with criss-cross strokes . . .

2. and the water with horizontal strokes.

3. Use the fan brush to paint the light clouds . . .

4. . . . then blend with the 2" brush.

5. Working in layers, add the dark clouds . . .

6. . . . and again use the 2" brush . . .

7. . . . to blend and fluff.

Blue Winter

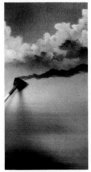

8. Paint the mountain top with the fan brush . . .

9. . . . blend downward with the 2" brush . . .

10. . . . then add snow with the knife.

11. Pull up tiny trees with the 1" brush . . .

12. . . . then add snow with the knife . . .

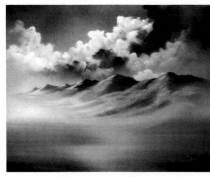

13. . . . to the base of the mountain.

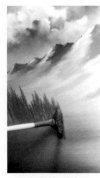

14. Add tiny evergreens with the fan brush . . .

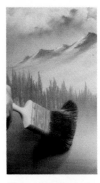

15. . . . then firmly tap to mist with the 2" brush.

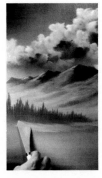

16. Use the knife to add snow.

17. Use the fan brush to push up grassy areas . . .

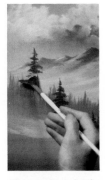

18. . . . and to paint the large evergreens.

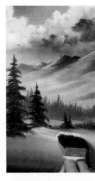

19. Add snow to the base of the evergreens.

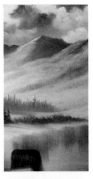

20. Pull down water with the 2" brush . . .

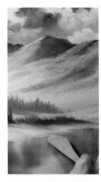

21. . . . then use the knife . . .

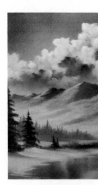

22. . . . to cut in water lines and ripples.

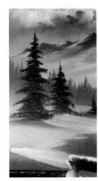

23. Working forward in layers, add snow . . .

24. . . . and the large evergreen.

25. Pull in the shadowed area . . .

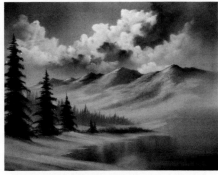

26. . . . at the base of the evergreen.

27. Add trees and snow to the right side . . .

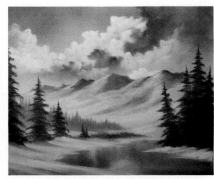

28. . . . and your painting is ready for a signature.

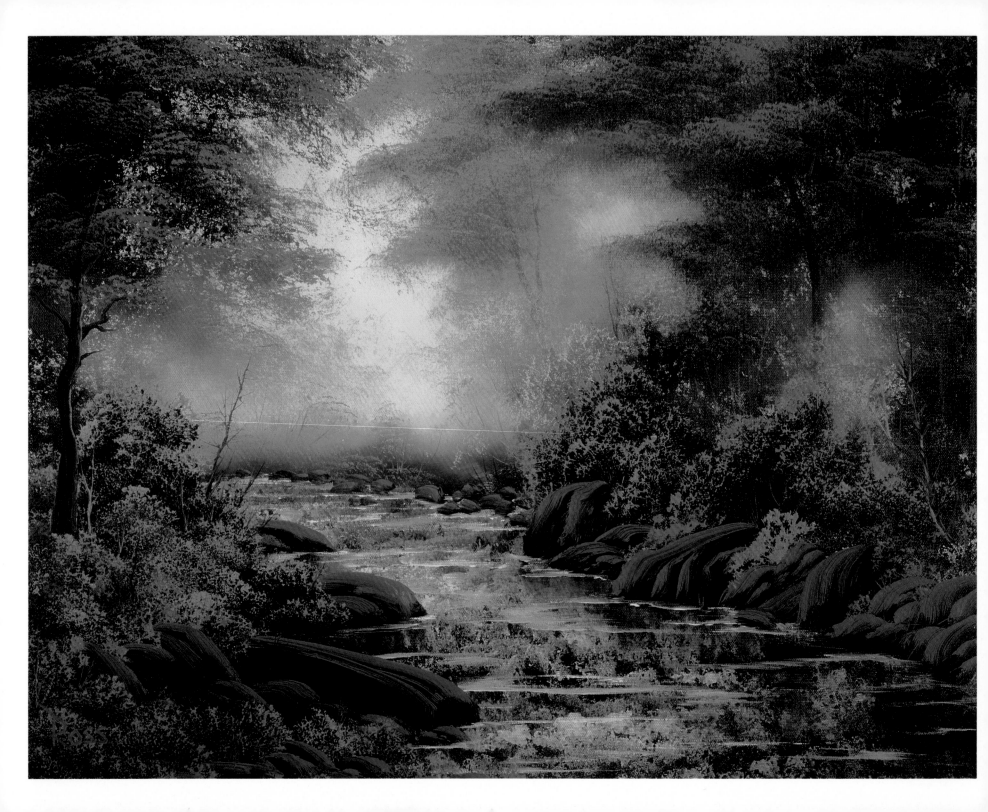

58. TRANQUIL WOODED STREAM

MATERIALS

2" Brush
1" Brush
1" Oval Brush
#6 Filbert Brush
#2 Script Liner Brush
Small Knife
Black Gesso
Liquid White
Liquid Clear
Titanium White

Phthalo Blue
Midnight Black
Dark Sienna
Van Dyke Brown
Alizarin Crimson
Sap Green
Cadmium Yellow
Yellow Ochre
Indian Yellow
Bright Red

Start by using a natural sponge and Black Gesso to loosely under-paint the water and the dark foliage areas of the canvas. Allow the Black Gesso to DRY COMPLETELY before proceeding. (Photo 1.)

When the Black Gesso is dry, use the 2" brush to completely cover the canvas with a VERY THIN coat of Liquid Clear. (It is important to stress that the Liquid Clear should be applied VERY, VERY sparingly and really scrubbed into the canvas! The Liquid Clear will not only ease with the application of the firmer paint, but will allow you to apply very little color, creating a glazed effect.)

Continue using the 2" brush, and criss-cross strokes to apply Indian Yellow to the center, lightest area of the canvas, just above the horizon. Apply Sap Green around the Yellow, then apply a Brown mixture of Alizarin Crimson and Sap Green to the edges of the canvas. The entire canvas should be slick, and wet, and ready to go!

SKY

Load the 2" brush by tapping the bristles into a small amount of Titanium White. Use criss-cross strokes to begin painting the misty glow in the lightest area of the background. (Photo 2.) Reload the 2" brush with the Alizarin Crimson-Sap Green mixture and again, with criss-cross strokes (Photo 3) add the darker misty area, just above the horizon (Photo 4).

BACKGROUND

Use various mixtures of Sap Green, Alizarin Crimson and Titanium White on the 2" brush to under-paint the large background tree on the right side of the painting. (Photo 5.)

Add the tree trunk with the Brown mixture and the liner brush. (To load the liner brush, thin the mixture to an ink-like consistency by first dipping the liner brush into paint thinner. Slowly turn the brush as you pull the bristles through the mixture, forcing them to a sharp point.) Apply very little pressure to the brush as you shape the trunk. Turn and wiggle the brush to give the trunk a gnarled appearance (Photo 6) then lightly tap the tree trunk with a crumpled paper towel to create a mottled effect (Photo 7).

Highlight the background tree and small subtle bushes with various mixtures of Sap Green, all of the Yellows and a small amount of Titanium White on the 2" brush. Proper loading of the brush is very important to the success of these lacy highlights. Load the brush by first dipping it into Liquid White, then holding the brush at a 45-degree angle, tap the bristles into the various mixtures. Allow the brush to "slide" slightly forward in the paint each time you tap (this assures that the very tips of the bristles are fully loaded with paint). To apply the highlights, hold the brush horizontally and gently tap downward (Photo 8) carefully creating the individual leaf clusters (Photo 9).

Working forward in layers, reload the 2" brush with Titanium White and use criss-cross strokes to extend the misty area forward, diffusing the right side of the large background tree. (Photo 10.)

FOREGROUND

Load a clean, dry 2" brush by tapping the bristles into a mixture of Midnight Black, Van Dyke Brown, Dark Sienna, Alizarin Crimson, Sap Green and Phthalo Blue. Working forward in the painting, still tapping downward, under-paint the larger, closer trees and bushes. Create reflections by just pulling the dark tree-color straight down into the water then lightly brushing across (Photo 11).

Add the foreground trunks with a thinned mixture of Brown

and White on the liner brush.

Highlight the foreground trees with the Sap Green-Yellows-Titanium White mixtures on the 2" brush. Be very careful not to completely cover all of the dark base color. *(Photo 12.)*

Working forward in layers, use the 1" brush to shape and highlight the small trees and bushes at the base of the large foreground trees. *(Photo 13.)* To load the brush, first dip it into Liquid White. Then, with the handle straight up, pull the brush (several times in one direction, to round one corner of the bristles) through various mixtures of Sap Green, Midnight Black, all of the Yellows and Bright Red. With the rounded corner of the brush up, start at the top of each bush, touch the canvas, and force the bristles to bend upward. Highlight individual trees and bushes, concentrating on shape and form—try not to just "hit" at random. *(Photo 14.)* If you are careful to not completely destroy all of the dark under-color, you can use it to separate the individual tree and bush shapes. *(Photo 15.)*

ROCKS AND STONES

Use a mixture of Midnight Black, with a small amount of Van Dyke Brown, Phthalo Blue and Alizarin Crimson to paint the rocks. The rocks are highlighted with a mixture of Titanium White, Midnight Black and Van Dyke Brown. Thin both mixtures with a small amount of paint thinner. Load the filbert brush with the dark mixture, then pull one side of the bristles through the light mixture, to double-load the brush. With the light side of the bristles up, use curved strokes to shape the small rocks and stones along the water's edge. *(Photo 16.)* By double-loading the brush, you can highlight and shadow each rock and stone with a single stroke. Double-load the oval brush *(Photo 17)* to paint the large stones.

Working in layers, continue using the 1" brush to add small bushes and foliage among the rocks and stones. *(Photo 18.)*

Load the small knife with a small roll of a mixture of Titanium White and a small amount of Phthalo Blue to scrub in the water lines at the base of the rocks and stones. *(Photo 19.)*

FINISHING TOUCHES

Use the point of the knife to scratch in the indication of sticks and twigs to complete your painting. *(Photo 20.)*

Don't forget to sign your painting: Again, load the liner brush with thinned color of your choice. Sign just your initials, first name, last name or all of your names. Sign in the left corner, the right corner or one artist we know signs right in the middle of the canvas! The choice is yours. You might also consider including the date when you sign your painting. Whatever your choices, have fun, for hopefully with this painting you have truly experienced THE JOY OF PAINTING!

Tranquil Wooded Stream

1. Underpaint the dark areas of the canvas with Black Gesso.

2. Then use criss-cross strokes . . .

3. . . . with the 2" brush . . .

4. . . . to paint the sky.

5. Underpaint foliage with the 2" brush . . .

Tranquil Wooded Stream

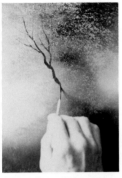 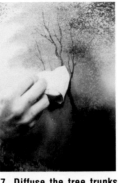 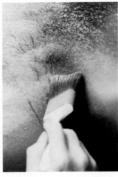 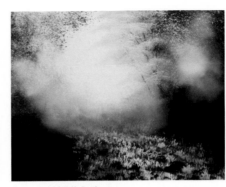

6. . . . then add tree trunks with the liner brush.

7. Diffuse the tree trunks with a crumpled paper towel.

8. Again, tap down with the 2" brush . . .

9. . . . to highlight the trees.

10. Working forward, add misty areas . . .

 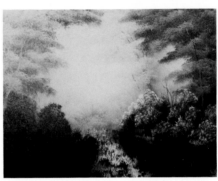

11. Use the 2" brush to pull down reflections . . .

12. . . . and to highlight the trees.

13. Add small trees and bushes with the 1" brush . . .

14. . . . to the base of the large trees . . .

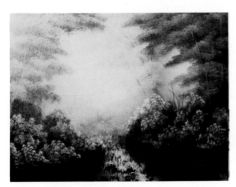 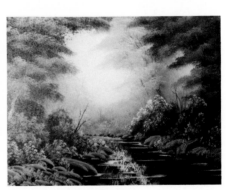

15. . . . always working in layers.

16. Paint small stones with the filbert brush . . .

17. . . . and larger stones with the oval brush.

18. Add small bushes with the 1" brush . . .

19. . . .then cut in water lines with the small knife . . .

20. . . . to complete the painting.

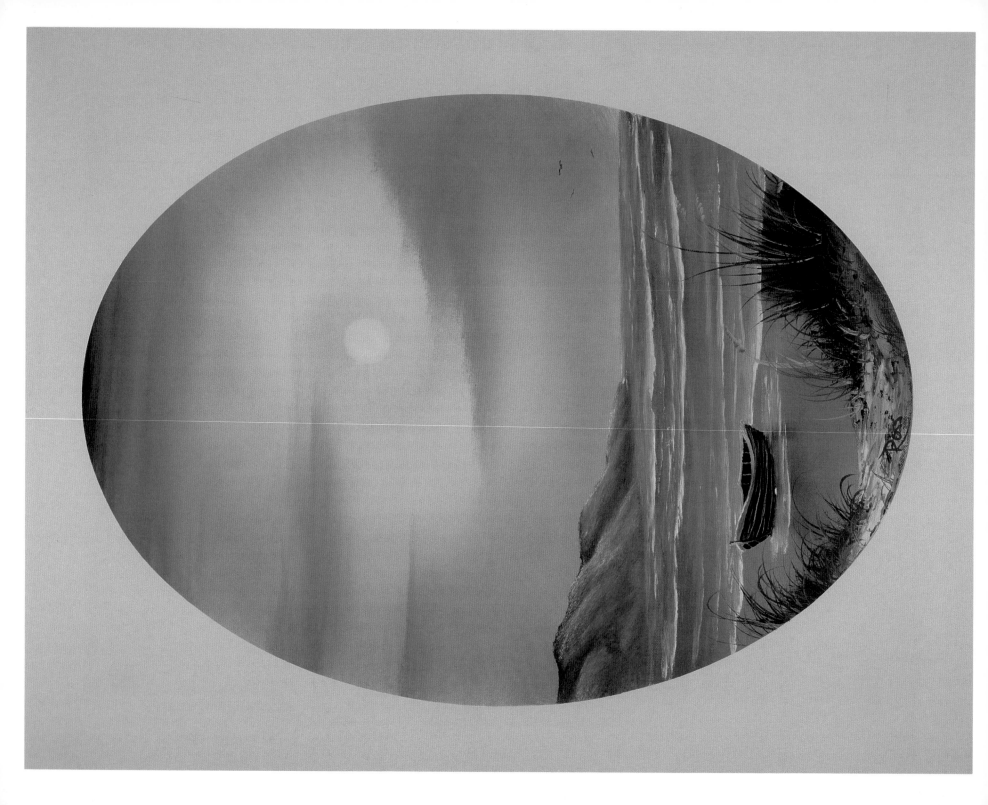

MATERIALS

2" Brush	Titanium White
1" Brush	Phthalo Green
#6 Filbert Brush	Phthalo Blue
#6 Fan Brush	Midnight Black
#2 Script Liner Brush	Alizarin Crimson
Small Knife	Sap Green
Adhesive-Backed Plastic	Cadmium Yellow
Liquid White	Yellow Ochre

Start by covering the entire canvas with a piece of adhesive-backed plastic (such as Con-Tact Paper) from which you have removed a center oval shape. (A 16 x 20 oval for an 18 x 24 canvas.) *(Photo 1.)*

(Note: If you wish, you can place a piece of masking tape across the oval, to mark the horizon. After painting the sky, remove the masking tape to expose a nice, straight horizon line. Be sure to fill in the small area, left dry by the tape, with a small amount of Liquid White before painting the water.)

Use the 2" brush to cover the exposed oval area of the canvas with a thin, even coat of Liquid White. With long horizontal and vertical strokes, work back and forth to ensure an even distribution of paint on the canvas. Do NOT allow the Liquid White to dry before you begin.

SKY

Start by painting a small light area in the sky with Cadmium Yellow on the 1" brush. Reload the brush with Yellow Ochre and begin working outward with small criss-cross strokes. *(Photo 2.)* Clean and dry the brush and continue working outward with a mixture of Titanium White and a small amount of Phthalo Green. Still working outward with small criss-cross strokes, reload the brush with a mixture of Titanium White, Phthalo Green and Midnight Black, then complete the sky with a mixture of Titanium White, Phthalo Green, Midnight Black and Phthalo Blue.

Use a clean, dry 2" brush to blend the sky. Starting just under the sun, hold the brush vertically (with the top corner of the brush in the lightest area of the sky). Use firm pressure to tap downward and outward, as you work around, and move out from the light area, until the entire sky has been blended. To avoid dragging the dark color into the light area, remember to always keep the lightest corner of the brush towards the center of the sky. *(Photo 3.)*

When the entire sky has been blended, clean and dry the brush, then repeat the process with a small amount of Titanium White on the brush, to create a glow, or rays of light in the sky. *(Photo 4.)* Lightly blend the entire sky with long, horizontal strokes.

Reload the 2" brush with the Titanium White-Phthalo Green-Midnight Black-Phthalo Blue mixture to tap in the indication of clouds. *(Photo 5.)* Blend the clouds with soft, horizontal strokes, then use a small amount of Titanium White on your fingertip *(Photo 6)* to add the sun *(Photo 7)*.

HEADLANDS AND WATER

With the Titanium White-Phthalo Green-Midnight Black-Phthalo Blue mixture on the 2" brush, starting just below the horizon, use long horizontal strokes to underpaint the water. *(Photo 8.)*

Use the same mixture on the fan brush to shape the headlands, or background hills, along the horizon. *(Photo 9.)* Lightly blend the hills with the 2" brush *(Photo 10)* then highlight with a small amount of Titanium White on the fan brush *(Photo 11)*.

With a small roll of a mixture of Titanium White, tinted with a small amount of Phthalo Green, on the underside of the small knife, use firm pressure and long, scrubbing, horizontal strokes to paint the waves, starting just below the horizon and working forward. *(Photo 12.)*

Use the same light mixture on the fan brush and vertical strokes to add reflected light to the wet sand, directly under the sun, in the foreground. *(Photo 13.)* Then, with the 2" brush, pull the reflections down and lightly brush across to create the glistening beach. *(Photo 14.)*

ROWBOAT

With the point of the small knife, you can scratch in the basic shape of the rowboat. Use the knife to make a Brown mixture on your palette with equal parts of Sap Green and Alizarin Crimson. Load the filbert brush with the Brown color to block in the shape of the boat. Add Midnight Black to the mixture for the dark areas then use a mixture of Titanium White and Midnight Black for highlights.

Use thinned Brown on the liner brush to add tiny details. (To load the liner brush, thin the mixture to an ink-like consistency by first dipping the liner brush into paint thinner. Slowly turn the brush as you pull the bristles through the mixture, forcing them to a sharp point.) Add highlights with thinned Titanium White on the liner brush.

Paint the boat reflection with the Brown mixture, pull down with the 2" brush and lightly brush across. *(Photo 15.)* Use a thin mixture of Liquid White and Titanium White on the knife to add the water lines *(Photo 16)* to the base of the boat *(Photo 17).*

FOREGROUND

Load the 1" brush with a mixture of Sap Green and the Brown mixture to block in the foreground foliage. *(Photo 18.)* Use a mixture of the Brown and Titanium White on the knife to add the land area, or dunes. *(Photo 19.)*

Use various thinned mixtures of the Brown, Sap Green, Yellow Ochre and Titanium White on the liner brush to pull up long grasses. *(Photo 20.)* Tiny dots on the ends of some of the grasses will make sea oats.

Highlight the sand dunes area with a mixture of Titanium White, the Brown and Yellow Ochre on the knife, using so little pressure that the paint breaks. *(Photo 21.)*

Paint tiny "m" birds with thinned Midnight Black on the liner brush. *(Photo 22.)*

FINISHING TOUCHES

When you are satisfied with your painting *(Photo 23)* carefully remove the Con-Tact Paper *(Photo 24)* to expose your finished masterpiece *(Photo 25)*.

Don't forget to sign your beautiful seascape with pride: Again, load the liner brush with thinned color of your choice. Sign just your initials, first name, last name or all of your names. Sign in the left corner, the right corner or one artist signs right in the middle of the canvas! The choice is yours. You might also consider including the date when you sign your painting. Whatever your choices, have fun, for hopefully with this painting you have truly experienced THE JOY OF PAINTING!

Rowboat On The Beach

1. After applying the Con-Tact Paper to the canvas . . .

2. . . . use the 1" brush to paint the sky.

3. Use the 2" brush to blend the sky . . .

4. . . . radiating out from the light area.

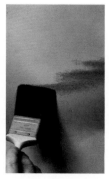

5. Tap in cloud shapes with the 2" brush . . .

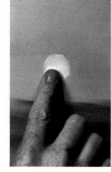

6. . . . add the sun with your finger tip . . .

7. . . . and the sky is complete.

Rowboat On The Beach

8. Use long, horizontal strokes to paint the water.

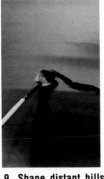

9. Shape distant hills with the fan brush . . .

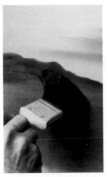

10. . . . then blend with the 2" brush.

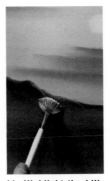

11. Highlight the hills with the fan brush.

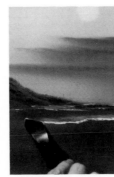

12. Use the small knife to paint waves in the water.

13. Add reflections to the beach with the fan brush . . .

14. . . . then blend by pulling down with the 2" brush.

15. Use the 2" brush to blend the boat's reflection . . .

16. . . . and the knife to add water lines and ripples . . .

17. . . . to the base of the boat.

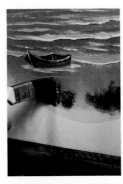

18. Add foreground foliage with the 1" brush . . .

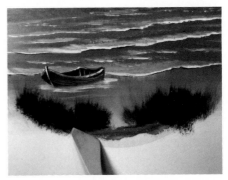

19. . . . and the land area with the knife.

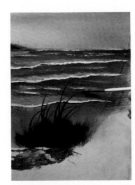

20. Pull up long grasses with the liner brush . . .

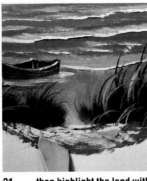

21. . . . then highlight the land with the knife.

22. Add tiny "m" birds with the liner brush . . .

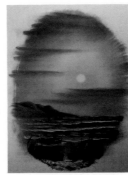

23. . . . to complete the painting.

24. Carefully remove the Con-Tact Paper . . .

25. . . . to expose your finished masterpiece!

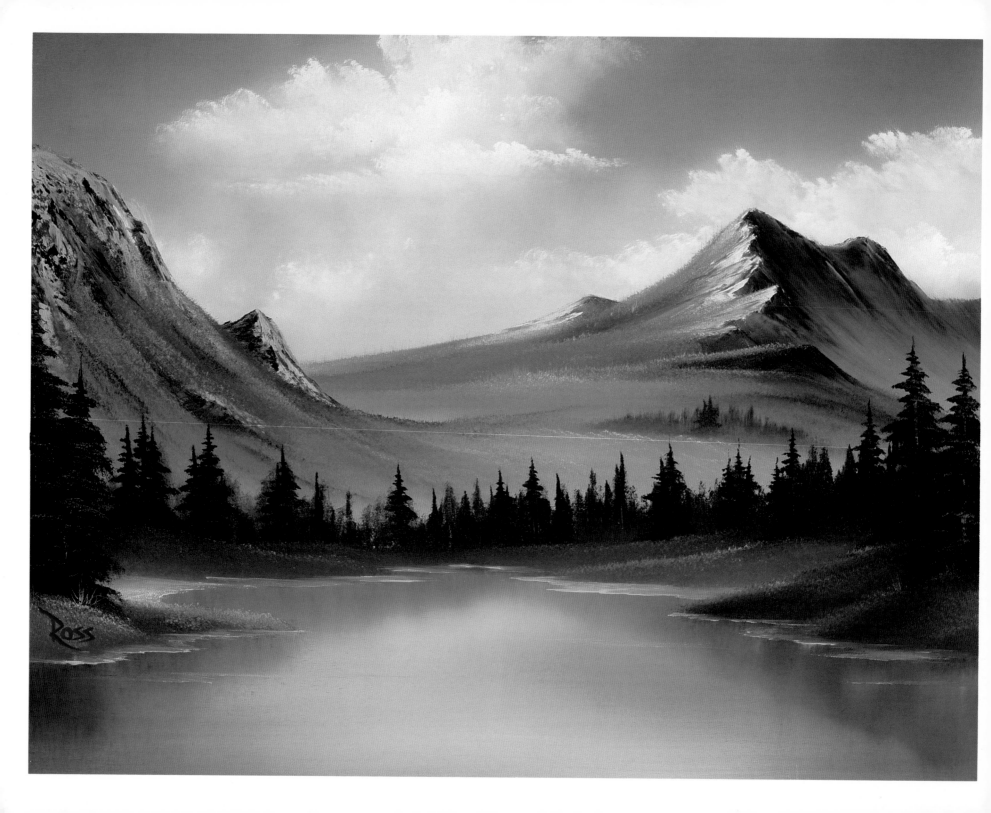

MATERIALS

2" Brush
#6 Fan Brush
#3 Fan Brush
Large Knife
Liquid White
Titanium White
Phthalo Blue
Prussian Blue
Midnight Black

Dark Sienna
Van Dyke Brown
Alizarin Crimson
Sap Green
Cadmium Yellow
Yellow Ochre
Indian Yellow
Bright Red

Use the 2" brush to cover the entire canvas with a thin, even coat of Liquid White. With long horizontal and vertical strokes, work back and forth to ensure an even distribution of paint on the canvas. Do NOT allow the Liquid White to dry before you begin.

SKY AND WATER

Load the 2" brush into a very small amount of Phthalo Blue, tapping the bristles firmly against the palette to ensure an even distribution of paint throughout the bristles. Starting at the very top of the canvas, working down towards the horizon, paint the sky with criss-cross strokes. *(Photo 1.)* The color will blend with the Liquid White already on the canvas and automatically the sky will become lighter at the horizon. Reload the brush with a small amount of Prussian Blue and again use criss-cross strokes to darken just the edges of the sky.

Reload the same brush with a mixture of Phthalo Blue and Prussian Blue to under-paint the water on the lower portion of the canvas. Starting at the bottom of the canvas and working upward, use horizontal strokes, pulling from the outside edges of the canvas in towards the center. You can create a sheen on the water by allowing the center of the canvas to remain light *(Photo 2.)* Use a clean, dry 2" brush with a very small amount of Cadmium Yellow to add a bright highlight to the light, center area of the water. Again, clean and dry the brush and blend the entire canvas with long horizontal strokes.

Paint the clouds in layers; load the 1" brush with Titanium White and make small circular strokes to each of the clouds. *(Photo 3.)* Still with circular strokes, blend out the base of the clouds with the top corner of a clean, dry 2" brush *(Photo 4)* then lightly lift upward to "fluff" *(Photo 5)*.

MOUNTAIN

Starting with the most distant mountain and working forward in layers, begin with the knife and a mixture of Midnight Black, Van Dyke Brown and Prussian Blue. Pull the mixture out very flat on your palette, hold the knife straight up and "cut" across the mixture to load the long edge of the blade with a small roll of paint. (Holding the knife straight up will force the small roll of paint to the very edge of the blade.) With firm pressure, shape just the top edge of the mountain. *(Photo 6.)* When you are satisfied with the basic shape of the mountain top, use the knife to remove any excess paint. Then, with the 2" brush, blend the paint down to the base of the mountain, completing the entire mountain shape. *(Photo 7.)*

Highlight the mountain with various mixtures of Titanium White and Dark Sienna. Again, load the long edge of the knife with a small roll of the mixture. Starting at the top (and paying close attention to angles) glide the knife down the left sides of the peaks, using so little pressure that the paint "breaks". *(Photo 8.)*

To add the soft grassy area at the base of the mountain, load the 2" brush by holding it at a 45-degree angle and tapping the bristles into various mixtures of all of the Yellows, Sap Green, Midnight Black and a small amount of Bright Red and Titanium White. (Allow the brush to "slide" slightly forward in the paint each time you tap; this assures that the very tips of the bristles are fully loaded with paint.) Starting at the base of the mountain, hold the brush horizontally and gently tap downward, paying close attention to angles as you work up the side of each peak. Work in layers, very carefully creating lay-of-the-land. *(Photo 9.)*

Use a small roll of Midnight Black on the knife, applied in the

opposing direction, to shadow the right sides of the peaks. *(Photo 10.)* Again, use so little pressure that the paint "breaks". *(Photo 11.)*

Load the small fan brush with a mixture of Midnight Black, Prussian Blue, Alizarin Crimson and Sap Green. Hold the brush vertically and just tap downward to shape the tiny evergreens at the base of the most distant mountain. *(Photo 12.)* Continues using the 2" brush to add the soft grassy area at the base of the trees.

Use the mountain mixture on the knife to shape the closer mountain top and again, use the 2" brush to blend the color down to the base of the mountain. Highlight the right sides of these peaks with various mixtures of Titanium White, Dark Sienna and Midnight Black on the knife. Paying close attention to angles, use the 2" brush to tap in the soft grassy area at the base of the mountain. *(Photo 13.)* Complete the closer mountain by tapping the base with a clean, dry 2" brush *(Photo 14)* to create the illusion of mist *(Photo 15)*.

BACKGROUND

Use the dark evergreen-mixture on the 2" brush to tap in the land area at the base of the mountains. *(Photo 16.)*

Load the large fan brush with a mixture of Midnight Black, Sap Green, Prussian Blue, Van Dyke Brown and Alizarin Crimson. Hold the brush vertically and tap downward to add the evergreens at the base of the mountain. *(Photo 17.)* Use the corner of the brush to add branches to the more distinct trees. *(Photo 18.)*

Use the 2" brush to pull the dark evergreen color straight down into the water, then lightly brush across to create reflections. *(Photo 19.)*

With various mixtures of all of the Yellows, Sap Green and a very small amount of Bright Red on the 2" brush, tap downward to highlight the soft grassy area at the base of the trees. *(Photo 20.)*

Use a small roll of Liquid White on the edge of the knife to cut in water lines and ripples. *(Photo 21.)*

FINISHING TOUCHES

Use a dark Green-mixture on the fan brush to very lightly touch highlights to the evergreens and your painting is complete. *(Photo 22.)*

Don't forget to sign your name with pride: Load the liner brush with thinned color of your choice. Sign just your initials, first name, last name or all of your names. Sign in the left corner, the right corner or one artist signs right in the middle of the canvas! The choice is yours. You might also consider including the date when you sign your painting. Whatever your choices, have fun, for hopefully with this painting you have truly experienced THE JOY OF PAINTING!

Mountain Ridge Lake

 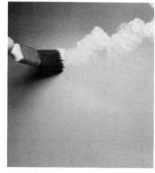 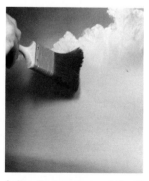

1. Use criss-cross strokes to paint the sky . . .

2. horizontal strokes to paint the water . . .

3. . . . and circular strokes to paint the clouds.

4. Use the top corner of the 2" brush . . .

5. to blend the clouds.

Mountain Ridge Lake

 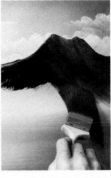 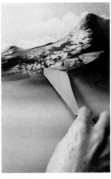 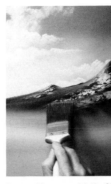 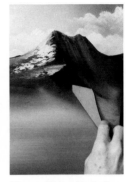 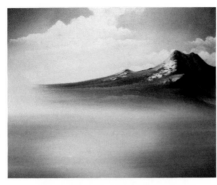

6. Shape the mountain top with the knife . . .

7. then blend the paint down with the 2″ brush.

8. Highlight the mountain with the knife . . .

9. add grass with the 2″ brush . . .

10. then add shadows with the knife . . .

11. to complete the most distant mountain.

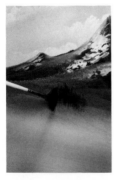 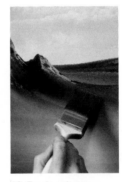 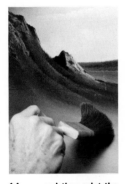 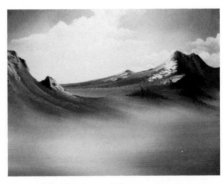 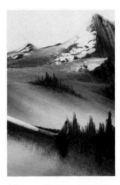

12. Paint tiny evergreens with the fan brush.

13. Tap in soft grass . . .

14. and then mist the base . . .

15. of the closer mountain.

16. Tap in the land area . . .

17. then use the fan brush . . .

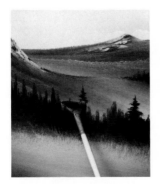 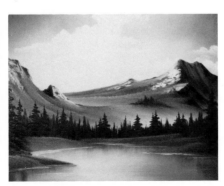

18. to paint evergreens.

19. Pull down reflections . . .

20. then tap in grassy highlights.

21. Cut in the water's edge . . .

22. to complete the painting.

JOY OF PAINTING: The Collection

VOL. 2 · VOL. 3 · VOL. 4 · VOL. 5

VOL. 6 · VOL. 7 · VOL. 8 · VOL. 9 · VOL. 10

VOL. 11 · VOL. 12 · VOL. 13 · VOL. 14 · VOL. 15

VOL. 16 · VOL. 17 · VOL. 18 · VOL. 19 · VOL. 20

VOL. 21 · VOL. 22 · VOL. 23 · VOL. 24 · VOL. 25

VOL. 26 · VOL. 27 · VOL. 28 · VOL. 29 · VOL. 30

ALL INQUIRIES REGARDING

THE AUTHOR AND THIS PAINTING TECHNIQUE

SHOULD BE ADDRESSED TO:

BOB ROSS

P.O. BOX 946

Sterling, Virginia 20167

Telephone: **1-800-BOB ROSS** (1-800-262-7677)

THE AUTHOR

Through his enduring PBS television series "The Joy of Painting," Bob Ross has become known to artists, both amateur and professional, all across the continent.

To millions of other viewers he is a friend who enters their homes weekly or ever daily with a half hour of relaxation and enjoyment and an appreciation of nature as only an artist can see it.

Countless others know him only as "that fuzzy-haired artist who does fabulous paintings in half-an-hour on PBS."

To experienced artists and professionals Bob has brought a fast and easy method of creating beautiful oil paintings. His remarkable wet-on-wet technique has conveyed many artists from the ranks of amateurs into the ranks of those who make what he calls "a happy buck" selling their work and instructing.

For beginners, Bob has provided the inspiration to pick up those difficult oil paints, perhaps for the first time, and begin to learn "The Joy of Painting." He has been the guide and mentor who has helped them from their first timid brush strokes to the proud completion of their first "masterpieces."

With 95% of all Public Television stations showing the series, "The Joy of Painting" has become the most popular learn-to-paint program of all time.

Viewers and painters in every state plus Canada, Mexico and Japan can join Bob at least weekly for a half hour; some stations have shown "The Joy of Painting" as often as three times a day.

It is Bob's gentle and encouraging manner that has won him so many friends and followers across the continent. "Painting should be fun," he constantly reminds viewers.

Bob grew up in Orlando, Florida, when it was still a swampy lowland untouched by the magic of Walt Disney. At 18, he joined the Air Force, beginning a 20-year career in Medical Administration. He was filled with dreams of faraway places. His first assignment was in Florida. "I joined the service to see the world and they sent me back home," he laughs.

Later those dreams did come true. Awesome and unspoiled, Alaska was his home for 12 of those 20 years. It was there that he saw many of those impossibly beautiful scenes he paints each week on "The Joy of Painting."

Throughout his service career, Bob's passion for painting grew. He studied art at colleges and universities across the country and trained under a number of top private instructors.

In 1981 Bob retired from the military to pursue painting full time. In those early years, he traveled constantly, demonstrating and teaching the wet-on-wet technique and sharing "the joy of painting" with thousands of people.

Lots of viewers who watch Bob Ross and "The Joy of Painting" have a special place in their homes devoted to painting, complete with a television set, a comfortable chair, "The Joy of Painting" books, painting supplies and so forth. This "studio" is often the center of activity as friends and family gather around to see what Bob and the "resident artist" are up to!

By making Bob Ross and "The Joy of Painting" a part of our lives, it's more than an interlude, much more than just a pleasant half-hour experience. We are developing a healthy, lifelong interest in nature's beauty and in our own personal sense of expression. As Bob says, "While 'The Joy of Painting' might be responsible for creating the spark, it is you, viewer and friend, who has nurtured and fed the spark into a warm and wonderfully glowing fire."

The happy painting goes on.